Landscape and Authority in the Early Modern World

PENN STUDIES IN LANDSCAPE ARCHITECTURE

JOHN DIXON HUNT, SERIES EDITOR

This series is dedicated to the study and promotion of a wide variety of approaches to landscape architecture, with special emphasis on connections between theory and practice. It includes monographs on key topics in history and theory, descriptions of projects by both established and rising designers, translations of major foreign-language texts, anthologies of theoretical and historical writings on classic issues, and critical writing by members of the profession of landscape architecture.

The series was the recipient of the Award of Honor in Communications from the American Society of Landscape Architects, 2006.

Landscape and Authority in the Early Modern World

Edited by Stephen H. Whiteman

PENN

University of Pennsylvania Press

Philadelphia

Published by
University of Pennsylvania Press
Philadelphia, Pennsylvania 19104-4112
www.upenn.edu/pennpress

Printed in the United States of America on acid-free paper
10 9 8 7 6 5 4 3 2 1

Hardcover ISBN: 978-1-5128-2358-5
Ebook ISBN: 978-1-5128-2359-2

A Cataloging-in-Publication record for this book is available from the Library of Congress.

Contents

PART III. DEFINING MARGINS

PART IV. IMAGINING SPACES

Acknowledgments

This volume began as a panel at the 2014 College Art Association Annual Meeting, "Early Modern Imperial Landscapes in Comparative Perspective." Since then, it has survived international moves, the arrival of children, professional disruptions too numerous to count, and the COVID-19 pandemic. My first and greatest thanks are to my contributors, who stuck with the project and saved their essays for it, despite what must have seemed like long odds. My gratitude, too, to the original CAA speakers: Kelly D. Cook, Mohammad Gharipour, Susan N. Johnson-Roehr, Julie-Anne Plax, and Anton Schweizer, whose papers encouraged me to press forward.

This volume would not have come to fruition without the patience and guidance of my editors at Penn Press, John Dixon Hunt and Jerry Singerman, who never seemed surprised when it resurfaced after a long hibernation; thank you, too, to the entire editorial and design team at Penn, who have helped produce a beautiful book. The advice and criticisms of two anonymous reviewers sharpened the volume and the arguments within it greatly. Support from the Center for Advanced Study in the Visual Arts, The Courtauld Institute of Art, and The University of Sydney assisted with research, travel, and editing over the course of writing and production.

Many of the ideas here first took root in discussion with Rivi Handler-Spitz, with whom I had the joy of team-teaching the early modern at Middlebury College; they have since been tested and refined with my early modern colleagues at The Courtauld, most especially Sussan Babaie. Eddie Vazquez and Marni Williams unstintingly offered support, friendship, and keen editorial insights. As ever, my family has encouraged, ignored, or forced me out the door at all the right times—thank you.

Landscape and Authority in the Early Modern World

Connective Landscapes

Mobilizing Space in the Transcultural Early Modern

Stephen H. Whiteman

C ourts and societies across early modern Eurasia were fundamentally transformed by the geopolitical, technological, and conceptual develop- ments of the period. Evolving forms of communication, greatly ex- panded mobility, the spread of scientific knowledge, and an increasingly integrated global economy all affected the means by which states articulated vi- sions of authority within societies that, in turn, perceived and responded to these visions in novel, and often contrasting, terms. Land—its possession and dispossession, use and exploitation, occupying and traversing—was the funda- mental material of early modern empire and wealth. Landscape—the cultural mediation of the land through sight, architecture, or representation—simulta- neously reflected and served as a vehicle for these transformations, as the rela- tionship between space and its imagination, construction, and consumption became a fruitful site for the negotiation of individual and collective identities within and beyond the precincts of the court.

Focused on sites and narratives from across Eurasia dating to between the early sixteenth and late eighteenth centuries, this volume presents connective and comparative perspectives on the relationship between landscape and au- thority in the early modern world. It explores the role of landscape in the forma- tion and expression of imperial and elite identities, and in the mediation of interactions between courts and their audiences. Nine studies spanning East and Southeast Asia, the Islamic world, and Europe illuminate how early modern courts and societies shaped, and were shaped by, physical spaces, such as gar- dens, palaces, cities, and hunting parks; and conceptual ones, such as frontiers, idealized polities, and the past. Together the essays argue for understanding the period as one of contact and mobility characterized by points of intercultural

congruence and historical coincidence, as well as by local distinctiveness, and its societies as defined by unique forms of connectivity and interchange, rather than simply as nascent modernities.

By taking the physical, conceptual, and represented forms of individual landscapes as ontologically equal yet rhetorically distinct articulations of authority, the volume invites consideration of the complexity with which early modern states constructed and deployed various modes of landscape for different audiences and with varying effects. Positioning an array of subjects and expressions in dialogue with one another, the volume seeks to expand our understanding of landscape as a communicative medium in this period. The essays treat not only unique formations such as gardens, paintings, and manuscripts but also their wider deployment or dissemination via newly accessible spaces of performance and display and rapidly developing technologies of reproduction. More significantly, the authors seek to unpack the relationships between different instantiations or iterations of their chosen landscapes to understand the formal processes by which courts conveyed innovative ideological visions.

The essays are divided into four sections of two or three chapters, arranged to draw out, through commonality and distinction, manifestations of early modern authority within and through the landscape. Part I, "Circulating Discourses," explores landscape as a medium for the global movement of knowledge and ideas via accounts of foreigners abroad, who took the imperial gardens and cities they visited as points of entry for interpreting the world and their individual or collective positions within it. The essays in Part II, "Constructing Identities," describe the conceptualization and articulation of kingly and corporate identities through landscape, particularly at moments of social or political change, demonstrating how these ideological constructions may be used to appreciate differences between rulers or polities. Part III, "Defining Margins," considers cases in which the production of landscape through monuments, maps, and other means served to expand or naturalize the empire's territory, as states sought to define and redefine themselves in geographic as well as ideological terms. Finally, Part IV, "Imagining Spaces," considers how site-specific experiments with pictoriality and virtuality, here through performance and painting, expanded the possibilities of two court landscapes beyond their physical bounds into new dimensions defined by science, memory, and imagination. Together, these themes enhance our understanding of landscape as a rhetorically expressive medium in the early modern world, a powerful means by which rulers, courts, and societies described themselves and others, resulting in diverse, often divergent modes of practice.

Toward a Connected History of Early Modern Landscape

A central purpose of this volume is to explore the possibilities presented by a connective history of early modern landscape across Eurasia, one that transcends the national and regional narratives that have until recent years largely characterized not only garden and landscape history but also art, architecture, and other branches of historical study. The potential for comparative inquiry across the early modern world is illustrated by the ways in which the production of space through garden building, urban design, the definition of territory, and picture making operated as processes for framing imperial identities under various regimes. Contrary to the largely discrete geographically determined and state-specific narratives through which the study of early modern space has long been interpreted, the essays that follow demonstrate the significance of understanding early modern landscapes as situated within a network of inputs and ideas composed of the interaction between local and transcultural factors.[1]

Histories of early modern landscapes have long relied on national boundaries and narratives in defining their subjects, a function of both the field's conventional sources and its long-standing orientation toward Europe. The texts and images through which early modern Europeans defined and described the landscapes they encountered, whether at home or abroad, strongly favored localized explanations of culture. Authors downplayed or domesticated borrowing or contact when it was encountered. Such tendencies reflect the importance of landscape—or, more pointedly, *the land* as mediated through gardens, agriculture, mapping, and other forms of physical or conceptual definition—in epitomizing local, collective identities in this period.[2]

Modern national formations serve as powerfully entrenched lenses through which premodern states are read, both by the nations themselves, whose identities hinge upon contemporary constructions of civilizational pasts, and by many scholars, who have accepted the nation as the essential frame of study, even for periods that predate its formation.[3] National styles and their associations have particularly deep roots in art history, one of garden history's originary disciplines, a regressive model that has rendered the objects of our study static—fixed, iconic signifiers, resistant to change at the imaginative level regardless of practical realities.[4] Thus frozen, if they do travel across political boundaries, they are taken wholesale, limited to either inflicting the blunt force of "influence" or acting as a sort of stylistic currency through which culture and acculturation are supposedly acquired.

Such histories obscure the complexities of the social, political, and cultural formations they seek to describe by overlaying anachronistic configurations

onto the premodern world.[5] Moreover, they occlude both state and social identities such as those characterized by tensions between state control and local or regional fracture; distort evidence of diachronic change, which tends to be similarly collapsed; and ignore the networks of transcultural interaction and interchange that is increasingly recognized as a defining aspect of the premodern world, even long before the so-called global early modern era.[6]

In moving away from the idea of discrete national garden cultures toward a transcultural approach to landscape history, some might argue first for consideration of a *regional* connective history.[7] While a regional perspective can be useful for thinking about the spectrum of ideas that emerged in Europe from the medieval into the early modern period, for instance, one might argue that its Achilles heel is trading the shortcomings of national discourses for those of area studies.[8] In so doing, it privileges particular intercultural interrelations—specifically, intraregional ones between nationally circumscribed actors—assuming them to be natural, leaving others that cross regional and, therefore, cultural boundaries to be either overlooked or treated as exceptional.[9] Moreover, such approaches often prioritize a particular "civilization" within those interactions, such as China within the problematically conceived "Sinosphere," establishing a hierarchy that belies independent local factors, specific historical circumstances, and the often significant transcultural character of such intraregional contact.

Attempts at comparative or world histories of landscape have, for the most part, been similarly problematic. Though the treatment of landscapes outside Euroamerican traditions has grown both more expansive and more refined through the field of so-called world garden histories over the course of the past century, the underlying narrative remains an essentially "Western" one.[10] When the product of a single author, such texts are invariably the work of a specialist in Euroamerican landscape, assuring that discussions of Chinese, Islamic, Indian, or other traditions outside this canon are, in James Wescoat Jr.'s words, all too often "awkward and impressionistic."[11] As Wescoat also notes, non-Euroamerican gardens are typically deployed tokenistically, situated chronologically or conceptually within the narrative in order to set off particular Euroamerican periods or styles through isolated exercises in contrast and comparison.[12] Through this treatment, non-Euroamerican examples become doubly inscribed as "Other," both not of the organizing (Western) structural framework and not comprehensive. As such, they function as silhouettes of historic moments or trends that, within the context of the study as a whole, remain external to the predominant interests of the field.[13]

While a form of Orientalist "Othering" underlies many of these constructs, a broader concern with transcultural, connected study for many scholars is the question of commensurability.[14] Historians have long proceeded from an as-

sumption of cross-cultural incommensurability—the notion that fundamental distinctiveness among cultures prevents them from being compared by a common set of standards—yet this position both derives from and depends upon an essentially Eurocentric historiographic model.[15] Such well-intended tactics are meant to serve as acknowledgment of cultural distinctiveness in the face of dominant interpretive lenses reflective of European paradigms. The result, however, is that this distinctiveness too often becomes fetishized and preserved, amber-like, within effectively Orientalized worlds, timeless and changeless in contrast to the evolving, modernizing West.[16]

Although the primary focus of such essays and collections has often been on specific styles, themes, or periods—a rethinking of the baroque, for instance, or the experience of motion in the garden—recent years have seen cross-cultural comparison take on a more central position and more powerful function, broadening understandings of certain historic forms and practices.[17] Wescoat's work on Mughal gardens is particularly instructive, both for his expansive approach to "comparative possibilities" and for the intentional limits within which he constrains this method. In an essay on the subject included in the 1999 cross-cultural volume *Perspectives on Garden Histories*, Wescoat argues that our understanding of Mughal gardens becomes richer when studied through "regional comparison" with parts of Islamic Central and Western Eurasia, as well as certain areas in Europe.[18] Such comparisons, he suggests, reflect the realities of global movements of ideas and capitalize on existing fields of scholarly strength.

Wescoat illustrates his point through a map visualizing "regional centers of Indian and Islamic garden research" juxtaposed with areas of significant Muslim population.[19] The former takes Al-Andalus, or Muslim Spain, as its western terminus and, leapfrogging the Mediterranean, picks up again in Turkey, stretching across Persia to Central Asia and India. Significantly, Muslim-populated areas stretch to the north and south on either side of this band, including much of Central Asia, the Middle East, and Africa, and extending east to Indonesia. While the map is highly effective in illustrating Wescoat's underlying point— that the complexities of Mughal gardens are fully legible only when read within a larger, "transnational" or transcultural context —it also highlights the limits of the field as it was then (and to some degree still is) conceived. As Wescoat's map clearly illustrates, Islamic culture was in no way hermetic: recent research has demonstrated the extent to which different parts of the Islamic world were deeply engaged with China, Western Europe, and other regions.[20] The context for Islamic landscape studies is potentially much broader than the canonical centers of the field as it has developed, however. Nothing should prevent the study of Islamic gardens extending accordingly, reaching beyond the

supposed borders of the Muslim world and expanding our knowledge of glocal interconnections in the process.

Wescoat's argument has broader implications for the essays in this volume, as well. The connections he describes strengthen our knowledge not only of landscape design but also of the ways in which Mughal rulers understood and used the garden's unique power as a social, cultural, and even strategic space.[21] Erik de Jong makes a similar point when he argues for the importance of investing our study of landscape with a sense of the "garden as process," urging a greater awareness of the routes by which "influence" was incorporated into local gardening practices.[22] Although the term "influence" is largely eschewed here for its inherent asymmetry, de Jong's point is nevertheless of crucial importance: the transcultural transmission of ideas was and is not a passive process, nor one that reflects a simple one-way flow from a charismatic center to an aspiring periphery.[23] Like Wescoat, de Jong understands the movement of knowledge and ideas about landscape as intrinsic to the processes of creating landscapes in early modern Europe, and therefore indispensable to a fuller understanding of their formation, reception, and use. If we think of these processes as reflecting active agency "affected by mutual reception and cultural exchange," then connected histories of landscape may serve to counter received notions of center and periphery that are implicit in models of "influence," advancing instead those of "interchange."[24]

As the field of garden and landscape studies shifts away from formalist and biographical approaches toward greater contextualization, an emphasis on reception, and the potential for comparison, connective histories of landscape suggest yet another turn.[25] The transcultural approach taken here expands the study of landscape history through an integrated examination of spatial practices that transcend national boundaries or Eurocentric frameworks, and draws attention to the transculturally interconnected and yet often locally distinct nature of early modern cultures.[26] This volume encourages engagement with difference via the various ways in which particular concerns, ideas, and approaches were treated in different parts of early modern Eurasia.[27] Grouping studies in a manner that highlights both historic and historiographic interchange means that connections and distinctions emerge not simply in retrospect, as static points of comparison, but are recognized as active agents central to the formation, enlivening, and reception of the landscapes.[28]

This view of transcultural history challenges the *a priori* privileging of connections within and among national and regional formations, instead understanding any one interconnection between two cultures as equivalent to another. Rejecting the designation of a particular culture as the standard against which others are implicitly or explicitly measured, various cultural nodes may, instead,

be imagined as "horizontally" related, connected not by unidirectional flows of influence but by agnostic "vectors" of interrelation.[29] Such self-consciously neutral terms are intended to counter past assumptions about intra- and international and intra- and interregional exchange. They suggest instead a model in which transcultural relationships that have conventionally been taken as somehow natural—China and Japan, or England and Ireland, to take two examples from the essays here—are, in the first instance, made strange, the two cultures revealed to be in one sense as foreign to each other as those on opposite sides of the continent.[30] That the problem of ingrained comparisons is not, in fact, so simple to untangle does not detract from the open-mindedness such a tack engenders, as we are now encouraged to look upon connectedness as value neutral—all connections are equally strange or, more to the point, equally natural, and each has the potential to expand the histories we are seeking to understand.

The nodes that populate such a web are, in principle, infinite, encompassing not only different places but also other contingent elements that help shape cultures and subcultures. In addition to the kinds of connections we might conventionally think of as "transcultural," we should also be alert to analogous interplays between the past, present, and future, across social, political, and linguistic boundaries, and, particularly with regard to landscape, between different artistic media, including the physical landscape and its pictorial expressions.[31] It is impossible to represent all such possible relations in a single volume, of course, or even a lifetime of volumes. The picture of an interconnected early modern Eurasia that emerges in the following pages is thus not an omniscient or encyclopedic one but rather one formed through "the limited and partial perspectives" of selected cases, a fact that need not lessen its instructiveness.[32]

These studies assembled here thus attend first to the times and places of their respective origins, forming a broader history only in concert with one another.[33] The book presumes that localized linguistic, cultural, and historical knowledge is foundational to writing connected histories of gardens and the built environment.[34] It follows that the project of a trans-Eurasian or global history of landscape not only requires collaboration but embraces it as a virtue.[35] Bringing together researchers from a range of disciplines, the volume stages a series of discussions that span methodologies, sources, and interests. While such historiographic interconnections are not new to landscape studies, which has long been an inherently transdisciplinary field, it is hoped that they will work alongside the historic ones outlined in the essays themselves to set both the contributors' subjects and the broader concerns of the field in new light.

"Early Modern" Landscapes

In viewing early modern landscape and the production of space upon which it is predicated from a connective perspective, two questions emerge. First, how does landscape fit within broader definitions of the early modern world, which have until recently focused largely on political, economic, and demographic concerns? And second, what characterizes early modern landscapes, particularly vis-à-vis the construction and articulation of authority?

What is termed the "early modern" period is commonly understood as being marked by a set of broadly congruent, interrelated transformations that occurred roughly concurrently between the mid-fifteenth and the mid-nineteenth centuries in states across the Eurasian landmass.[36] These include significant population growth, intensified agricultural practices, the establishment of large empires, and increasingly commercialized economies; growing degrees of global interconnectivity and its effects, including the far greater reach of seafaring, the development of a world economy, and the accompanying diffusion of information and technologies; and a series of interrelated trends associated with what Victor Lieberman calls the "intellectual contexts" of the early modern world, including the growth of printing, markedly increased informational mobility, rising literacy rates, and more powerful and bureaucratically regularized systems of state control.[37] Within this overarching framework, particular manifestations of these broader developments necessarily reflected the conditional, contingent, and, above all, local nature of change, such that those elements characterizing the early modern emerge at times (and in ways) specific to each locale. The supracultural aspects of early modern change complemented and contextualized internal discourses (not supplanting or superseding them), and vice versa, such that early modern history may be understood in one sense as the dynamic interplay between the local and the transcultural.

While initial theorizations of the early modern engaged with intellectual history, cultural histories were long left essentially untouched. More recently, historians have broadened their scope to include cultural exchange, while in art history, interest in a global frame of cultural analysis has risen dramatically.[38] The latter is of particular relevance to contextualizing this volume, not only because of the strongly visual orientation of the arguments presented, but also thanks to the close historiographic, methodological, and disciplinary ties between histories of garden and landscape and those of art and architecture.[39]

For art historians, the so-called global turn has focused largely on two closely related areas, both of which are instructive in thinking about the prospects of connected histories of landscape: first, the movement of objects across space, including issues of production, reception, and display; and, second, the

movement of concepts and ideas as carried by individuals and objects (including both works of art and books).

The accelerated mobility of objects was first and foremost an outgrowth of early modern economic evolution and, by extension, the increased human mobility that was central to early modern interconnectivity. Trans-Eurasian trade in the early modern centered not only on exotic foodstuffs but also on porcelain, silk, and other aspects of material culture. The fever felt in Europe and America for goods from across Asia drove trading ships and, via them, new developments in taste, design, and production. Exploring these objects' trajectories has revealed the significant degree to which early modern societies were engaged with one another across regional boundaries, as well as the roles such patterns of exchange played in the formation of early modern social and cultural identities.[40]

The latter category of inquiries builds upon the former by charting the migration of ideas, such as vision and visuality, across cultures.[41] Often (though not always) embedded in material objects, these patterns of interchange have been slower to emerge in scholarly literature, both for the elusive nature of the evidence that speaks to them—"hybrid" images, passing textual references, long-forgotten objects in museum storerooms—and for the difficulty in parsing endogenous and exogenous elements in something so intangible as an idea or way of seeing.

It is through the ideas embedded in or behind works of art, including the complex relationships between art and social identities, that connected histories of art and landscape are best able to extend understandings of the early modern beyond the immediate reaches of economic, political, demographic, and even intellectual histories. The diverse dimensions through which landscape is manifested and experienced, drawing on not only the material, visual, and conceptual, but also the physical, spatial, temporal, and virtual, expand the array of interconnections made available by such transcultural interchange.[42] Indeed, given the essential currency of land, the sea, and the mediation of space as cultural practice, landscape may be understood as the foundational frame from which these questions arise—the ground, both literally and metaphorically, upon which the connected early modern stands.

This volume thus considers how landscape acts as a medium for constructing, articulating, and deploying notions of authority in manners legible and meaningful to audiences within and across early modern cultures. W. J. T. Mitchell describes landscape as a "medium" in the sense that it is "a material 'means' . . . like language or paint, embedded in a tradition of cultural signification and communication, a body of symbolic forms capable of being invoked and reshaped to express meanings and values."[43] In this sense, landscape-as-medium exists in productive tension with the more conventional media of its

formation—not only the earth, stone, and wood of its physical sites, such as gardens, cities, and countrysides, but also the textual accounts, paintings, prints, modes of performance, discourses on cultured behavior, notions of kingship, and other constructions that individually and collectively constitute the ideation of a particular landscape. While Mitchell's emphasis on Marxist concepts of value and postcolonial readings of landscape ("the dreamwork of imperialism") are less relevant to this inquiry, his recognition that landscape should be understood "not as an object to be seen or a text to be read, but as *a process* by which social and subjective identities are formed" is directly apropos.[44]

Such processes of identity formation engage both creator and audience in a form of interconnected dialogue articulated through, and mediated by, the landscape. The diverse iterations through which a given landscape can be imagined or constituted allow these dialogic interactions to take a variety of forms. Like more familiar media, the expressive qualities of landscape are shaped by specific material and cognitive (or perceptual) concerns that may be exploited in new ways through the interrelation and manipulation of a landscape's various iterations. Visual and textual associations, the nature of media and performance, and the dynamic experience of space itself allowed early modern rulers to extend the landscape spatially, temporally, and imaginatively in ways that powerfully augmented their ideological messages. Understanding the potential for landscape to function as an interactive, multifaceted process for identity formation simultaneously increased the range of audiences the state might engage and the sophistication required to do so successfully. In this context, Mitchell's "social and subjective identities" connote aspects of authority, such as philosophies of rulership, state formation and legitimization, and charismatic constructions of the king (or other powerful figures), the effective formation and expression of which was a central function of imperial landscapes.

Two interrelated phenomena of the early modern period were particularly significant in these rhetorical exercises: the consolidation and bureaucratic routinization of the state and its elite supporters; and the rise of technologies of communication and scientific knowledge, which contributed to the simultaneous development of new forms of ideological communication and the emergence of increasingly literate audiences for these ideas.

The early modern period saw the emergence of a number of "large, stable states" across Eurasia, including the Tokugawa shogunate, the Qing dynasty, Joseon Korea, czarist Russia, Bourbon France, the Ottomans, the Safavids, Mughal India, the Spanish and Portuguese colonial empires, the Dutch trade empire, and the expansion of England through its own colonial enterprises.[45] Administratively and politically innovative, these states were marked by their ability to establish new systems of state control, leading to territorial consolida-

tion, demographic transparency, and widespread economic expansion.[46] While such changes in bureaucratic efficiency and state–society interrelations were in part a function of systemic and structural advances to state apparatuses, they also reflected the effects, on both sides of the equation, of the explosion of communication enabled by new technologies.[47] Chief among these changes were print and human mobility, whether social or physical. Together, these contributed to the circulation of information and ideas, and, more broadly, a concomitant expansion of the "limits of the inhabited world" on the one hand, and interactions between the local and the regional that resulted in "changing intellectual contexts," on the other.[48]

The emergence of printing in Europe and its massive growth across much of East Asia simultaneously reflected and fed into an increasingly literate, engaged audience for books and images in the fifteenth and sixteenth centuries. As is well established, the "explosion of information" brought about through the expansion of printing served to spread ideas and knowledge of a wide variety across traditionally inscribed geographic and social boundaries, including religions and rituals, literary and artistic cultures, notions of place and identity, and political ideologies.[49] One result was, in Lieberman's terms, to "draw local groups into more sustained interaction."[50] Though Lieberman is not specific about his definition of "local groups," examples that bear his observation out, including those in this volume, demonstrate at least three primary levels of increased engagement in which landscape played a significant role: the local definition of place; transcultural spatial curiosity; and expanded state–subject interrelations.

With the rise of new media cultures and growing mobility, interrelated regional and national identities began to crystallize, such that the local was considered both separate from, and part of, a larger, corporate whole. Local identities were shaped by this new recognition of distinctive cultures and geographies and spread through travel, trade, and new approaches to recording place pictorially and textually. In the early Qing period, for example, a singular sense of place emerged around Anhui Province that was strongly associated with the remarkable topography of the Yellow Mountains (Huangshan 黃山). An Anhui school of painting and printing arose that specialized in images of the region. Patronized by both Anhui merchants, who lived abroad in great numbers, and officials from other parts of the empire who had been posted there, the images formed the foundation of a broader appreciation of Anhui through its landscape that extended well beyond the province's borders.[51] Similar transformations occurred in Japan, parts of the Islamic world, Europe, and elsewhere, aided in large part by developments in the technology and prevalence of cartography, which helped to define and extend knowledge of places and their peoples both at local levels and beyond.[52]

Though perhaps less prevalent a force than intraregional connections, transcultural interchange similarly emerged as an influential factor at the intersection of space and early modern ideas about the world. The ubiquity of Ming blue-and-white porcelain in fashionable European interiors from the sixteenth century, for instance, reveals the degree to which the foreign was a visual and conceptual presence in Europe.[53] Evidence of both European images and material goods in Asia from the same period, although not as numerous or substantial, confirm that this movement was by no means unidirectional.[54] Landscape was of particular importance as a site for engagement across cultures, especially in the minds of Europeans, a bias reflected equally in the decorative patterns featured within their porcelain rooms and the weight given to maps, geographies, travel accounts, and other forms of spatial knowledge in the growing corpus of literature describing Asia for European audiences.[55]

Encompassing aspects of both local and transcultural levels of engagement is a third, that of state–subject interrelations. The "routinization of authority" described by Lieberman has often been defined through administrative reach, including bureaucratic efficiency, improved communication, and what James C. Scott terms "state simplifications," or methods by which the state rendered its population legible at increasingly granular, ultimately individual, levels.[56] While essentially impersonal, these transformations had the effect of shortening the effective distance between the state and its subjects.

Equally important, however, were the innovative methods of communication that expanded the terms of interaction between rulers and subjects. These included verbal, pictorial, and interpersonal modes of ideological expression through which states sought to express notions of authority via media and performative practices, such as commemorative records and touring, in addition to more established forms, such as monumental architecture and ritual. Integral to these emerging forms of communication were interrelated developments in communicative media, especially print, and the rise of literacy broadly writ. The latter should be understood as including not only textual literacy but visual literacy as well, which together contributed to what might be thought of as a nascent cultural literacy—growing engagement with an increasingly shared body of knowledge and information circulating across social and regional lines.

While the emergence of "print capitalism" and its social effects, both unifying and subverting, have received much of the attention in studies of these developments, courts were no less attuned to the possibilities of print than were commercial publishers.[57] In a situation we now see echoed in the use of social media by politicians, many early modern states deployed print as a way of amplifying and augmenting their messages, often applying a remarkably modern-seeming sensitivity to the play between the formal qualities of medium and

genre and experiments with new modes of communication.[58] This, in turn, advanced the complexity with which states designated their subjects as reading and viewing publics, as well as expanding the means by which audiences engaged with state ideology.[59] Beyond more diverse treatments of text and image, the era's arsenal of innovative communication technologies included relating visual media, especially public painting, to the built environment.[60] With the blossoming of a public sphere, the expanding, increasingly sophisticated audience for information and ideas of all sorts, including those disseminated by the state, was met by an equal anticipation of the audience's attention on the part of the state, causing it to cultivate its own more nuanced grasp of how that audience might be engaged.

Virtualization and Iteration

Just as conceptual modes such as text and images were imbued with new power, the physical spaces of early modern authority were also transformed on a number of fronts. Public and private landscapes emerged as sites for the performance of often subtle articulations of authority, including those inflected by ideas of cosmopolitanism, the underpinnings of imperial expansion, and the possibilities offered by new technologies. In various ways, gardens, cities, and territories were imagined, planned, built, used, and reproduced by early modern states to serve rhetorical functions linked to, and reflective of, the broader political, social, economic, and technological changes of the period.

In such cases, the landscape's potential for encoding and conveying ideology did not lie just in the designed or natural environments of authority, such as parks, palaces, or famous places, which operated according to particular visual and spatial rhetorics. It also found expression through the era's innovative virtual, ephemeral, and conceptual means: the embodied experience of the mobile visitor, the spread and consumption of pictorial and textual iterations, the coordination of disparate ideas through ordered vision, and the extension of space beyond its physical boundaries through memory, association, and imagination. In understanding the rhetorical operation of landscape in the early modern period, it is therefore vital not only to consider the dissemination or mobilization of the landscape but also to return to a larger, overarching issue: that of its virtualization in various forms and the implications of multiple interrelated yet distinctive iterations of ideologically meaningful space.

Central to understanding these processes of iteration and virtualization is the interrelationship between the physical landscape and its pictorial, textual, and imaginative forms. Although the following essays problematize these rela-

tionships in a number of different ways, they share a common thread in that they each engage the sense of sight, whether literal or figurative. The importance of vision, or supposed vision, to the rhetorical articulation of landscape identities is well established in studies of both physical and represented spaces.[61] In Denis Cosgrove's terms, the "idea of landscape"—its cultural constructedness—may be understood as "a way of seeing," one that is particularly connected to habits of looking at and understanding pictures.[62] Perspective and its three-dimensional correlate, axiality, play particularly significant roles in these discussions. As an artificial system for ordering space that bears the promise of transparent reality, perspective offers a visual "duplicity" that is, in formal terms, analogous to Stephen Daniels's aesthetic and affective ones—landscape as "an ambiguous synthesis . . . which can neither be completely reified as an authentic object in the world nor thoroughly dissolved as an ideological mirage."[63] Whether perspectively defined or more broadly sensorial, this duplicity of vision derives in part from the inherent tension between the perceived and the imagined.

Vision and visual representation were not the only means by which landscapes were extended and virtualized, even if they were perhaps the most exploited among early modern courts. The first-hand accounts of travelers, imaginative interventions in physical sites, references to real or imagined pasts, poetic and other culturally embedded mediations, and collective memory were all employed by rulers in constructing multivalent spaces. In each case, the capacity for landscapes to be virtualized and for audiences to engage with these virtual iterations, if not on the same terms then in fashions complementary to, or even in lieu of, the physical site, was central to the processes by which landscape operated as a medium for ideological expression.

The use in English of a single word, "landscape" (or its many "-scape" variations), to refer broadly to a variety of forms—physical spaces, a genre of pictorial representation, and the visual or conceptual expressions by which the "landscape" emerges from our interaction with these primary manifestations—further complicates efforts to parse the relationships between them.[64] Some scholars have focused on the degree to which the physical landscape, either "natural" or designed, is understood and consumed in relation to pictorial values.[65] Many others have read landscape pictures as documenting the physical landscape, including acting as vehicles for the diffusion of ideas about design and the experience of space for both historical audiences and modern scholars.[66] These approaches situate the image within a hierarchical relationship, in which the physical space is taken as primary and authoritative. The image is thereby rendered secondary and in some way explanatory, a more or less faithful representation of a particular site, or an illustration of design or normative experience.

For representations of landscape to construct meaning of their own generally requires that they be uncoupled from the specifics of a particular physical site through generic pictorial conventions or temporary disassociation, a move that acknowledges the established "real/representation" dyad even as it suspends its constraints.

What if we instead view topographical images of all sorts and the physical sites to which they ostensibly refer as fully formed, spatial constructions in dialogical relationship with other, related spaces? How might these relationships be accessed, described, and understood? Treating these cognate iterations of the landscape as at once distinct from and also intimately related to each other makes them available not only as sites, texts, images, or ideas defined by another, external site, but also as parallel forms of the landscape through which different audiences could have spatialized experiences of places at varying degrees of physical, temporal, and/or psychological remove from a particular moment in time or geographic locale.[67]

Of course, the pictorial genre of landscape is only one of a number of visual forms through which space was visually constructed in the early modern period. Maps and maplike views, ethnographic images, cityscapes, and other, hybrid pictorial types invested constructions of space with "naturalized systems of power" by rendering authority both legible and seemingly "natural and inevitable."[68] That such effective visual communication was possible even through newly emerging modes of visuality speaks to a number of interrelated conditions: the simultaneous cultivation of multiple audiences by the state and those audiences' growing visual sophistication, described above; the emergence of visual cultures that were increasingly shared across social and political lines rather than being defined by them; particular developments in the understanding of vision and viewing in the early modern period, including "an illusionist representational mode" present in many Eurasian courts that "erode[d] the space between the viewer and the image"; and the productive tension between pictorial and physical space mediated by what may be broadly described as "picturesque vision."[69]

To fully grasp the potential for landscape to operate as a rhetorical medium, it is necessary to explore the interconnection between these various forms or expressions, understanding each as an ontologically equivalent construction rather than a hierarchically ordered series of "primary" and "secondaries." Put differently, understanding landscape as a medium for expression requires not simply recognizing that "places" as complex configurations of meaning and ideas may be constituted of many "spaces" (some more literally spatial and others more abstractly so); it further necessitates a reading of landscape in which the multiple spaces of the physical and the virtualized can each only be fully

realized when understood relationally, as nodes operating within a network of meaning. By attending to these multiple valences through which the landscape operates, we gain a richer sense of the tapestry of spatial, visual, and cognitive elements of which the landscape is holistically composed, and of the terms upon which audiences were intended to, and may in fact have, engaged with these spaces of authority.

Rhetorics and Articulations

The nine essays in this volume each address the issues introduced here in different ways, together working to outline a connective history of landscapes of authority in the early modern world. Incorporating the work of scholars trained in different disciplines and focused on different regions of the world, these essays naturally reveal diverse interests, approaches, and understandings of historical context, and therefore varied engagements with the questions posed. Although the essays also represent distinct vectors within a contextual "matrix of vantage points" through which we may approach landscape histories, it is hoped that at the interstices of the authors' various trajectories, interesting and powerful ideas and connections will emerge.[70] The four sections, while each reflecting central themes in the arguments outlined here, should not be understood as determinative. The chapters could have been organized in any number of ways, and readers are encouraged to experiment with alternative pairings and engaging in further comparisons that they find productive.

The two essays in the first section, "Circulating Discourses," explore the global movement of landscape through travel, encounter, and exchange. Gardens, cities, and the broader environment were all seen as sites for the encoding and enactment of social and political notions, and therefore as vehicles by which receptive foreign audiences could gain fundamental insights into other cultures. That these perspectives offered by travelers and missionaries, prized for their perceived authenticity, reflected more clearly their authors' own values and priorities is not surprising; indeed, this juxtaposition of reportage and projection suggests that early modern identities were actively being negotiated through encounter not only internally or regionally but also, increasingly, globally.

Robert Batchelor's study follows the transcontinental travels of Englebert Kaempfer (1651–1716), from the mapping of Russia to the urban landscapes of Isfahan and Kyoto; John Finlay's essay focuses on collections of information about Qing China from Jesuit sources gathered by Henri Bertin (1720–1792) during his time in the court of Louis XV. Both Kaempfer and Bertin explored foreign landscapes undergoing transformations that echoed similar changes in

their own respective states.[71] Kaempfer's writings and images of Isfahan and Kyoto reveal capitals that he understood to have evolved as part of the Safavid's and Tokugawa's emergence as confessional monarchies. While Kaempfer's perspective certainly reflected contemporary issues in Europe and his own political preferences, Batchelor argues that the German's publications may also offer evidence that such a political transition was characteristic of a number of medium-sized states across Eurasia, not just those in Europe with which it has most often been associated.

For Bertin, gardens and architecture were of particular significance as he sought to gain an understanding of "authentic" China. In the minds of Bertin and many of his peers, China was not only the Qing—a contemporary Eurasian power with which European courts had been in increasingly close contact since the late seventeenth century—but also a place of great antiquity and knowledge, one from which Europe might learn to address certain social and political short-comings. Bertin's sources for this information were Jesuits serving in the Qianlong (r. 1735–1795) court, whose drawings, in Finlay's reading, attest to the interpretive potential of the pictorial virtualization of landscapes that were, for the Frenchman, otherwise beyond reach.

It is a truism of court art and architecture that its monumentality expresses the majesty of the ruler; such is the underlying principle of the grand geometries of Versailles, the forts of Mughal India, even the restrained gardens and interiors of Nijo.[72] The studies that constitute Part II, "Constructing Identities," seek to expand on this idea by looking at landscape not simply as conveying notions of authority but as a medium through which imperial identities were conceptualized and articulated, particularly during periods of political change.

In both high Safavid Isfahan and the central Kansai region of Momoyama Japan, rulers transformed the plans of major cities, and thus the visual and embodied experiences of those spaces, in response to changing political conditions. Ali Emrani maps the descriptions of Isfahan's boulevards and gardens found in a broad variety of traveler's accounts to recreate the complex spatial arrangements of Shah Abbas I's (1571–1629) expanded plan for his capital city. Taking the garden as both underlying plan and constituent element, Shah Abbas transformed his capital to accommodate the changing demographic and political circumstances of his reign while linking it, and his rule, to earlier Persian regimes. Accordingly, the new urban form of Isfahan did not simply express the ruler's authority, it constituted a physical instantiation of a particular mode of cosmopolitan rulership, one widely perceived by the city's diverse range of visitors.

As several centuries of warfare drew to a close in late sixteenth century Japan, Toyotomi Hideyoshi (1536/37?–1598), too, turned to urban form as a me-

dium for constructing a new vision of rulership. Faced with the need to define his own authority independent from, yet relative to, the emperor's, Hideyoshi experimented with new modes of dialogic space that wove his regime's identity "into the fabric of functional cities" through the use of avenues and axes, vision and monumentality—many of the same basic components that appeared in the shaping of landscapes in not only Isfahan but also Rome, Ireland, and elsewhere.[73] Across both urban and palatial spaces, the architectures of authority constructed by Hideyoshi relied upon "a multilayered system of spatiotemporal references," including material evocations of classical Chinese palaces and quite possibly exposure to contemporary Jesuit thinking regarding urban design. These multivalent spaces of power engaged audiences at bodily, sensory, and cognitive levels, the combination of established and innovative elements simultaneously drawing on viewers' collective conscience while actively reshaping their understanding of authority in early modern Japan.

The trio of essays in Part III, "Defining Margins," investigate liminal spaces, the articulation of boundaries, and the processes by which landscape mediates between center and periphery in the expression of imperial identities. In her study of elite landscapes along the River Boyne following the triumph of King William III (1650–1702) in Ireland in 1690, Finola O'Kane examines the linking of history and memory through a series of views connecting monuments and significant places. Arguing that "changing and altering how land is perceived, both by the conquered and the conquerors, is essential for any imperial project," O'Kane describes the inscription of the history of Protestant victory over Catholic forces through the means of gentry estates, history paintings, stele, and other markers. By these means, the king's authority effectively overwrote that of the area's previous owners, projecting the ideology of the center, if not its physical edifices, onto the newly conquered territories.

Caroline Fowler considers a very different form of margin in the ethereal "sea-drafts" of Willem van de Velde the Elder (1611–1693). A Dutchman by birth who spent the latter years of his life painting for the English court, van de Velde created these images within the context of emerging legal debates about sovereignty and the sea. Fowler argues that van de Velde's seascapes operated in a manner analogous to inland pictorial landscapes, functioning as "a central catalyst in the construction of national identities" while defining the sea as a liminal space between competing nations that was not at all empty but instead increasingly social and political. Fowler's study underlines the capacity for images to define physical or imaginative space, rather than the other way around, destabilizing conventional landscape hierarchies. Moreover, it reminds us that while the emergence of international law was a central feature of early modern "glo-

bality," both the law and globality were often partial, defined by and for certain interests while excluding others.[74]

In "Dutch Representations of Southeast Asia," Larry Silver explores the Netherlandish imagination of the Dutch East India Company's quasi-colonial holdings in archipelagic Southeast Asia. Examining a range of pictorial constructions of the Spice Islands, including maps, landscape paintings, and portraits, as well as considering the manners in which they were displayed, Silver argues that Dutch identities—collective and individual, national and territorial—were in part formed through their shaping of Asian space and peoples by means of familiar forms and attributes. The images' inherent claims to truthfulness through visual evidence, a feature shared by Bertin's Jesuit albums, Kaempfer's accounts, and many other examples, allowed viewers to suppose knowledge, and therefore possession, of distant territories, even at third hand, thus integrating the East Indies conceptually, if not legally, into a Dutch imperium.

Inherent in landscape's functioning as a rhetorical medium is, of course, communication between patron and audience, which is most often—though not exclusively—visual. Eyewitnesses and their accounts, the construction of symbolic axes, strategies of display, the pictorial instantiation of otherwise imagined spaces—it is by these visual means that the possibilities of the land have been extended and transformed into landscape of whatever medium. The essays comprising Part IV, "Imagining Spaces," build upon landscape's ability to shift across typologies and the issues of pictoriality, performance, and virtuality raised in earlier essays. They explore ways in which the sense and science of sight, both actual and supposed, operated within landscapes by playing on the act of looking and the viewer's perception of reality.

In arguing for the ontological equivalence of different iterations of a landscape, and for the production of meaning from the dialogue between those iterations, a further, more fundamental question emerges: In formal terms, what is the relationship between any two iterations, and how can we describe or analyze it? On what terms, for instance, may we understand the relationship between a picture of a garden and the physical garden it purports to record? My own essay, "Landscape and Emperorship in the Connected Qing," looks at the multiple pictorial rhetorics employed simultaneously in a depiction of an early Qing imperial estate in order to understand the complex meanings attached to the construction of space in the court. Drawing on endogenous landscape traditions and newly introduced techniques for surveying and perspective, the artist, Leng Mei, linked the site and its portrait through shared acts of cultural association, mathematical measurement, and embodied experience. The result was a form of visual and spatial cosmopolitanism, the emergence of landscape through which the substance of global early modern rule was negotiated.

A significant function of landscape in all contexts is to act as a stage for performance. For early modern monarchs, the garden, perhaps even more so than the city, the hunting ground, or any number of other rhetorically expressive spaces, served admirably in this regard, precisely because a blurring between reality and artifice is inherent to the garden's physical and imaginative forms. In this sense, visibility and its manipulation allowed for a direct connection between ruler and audience, one in which the constraints normally imposed upon such interactions could be altered to serve expressive needs. In Katrina Grant's reading of dramatic entertainment in the courtly gardens of Italy, Spain and France, theater becomes a means of extending the landscape akin to, but distinct from, that of images. Reconstructing specific experiences and events within the garden space, Grant illustrates its role as a literal stage for imperial as well as dramatic performance, and rituals of hospitality that spread through word of mouth and pictorial representation across Europe. For Grant, elaborate sets erected for extended performances created a bridge between the mundane landscape and dramatic fairy worlds, blurring the margin between the two by playing upon the garden's well-established status as a liminal space.

Conclusion

If much of this essay has focused on new ways of framing the history of gardens and landscapes, or suggesting what new insights into these histories other fields and frameworks may help engender, it is worth also asking what such an approach to landscape brings to these other fields. What new questions would the introduction of landscape pose, and what fresh insights does it have to offer? And how are issues of historiography and methodology implicated in these concerns? The field of landscape studies is in many regards quite different to when John Dixon Hunt posed similar questions in 1999, but the vision of this volume is no less ambitious: it aims to offer conceptual and practical grist for rethinking our study of early modern landscape history.[75]

In the way of the "spatial turn," critical engagement with landscape, broadly writ, provides a productive contextualization of the early modern world, particularly around discourses of authority, knowledge, and culture. The idea of space as a communicative medium is not new, but its mobilization as evidence in constructing broader historical narratives is still inconsistently applied. As this collection of essays demonstrates, transcultural histories of landscape, and of art and architecture more generally, feed productively into the economic, political, demographic, and intellectual histories upon which the field was founded. The "idea" of landscape in the early modern was not just an abstract notion or ideal—

it was rooted in the cities, gardens, seas, and territories within and across which early modern transformations took place, and which thus formed the most fundamental terms through which authority was negotiated and expressed.

This project also seeks to model a connected early modern world that offers an alternative to nationally and regionally defined histories of landscape, as connectivity has for other fields. Yet in doing so, this collection also serves to highlight certain persistent limitations in both landscape studies and early modern history. The Global South and precolonial indigenous cultures are almost entirely absent from the present volume, not for lack of effort but because of how limited the field of landscape history in these areas remains.[76] Yet a truly *global* early modern must include these regions, both to extend our understanding of the boundaries of global interconnectivity and to expand our definition of what constituted the early modern beyond the terms set by the major Eurasian territorial empires. These limitations notwithstanding, it is hoped that this volume will help advance existing conversations in the histories of early modern space and landscapes while contributing productively to the progress of garden and landscape studies as a whole in its move toward an inclusive, global, and decentered discipline.

Notes

1. Although Victor Lieberman defines "connective history" as "seek[ing] to establish linkages among contemporary societies without necessarily examining internal forms," the argument here follows Charles H. Parker, who writes: "External interaction of groups . . . plays a vital role in the internal changes that take place in a society." Lieberman, "Introduction," in Lieberman, ed., *Beyond Binary Histories: Re-imagining Eurasia to c. 1830* (Cambridge: Cambridge University Press, 1997), 6–7; Parker, *Global Interactions in the Early Modern Age, 1400–1800* (Cambridge: Cambridge University Press, 2010), 10. On the importance of the local in global histories, see Sanjay Subrahmanyam, "Connected Histories: Notes Towards a Reconfiguration of Early Modern Eurasia," *Modern Asian Studies* 31, no. 3 (1997): 735–62; Subrahmanyam, "Holding the World in Balance: The Connected Histories of the Iberian Overseas Empires, 1500–1640," *American Historical Review* 112, no. 5 (2007): 1359–85; and Subrahmanyam, "Par-delà l'incommensurabilité: Pour une histoire connectée des empires aux temps modernes," *Revue d'histoire moderne et contemporaine* 54, no. 4 bis (2007): 34–54.

2. Erik de Jong dates the notion of national schools of gardening in Europe, in some cases linking "geography, ways of living, and specific modes of gardening," to at least the seventeenth century but argues that the explicit link between "national boundaries" and "a 'national' style" does not emerge until the nineteenth century. De Jong, "Of Plants and Gardeners, Prints and Books," in Michel Conan, ed., *Baroque Garden Cultures: Emulation, Sublimation, Subversion* (Washington, DC: Dumbarton Oaks Research Library and Collection, 2005), 44–45, 49.

3. As an example, a central tenet of so-called New Qing History is that modern China is politically, territorially, and historically distinct from its ostensible predecessor, the Qing

(1644–1911), and that, by extension, not only were all dynasties distinct from one another (the Ming and the Qing as different as the Qing and China) but speaking of "dynastic China" is fundamentally anachronistic. Monica Juneja writes, "Disciplines here have come to be closely tied to identity formations around the nation: this has meant that the nation is the unit of analysis; a narrative of its unique achievements, past and present, explained purely from within, is transmitted through disciplines and institutions." See Juneja, "Circulation and Beyond—The Trajectories of Vision in Early Modern Eurasia," in Thomas DaCosta Kaufmann, Catherin Dossin, and Béatrice Joyeux-Prunel, eds., *Circulations in the Global History of Art* (Farnham: Ashgate, 2015), 59; also, Prasenjit Duara, *Rescuing History from the Nation: Questioning Narratives of Modern China* (Chicago: University of Chicago Press, 1995).

4. On art history as one of garden history's originary disciplines, see de Jong, "Of Plants and Gardeners," 40.

5. Subrahmanyam, "Connected Histories," 738–39.

6. As Subrahmayan, "Connected Histories," 761, writes, "Nationalism has blinded us to the possibility of connection," a process aided by "historical ethnography . . . the thrust of [which] has always been to emphasize difference, and more usually the positional superiority of the observer over the observed." The term "global early modern era" is broadly used in current scholarship, though is used here advisedly out of concern for how "global" it actually was, or what the terms of that globality implied for certain portions of the world. See, e.g., Prasenjit Duara, Viren Murthy, and Andrew Sartori, "Introduction," in Duara et al., eds., *A Companion to Global Historical Thought* (Chichester: Wiley Blackwell, 2014), 6.

7. For example, Michel Conan, "The New Horizons of Baroque Garden Cultures," in Conan, ed., *Baroque Garden Cultures*, 1–36. For European networks focused on landscape creators, see de Jong, "Of Plants and Gardeners," and Lucia Tongiorgi Tomasi, "Gardens of Knowledge and the *République des Gens de Sciences*," in Conan, ed., *Baroque Garden Cultures*, 85–129.

8. Cf. Kären Wigen and Martin W. Lewis, *The Myth of Continents: A Critique of Metageography* (Berkeley: University of California Press, 1997), which argues that the divisions that conventionally define macrogeography do not form culturally coherent regions but are rather the product of a modern, politically inflected, and fundamentally Eurocentric drawing of world boundaries.

9. On intercultural interrelations as natural, see Subrahmanyam, "Connected Histories," 743.

10. For treatments of landscapes outside Euroamerican traditions see, for instance, Michel Conan, ed., *Middle Eastern Garden Traditions: Unity and Diversity* (Washington, DC: Dumbarton Oaks Research Library and Collection, 2007), or two special issues on histories of Chinese gardens edited by Stanislaus Fung in *Studies in the History of Gardens and Designed Landscapes*, 18, no. 3 (1998), and 19, nos. 3–4 (1999). While scholarship of non-Euroamerican landscapes has extended beyond Islamic and Chinese gardens, these two categories have enjoyed particularly favored status in European-language scholarship. Consider, for instance, the comparative dearth of publications on Japanese gardens as opposed to those of China, as well as the near complete absence of the Global South from garden and landscape studies. For a critical discussion from the perspective of Mughal gardens, see James L. Wescoat Jr., "Mughal Gardens: The Re-emergence of Comparative Possibilities and the Wavering of Practical Concern," in Michel Conan, ed., *Perspectives on Garden Histories* (Washington, DC: Dumbarton Oaks Research Library and Collection, 1999), 107–35. For "world garden histories," see Wescoat Jr., "Mughal Gardens," 127–29.

11. Wescoat's characterization of Geoffrey and Susan Jellicoe's treatment of Indian gardens in *The Landscape of Man: Shaping the Environment from Prehistory to the Present Day* (London: Thames and Hudson, 1975; 1995); "Mughal Gardens," 128.

12. For example, Wescoat notes that Mughal landscapes "are situated after the chapter on ancient or medieval gardens but always anachronistically before the Renaissance." "Mughal Gardens," 128. Relatedly, in his introduction to *Baroque Garden Cultures*, Michel Conan argues for including an essay on Northern Song (960–1125) imperial gardens in a volume that otherwise focuses on Europe in the late seventeenth and early eighteenth centuries on the basis of asking "similar questions . . . about distinct objects, . . . when the joint discussion broadens our discussion of the common issues at stake." Conan, "The New Horizons of Baroque Garden Cultures," 26; also, Stephen H. West, "Spectacle, Ritual, and Social Relations: The Son of Heaven, Citizens, and Created Space in Imperial Gardens in the Northern Song," in Conan, ed., *Baroque Garden Cultures*, 291–321.

13. This critique has not stopped the advancement of a certain strain in global historical studies that adopts European terms of periodization and a largely Eurocentric approach while claiming a global view. For instance, both the "global Renaissance" and the "global baroque" are increasingly popular frameworks, particularly (and perhaps not surprisingly) in cultural histories, but their essentially European orientation sets such projects apart from what is argued for here.

14. For recent discussions of commensurability in various branches of comparative historical studies, see, for instance, Subrahmanyam, "Par-delà l'incommensurabilité," and DaCosta Kaufmann, "Reflections on World Art History," in DaCosta Kaufmann, et al., eds., *Circulations in the Global History of Art*, 23–46.

15. In "The New Horizons of Baroque Garden Cultures," 26, Michel Conan writes, "How can we compare Chinese and European arts, and why should we? We may of course look for comparisons when similar questions can be raised about distinct objects, and when the joint discussion broadens our understanding of the common issues at stake. Such a comparison is even more commendable if it sheds new light on the different objects being compared!" Conan and Chen Wangheng express a similar sentiment in their introduction to *Gardens, City Life, and Culture*, where they write: "The contributions of gardens to city life in China are entirely specific to China and reflect the historical capacity for change and renewal of its culture." Michel Conan and Chen Wangheng, "Introduction," in Conan and Chen, eds., *Gardens, City Life, and Culture: A World Tour* (Washington, DC: Dumbarton Oaks Research Library and Collection, 2008), 5.

16. Cf. Craig Clunas, "Nature and Ideology in Western Descriptions of the Chinese Garden," in Joachim Wolschke-Bulmahn, ed., *Nature and Ideology: Natural Garden Design in the Twentieth Century* (Washington, D.C.: Dumbarton Oaks Research Library and Collection, 1997), 21–33.

17. On the baroque or the experience of motion in the garden see Conan, ed., *Baroque Garden Cultures*, and Michel Conan, ed., *Landscape Design and the Experience of Motion* (Washington, DC: Dumbarton Oaks Research Library and Collection, 2003).

18. Wescoat Jr., "Mughal Gardens," 110.

19. Wescoat Jr., "Mughal Gardens," 111, fig. 4.

20. Many examples attest to this; see, for instance, the work of Nebahat Avcıoğlu, Sussan Babaie, Finbarr Barry Flood, and Yael Rice, to name four.

21. For example, James L. Wescoat Jr., "The Changing Cultural Space of Mughal Gardens," in Rebecca M. Brown and Deborah S. Hutton, *A Companion to Asian Art and Architecture* (Malden: Wiley-Blackwell, 2011), 201–29; Wescoat Jr., "Gardens Versus Citadels: The Territorial Context of Early Mughal Gardens," in John Dixon Hunt, ed., *Garden History: Issues, Approaches, Methods* (Washington, DC: Dumbarton Oaks Research Library and Collection, 1992), 331–58.

22. De Jong, "Of Plants and Gardeners," 40.

23. A point relevant to several, though by no means all, of the essays that follow; see those by John Finlay, Katrina Grant, and Anton Schweizer, for instance.

24. "Affected by mutual reception and cultural exchange" in de Jong, "Of Plants and Gardeners," 49.

25. Regarding greater contextualization, emphasis on reception, and potential for comparison see, for instance, Conan, "The New Horizons of Baroque Garden Culture," 1.

26. Cf. Thomas DaCosta Kaufmann, Catherin Dossin, and Béatrice Joyeux-Prunel, "Introduction: Reintroducing Circulations: Historiography and the Project of Global Art History," in *Circulations in the Global History of Art*, 17: "This book arises out of our shared belief that the study of circulations allows for an escape from the Western, or even Northern Atlantic limitations of art historical questions, methods, and institutions, and opens up a new and necessary articulation of theory that is conjoined with pragmatism and materialism in art history." As scholars in other branches of historical study have recently noted, global or connective histories should be understood as an answer not to Western history but to histories constructed through national, Eurocentric, or area studies lenses. See DaCosta Kaufmann, "Reflections on World Art History"; Juneja, "Circulation and Beyond"; and Subrahmanyam, "Connected Histories."

27. As DaCosta Kaufmann and colleagues write, such an approach "invite[s] us not to universalize such terms as the 'eye' or the 'image,' but rather to examine how in different times and places the same object or idea could be seen differently, and to realize the extent to which the issue of cultural differentiation and variation of the 'gaze' mattered to artists, their patrons, and audiences." DaCosta Kaufmann et al., "Reintroducing Circulations," 17–18.

28. Monica Juneja writes, "Both incommensurability and commensurability, I would argue, are seemingly paradoxical dimensions of encounters: they are better grasped as processes rather than reified or static attributes, and could be viewed as constituting a field of forces where they are negotiated through the mediation of different historical agents and practices that repeatedly produce different grades of the commensurable and incommensurable in specific historical conjunctures and local contexts. Their coexistence can induce reflexivity and transformative impulses which are constitutive for the cultures and individuals involved." Juneja, "Circulation and Beyond," 62. Cf. de Jong, "Of Plants and Gardeners."

29. On horizontal relation: "Our ambition is to tackle the difficult subject of 'interculturization' or 'métissage' in a satisfactory, horizontal way that does not try to assign artistic superiority to any agents of the encounter Rather, we wish to examine, horizontally, the complex interplay of alterity and reciprocity at work in the relations between cultures, as well as the dynamics of transformation and integration that result from cultural encounters and confrontations." DaCosta Kaufman et al., "Reintroducing Circulations," 2. On vectors of interrelation see Mary Roberts, *Istanbul Exchanges: Ottomans, Orientalists, and Nineteenth-Century Visual Culture* (Berkeley: University of California Press, 2015), esp. 4–15.

30. On gardens in China and Japan or England and Ireland see the essays by Anton Schweizer and Finola O'Kane, respectively.

31. On analogous interplays between the past, present, and future see David Lowenthal, *The Past Is a Foreign Country* (Cambridge: Cambridge University Press, 1985).

32. As DaCosta Kaufmann and colleagues write, "A comprehensive, global approach does not have to include all possible points of view"; "Reintroducing Circulations," 18. "Global" histories, whether of economics, art, or landscape, are not the same as "non-Western" history, in terms either of a focus on non-Euroamerican subjects or of a simple expansion of the canon to include non-Western objects. Rather, in Duara et al., "Introduction," 1, "the idea of the global" as it is now conceived reframes the study of history, rejecting a view originating in, and returning to Europe, toward "a concept that brings together space and time, such that global spatiality implies global history and vice versa."

33. DaCosta Kaufmann, "Reflections on World Art History," 34. One advantage to taking the early modern as defined here as our period of study lies in the question of multiple temporalities. While affirming the broad notion of local temporalities, the premise of an "early modern" period implies another, broader, and relatively shared temporality across which linkages and comparisons may be observed.

34. Contra Peter Blundell Jones and Jan Woudstra, "Social Order Versus 'Natural' Disorder in the Chinese Garden," *Studies in the History of Gardens and Designed Landscapes* 33, no. 2 (April 2013): 71. Accordingly, the word "global" is also avoided whenever possible, both for its inaccuracy—little is truly "global," and the term serves only to reinforce the erasure of already marginalized regions and cultures—and out of concern that its application in contemporary discourse amounts to a form of Eurocentric intellectual recolonization.

35. Cf. DaCosta Kaufmann, "Reflections on World Art History," 24. DaCosta Kaufmann speaks more ambitiously of a "new world art history" but sees the practical concerns of expertise and narrative as central challenges to be addressed in this process.

36. For concise definitions, see, e.g., Lieberman, "Transcending East–West Dichotomies," 59–61; and John F. Richards, "Early Modern India and World History," *Journal of World History* 8, no. 2 (1997): 199–202. Broader treatments may be found in Duara et al., eds., *A Companion to Global Historical Thought*; Parker, *Global Interactions in the Early Modern Age, 1400–1800*; and Lieberman, ed., *Beyond Binary Histories*. Various periodizations have been offered, including, ca. 1450–1830 (Victor Lieberman, "Transcending East-West Dichotomies: State and Culture Formation in Six Ostensibly Disparate Areas," in Lieberman, ed., *Beyond Binary Histories*, 24); ca. 1350–1750 (Subrahmanyam, "Connected Histories," 736); ca. 1500–1800 (Prasenjit Duara et al., "Introduction," 6; and Richards, "Early Modern India and World History," 197); and ca. 1500–1850 (Jack A. Goldstone, "The Problem of the 'Early Modern' World," *Journal of the Economic and Social History of the Orient* 41, no. 3 (1998): 254). For our purposes here, more important than a particular starting date is the idea that the cultural processes that may be seen as characteristically early modern are clearly present or emerging by circa 1500 (a date noted by DaCosta Kaufmann, as well; "Reflections on World Art History," 37), while the industrial, economic, and geopolitical changes that seem to mark the onset of the "modern" have asserted themselves by the early to mid-nineteenth century (e.g., Lieberman, "Transcending East-West Dichotomies," 90).

37. "'Intellectual contexts' refers here to those formal doctrines and informal currents that defined normative state activity, that sanctioned new interventions, and that both interacted with the material interest and shaped the perception of those interests." Lieberman, "Transcending East-West Dichotomies," 76–77.

38. On historians broadening their scope to include cultural exchange, see, e.g., Subrahmanyam's suggestion of the primary themes of "connected histories" as diplomacy, war, and art; Subrahmanyam, "Par-delà l'incommensurabilité." Collaborative introductions to the questions at stake may be found in Jill H. Casid and Aruna D'Souza, eds., *Art History in the Wake of the Global Turn* (New Haven: Yale University Press, 2014); James Elkins, ed., *Is Art History Global?* (New York: Routledge, 2007); and DaCosta Kaufmann et al., eds., *Circulations in the Global History of Art*.

39. John Dixon Hunt, "Introduction," in Hunt, ed., *Garden History: Issues, Approaches, Methods* (Washington, DC: Dumbarton Oaks Research Library and Collection, 1992).

40. Several important recent examples include Nebahat Avcıoğlu and Finbarr Barry Flood, eds., *Globalizing Cultures: Art and Mobility in the Early Eighteenth Century, Ars Orientalis* 39 (2010); Daniela Bleichmar and Peter C. Mancall, eds., *Collecting Across Cultures: Material Exchanges in the Early Modern Atlantic World* (Philadelphia: University of Pennsylvania Press, 2013); Caroline Frank, *Objectifying China, Imagining America: Chinese Commodities in Early America* (Chicago: University of Chicago Press, 2012); and Anne Gerritson

and Giorgio Riello, *The Global Lives of Things: The Material Culture of Connections in the Early Modern World* (London: Routledge, 2016).

41. Exemplary recent publications include Kristina Kleutghen, *Imperial Illusions: Crossing Pictorial Boundaries in the Qing Palaces* (Seattle: University of Washington Press, 2015); and Dana Leibsohn and Jeanette Favrot Peterson, eds., *Seeing Across Cultures in the Early Modern World* (London: Routledge, 2012).

42. The latter characteristics may also be said to apply to works of art, particularly as art is understood today to include relational, site-specific, performance, and installation-based practices, but they are not inherent to the material, visual, and conceptual qualities of the art of the time, for example, a painting or dish, in the way that they are for landscapes.

43. W. J. T. Mitchell, "Imperial Landscape," in Mitchell, ed., *Landscape and Power*, 2nd ed. (Chicago: University of Chicago Press, 2002), 14–15.

44. "The dreamwork of imperialism": Mitchell, "Imperial Landscape," 10. "As *a process*" (emphasis added): Mitchell, "Introduction," in Mitchell, ed., *Landscape and Power*, 1. Cf. de Jong, "Of Plants and Gardeners," 40.

45. "Large, stable states": Richards, "Early Modern India and World History," 201. Of course, not all of these constituted states on precisely the same terms, nor were all equally large; for the purposes of this volume, however, stability is the shared characteristic, while forms of state communication and control are of greater significance than the relative landmass under control.

46. Lieberman, "Introduction," 30–33; Richards, "Early Modern India and World History," 201–2; cf. James C. Scott, *Seeing Like a State: How Certain Schemes to Improve the Human Condition Have Failed* (New Haven: Yale University Press, 1999), chap. 1, "State Projects of Legibility and Simplification."

47. What Richards refers to as "the diffusion of new technology and organized responses to them throughout the early modern world," though he is referring specifically to crops, gunpowder, and printing; Richards, "Early Modern India and World History," 203–4.

48. "The early modern period defines a new sense of the limits of the inhabited world, in good measure because it is in a fundamental way an age of travel and discovery, of geographical redefinition The period witnesses the expansion in a number of cultures of travel, as well as the concomitant development of travel-literature as a literary genre These voyages were accompanied by often momentous changes in conceptions of space and thus cartography; significant new 'ethnographies' also emerged from them." Subrahmanyam, "Connected Histories," 737. "Changing intellectual contexts": see my note 46.

49. Mary Elizabeth Berry, "Was Early Modern Japan Culturally Integrated?" in Lieberman, ed., *Beyond Binary Histories*, 116.

50. Lieberman, "Transcending East-West Dichotomies," 44.

51. See James Cahill et al., *Shadows of Mount Huang: Painting and Printing of the Anhui School* (Berkeley: University of California, Berkeley Art Museum, 1981).

52. See, for instance, papers delivered as part of "Ottoman Topologies: Spatial Experience in an Early Modern Empire and Beyond" (Stanford University, 16 May 2014); and Marcia Yonemoto, *Space, Place, and Culture in the Tokugawa Period, 1603–1868* (Berkeley: University of California Press, 2003).

53. For instance, Anne Gerritsen, *The City of Blue and White: Chinese Porcelain and the Early Modern World* (Cambridge: Cambridge University Press, 2020); Dawn Odell, "Porcelain, Print Culture, and Mercantile Aesthetics," in Alden Cavanaugh and Michael E. Yonan, eds., *The Cultural Aesthetics of Eighteenth Century Porcelain* (Farnham: Ashgate, 2010), 141–58; and Thijs Weststeijn, "Cultural Reflections on Porcelain in the Seventeenth-Century Netherlands," in J. van Campen and Titus Eliens, eds., *Chinese and Japanese Porcelain for the Dutch Golden Age* (Amsterdam: Rijksmuseum, 2014), 213–29, 265–68.

54. While oversimplifying aspects of global interchange, Timothy Brook, *Vermeer's Hat: The Seventeenth Century and the Dawn of the Global World* (New York: Bloomsbury, 2008), chaps. 6–8, offers relatively unusual accounts of the reception of European objects and goods in China. More compelling is the recent work of such art historians as Timon Screech and Lai Yu-chih, among others, who demonstrate the presence of specific images and pictorial technologies in Japan and China, respectively, through domestic artistic production; see, for example, Timon Screech, *The Lens Within the Heart: The Western Scientific Gaze and Popular Imagery in Later Edo Japan* (Honolulu: University of Hawai'i Press, 2002), and Lai Yu-chih, "Images, Knowledge, and Empire: Depicting Cassowaries in the Qing Court," *Gugong xueshu jikan* 29, no. 2 (2011): 1–75; translated and reprinted in *Transcultural Studies* 1 (2013): 7–100.

55. Works of this genre are far too numerous to cite here; such materials are central to the studies by Robert Batchelor, Ali Emrani, and John Finlay in this volume.

56. Lieberman, "Transcending East-West Dichotomies," 26; Scott, *Seeing Like a State*, chap. 1. Examples of "state simplifications" include cadastral surveys, household registration, and, in later eras, individual identifiers, such as identification papers of various sorts.

57. For "print capitalism," see Benedict Anderson, *Imagined Communities: Reflections on the Origin and Spread of Nationalism* (London: Verso, 1991); cf., for instance, Roger Chartier, *The Cultural Uses of Print in Early Modern France* (Princeton: Princeton University Press, 1987).

58. For an example relating to landscape in the Qing court, see Stephen H. Whiteman, "Translating the Landscape: Genre, Style, and Pictorial Technology in the *Thirty-Six Views of the Mountain Estate for Escaping the Heat*," in Richard E. Strassberg and Stephen H. Whiteman, *Thirty-Six Views: The Kangxi Emperor's Mountain Estate in Poetry and Prints* (Washington, DC: Dumbarton Oaks Research Library and Collection, 2016), 73–119.

59. "Designated their subjects as reading and viewing publics": used here after Anne E. McLaren, "Constructing New Reading Publics in Late Ming China," in Cynthia Brokaw, ed., *Printing and Book Culture in Late Imperial China* (Berkeley: University of California Press, 2005), 153, to mean "the target public addressed by the author or publisher as distinct from the 'audience' or actual historical readers"; cf. Natalie Zemon Davis, "Printing and the People," in Davis, *Society and Culture in Early Modern France* (Stanford: Stanford University Press, [1965] 1985), 192–93.

60. See, e.g., Larry Silver's essay and my essay in this volume. An important study of innovations in the interaction between painting and architecture in this period is William H. Coaldrake, *Architecture and Authority in Japan* (London: Routledge, 1996), chap. 6, "Nijo Castle and the Psychology of Architectural Intimidation," 138–62.

61. For a diverse sample of this substantial literature, see, for instance, Denis Cosgrove, "Prospect, Perspective, and the Evolution of the Landscape Idea," *Transactions of the Institute of British Geographers* 10, no. 1 (1985): 45–62; D. Fairchild Ruggles, *Gardens, Landscape, and Vision in the Palaces of Islamic Spain* (University Park: Pennsylvania State University Press, 2000); and Svetlana Alpers, "The Mapping Impulse in Dutch Art," in *The Art of Describing: Dutch Art in the Seventeenth Century* (Chicago: University of Chicago Press, 1983), 119–68.

62. Denis Cosgrove, *Social Formation and Symbolic Landscape*, 2nd ed. (Madison: University of Wisconsin Press, 1998), esp. the introduction and chap. 1. Although Cosgrove quite intentionally confined his argument to European traditions of landscape formation, his argument applies equally well to other Eurasian cultural contexts.

63. Stephen Daniels, "Marxism, Culture and the Duplicity of Landscape," in Richard Peet and Nigel Thrift, eds., *New Models in Geography* (London: Routledge, 1989), 425.

64. For discussions of the meaning and origins of "landscape" as a cultural, geographic, or art historical term, see, e.g., John Brinkerhoff Jackson, "The Word Itself," in *Discovering the Vernacular Landscape* (New Haven: Yale University Press, 1984), 1–8.

65. E.g., Katherine Myers, "Visual Fields: Theories of Perception and the Landscape Garden," in Martin Calder, ed., *Experiencing the Garden in the Eighteenth Century* (Bern: Peter Lang, 2006), 13; cf. Linda Cabe Halpern, "The Uses of Paintings in Garden History," in Hunt, ed., *Garden History: Issues, Approaches, Methods*, 183n3.

66. Albeit on different terms. See, for examples, essays in Conan's volume *Baroque Gardens*, esp. Conan's introduction, pp. 30–33, which discusses representations of gardens as sources for their "social reception." Also, Halpern, "The Uses of Paintings in Garden History," 184; Alpers, "The Mapping Impulse in Dutch Art"; and Edward S. Casey, *Representing Place: Landscape Paintings and Maps* (Minneapolis: University of Minnesota Press, 2002).

67. Cf. David L. Hall and Roger T. Ames, "The Cosmological Setting of Chinese Gardens," *Studies in the History of Gardens and Designed Landscapes: An International Quarterly* 18, no. 3 (1998): 175–86.

68. Berry, "Was Early Modern Japan Culturally Integrated?" 131.

69. "An illusionist representational mode": Juneja, "Circulation and Beyond," 71. "Picturesque vision": Myers, "Visual Fields," 13–14.

70. "Matrix of vantage points": Wescoat Jr., "Gardens Versus Citadels," 335.

71. Isfahan and Kyoto are discussed separately in essays by Ali Emrani and Anton Schweizer, respectively.

72. On varieties of architectural monumentality, see Coaldrake, *Architecture and Authority*, chap. 1, "Authority in Architecture: Container and Contained," 1–15.

73. E.g., Finola O'Kane's essay in this volume.

74. While in this case European, this type of partial globality (which might also be understood as a form of asymmetrical transcultural interchange) was by no means exclusively European. The case of the Macartney Embassy to the Qing court in 1793 offers a famous example of an encounter between competing ideas of international custom, there in the context of diplomatic protocol. See, e.g., James Hevia, *Cherishing Men from Afar: Qing Guest Ritual and the Macartney Embassy of 1793* (Durham: Duke University Press, 1995).

75. John Dixon Hunt, "Approaches (New and Old) to Garden History," in Conan, ed., *Perspectives on Garden Histories,* 77–90, asks this question more broadly, and rhetorically, with regard to the history of gardens as a whole in framing his essay.

76. Goldstone also notes the historiographic problem of an "early mordern world" that excludes "China, Korea, Southeast Asia, Russia, the Middle East, and Africa"; although he has proven mistaken about a number of those regions, which are now central to our readings of the early modern, the critique remains substantially salient with regard to Africa, South America, and much of Australasia; Goldstone, "The Problem with the 'Early Modern' World," 255. On the exclusion of Africa, in particular, from the history of landscape, see Grey Gundaker, "Design on the World: Blackness and the Absence of Sub-Saharan Africa from the 'Global' History of Garden and Landscape Design," in John Beardsley, ed., *Cultural Landscape Heritage in Sub-Saharan Africa* (Washington, D.C.: Dumbarton Oaks Research Library and Collection, 2016), 15–60.

PART I

Circulating Discourses

From Imperial to Confessional Landscapes

Engelbert Kaempfer and the Disenchantment of Nature in Safavid and Tokugawa Cities

Robert Batchelor

> Landscape might be seen more profitably as something like the "dreamwork" of imperialism, unfolding its own movement in time and space from a central point of origin and folding back on itself to disclose both utopian fantasies of the perfected imperial prospected and fractured images of unresolved ambivalence and unsuppressed resistance.
>
> —W. J. T. Mitchell, *Landscape and Power*

From the gardens of Qing Beijing (1644–1912) and Mughal Agra (1526–1857) to those of Bourbon Versailles (1589–1792, 1814–1830), new strategies for creating imperial landscapes emerged in empires across the globe during the early modern period. Part of imperial "repertoires of power," such efforts should not merely be seen as a kind of crude ideological domination of territory. They had strong links with other cultural techniques for shaping both space and time, ranging from observatories and calendars to urban planning and maps that worked in tandem to reshape understandings of cosmology and religion. Landscapes in this context increasingly served as a kind of interface for defining an ethical sense of nature.[1] To bolster that ethical dimension, in certain cases, such as Safavid Persia (1501–1736) and Tokugawa Japan (1603–1868), imperial techniques were taken in what might be called confessional directions to distinguish regionally focused polities from nearby multiethnic empires with

universalist aspirations like the Ottoman (1299–1922) or the Qing. These confessional landscapes desacralized nature and at the same time abandoned the lingering and still totalizing claims to the sacred put forward by larger empires. In this sense, they exhibited both the fracturing aspects of ambivalence and resistance that W. J. T. Mitchell writes of, as well as, in the case of the traveler Engelbert Kaempfer (1651–1716), a "folding back" that addressed European and specifically British fantasies of the imperial.

The imperial landscape was in many ways a more profound development than the imperial map, also characteristic of the early modern period.[2] Landscapes broadly conceived in terms of managed terrains, planned gardens, and material images helped develop what Mitchell has called "critical idolatry" or "secular divination," framing and narrowing older unified cosmographic images of nature while at the same time resisting more radical forms of iconoclasm also characteristic of the period. The reflecting pools, pavilions, and grottoes of such gardens became what Mitchell calls "echo chambers" or, to use the more fluid metaphor of the Kangxi 康熙 emperor (1654–1722) for a garden river, "thinking space" (*Hao Pu jianxiang* 濠濮間想).[3] Even within large empires like the Qing, these new landscapes embodied and maintained ambivalences about the coherence of the sacred, ambivalences that emerged through the imperial and global interactions of this period. Whether the irrational double body of the king at the head of rational Versailles or the formal typologies of a southern Chinese literati landscape at Kangxi's Bishu shanzhuang 避暑山莊 placed in the service of a Manchu empire with Lama Buddhist leanings, imperial landscapes often worked to supplant the religious or enchanted dimensions of nature, folding in mystical or unseen powers and creating spaces for a thinking subject bounded by the landscape.[4]

The confessional landscape of smaller polities took this a step further in competition with the cultural gravity of large empires like the Qing, Ottoman, and Russian. Such landscapes could consolidate and naturalize the emerging state, acting as a defense against political and religious conflicts. Such conflicts often emerged in dynamic relationships with overseas merchants, especially those tied to maritime empires and polycentric oceanic economies like the Portuguese, Dutch, and English. For both the Safavids, who built a new capital at Isfahan (1598), and the Tokugawa, who built their power from Edo (1590), this rapid urbanization of the center stood in tension with at least three contrasting models of urbanization—the dynamics of regional commercial centers like Tabriz and Osaka, religious and cultural centers like Shiraz and Kyoto, and globally connected ports like Bandar-e ʿAbbās and Nagasaki.[5] Confessional landscapes secularized in relation to pleasure and sociability yet retained allusions to older cultural traditions and religious concepts. This served as a substi-

tute for and a supplement to the older sacred landscape of shrines and pilgrimage sites. They also attempted to blend and resolve significant sectarian fractures, such as those between Sufi urban guilds and the institutions of the Shi'a 'ulama in Safavid Persia or among the various competing and often syncretic schools of Shinto, Buddhism, and neo-Confucianism in Japan. The center sought a coherent and balanced natural aesthetic, a sociability reliant on forms of domestic tourism, and even an ethics that could appeal to a broader popular imagination. As a result, both gardens and landscape imagery took on a larger cultural role beyond courtly centers. This tapped into both the commercialized imagery of the cities and the increasing global circulation of image-bearing commodities, including books and prints.

The disenchantment of the landscape as well as the emergence of confessionalism are developments often uniquely associated with the European Enlightenment—more precisely the long Enlightenment that emerged in the aftermath of the Thirty Years' War (1618–1648).[6] Scientific and rational thinking about the world supposedly replaced the totalizing magical and sacred landscape associated with Christian cosmology and its pagan inheritances. Such scholarship has relied in part on Max Weber's broader concept of "the disenchantment of the world" (*die Entzauberung der Welt*).[7] For Weber, disenchantment emerged because of multiple layers of technical commodification and the impact of new kinds of distant actions. More remote institutions and technologies had the power to deeply impact the imagination on a regional or local scale. This "modern" disenchanted landscape was decidedly post-paradisiacal, having lost the sense of nature as an enchanted Edenic garden infused with sacred and local meaning. As Jean-Jacques Rousseau's (1712–1778) character Saint-Preux complained in *La Nouvelle Héloïse* (1761), the landscape had turned virtual.[8] A quasi-utopian and transcendent sense of secular authority and of nature itself helped internalize religious meaning.[9] Meanwhile, the production of the visible landscape increasingly depended on layers of imagery created through distant and unseen processes—a process called "l'assemblage" by Rousseau. In such a world, landscape became a technique of meaning, a medium or even more precisely an interface to make the previously invisible sacred at least partially visible. The fixed authority of lineage and kinship became potential for "natural" movement, critique, and change.

Recent debates over the question of the secular and the post-secular have revived Weber's ideas while at the same time questioning their totality as social facts. Post-secularists in particular have argued that, despite the appearance of a sharp break around 1700 (the Enlightenment), the conceptual terms of secularism largely replicated and often simply inverted Christian ideas about immanence and transcendence.[10] Thomas Hobbes's (1588–1679) sovereign hovering

over the landscape or Voltaire's (1694–1778) character Candide returning to the garden both build a kind of metaphysical dimension into apparently secular critiques. In such canonical interpretations, the phenomenon of disenchantment still remains *culturally* tied to Europe. But as the earlier reference to Kangxi suggests, *temporally* across early modern Eurasia radically new perceptions of the landscape simultaneously emerged in which a disenchanted nature driven by globally oriented techniques of power took on an increasingly important role.

The disenchantment of the early modern landscape was then, to use Mary Louise Pratt's word, *transcultural*, and it took place in the aftermath of mass global movements of actual images of natural forms and landscapes, most commonly floral patterns or pastoral scenes appearing on exported commodities during the sixteenth and seventeenth centuries such as porcelains, cloth, prints, and other pieces of material culture.[11] In confessional landscapes of the late seventeenth and eighteenth centuries, these processes began to fold back in and create an image of a disenchanted and transcultural engagement with nature, both in some of the emerging "national" spaces of Europe and in certain middle-sized "empires" like Safavid Persia and Tokugawa Japan.[12] Indeed, the confessional landscape can even be thought of as post-confessional, a strategy for naturalizing a prior break from universalist ideas about religion and imperial authority.

As a "natural" and open-ended mix of the secular and the sacred tied to the emergence of the early modern state, the confessional landscape thus differs substantially from the classical notion of the confessional state. In Europe, the rise of the confessional state is often associated with the conflicts of the Holy Roman Empire, especially after the Peace of Westphalia in 1648. It took classic form in small polities like Saxony, where confessional authority could be tightly regulated. For the confessional landscape, however, the more ideologically tolerant examples of Britain and the Netherlands offer paradigmatic European cases. In both, a visual sense of open naturalness allowed nature to supplant church and king as authorities. Unlike imperial landscapes, this vision of nature was not directly tied to a form of absolutist state. Openness instead involved spatially limited and historically determined understandings of religion and culture expressed through the landscape itself.[13] So in Britain, the naturalized garden and landscape expressed a sense of "natural liberty" distinct from more geometrically rigid and Catholic-oriented continental powers like France or Spain, alluding to the civic humanist models of Palladian Venice that had resisted the influence of Rome and to secular ideas of merit drawn from Qing China.

On a global scale, only where distinction was necessary—efforts to separate from the Catholic universalism of Bourbon France and Spain, the Ottoman

Caliphate, or from Ming (1368–1644) and Qing claims to the throne of heaven—did confessional strategies play a role in defining the landscape. Smaller confessional polities did not have the resources, the commercial dynamics, or the global connections to develop confessional landscapes. Whereas imperial landscapes still tried to make totalizing theological-political claims in the seventeenth and eighteenth centuries, the confessional landscapes of medium-sized states explicitly built in the possibility of the secular observer distinct from the king or emperor as well as the various communities of religious scholars. The confessional landscape was thus both more delimited and more disenchanted than the imperial one.

These new conditions helped produce and incentivize large numbers of travelers, especially from aspirational confessional states, who could frame themselves as secular observers of various other landscapes and on their return publish their observations and images.[14] The dynamics here are suggestive of the kinds of "connected histories" that Stephen Whiteman has pointed to in the introductory chapter to this volume, in which simultaneous internal and external dynamics mean that analysis cannot be strictly comparative but always remains transcultural. The traveler, along with their writings and, perhaps more importantly, their collections, represents one vector for attempting to build commensurability. The result is less a shared nomenclature than a shared sense of forms or interfaces designed to mediate between the inside and the outside. Travelers, notably in the cases of Safavid Persia and Tokugawa Japan, were guided through spaces and permitted, within limits, to wander and interact in certain landscapes.

The writings and collections of Engelbert Kaempfer are illustrative of these trends. Kaempfer, as a physician, showed interest in botanical specimens and drawings, a set of practices long associated with transcultural exchanges of drugs. But his ability to collect images and maps beyond traditional courtly gift exchanges was historically relatively new, conditioned by the tourist cultures and vendors that had developed both internally and in relation to foreign visitors. The various forms of media Kaempfer obtained during his travels acted as signs of and supplements to the commercial popularity of the Safavid and Tokugawa landscape building programs.

Born in the old Hanseatic city of Lemgo in the Holy Roman Empire, Kaempfer became a Swedish diplomatic envoy and later Dutch East India Company (Vereenigde Oostindische Compagnie, or VOC) employee. His itinerary in the 1680s and 1690s is in many ways a checklist of minor empires experimenting with confessional approaches to landscape in the late seventeenth century—Sweden (1681–82), Russia (1683), Persia (1684–88), Ayutthaya (1690), and Japan (1690–92). Kaempfer worked in relation to two very different confessional

states—absolutist Sweden and the Calvinist Dutch. He knew well the conventions of printed travel literature. He carried with him among other books Adam Olearius's (1599–1671) massive illustrated account of the legation sent by Frederick III of Schleswig-Holstein-Gottorf (1597–1659) to Russia and Persia in hopes of establishing an overland silk trade.[15] Once Kaempfer left Persia, the VOC's ships and trading outposts from Batavia to Nagasaki both enabled and framed his experiences.

As Jürgen Osterhammel has argued, Kaempfer was a key figure in the disenchantment of Asia for Europeans. The most obvious problem with Kaempfer as an observer was his predisposition to see confessionalism and closed landscapes everywhere he went.[16] Indeed, the sources of the comparative ambitions of Weber's work might be found in German-language travelers of this period like Olearius and Kaempfer himself. Kaempfer's writings were so profound in this regard that they became, in both Europe and Tokugawa Japan, the source for making Japan the locus classicus example of "closed" confessional landscape.

Kaempfer famously highlighted "the shutting up of the Empire of Japan" as a cultural landscape protected from Catholic influence from 1639 onward. He understood this process as precisely historical rather than cultural. In Japan, closure meant a brutal purging of Catholicism, which had been very successful in missionary efforts on the southern island of Kyushu. This purge was limited in the sense that both the Chinese and the Dutch could trade from quarters in Nagasaki, Koreans through Tsushima, and Ainu through Hokkaido. Following this "closure" as well as the collapse of the Ming dynasty (1644), the boom in printing and commercial culture enabled new forms of Tokugawa cultural autonomy, as Kaempfer's own extensive archive of Japanese books, maps, and prints demonstrated. When Shizuki Tadao (1760–1806) translated the appendix to Kaempfer's posthumously published *History of Japan* (London: 1727) into Japanese in 1801, he coined the Japanese term "closed country," or *sakoku* 鎖國.[17] Was *sakoku* simply one more European concept exported through the imperial processes of the Enlightenment? Or were Kaempfer's practices indicative of the kinds of fractures in early modern connected histories? "Internal" (later "national") histories of various polities not only always remain incommensurable because of unique cultural and religious traditions, but they also remain open to greater or lesser degrees to translation, as they were born out of translation in complex and global ways.

Kaempfer as an observer differed from other European travelers in two important aspects that made his work uniquely transcultural. First, untrained in mapmaking and landscape design, he appears to have learned many of his observational techniques and methods for describing landscapes outside Europe—with mapmakers in Moscow, in the gardens and among the album painters of

Isfahan, and most profoundly in relation to Japanese printing and mapping. Second, he brought back a rich archive of images created in Persia and Japan that illustrated shifting understandings of the landscape already taking place.[18] Kaempfer's remarkably intact archive contains what had become common in the late seventeenth century but now, due to their ephemeral nature and popular audience, are quite rare surviving examples of bottom-up efforts to map, visualize, and indeed disenchant the landscape in Persia and Japan. Such material objects were not commensurable between Persia and Japan at the level of language or concept, but they did have similarities in technique and form likely rooted in global exchanges of image-bearing commodities. These efforts were novel rather than traditional and related to medium-sized state consolidation. They emerged in part in relation to "crisis" on a global scale in the mid-seventeenth century, but they had regional roots in the sixteenth-century civil and frontier wars that shaped both the Safavids and Tokugawa. New languages and new media helped imagine new landscapes, frequently relying upon transcultural processes and spaces like the port of Nagasaki or the Maidān of Isfahan.[19]

The answer to the problem of Kaempfer as observer is thus historical more than cultural and suggests a two-way street. Confessional landscapes emerged in different places and in different ways in the early modern period in relation to imperial landscapes. They cannot be understood as strictly postcolonial. The most important examples—Russia, Persia, Japan, and Siam—successfully resisted European (and non-European) colonialism, in part because of the production of new kinds of landscapes. As with the "Anglo-Chinese" gardens at Stowe that Rousseau took exception to, the processes involved in making confessional landscapes were complex, never one directional, and networked in ways that could project a sense of natural, spatial, historical, and ethical coherence both internally and externally.

Hanseatic Cities, Swedish Gardens, and Russian Mapping

How did Kaempfer become interested in landscapes? Kaempfer did not travel to Persia or Japan with innocent eyes. It should perhaps come as no surprise that someone born in 1651 in Westphalia would be attracted to the idea of confessional landscapes. His hometown Lemgo had been a prominent Hanseatic town until the 1590s, with some of the wealthiest and thus most independent burghers in all of the German states. In the cities and principalities of the Holy Roman Empire before the Thirty Years' War, interest in landscape gardening, alchemy, and medicine had been expressions of a more general optimism that

human artifice could ply open the secrets of nature, develop unified theories of occult forces, and return a sense of cosmographic unity lost in the wars of religion.[20] After the war, Frederick III, Olearius's patron in Schleswig, revived such ideas of mystical unity. Olearius's *Newen Orientalischen Reise* of 1647 in some ways tried to extend such ideas of mystical unity outward to Persia.

The enduring "myth" of the bilateral treaties of Westphalia signed in 1648 is that they created the modern system of sovereign independent states with corresponding territorial integrity and confessional authority—confessional states.[21] In reality, the collapse of regional political and commercial structures engendered both contraction and a search for new forms of meaning. The Thirty Years' War disrupted many traditional structures related to the Holy Roman Empire. It also dealt the final blow to the Hanseatic League, which had its last meeting in 1669 at Lübeck, the city where Kaempfer went to attend gymnasium in 1670. From a young age Kaempfer admired absolutism and in particular undivided sovereignty—the Leviathan state with its surveilled landscape—as a solution to the kinds of problems that his hometown had witnessed in the seventeenth century.[22] In the aftermath of the devastation of the Thirty Years' War, Lemgo turned inward in a series of notorious witch hunts that continued into the late 1700s.[23] These witch hunts created a kind of anti-confessional landscape, nature riven and destabilized by unseen heretical forces and open social conflict. Kaempfer's desire for a strong confessional state in this context is not surprising.

There is no evidence that Kaempfer held any interest in gardens and the landscape more broadly before he arrived in absolutist and strictly Lutheran Sweden in 1681. He had his first serious encounter with gardens at Uppsala, where he went to university. The botanical gardens (founded 1655) had been developed and used extensively by Peter Hoffwenig (1631–1682) and Olaus Rudbeck (1630–1702), Kaempfer's mentors in his studies of medicine. As with most European botanical gardens, the collection of plants allowed medical research based on access to unique scholarly and commercial networks. Such botanical collections were also, like the library or the Renaissance museum, abstract emblems of those networks of knowledge and power.[24] On the margins of Europe, Kaempfer's mentor Rudbeck, as the founder of the Uppsala garden, spent much of his career trying to prove Sweden was in fact Atlantis and Swedish the Adamic language. For him, the botanical garden became not merely an emblem of imperial ambitions to a comprehensive understanding of nature but an effort to ground confessionalism (Lutheranism from the Uppsala Synod of 1593) in a localized history in which Sweden was the natural center of the world. As with Clusius's Leiden garden in the 1590s, where Kaempfer would later study after returning from his travels, the Uppsala garden emerged as a reaction to Catholic

universalism, reworking the totalizing tropes of both Eden and the *hortus conclusus* (enclosed garden) associated with monasticism. As spaces of collection, botanical gardens created thinking space in a confessional manner. Such gardens, however, were hardly landscapes, and Kaempfer's experience in Uppsala trained him more in the practices of botanical collection than in conceptualizing the landscape.

Only from Moscow, where Kaempfer went in July 1683 as part of a Swedish embassy under the Brazilian-born Lodewyck Fabritius (1648–1729), did he begin to think seriously about the broader imperial landscape he traveled through. Kaempfer mapped riverine systems and towns on the way from Moscow to Isfahan, notably after meeting with a particularly innovative group of mapmakers trying to comprehend the vastness of the Russian empire.[25] The most obvious inspiration for Kaempfer's efforts to map the landscape as he traveled in Russia and into Persia was Olearius, a text composed a half-century earlier during the Thirty Years' War (1633–39). Already in the 1660s and 1670s, Swedish envoys found Olearius dated and inadequate. By the time Kaempfer arrived in Moscow, two other Swedish embassies (1669, 1673–74) and a Dutch one (Jacob Boreel, 1664–65) had preceded Fabritius.

Both earlier Swedish missions had made copies of a circa 1666–67 map by the Tobolsk commander Petr Ivanovic Godounov (?–1670), a map now seen as the launching point for Russian imperial cartography.[26] Like Olearius, Godounov mapped river systems as route systems, strikingly including the trails that connected the river systems all the way across Siberia to the Great Wall of China (*Kitáy*, Китай). No evidence exists that Kaempfer had any exposure to copies of the Godunov map before he reached Russia, although it was already in the Swedish archives before the 1683 embassy left. But while Kaempfer was in Russia he did see a copy, and he had access to actual Russian mapmakers.

Later, after going down the Volga to Astrakhan on the Caspian Sea, Kaempfer saw several hand-drawn maps, or *čerteži* (чертежи, figure 2.01). The first was "a rough, ungraded map of Siberia, which an exiled bandit had cut into wood," a Siberian exile who had talked with Koryaks and Chukchis. Peter the Great's (1672–1725) Dutch-born tutor and the inspector of pharmacies Andreas Vinius (1641–1717) had made the second. Kaempfer possibly saw a third, dated 1682, by the Romanian Nikolai Milescu (1636–1708, aka Spathari or, for Kaempfer, "Spafarii"), the court interpreter who knew Latin, Greek, French, German, Turkish, Swedish, and Russian and had headed an embassy that traveled to Kangxi's court between 1675 and 1680. Taken together, these maps suggested how the Russians and in particular Vinius and Milescu organized the mapping of Asia to create an archive that in Kaempfer's words represented "the true state, situation and extent of the Czar's dominions."[27] The exile's map and the Vinius map

were both in their basic structure heavily influenced by the Godounov map, although they differed enough from it to suggest that Kaempfer may have also seen the latter. Using the exile's map Kaempfer created an almost formulaic ethnographic charting ("a, b, c") in which a series of different competing and distinct "nations," all claimed under Russian sovereignty, constituted the route to China.[28]

As Valerie Kivelson has argued, Russian maps from this period, starting with the Godounov map, reveled in ethnographic difference under the broader umbrella of the Orthodox Church, creating a kind of sacred landscape along the routes going eastward.[29] They were guided by the Russian concept of *urochische* (also *uročiše*, урочище), which literally means "tract" but emerged from the concept of a grove of trees or landmark that defined a particular space, a landscape concept used as a basic mapping unit.[30] Both Vinius and Milescu wanted to develop a new kind of imperial map that in contrast to other maps from this period was also confessional, where icons indicating the church played a stabilizing role in defining a system of routes across the continent's different nationalities. Actual or projected churches in this sense became *urochishche* markers on the map, theoretically visible from a distance, like a rock outcropping or grove of trees. Milescu's own embassy to the Qing from 1675 to 1678 had gathered valuable data. He could look to material from the Jesuits as models, who through Ferdinand Verbiest (1623–1688) were busy creating a world map showing the Qing's place in it. Milescu remained committed to putting his ideas about cartography and landscape into imperial and universal terms—the czar as the successor to the mantle of the Roman and Byzantine Empires as well as to the divine leadership of Christianity on earth—but these ideas were novel and had to be made explicitly as a textual and visual argument.[31]

As Kaempfer observed firsthand, however, much of the cartographic knowledge for the Russian maps came from neither the church nor the imperial bureaucracy, such that it was, but from the bottom up—from trappers, exiles, and prisoners and local ethnographic sources. The knowledge base was not global but localized and fragmented. The rough map cut by the exiled bandit onto wood was itself a kind of disenchantment, revealing the kind of data gathering that went into imperial maps. This multipolar process also looked a great deal like a kind of Enlightenment—a slow conversion of traditional landmarks, routes, and techniques of way finding into a rationalized image of empire. But there was no broader aesthetic or ethical conception of landscape beyond the "tract" as the purview of a particular church. In Sweden, in the botanical gardens of Rudbeck, Kaempfer saw a kind of confessional landscape without a broader imperial or cartographic vision. In Russia, the mapping efforts of Mi-

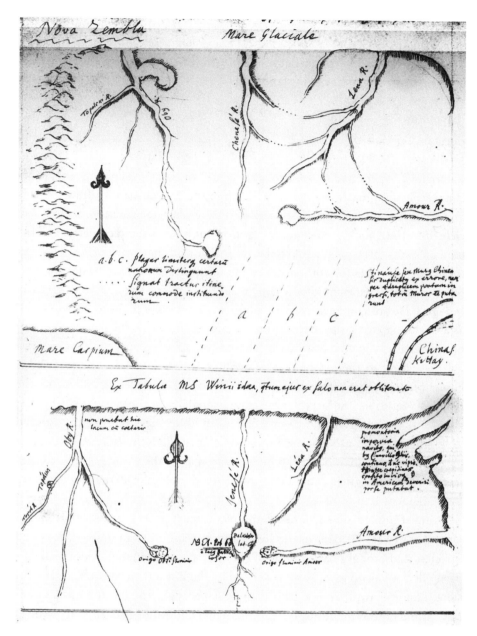

Figure 2.01. Engelbert Kaempfer, sketch copies of the exile map, "Tabula Sclavonica Idomate Typo ligneo impressa in Sybiris exilo," and the Vinius map, "Ex Tabula MS. Winii ideae, quotum ejus ex salo non erat obliterate," ca. 1683. Ink on paper, 300 × 220 mm. British Library, Sloane 2910, fol. 28.

lescu in particular put forward a vision of imperial mapping without a clearly delimited or closed confessional landscape, a vision of a new imperial landscape tied to the expanding frontiers of the empire in which Orthodox churches could perform the role of *urochishche* landmarks.

Persian Gardening

Kaempfer's experience in Isfahan, the capital of Safavid Persia, dramatically changed his approach to landscape.[32] While there, he began to draw gardens and landscapes, lots of them. He used this experience to structure the first fascicle of his 1712 book, *Amoenitatum exoticarum*.[33] For Kaempfer, Persia was the land of "exotic pleasures" par excellence. The Safavids had learned how to structure these pleasures for both visitors and their own internal political goals. Unlike Russia, where he could only copy maps, Kaempfer had a tourist experience in Persia. He brought back a tourist album of drawings of hunting scenes as well as a world map to compare with Russian efforts. In Russia, the project of developing a confessional landscape through cartography was largely closed to outsiders—except to the extent that people like Vinius and Kaempfer's Swedish companion Johan Sparwenfeld (1655–1727) could directly contribute to the mapping. In Persia, the largely novel confessional landscape helped to bring outsiders into the court, to give a sense of Persian uniqueness and integrity, and to highlight its difference from surrounding empires like the Russian, the Ottoman, and the Mughal. A Persian manuscript map of the world, a copy of a sixteenth-century original, came along with other drawings from the market rather than aristocratic archives.

Almost immediately from Isfahan's reconstruction as the Safavid capital of Shah Abbas I (1587–1629) in the 1590s and 1600s, European ambassadors and travelers had brought back stories of the city's cosmopolitan glories. Shah Abbas built it along an axial pattern defined by the Zāyandehrud River, a series of canals, and the royal avenue Khiyābān-i Chahārbāgh. The resulting four quadrants imitated the *chahārbāgh* ("four garden") pattern of Persian and Timurid garden design (particularly that of Herat), a mixture of Turkic and Persian ideas about imperial cities.[34] The idea was to centralize administrative, diplomatic, and religious functions in the *dar al-saltaneh* ("abode of government," where the shah lived), foreshadowing what Louis XIV would later do with Versailles. Rather than retreating from the city like the French king, Abbas used water courses and the river to link the palaces and garden landscapes to the broader urban fabric.[35] Abbas also moved much of the 'ulama, the scholarly elite of Shia Islam, to his new capital to centralize religious authority. This aided in the fur-

ther Shi'ification of the empire, moving it away from its historical roots in Shah Ismail's (1501–24) role as the *murshid-i kāmil* ("perfect Sufi master") and chief of the Safavi tariqah (Safaviyya), the Kurdish Sufi order that gave rise to the dynasty. Yet, as late as the reign of Shah Sulaymān (1667–94), when Kaempfer was in Isfahan, the Safavid bureaucracy could still maintain a sense of Sufi openness in relation to the stricter rules of the Shi'a 'ulama.[36]

By design, Abbas's city remained multiethnic and multireligious. Armenian merchants, Capuchin monks, a Georgian slave administration, Zoroastrians, and Sufi mystics jostled with diplomatic representatives from the Ottomans, Mughals, and various European powers. Known for its public spaces, the vast Maydān (Maydān-i Naqsh-i Jahān, or "Image of the World Square") in particular became a center of Sufi coffeehouse culture from the early 1600s, as well as of commerce, music, theater, games, and storytelling. Abbas's public spaces (especially the Maydān and Chahārbāgh) still flourished when Kaempfer arrived in March 1684, and they remained worrisome to the upper echelons of the 'ulama as encouraging discussion of dangerous "philosophical" tendencies and the popular Sufism tolerated under the umbrage of royal authority. Such concerns continued until, under pressure, Shah Sultan Husayn (1694–1722) put forward in 1695 a restrictive edict, beginning a general tightening of Shi'a confessionalism. But Isfahan was in 1684 still a confessional landscape in which actual gardens played a key role, rather than a confessional state.

During Kaempfer's time in the city, the court under Suleiman I (1666–94) thrived on confessional moderation tied to garden landscapes. Even more than previous shahs, Suleiman used landscape gardening to define a sense of natural authority and bounded openness. Suleiman built two new palace complexes. The Takht-e Soleymān ("Solomon's Throne," ca. 1684) on Soffeh Mountain south of the city was constructed above the Bagh-i Hazar Jarib built by Abbas and named after the famous Ilkhanate summer hunting palace in western Persia of Abaqa Khan (r. 1265–82).[37] It linked the lower palace with the upper reaches of the mountain popular with Sufi mystic hermits. It also structured sources of spring water from the mountain to produce verdant spaces. The Hasht Behesht ("Eight Paradises," built 1666–69) pavilion and gardens at the northeastern end of the Chahārbāgh used a popular Timurid plan for a central hall surrounded by eight rooms, adopted by the Mughals as well for the Taj Mahal (1632) and other buildings. The explicit evocation of paradisiacal and cosmological topoi situated Sulieman as transcending the popular religious, dynamic market, and worldly cosmopolitan aspects of Isfahan and indeed the Safavid Empire as a whole. These new buildings helped highlight and regulate the three principal spaces for nonorthodox cultural expression that had developed over the course of the seventeenth century—the popular and mercantile Maydān in the city center, the

conspicuous aristocratic houses along the Chahārbāgh, and the landscape of hermit-like religious mysticism of Soffeh Mountain that loomed above Abbas's old Bagh-i Hizar Jarib.

Kaempfer's panorama of the city made the gardens of Soffeh Mountain and the summer retreat of Takht-e Soleymān the locus of the observer's vista (figure 2.02). In the panoramic engraving, the observing figure sketching in the lower right corner is presumably Kaempfer himself, a part of the extra-urban landscape with his servant and parasol. The long watercourse coming springlike from the Soffe Mountain pleasure gardens ("A," "B," and "C" on the engraving) suggested more mystical sources of power than the axial river and watercourses of the city itself, Suleiman's transcendence of Abbas's city. Kaempfer meticulously sketched out the whole series of cascades and fountains on Soffe (figure 2.03).[38] Kaempfer's densely labeled "Planographia" (figure 2.04), on the other hand, highlighted the tree-lined streets and formal gardens of the more traditional urban precincts of the palace (*dawlatkhānah*) in Timurid-era gardens (called Bāgh-i Naqsh-i Jahān from the fifteenth century) next to the Maydān. This included the Guldasta pavilion and gardens (1598) of Shah Abbas as they bordered on the new Hasht Behesht, with its Sufi cosmological themes, and the Chahārbāgh, where the administration of the chief vizier had its own gardens.[39]

As Suleiman and his administration tried to moderate those looking for a stricter Shi'a orthodoxy in the late seventeenth century, his efforts also promoted an ethics of pleasure that disenchanted the landscape by disabling any strongly cosmographic interpretations.[40] Unlike Swedish or Russian churches, the 'ulama would not dominate the landscape. Along the Khiyābān-i Chahārbāgh, thirty gardens had been given to prominent officials. Suleiman's new Hasht Behesht pavilion, with its bright yellow, green, turquoise, and cobalt blue tiles, colored marble, and Venetian glass mirrors, seemed designed to keep fashions current along this axis. The new Hasht Behesht gardens were now the largest in the city and much admired by European travelers like Kaempfer and Chardin. At the same time, new mansions of court officials and merchants proliferated around the city in the late seventeenth century. Gardens, with their various levels of publicness, were where these layers of society mixed. Gaining access to these spaces could take time, moderating the rhythms of the city itself. Fabritius's embassy had to wait three months to see the shah, and the mission stayed for three years, with Suleiman receiving him eleven times. Diplomacy was slow, perhaps deliberately creating time for visiting diplomats and merchants to absorb the city's landscapes. The overriding metaphor of the city remained the paradise garden—both Eden and the eight paradises of the Islamic afterlife.[41] But this was in many ways a metaphor for the pleasures of the administrative class

itself, an elite grounded in an allusive Sufi language that no longer had a strong relation to actual Sufi practice.

During his time in Isfahan, Kaempfer formed a relationship with a painter most likely named Jání, who made him an album of conventional scenes of animals involved in the hunt, of Sufi mystics in the mountain spaces around Isfahan, and of the different peoples of the capital's urban life. At the end of the album was a world map (figure 2.05 [plate 1]), a map that reveals a surprising amount about popular Safavid understandings of the relationship between the world and landscape in this period. The map is clearly a copy. It matches almost exactly another map made approximately one hundred years earlier for a sixteenth-century copy of Zakariyā' al-Qazwīnī's (1203–83) *'Ajāyib al-makhlūqāt* ("Wonders of Creation"), itself a thirteenth-century Persian text made during the Mongol Ilkhanate. But the sixteenth-century map now in the Walters Art Gallery was not al-Qazwīnī's. Scholars have thought that map to be by a Persian exile at the Ottoman court, but Kaempfer's copy suggests it may actually be the earliest surviving version of a Safavid map of the world.[42] It shows the Pacific as a "South Sea" and a very rough indication of North and South America, including Panama. Kaempfer's copy was made in Isfahan, indicating that the map remained popular there in the late seventeenth century and part of a copyist's repertoire for tourist albums. Kaempfer's was a cheap copy. The indigo watercolor and gold paint in the Walters Gallery's elegant manuscript filled with miniatures are replaced by an ink wash and gold watercolor accompanied by hastily done, albeit at times more legible, Persian calligraphy.

The map itself shows both a Safavid sense of openness to the Indian Ocean and the polity's relation to the important river systems of the word, including the Forat (Euphrates), Dejle (Tigris), Indus, and even the Nile, as well as the Aral and Caspian Seas. On Kaempfer's copy, paper labels for oceans have been added, most likely because in the original they were hard to see in the indigo-colored water, as evident on the Walters version. But the labels also highlight the importance of such bodies of water. A jumble of rivers converge on Safavid cities—from the old Ilkhanate (1256–1335) capital of Tabriz, to the sixteenth-century Safavid capital Qazvin (until 1598), to the cultural center of Shiraz. This was the pre-Isfahan empire of Shah Tahmasp (1524–76) and his successors that was reformed and centralized by Abbas I (1588–1629). For the scribe at least, the map would have been obviously historical, since it did not depict Isfahan, but it was bound in a volume with conventional scenes of contemporary figures in and around the new capital. The tension seems to prefigure the clichéd pun and proverb "Isfahān nesf-e-jahān ast" ("Isfahan, half the world"), and it would be fitting if Kaempfer actually acquired the album in the Maydān-i Naqsh-i Jahān, the square of the world picture.[43]

Figure 2.02. F. W. Brandshagen, "Isphahanum," *Amoenitatum exoticarum*, vol. 1, 162–63, 1712. Copperplate engraving on paper, 185 × 450 mm. Collection of the Royal Society. Photograph by Robert Batchelor. Labeled are: A. Mons Sophia

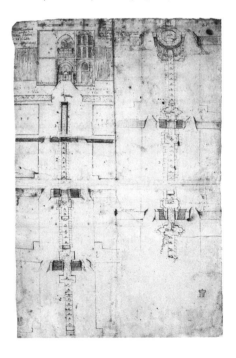

Figure 2.03. Engelbert Kaempfer, "Porta Hadradrerib versus Tauteta Solyman," ca. 1684. Ink on paper, 600 × 380 mm. British Library, Add. MS 5232, fol. 45v. The watercourse and gateway at the summer house Takht-i-Suleiman ("Seat of Solomon/Suleiman," also called by Kaempfer "Praedioum Solymani"), built in the late seventeenth century on Soffeh Mountain, showing the watercourse down to the Bagh-i Hazar Jarib of Shah Abbas.

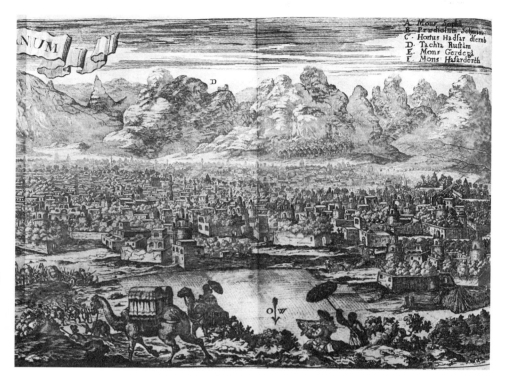

(Soffeh Mountain), B. Praediolum Solymani (Takht-e Soleymān), C. Hortus Hadsar dsernb (Bagh-i Hazar Jarib), D. Tachia Rustam, E. Mons Gerdega, F. Mons Hasardereh.

Figure 2.04. F. W. Brandshagen, "Planographia Sedis Regiae," *Amoenitatum exoticarum*, vol. 1, 179, 1712. Copperplate engraving on paper, 185 × 150 mm. Collection of the Royal Society. Photograph by Robert Batchelor.

Figure 2.05. Jání (?), World Map, in Kaempfer's "Persian Album," ca. 1684–85. Ink wash on paper, 210 × 300 mm. British Museum 1974,0617,0.1.35, originally Sloane 2925.

Kaempfer's album reorients the map from the south at top to the north to follow European conventions. This suggests that Kaempfer not only recognized it as a world map but would also have been aware of the Ptolemaic resonances of the seven vertical climate (*klimata*) lines. Such lines made the Safavids like the Russians into inheritors of the classical tradition and meditators between East and West. Isfahan was famous for lying on the fourth clima at the center of the Ptolemaic world, which on the map runs through the tip of the Caspian Sea and the northern part of Safavid Persia.[44] Even though the South Pacific appears passable by way of Panama, the map gives no sense that navigation around the Horn of Africa is possible. Indeed, the inscriptions at the top and bottom of the map are about the torrid zones and periods of perpetual night and day. To the south, below the climate lines and the golden desert at the mountains of the moon (the source of the Nile), the maps note, "There is no information about this region and because of extreme heat there are no animals in this region." Continuing lower, an inscription similar to the one for the

north pole reads, "From the first point (cusp) of Libra (September 23–27) to the end point of Pisces (March 17–21) is one day, and from the first point of Aries (March 21–25) to the end point of Virgo (September 18–22) is one night." This odd perpetuation of the Ptolemaic system in the face of the discovery of both the Americas and the Pacific seems to be an effort to maintain a sense of the "Inhabited Quarter." That region represents a world defined by the centrality of Islam and in particular the Safavid Empire, which is placed in a global landscape of temporal regularity, circulations of water, mild climate, and thriving human and animal life. At the same time, the depiction of the Indian Ocean and Western Pacific suggests that the Safavids have gone beyond the Greeks. Overall, both Kaempfer's map and the Walters map before it presented an image of a global landscape, where script-like waterways and desert bands shaped the Safavid relationship with the world. It was an imaginary but, more important, diagrammatic and largely secular depiction of power and influence reaching outward over water.

Both surviving versions of the Safavid world map are bound together with a series of landscape images, but Kaempfer's album reveals a connection between world and landscape very different from the earlier Walters edition of al-Qazwīnī. The manuscript containing the Walters map has 181 illustrations. These mostly consist of fantastic stories, including zodiac and planet stories, scenes from the life of Mohammed and Zoroaster, various warrior heroes and leaders from Alexander to the Abbasid Caliph Hārūn al-Rashīd, as well as demons, monsters, rare birds, and other animals. It is an exercise in nostalgia and fantasy tied to the old Islamic world system and Mongol Empire of the Ilkhanids.[45] Kaempfer's album, in part reflecting European tastes, contrasts sharply with its pairings of contemporary people and of animals, largely those used in the hunt. The diagrammatic aspects of the map thus work differently in the Walters album, where it is about the relation between the classically inhabited quarters of the world and the marvelous. In Kaempfer's album, it forms a bridge between the late Safavid cultural landscape of Isfahan and the cosmopolitan world of the seventeenth century.

The Safavids had an almost obsessive tradition of collecting animals from the countryside and maintaining large stocks of birds of prey and horses for massive and organized hunts. By the seventeenth century, this had also become a kind of cultural expression of legitimacy as well as a way of disciplining the surrounding landscape. Kaempfer himself notes that in the summer prior to his arrival, from May to July 1683, Suleiman organized a huge ring hunt with eighty thousand beaters. Thomas Allsen describes these hunts as a kind of fashion system, with the Safavid predilection for hunting known as far away as

Europe and Siam and drawing upon Mughal and Ottoman models.[46] Part of Kaempfer's album represented a kind of paper menagerie of animals collected in the hunt. As in the Mughal tradition of the "patched" (in Persian, *muraqqa'*) album, Kaempfer himself drew on a blank page a picture of the sixty-foot column of horns supposedly made by Shah Tahmasp (1524–76) out of thirty thousand hart and other deer skulls. The column was commented upon by almost every European observer to Isfahan, many of whom repeated marketplace rumors about it including human skulls. Here it echoed the map, which also seems to have been a product of Tahmasp's reign and an earlier Safavid vision of the world.

The landscape of the hunt menagerie in Kaempfer's album is not only juxtaposed to the world map but also interspersed with a more localized ethnography of paired figures. These include popular Sufi and Shia entertainments like goat and cock fighting and *koshti pahlevani* wrestling, along with at times ironic scenes of urban character types. A mullah reads from a law book next to a bazaar prostitute smoking a water pipe and drinking a cup of what is most likely wine. The pairings represent dialogic contrasts—local storytellers put next to foreign storytellers, Mughal and Ottoman men, Georgian and Indian women. Single-figure paintings were characteristic of Safavid art from the reign of Tahmasp as an alternative source of income in Isfahan for court painters. By the late seventeenth century, these formed a commercial souvenir market for travelers. Although the single-figure style seems to have emerged from the court, it drew on popular imagery and later European prints like Willem (1571–1638) and Joan Blaeu's (1596–1673) *Atlas* (1635 and after). In addition to manuscripts like the Kaempfer album, such figures in landscape groups also appeared in Isfahan in murals on public buildings and then in the homes of private merchants—Europeans, Armenians, Indians, and others—developing into what Eleanor Sims calls the "eclectic style."[47] Jání's manuscript replicated at a greatly simplified level what would have been on the walls of the city itself. It popularized, or perhaps served as an interface for, a not quite coherent confessional landscape, one emerging before the Safavids had become a confessional state with a bureaucracy largely controlled by the 'ulama.

Kaempfer stayed in Isfahan until November 1685, at which point he left the embassy, taking on a position as a surgeon with the Dutch VOC and traveling some five hundred kilometers south to Shiraz. Beyond its global connections through Armenian, English, French, Dutch, and Portuguese agencies, Shiraz had far deeper Sufi cultural resonances than Isfahan. Kaempfer on his arrival again sought out gardens to draw.[48] The gardens and images of Isfahan gave Kaempfer only a vague sense of the subtle and novel understanding of the natural landscape generated by Sufi Islam that had informed the older traditions of

Shiraz. But Shiraz's increasingly global literary legacy gave cultural depth to these gardens that would have been hard to see in Isfahan. Two Shiraz poets, the thirteenth-century poet Saadi Shirazi (1210–91 or 92) and the fourteenth-century Sufi poet Hafez (1315–90), both made extensive use of the allegorical garden as an image of mystical love and transcendence. Their works were well known across the Islamic world and in Europe by the seventeenth century, an indication of their dissemination at the time.[49] Hafez's tomb outside the town on the road to Isfahan became a pilgrimage site among the many other sepulcher gardens in the Bāghestan suburb (literally "the place of gardens") north of the city, sites of frequent feasts and entertainments. Poets, famous itinerant preachers (*sheykh*) and mystics (*sufi*), descendants of the prophet Mohammed (ca. 570–632), judges (*qazi*), and philosophers (*hakim*) all had suburban gardens devoted to them, mostly along a long, straight avenue going toward Isfahan. Contemporary exemplars of these figures who contributed to Safavid cultural and intellectual life could be found in the coffeehouses and gardens of Isfahan as well. Only the gardens of Shiraz explicitly commemorated and celebrated them. The commercial culture of Shiraz put money into landscape architecture as a way of putting forward a cultural counterpart to as well as a continuity with the capital itself, a provincial and particularly Sufi effort to exert influence over the nature of confessionalism being shaped in Isfahan that moderated between the Shi'a 'ulama and Sufi practice.

In this sense, the confessional landscape was both more closely tied to Sufism and more profound in Shiraz than in Isfahan. It also indicated how limited the overall control of the state was over landscape representations. In Shiraz, the landed and merchant classes had enough vitality and independence to express their commitment to cultural and religious Sufism through gardens, poetry, and cemeteries, continuing and revitalizing traditions that went back to the era of the Ilkhanate. These classes maintained their distance from the politics of the increasingly centralized 'ulama that would so profoundly reshape the confessional landscape of Isfahan after Kaempfer's departure. If indeed the 'ulama shifted away from the confessional garden and towards the confessional state in Isfahan by the eighteenth century, they could not do the same in Shiraz. Moreover, as the 'ulama transformed the state bureaucracy in Isfahan along confessional lines during the early eighteenth century at the expense of the cultural strategies indicated by gardens and landscape imagery, the dynasty itself began to unravel, finally collapsing in the middle of the eighteenth century.

Japanese Urbanism

During his lifetime, Kaempfer chose to publish his materials on the Safavids rather than his much more extensive archive about Japan, where he lived from September 1690 to October 1692. Later the Japanese material would be partially published posthumously in London with the help of Sir Hans Sloane (1660–1753) by the Swiss physician John Gaspar Scheutzer (1702–29) as the *History of Japan* (1727), becoming wildly successful across Europe in various editions. As with Russia, Kaempfer mediated his assessment of Persia through his own drawings and notes on them. The album maker Jání, if that indeed was his name, represents a singular exception to this, but the material from the album including the world map did not show up in the *Amoenitatum exoticarum* (1712) and has been largely forgotten as a result. Kaempfer, however, collected a far richer archive of Japanese books, maps, and prints. This archive rested upon the sustained relationship of Kaempfer with his medical student Imamura Gen'emon (1671–1736).[50] Because of Japan's highly developed commercial tourist landscape and commodity culture, Kaempfer could illicitly collect, at times in multiple and richly illustrated editions, maps of cities and of Japan, tourist site guides, Buddhist shrine itineraries, calendars, tourist paintings, texts of *nō* and *kabuki* dramas, *jōruri* and *monogatari* ballads, registers of families, even decorative silk patches and imported Chinese multicolor prints. Ultimately, a stable confessional landscape that created the possibility for the dynamic practices of "critical idolatry" and "secular divination" required a density of such cultural techniques involving cultural and religious aesthetics, topological mapping, and visualization of spaces as well as natural investigations.

While often compared to Montesquieu's (1689–1755) fanciful *Lettres persanes* (1721) in terms of its effects on the Enlightenment, Kaempfer's *History of Japan* rested on this substantial archive of popular forms and cultural techniques made possible by the commercial and printed construction of the confessional landscape in Japan. Kaempfer's own description of Japan's closure put forward a simplified version of confessionalism, notably the Buddhist relation to a more primitive Shinto past (idolatry for Kaempfer), the explicit rejection of Catholicism, and the confinement of the Calvinist Dutch to an artificial island in Nagasaki. The emperor (the "Mikado") himself remained radically enclosed in Kyoto, in Kaempfer's account supposedly never touching the ground, safely sacred and indeed quasi-mythical.[51] Buddhist and Shinto shrines had become part of both pilgrimage and tourist itineraries, understood as elements of a distinct, enclosed, and managed landscape related to the broader urban fabric. In Kaempfer's account as mediated and edited by Sloane and Scheutzer, the confes-

sional landscape had direct ties to a confessional state, where constant surveillance and state-driven enclosure maintained religious stability.

The archive itself, however, which gave the *History of Japan* much of its originality and vitality, tells a different story. Kaempfer's copy of a printed street map of Kyoto is a good example. The version engraved for Scheutzer's *History of Japan*, the "Ichnographia Urbis Miaco [Kyoto]" used an orthogonal aerial (ichnographic) view to emphasize the rationalized grid pattern of Kyoto, implicitly linking it with what were presented in Europe as similarly rationally planned cities like Beijing, Mexico City, and, by the time it was published, St. Petersburg.[52] By contrast Kaempfer's copy of Hayashi Yoshinaga's *Kyō ōezu* (1686; figure 2.06 [plate 2]), upon which the "Icnographia" was based, is a magnificently complex map. Woodblock printed in black and five overlaid colors (yellow, green, blue, red, and brown), it is a monument to printing in Kyoto, where by the 1650s there were more than one hundred print shops.[53] Large, approximately 1 x 1.5 meters, it was durable and folded to be pocket-sized. Scheutzer changed the overall appearance and, most important, greatly reduced the pictorial detail of the temples and landscape surrounding the city to fit the map into the book. Lacking the techniques of color printing, he left it black and white (figure 2.07). Stripping the map down to what would be familiar from European ichnographic prints, he disenchanted it for a European audience.

Such disenchantment, however, was not merely a function of Scheutzer's eye—and Kaempfer himself never explicitly made such a reduction—but was enabled by the structure and form of the map itself. It may even have brought the map closer to the first street maps of Kyoto called the "Rakuchu Ezu" made in 1637 and 1642 by the Nakai family, which showed none of the temples and hills surrounding the city.[54] In the details of the later edition of the Kyoto map that Kaempfer obtained, an explicit dynamic already appeared between disenchantment, tourism, and the state. The more austere order of the urban grid gets supplemented by the renewal of suburban temple garden landscapes by monks and priests encouraged and funded by devout pilgrims and pleasure-seeking tourists and the shogunate itself.

In the early seventeenth century, the shogunate, or *bakufu*, came to play a direct role in the preservation of shrines in cities like Edo, Kyoto, and Osaka. The most prominent on the Kyoto map is a nicely detailed picture of the popular sightseeing destination on Mount Otowa, the Hossō Buddhist "Clear Water" temple Kiyomizu-dera (清水本堂, labeled on the roof of the main building or *Hondō*), appearing near the character for east 東 (figure 2.08 [plate 3]). The general Sakanoue no Tamuramaro (758–811) founded this temple in 778. Destroyed in the civil wars, Tokugawa Iemitsu (1604–51) ordered its spectacular

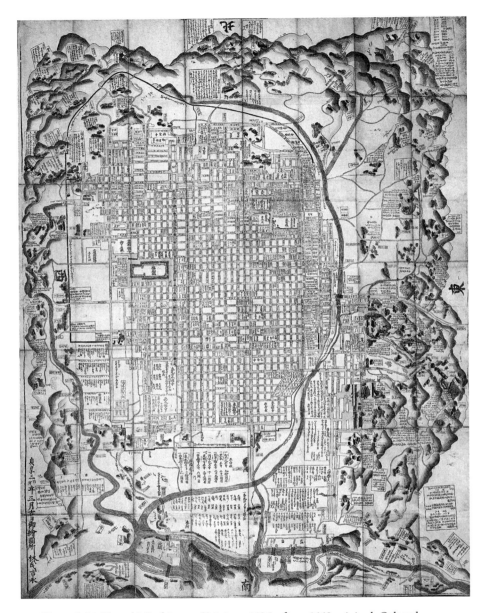

Figure 2.06. Hayashi Yoshinaga, *Kyō ōezu*, 1686, after a 1668 original. Colored woodcut on Japanese paper, 166 cm × 121 cm. British Library, OIOC Or 75.f.16.

reconstruction between 1624 and 1644 (esp. 1631–33) to house figures of the bodhisattva Kannon. Along with maintaining its established place as one of the thirty-three temples on the Saigoku Kannon pilgrimage, the temple came to serve as a more local popular tourist site both for residents of Kyoto and for visitors to the city who were not pilgrims. In addition to the map, Kaempfer ob-

Figure 2.07. Detail of the Kiyomizu-dera temple complex shown in figure 2.08, from John Gaspar Scheuchzer, "Ichnographia Urbis Miaco, [Kyoto] quae Summi Japoniae Pontificis Sedes est. Ex Japonum Mappa, quinque pedes Anglicos cum dimidio longa, quatuor lata, contraxit I. G. SCHEVCHZER," in Engelbert Kaempfer, *History of Japan* (London: 1727), tab. XXVII. Copperplate engraving on paper, 305 mm × 415 mm. Collection of the Royal Society. Photograph by Robert Batchelor.

tained three different printed guides to the Kannon pilgrimage—two chapbooks and a large scroll.[55] Linked to Kyoto's burgeoning printing industry, the new temple embodied the new approach to landscape under the Tokugawa, which combined urban commercial culture with explicit maintenance of traditional religious sites. There was no strong push for orthodoxy here—a confessional state—but the new urban landscape was more broadly confessional than the older pilgrimage-based one.

As part of this process, the spatial composition of the temple complex itself changed completely. The new main temple, spectacularly built without nails, became famous for its vistas of the city from its thirteen-meter-high *butai* platform (figure 2.08 [plate 3], upper right). To give the appearance of a sacred vista, the Tokugawa as patrons designed it to face southward toward the "Southern Paradise" of Kannon. In the process, it developed a new popular mythos—granting wishes if one survived jumping off the platform (*Kiyomizu no butai kara tobi oriru* 清水の舞台から飛び降りる). The mental and physical rush of

Figure 2.08. Detail of the landscape to the east of Kyoto, including Kiyomizu-dera. Hayashi Yoshinaga, *Kyō ōezu*, 1686, after a 1668 original. Colored woodcut on Japanese paper, 166 cm × 121 cm. British Library, OIOC Or 75.f.16.

the leap, and the anticipatory desire among those hoping to see it happen, replaced some of the lost aura of the temple pilgrimage itself. The map depicts many of the other new structures in the complex, including the inner temple, or *Okuin* 奥院 (1633, to the right of the main temple in figure 2.08 [plate 3]), supposedly the original site of the historical hut of the quasi-mythical Buddhist hermit Gyōei Koji 行叡居士 (ca. 778), as well as a new building channeling the lucky three-stream waterfall, *Otowa-taki* 音羽瀧, where he performed his purification rituals. The performative and the historical emerged as Tokugawa supplements to the traditionally venerated icons.

All of these new buildings, signs of the largesse, taste, and at least superficial devotion to Buddhist tradition of the Tokugawa *bakufu*, aimed to promote its legitimacy after having forced the emperor Go-Mizunoo 後水尾天皇 (1596–1680), residing in the city below, to resign in 1629 because he had bestowed too many honors on Buddhist priests.[56] The building complex represented the efforts of the *bakufu* to break the link between the emperor's imperial landscape emanating from Kyoto and the sacred landscape of Buddhism. It did so by creating a new confessional landscape that relied directly upon neither. The map re-

enchants the process of politically motivated state patronage by concealing the history of the changes made through Tokugawa patronage.

A similar process is visible in a unique set of tourist prints collected by Kaempfer, an item probably common in the late seventeenth century but no longer surviving in other examples. Of all the materials in Kaempfer's collection, the fifty paintings of famous sights (*meisho* 名所) were probably the most dramatic.[57] The first one of these, the temple Saihō-ji 西芳寺 (figure 2.09 [plate 4]), is also depicted on the map of Kyoto on the west side of the map but in a far less elaborate manner than the Kyomizu-dera. The monk Musō Soseki 夢窓疎石 (1275–1351) had famously redesigned these gardens between 1339 and 1344. With both religious motivations and an eye toward generating traffic and funding, Soseki introduced tea-drinking pavilions and pleasure boats for visitors, encouraging viewing as much as meditation.[58] The temple itself was dedicated to Rinzai Zen Buddhism, popular during the Muromachi period (1336–1573), but the Rinzai sect, whose monks were particular targets in the broader purges around the Purple Robe Incident (1627), went into decline during the early Tokugawa. The Tokugawa seem to have had no interest in Saihō-ji. It famously became moss covered due to neglect during the Meiji era. On the Kyoto map, the once famous Saihō-ji (labeled as Saigyō zen), on the opposite side of the city from the Kyomizu-dera, is now far less prominent. Yet it is the first image in the tourist album. Arguably, then, the map, unlike the album, shows a shift in gravity from the west to the east because of the Tokugawa regime's strategic rebuilding plan. One might read the map as ideological reformation of the temple landscape even if it was not explicitly commissioned by the *bakufu*.

Thus the map represents only one part of a much more complex and at times conflicting set of views of Kyoto's temples, what Mary Elizabeth Berry describes as a "fissured landscape," and the view of Saihō-ji remains a significant one in Kaempfer's album.[59] It is also the first of the views, assuming the series was not reordered when bound. Behind the simple maintenance of a pilgrim tourist aura, the album depicts a renewal in the seventeenth century of what became a classical style, notably Musō Soseki's "promenading garden," secularized and brought into the broader confessional landscape of the Tokugawa. The painting in Kaempfer's album emphasizes the social and casual nature of the gardens, including a game of *go*. In general, the album paintings are conversation pieces without allusion or substance, at times approaching pure color in the great swaths of gold, green, and blue. Confessionalism of the kind that took place with the active involvement of the state at the Kyomizu-dera allowed and even necessitated this kind of disenchanting tourist commodification of the landscape at other temples, like the Saihō-ji. The two worked hand in hand to build what Eiko Ikegami calls "aesthetic networks," which envisioned and created a simul-

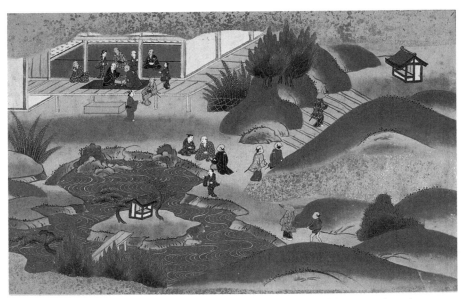

Figure 2.09. Anonymous, "Saihō-ji," from Kaempfer's album of famous sights of Japan. Painting on Japanese paper, 215 × 322 mm. British Library Add.MS.5252, fol. 1.

taneously confessional and disenchanted landscape amid burgeoning urban centers.[60]

Kaempfer himself valued the tourist album as a source for structuring and composing his narrative more than the Japanese maps, which he largely treated as icons of the extensive networks of large cities. In this sense, the formal qualities of the album as a sequence of views, while at times misread and reordered by Kaempfer and Scheutzer, nevertheless performed a similar function of organizing an itinerary in the mind of Kaempfer and later on Scheutzer's page. Translation and transmission may have been far from perfect here, subject to misinterpretation, historical shifts, techniques of exoticism, and the compromises of translations, but the series of prints and related aesthetic networks already demonstrated transmissible formal qualities.[61] What Japanese media did even more effectively than Safavid media in this period was to create such network collisions in order to generate a dynamic confessional landscape at home that could also be transmitted abroad. Kaempfer as a traveler could thus through the album experience achieve what Osterhammel refers to as the disenchantment of the distant neighbor (*entfernten Nachbarn*), in which the Japanese, despite a profound cultural difference and contemporary transformative cultural conflicts, emerge on the same basic level of discourse as Europeans. This discursive equality was already envisioned within the garden scenes in relation to Japanese tourists. The artist depicted the various conversations, games, and

viewings occurring at different levels of the garden as all essentially equivalent in terms of aesthetic networks and collectively naturalized at the level of religious sectarianism. For Kaempfer, the possession of a set of parallel media—the maps, prints, books, and tourist paintings that as a collection overshadowed his single Persian album—allowed him to participate in Japanese aesthetic networks virtually, something that presumably Japanese tourists also did at home with such albums, maps, and books. They could imagine themselves as any one of the figures on a page of the album, sharing in the confessional landscape.

Conclusion

At some level, the confessional landscape might seem like a cultural or aesthetic landscape, but the confessional landscapes of Safavid Persia and Tokugawa Japan were neither purely secular nor culturally "closed." They remained open both to history and to outside influences, sharing this quality with the more conscious juxtaposition of forms practiced in imperial landscapes. It is indeed hard to imagine the confessional landscape in Britain, Sweden, Persia, or Japan without the efforts to create broader and more imperial landscapes by the Spanish, Russians, Ottomans, Mughals, Ming, and Qing.

Safavid Persia and Tokugawa Japan actively built new landscapes out of the intersections of regional and religious traditions to express cultural particularity and uniqueness rather than the cosmological or mystical unity of "all under heaven." Accordingly, they simultaneously disenchanted and re-enchanted the landscape. Here one catches a glimpse of a multipolar world of disenchantment. Following Paul Ricoeur, the comparative examples offered by these very different kinds of polities and confessional landscapes might be called "ways of disenchantment" in the sense that the modes were disparate. In reacting against larger imperial projects while recognizing the problems that the distant action of commercial and religious networks created, Safavid Persia and Tokugawa Japan did not isolate themselves and turn inward culturally, as evidenced by Kaempfer's appropriations. Although the British, Dutch, Safavids, and Japanese polities often get lumped under the term "empire," it is not a particularly precise word historically for these polities and their landscapes. Like the British and the Dutch, the Safavids and Tokugawa avoided making totalizing claims on the landscape, a "strange parallel" in Victor Lieberman's comparative methodology.[62] Dynamic administrative and commercial efforts created novel kinds of confessional landscapes in the late seventeenth century. These were not quite the imagined community of the nation, open to all readers, but they did allow for

the creation of an apparently independent ethical observing subject in the face of an imagined natural world.

Notes

Epigraph. W. J. T. Mitchell, *Landscape and Power* (Chicago: University of Chicago Press, 1994), 10.

1. For "imperial repertoires," see Jane Burbank and Frederick Cooper, *Empires in World History* (Princeton: Princeton University Press, 2010), 10. On "cultural techniques" see Bernhard Siegert, *Cultural Techniques: Grids, Filters, Doors and Other Articulations of the Real* (New York: Fordham University Press, 2015).

2. See James Ackerman, ed., *The Imperial Map: Cartography and the Mastery of Empire* (Chicago: University of Chicago Press, 2009); Laura Hostetler, *Qing Colonial Enterprise* (Chicago: University of Chicago Press, 2001), chaps. 1–2. On interfaces and the ideological versus the ethical see Alexander Galloway, *The Interface Effect* (Cambridge: Polity, 2012), 51.

3. W. J. T. Mitchell, *What Do Pictures Want?* (Chicago: University of Chicago Press, 2005), 26–7. For the Kangxi quote see Robert Batchelor, "A Taste for the Interstitial (間): Translating Space from Beijing to London," in David Sabean and Malina Stefanovska, eds., *Spaces of the Self* (Toronto: University of Toronto Press, 2012), 281–304.

4. Chapter 9 (by Stephen Whiteman) of this volume addresses aspects of Bishu shanzhuang, or the Mountain Estate to Escape the Heat, under the Kangxi emperor.

5. Chapters 4 (by Ali Emrani) and 5 (by Anton Schweizer) of this volume go into greater depth about the respective urban landscape projects developed by Shah Abbas I (1571–1629) in Isfahan and by Toyotomi Hideyoshi (1536/37?–1598) in Osaka.

6. See Keith Thomas, *Religion and the Decline of Magic* (London: Weidenfeld and Nicolson, 1971) and *Man in the Natural World* (London: Allen Lane, 1983). For an overview of the "confessionalization paradigm," see Philip Gorski, *The Disciplinary Revolution: Calvinism and the Rise of the State in Early Modern Europe* (Chicago: University of Chicago Press, 2003), 15–19 and passim. Gorski cites in particular the work of Ernst Zeeden and Heinz Schilling.

7. Max Weber, "Wissenschaft als Beruf," *Gesammlte Aufsaetze zur Wissenschaftslehre* (Tubingen: 1922), 524–55. Weber had already famously argued in *Die protestantische Ethik und der Geist des Kapitalismus* (1905) that the Protestant religion had pushed magic to the side. For the Enlightenment as a cause, see Theodor Adorno and Max Horkheimer, *Dialectic of Enlightenment: Philosophical Fragments* [1947], trans. Edmund Jephcott (Stanford: Stanford University Press, 2002).

8. Paul Ricoeur, "Bouretz on Weber," in *Reflections on the Just* (Chicago: University of Chicago Press, 2007), 150–53. For Rousseau's critique see *Julie, ou la Nouvelle Héloïse*, vol. 2, *Oeuvres complètes*, edited by Bernard Gagnebin and Marcel Raymond (Paris: Gallimard, 1961), 471–84.

9. In the context of early nineteenth-century America, Richard White (following Leo Marx) attributes this to less to Thoreau's transcendentalism than to Kant's; *The Organic Machine* (New York: Hill and Wang, 1995), 35.

10. The key texts here are Marcel Gauchet, *Le désenchantement du monde: Une histoire politique de la religion* (Paris: Gallimard, 1985), esp. 232–33, the beginning of the chapter "Figures du sujet humain," on the ca. 1700 break; Talal Asad, *Genealogies of Religion* (Baltimore: Johns Hopkins University Press, 1993); and Charles Taylor, *A Secular Age* (Cambridge,

MA: Harvard University Press, 2007). For a critique of this scholarship, see the special issue of *Boundary 2* 40, no. 1 (Spring 2013), edited by Aamir Mufti and Stathis Gourgouris, *Lessons in Secular Criticism* (New York: Fordham University Press, 2013).

11. Robert Batchelor, "On the Movement of Porcelains: Rethinking the Birth of the Consumer Society as the Interaction of Exchange Networks, China and Britain, 1600–1750," in John Brewer and Frank Trentmann, eds., *Consuming Cultures: Global Perspectives* (Oxford: Berg, 2006), 79–92. On the transcultural, see Mary Louise Pratt, *Imperial Eyes: Travel Writing and Transculturation* (London: Routledge, 1992). Benjamin Schmidt has argued that the Dutch played a key role in "inventing exoticism" for European consumption, because their eyes were not precisely imperial; *Inventing Exoticism: Geography, Globalism, and Europe's Early Modern World* (Philadelphia: University of Pennsylvania Press, 2015).

12. The clearest articulation of this process has been in Benedict Anderson's *Imagined Communities*, 2nd ed. (London: Verso, 1991), which associates it with print capitalism. Landscapes go unmentioned, but the revised edition discusses the images produced by maps and museums (170–85).

13. For Britain's confessionalism emerging in a global context, see Robert Batchelor, *London: The Selden Map and the Making of a Global City, 1549–1689* (Chicago: University of Chicago Press, 2014), esp. chaps. 4, 5 and the conclusion, as well as Batchelor, "Concealing the Bounds: Imagining the British Nation Through China," in Felicity Nussbaum, ed., *The Global Eighteenth Century* (Baltimore: Johns Hopkins University Press, 2003), 95–122.

14. For exploration as a kind of grand tour see Alison Games, *Web of Empire* (New York: Oxford University Press, 2008), esp. chap. 1. Pratt argues that "planetary consciousness" aimed at the "systematizing of nature" creates a "European global or planetary subject" by 1700; Pratt, *Imperial Eyes*, 29–30.

15. Adam Olearius, *Vermehrte Newe Beschreibung der muscowitischen und persischen Reise* (Schleswig: 1656), 2nd ed., 778 pages and index in six books. The first edition, printed in Schleswig just before the end of the Thirty Years' War was entitled *Offt begehrte Beschreibung der newen orientalischen Reise, so durch Gelegenheit einer Holsteinischen Legation an den König in Persien geschehen* (Schleswig: Jacob zur Glocken, 1647). Olearius was very popular, and the publishing history is complex in several European languages. Scholarship on both Olearius's and Kaempfer's accounts of Safavid Persia has remained ambivalent about their status as "scientific" observers and remains limited by the lack of comparative perspective. See Elio Brancaforte, *Visions of Persia: Mapping the Travels of Adam Olearius* (Cambridge, MA: Harvard University Press, 2003); Brancaforte, "Seduced by the Thirst for Knowledge: Engelbert Kaempfer's Scientific Activities in Safavid Persia (1683–1688)," in *Revista de Cultura/Review of Culture* 21 (2007): 82–99; Rudi Matthee, "The Safavids Under Western Eyes: Seventeenth-Century European Travelers to Iran," *Journal of Early Modern History* 13, no. 2 (2009): 131–71.

16. Jürgen Osterhammel, *Die Entzauberung Asiens: Europa und die asiatischen Reiche im 18. Jahrhundert* (Munich: C. H. Beck, 1998), 12–13 and passim. On the broader popularity of Kaempfer in the Enlightenment, see Peter Kapitza, "Engelbert Kaempfer und die europäische Aufklärung: Zur Wirkungsgeschichte seines Japanwerks im 18. Jahrhundert," in *Engelbert Kaempfers Geschichte und Beschreibung von Japan: Beiträge und Kommentar* (Berlin: Springer, 1980), 41–64. Voltaire, as Kapitza notes, thought after reading Kaempfer that in Japan "the laws of nature ha[d] been transformed into civil laws" (57). On Kaempfer more generally, see Detlef Haberland, ed., *Engelbert Kaempfer (1651–1716): Ein Gelehrtenleben zwischen Tradition und Innovation* (Wiesbaden: Harrassowitz, 2004), and Derek Massarella and Beatrice Bodart-Bailey, *The Furthest Goal: Engelbert Kaempfer's Encounter with Tokugawa Japan* (Folkestone: Japan Library, 1995).

17. Engelbert Kaempfer, "An Enquiry, whether it be conducive for the good of the Japanese Empire, to keep it shut up, as it is now, and not to suffer its inhabitants to have any Commerce with foreign nations, either at home or abroad," trans. J. G. Scheuchzer, *The History of Japan* 3 (London: 1727; 2nd ed., 1729), 301–36. In 1801, Shizuki Tadao translated this essay from the 1729 Dutch edition (2nd ed., 1733) in his manuscript *Sakokuron* (BL copy Or.14947; several others extant). See Donald Keene, *The Japanese Discovery of Europe, 1720–1830* (Stanford: Stanford University Press, 1969), 76; Tashiro Kazui, "Foreign Relations During the Edo Period: Sakoku Reexamined," *Journal of Japanese Studies* 8, no. 2 (1982), 283–84; Ronald Toby, "Three Realms/Myriad Countries: An Ethnography of Other and the Rebounding of Japan," in Kai-Wing Chow et al. eds., *Constructing Nationhood in Modern East Asia* (Ann Arbor: University of Michigan Press, 2001), 15–46; and Robert Liss (Lissa Roberts), "Frontier Tales: Tokugawa Japan in Translation," in Simon Schaffer et al., *The Brokered World* (Sagamore Beach: Science History Publications, 2009), 17–31.

18. For a description of these, see Kenneth Gardner, "Engelbert Kaempfer's Japanese Library," *Asia Minor* 7, nos. 1–2 (1959): 72–78; Gardner, *Descriptive Catalogue of Japanese Books in the British Library Printed Before 1700* (London: British Library, 1994); and Kawase Kazuma and Okazaki Hisaji, eds., *Daiei Toshokan shozōwakansho somokuroku* (Tokyo: Kōdansha, 1996).

19. The thesis of medium-sized state consolidation across Eurasia in this period is one advanced by Victor Lieberman, "Transcending East-West Dichotomies: State and Culture Formation in Six Ostensibly Separate Areas," *Modern Asian Studies* 31 (1997): 468–520; and *Strange Parallels: Southeast Asia in Global Context, c. 800–1830* (Cambridge: Cambridge University Press, 2003). Lieberman is also responsible, as Whiteman points out, for one definition of "connective history." The idea of a general mid-seventeenth-century ecological and political crisis is put forward by John Richards, *The Unending Frontier* (Berkeley: University of California Press, 2003), and Geoffrey Parker, *Global Crisis* (New Haven: Yale University Press, 2013).

20. See Pamela Smith, *The Business of Alchemy: Science and Culture in the Holy Roman Empire* (Princeton: Princeton University Press, 1994). For gardens, see in particular Salomon de Caus, *Hortus Palatinus a Friderico Rege Boemiae Electore Palatino Heidelbergae extructus* (Frankfurt: 1620), and Richard Zimmerman, "The Hortus Palatinus of Salomon de Caus," in Monique Mosser and Georges Teyssot, eds., *The Architecture of Western Gardens* (Cambridge, MA: MIT Press, 1991), 157–59.

21. On the myth, see Benno Teschke, *The Myth of 1648* (London: Verso, 2004); Andreas Osiander, "Sovereignty, International Relations, and the Westphalian Myth," *International Organization* 55, no. 2 (2001): 251–87. The general critique is aimed at Leo Gross, "The Peace of Westphalia, 1648–1948," *American Journal of International Law* 42, no. 1 (1948): 20–41.

22. See Kaempfer's dissertation from his time, begun while he was at the Lübeck Latin gymnasium but published once he moved to the Danzig athenaeum, *Exercitatio politica de Majestatis divisione* (Danzig: David-Fridericus Rhetius, 1673); and Beatrice Bodart-Bailey, *Kaempfer's Japan: Tokugawa Culture Observed* (Honolulu: University of Hawai'i Press, 1999), 17.

23. On the witch hunts in Lemgo and their relation to medicine, see Gerhard Benecke, *Society and Politics in Germany: 1500–1750* (London: Routledge, 1974), 174–180; Heinz Roehrich, "Ein Apotheker als 'Hexenmeister' im 17. Jahrhundert: David Welman(n) (1590–1669), Rats-Apotheker in Lemgo," *Persee* 63, no. 226 (1975): 507–13; and Karl Meier-Lemgo, *Hexen, Henker und Tyrannen: Die letzte blutigste Hexenverfolgung in Lemgo 1665–1681* (Lemgo: 1949).

24. See generally Paula Findlen, *Possessing Nature: Museums, Collecting and Scientific Culture in Early Modern Italy* (Berkeley: University of California Press, 1994). On medicine as a transcultural medium, see Harold Cook, *Matters of Exchange: Commerce, Medicine, and Science in the Dutch Golden Age* (New Haven: Yale University Press, 2007).

25. These maps can be found on fols. 26–28 in BL Sloane 2910, analyzed in more detail below, and on fols. 4–27 in BL Sloane 5232 (*Occae Fluminis Delineatio* "Map of the River Oka" is fol. 4, fols. 5–23 are a long map of the Volga, fol. 24 is the Caspian Sea, fol. 25 the route from Tarku to Isfahan, and fol. 27 two maps of Siberia). See Margarete Lazar, "The Manuscript Maps of Engelbert Kaempfer," *Imago Mundi* 34 (1982): 66–71. Kaempfer kept a diary of his journey from Stockholm to Moscow, Sloane 2923, fols. 116–53, and his Russia diary for 1683 is *Werke: Volume 6, Russlandtagebuch 1683*, edited by Michael Schippan (Munich: Iudicum, 2003).

26. In 1669, Fritz Cronman (ca. 1640–ca.1680), the head of the Swedish embassy, and the young Claes Johansson Prytz (1651–1707) made the first copies of Godunov's map (ca. 1666), now in the Swedish Riksarkivet, SE/RA/2113/2113.1/1/38/84. In 1673/4, Eric Palmquist, who was part of the second embassy, made a copy of two versions of Godunov's map (1668 and a ca. 1673 posthumous revision). Palmquist's extensively illustrated journal, with river maps similar to Kaempfer's, is SE/RA/81001/#/0636:00001 (https://sok.riksarkivet.se/bildvisning/ R0001525_00014, accessed 28 July 2021). The maps "Copia aff den Charta of wer Siberia des Tobolsky," are fols. 31 and 35. Cf. Leo Bagrow, *A History of Russian Cartography: Volume 1*, edited by Henry Castner (Wolfe Island, Ontario: Walker Press, 1975), 26–30. Johan Sparwenfeld, who arrived in Moscow with Kaempfer in 1683, made a copy in 1687 that he used to make his own map of Asia in 1688/9, now at the University of Uppsala Library. Both are reproduced along with the original in St. Peterburg in Leo Bagrow, "Sparwenfeld's Map of Siberia," *Imago Mundi* 4 (1947): 65–70. There are other copies of the 1667 map by Semën Remezov, *Sluzhebnaia chertezhnaia kniga* (1666/7): Russian National Library, Ermitazhnoe sobranie 237, Sketchbook II, 30v–31r and MS Rus 72 (1); and Leo Bagrow Collection, Houghton Library, Harvard University, originally bound in Remezov, *Khorograficheskaya kniga* (ca. 1696), MS Rus 72 (6).

27. Translation in Bodart-Bailey, *Kaempfer's Japan*, 45. These passages were all written after Kaempfer's return to Europe, as they mention both Nicolaas Witsen's map of "Tartaria" (Amsterdam: 1687/1690), with an accompanying description *Nord en Oost Tartarye* (Amsterdam: n.d, 1692, 2nd ed. 1705)], and the map's use by Evert Ysbrants Ides, Ivan's and Peter I's ambassador to the Qing Empire (1692–95), whose account was published as *Driejaarige Reize naar China* (Amsterdam: François Halma, 1704, 1710; English translation 1706) along with Witsen's "Nova Tabula Imperii Rusicii, a Everardo Ysbrants Ides," (Amsterdam: François Halma, 1704). On Vinius, who was originally hired to set up a postal/news system and translate Dutch newspapers, see Kees Boterbloem, *Modernizer of Russia: Andrei Vinius, 1641–1716* (London: Palgrave Macmillan, 2013). It is unclear whether Kaempfer saw Milescu's itinerary through one of Vinius's maps or on the "Sparthios Map" itself, but the results are BL Sloane 2910 fol. 26. For Milescu's map see Nikolai Gavrilovich Spathari [Nicolae Milescu], "Spatharios Map" (1682), MS Russ 72 (2), Bagrow Collection, Houghton Library, Harvard University. See Marina Tolmacheva, "The Early Russian Exploration and Mapping of the Chinese Frontier," *Cahiers du monde Russe* 41, no. 1 (2002): 41–56; Daniela Dumbrava, "John G. Sparwenfeld e Nicolae Milescu (Mosca, 1684): Rapporti diplomatici, scambi d'informazione e convergenza delle fonti," *Stvdia Asiatica* 10 (2009): 297–307.

28. "Certaru nationum distinguunt signat tractus itine cum commode instituendo cum." The implied route is from the "source" of the Ob River south and east to the western end of the Great Wall. It is shown as a road on Witsen's 1687 map.

29. Valerie Kivelson, *Cartographies of Tsardom: The Land and Its Meanings in Seventeenth-Century Russia* (Ithaca: Cornell University Press, 2006); Kivelson, "Exalted and Glorified to the Ends of the Earth: Imperial Maps and Christian Practices in Seventeenth and Early Eighteenth Century Russian Siberia," in Ackerman, ed. *The Imperial Map*, 47–91. Kaempfer tried his hand at drawing Russian churches in BL Sloane 5232 fol. 3 and map icons that followed these sketches in that same volume.

30. On the usage of this term in the late seventeenth and early eighteenth centuries, see David Moon, *The Plough That Broke the Steppes* (Oxford: Oxford University Press, 2013), 41; Dumbrava, "The Spatharios Map, 1682 (?) MS Russ 72 (2) in the Leo Bagrow Collection at the Houghton Library," and John Baddeley, *Russia, Mongolia, China* (London: Macmillan, 1919), 194. My thanks to Daniela Dumbrova for her help with this concept.

31. See his manuscripts *Khrismologion* (Book of prophecy) (1672) and *Vasiliologion* (Book of rulers) (1674) as described in Michael Pesenson and Jennifer Spock, "Historical Writing in Russia and Ukraine," in José Rabasa et al., eds., *The Oxford History of Historical Writing: Volume 3: 1400–1800* (Oxford: Oxford University Press, 2012), 294–95.

32. Notably the long-term effects of Shah Abbas I's redesign of Isfahan described in chapter 4 of this volume.

33. The draft of the *Amonenitatum* section can be found in Sloane 2907 fols. 92v–109v; plans 2910, 86r–106v; also Sloane 2920 and variously in 2923, fols. 40–100. While in Isfahan, Kaempfer drew a map of the Khiyābān-i Chahārbāgh (Sloane 5232, fol. 41) showing the locations of twenty-nine gardens, as well as individual drawings of the main palace Dawlatkhānah (Sloane 5232, fol. 38), Bāgh-i Ḵalvat, Chihil Sutun (Sloane 2910, fol. 102), Bāgh-i Angurestan (Sloane 5232, fol. 38), Bāgh-i Guldasta (Sloane 5232, fol. 38; Sloane 2910, fols. 92–93), Bāgh-i Bulbul (Sloane 2910, fol. 93), and the Bāgh-i Hazār Jarib (Sloane 5232, fol. 45v). See Detlef Haberland, "Engelbert Kaempfer," *Encyclopaedia Iranica* 15, no. 3 (2009): 332–35. Kaempfer also spent a great deal of time with the Capuchin Father Raphaël du Mans (1613–96), who had arrived in Isfahan in 1647, largely ministering to the Armenian Christians in the city. He gave Kaempfer his account of Persia (*De Perse*).

34. Kaempfer, *Aeomontitatum* 1, 172, possibly borrowing from the account of Johan Albrecht de Mendelslo (1616–44). Scholarly assessments include Baqher Shirazi, "Isfahan, the Old: Isfahan, the New," *Iranian Studies* 7, part 2, nos. 3–4 (1974): 589; Susan Babaie, *Isfahan and Its Palaces: Statecraft, Shi'ism and the Architecture of Conviviality in Early Modern Iran* (Edinburgh: Edinburgh University Press, 2008); Heidi A. Walcher, "Between Paradise and Political Capital: The Semiotics of Safavid Isfahan," *Middle Eastern Natural Environments: Lessons and Legacies* 103 (1998): 330–48; Masashi Haneda, "The Character of Urbanization of Isfahan in the Later Safavid Period," *Pembroke Papers* 4 (1996): 369–88; Masahi Haneda, "Mayden et Bagh: Reflexion à propos de l'urbanisme du Sah Abbas," in Haneda, *Documents et archives provenant de l'Asia Centrale* (Kyoto: Association Franco-Japanase des Études Orientales, 1990), 87–89.

35. Walcher, "Between Paradise and Political Capital."

36. On the Shia ascendancy see Marshall Hodgson, *The Venture of Islam, Volume 3: The Gunpowder Empires* (Chicago: University of Chicago Press, 1974), 30–57.

37. See the separate sketch of the Bagh-i Hizar Jarib in the collection of Dumbarton Oaks, https://www.doaks.org/resources/middle-east-garden-traditions/catalogue/C170, accessed 28 July 2021; Mahvash Alemi, "Safavid Royal Gardens and Their Urban Relationships," in Abbas Daneshvari, ed., *A Survey of Persian Art, from Prehistoric Times to the Present: Volume 18, Islamic Period: From the End of the Sasanian Empire to the Present* (Costa Mesa, CA: Mazda, 2005), 1–24. Nothing remains of either garden.

38. Kaempfer describes this in *Amonenitatum* 1, 195–8, including an engraving of part of the watercourse on 197.

39. Kaempfer's plan for the Guldasta gardens is reproduced in the Dumbarton Oaks catalog, https://www.doaks.org/resources/middle-east-garden-traditions/catalogue/C172, accessed 28 July 2021.

40. Jean Calmard emphasizes the popular use of public space, festivals, and rituals, including polo and horse racing, which included increasing importance placed on Shi'a Muharram rituals (the anniversary of the martyrdom of Hussein Ibn Ali), in "The Consolidation

of Safavid Shi'ism: Folklore and Popular Religion," in Charles Melville, ed., *Safavid Persia* (London: I. B. Taurus, 1996), esp. 158–64; Andrew Newman, *Safavid Iran* (London: I. B. Tauris, 2006), 96–103. On the Muharram ritual before Suleiman, see Babak Rahimi, *Theater State and the Formation of the Early Modern Public Sphere in Iran* (Leiden: Brill, 2012), esp. 188–98.

41. The paradise theme is articulated by the earliest commentators in Persian, notably the court astronomer Jalal al-Din Muhammad Yazdi's; "Tarikh-i Abbasi" BL Or. 6263, ca. 1612. Cf. R.D. McChesney, "Four Sources on Shah Abbas's Building of Isfahan," *Muqarnas* 5 (1988): 103–34.

42. Zakariyā᾽ al-Qazwīnī (1203–83) and Muhammad al-Tūsī (1201–74), *᾽Ajāyib al-makhlūqāt va-gharāyib al-mawjūdāt* [بئاجع المخلوقات وغرائب الموجودات "Wonders of Creation and Marvelous Possessions"], sixteenth century, Persian scribe, Walters Art Gallery, Baltimore, W.593. On this map see Walters Art Gallery, Baltimore, http://www.thedigitalwalters. org/Data/WaltersManuscripts/html/W593/description.html for a page-by-page digitization of the whole manuscript; and Karin Rührdanz, "An Ottoman Illustrated Version of Muhammad al-Tusi's Aja'ib al-Makhluqat," *Arab Historical Review for Ottoman Studies* 19–20 (1999): 455–75. On "Wonders of Creation" books as emerging during the Mongol (Ilkhanid) period in Iran and their popularity through the fourteenth century, see Persis Berlekamp, *Wonder, Image and Cosmos in Medieval Islam* (New Haven: Yale University Press, 2011). The maps in the Walters manuscript and in Kaempfer's album are very different from earlier maps in al-Qazwīnī manuscripts, notably the earliest surviving fourteenth-century version in al-Qazwīnī's *Athar al-bilad* (1329), British Library, MS. Or. 3623, which also includes a climate diagram on fol. 5. It generally relies on the 1029 CE sketch map by al-Biruni, preserved in a 1238 copy of *Kitab al-tafhim li-awa'il sina'at al-tanjim*, British Library, MS. Or. 8349, fol. 58, and a 1539 version of al-Qazwīnī's *᾽Ajāyib al-makhlūqāt*, MS Pococke 350, fol. 73v. Cf. J. B. Harley and David Woodward, eds., *The History of Cartography* 2:1 (Chicago: University of Chicago Press, 1987), 141–42; Hyunyee Park, *Mapping the Chinese and Islamic Worlds*, 78–79. See the fuller description of both maps in Robert Batchelor, "The Global and the Maritime: Divergent Paradigms for Understanding the Role of Translation in the Emergence of Early Modern Science," in Patrick Manning, ed., *Found in Translation: World History of Science, 1000–1800 CE* (Pittsburgh: University of Pittsburgh Press, 2018), 83–87.

43. Sussan Babaie alludes to the nostalgic rather than historical aspects of the proverb; Babaie, *Isfahan and Its Palaces*, 65.

44. On the debate over this centrality and climates in Islamic sources, see J. T. Olsson, "The World in Arab Eyes: A Reassessment of the Climes in Medieval Islamic Scholarship," *Bulletin of the School of Oriental and African Studies* 77, no. 3 (2014): 487–508.

45. The classic description of the Islamic World System is Janet Abu-Lughod, *Before European Hegemony: The World System A.D. 1250–1350* (Oxford: Oxford University Press, 1989).

46. Thomas Allsen, *The Royal Hunt in Eurasian History* (Philadelphia: University of Pennsylvania Press, 2006), 31, 140, 203, 264. Kaempfer's drawing of the tower of horns or skulls (*Kelleh Minar*) is British Museum 1974,0617,0.1.5. Both Jean Chardin (1643–1713) and Nicholas Sanson ("Tower of Bones and Hornes," in *The Present State of Persia*, 1695) included engravings of it, while Herbert and Tavernier also mention it.

47. Eleanor Sims, *Peerless Images: Persian Painting and Its Sources* (New Haven: Yale University Press, 2002), 65–66, 75–77.

48. Kaempfer's drawing of the Khiyābān-i Chahārbāgh around the great basin (Daryācha Qorbungah, "Qorbungah Basin") is MS Sloane 2912, fol. 34v. Kaempfer also made a drawing of the whole city showing the mountains and the *bāghestan* (fol. 45), which seems to indicate a kind of tourist itinerary, as many of the sites are also mentioned by Pietro della Valle (1586–

1652), Jean-Baptiste Tavernier (1605–1689), and Jean Chardin. Kaempfer also drew, in the same journal, a plan of the garden of Vizir Imani Beyk ("Vizir Imambek," fol. 34r), the tomb of Shah Mansur (d. 1393) (fol. 41), a plan of his favorite garden, the fourteenth-century Bāgh-i Delgosha of the Kalantar Murtesa Quli Khan ("Der Kelantar Wohn [residence]," fol. 36v) near the tomb of Saadi, the Bāgh-i Shah of the governor of Shiraz Emam Qoli Khan (fol. 35v), and the aforementioned tomb of Hafez. Kaempfer makes note of several others. Mahvash Alemi notes that almost all the places Kaempfer drew in Shiraz had popular sacred associations, including certain cypress trees, springs, and mountains, "Shiraz: The City of Gardens and Poets," in Salma Jayyusi et al., *The City in the Islamic World* (Leiden: Brill, 2008), 2:536–39.

49. Saadi Shirazi's *Bustan* ("The Orchard," 1257) and *Gulistan* ("The Rose Garden," 1258). Both circulated widely in the Islamic world by the seventeenth century. The French ambassador to the Ottomans André du Ryer made a partial French translation of *Gulistan* in 1634 (*Guilistan, ou l'empire des roses*) out of his extensive library, and Olearius translated both into German (*Persianischer Rosenthal. In welchem viel lustige Historien scharffsinnige Reden und nützliche Regln. Vor 400 Jahren voneinem sinnreichen Poeten Schich Saadi in Persianischer Sprache beschrieben* [Schleswig and Hamburg: Holwein und Nauman, 1654]). Hafez was not translated in Europe until the 1771 English translation of William Jones, but Pietro della Valle visited Hafez's tomb in July 1622, calling him "Poeta famoso tra Persiani." Biblioteca Apostolica Vaticana, MS. Ottoboniano Latino 3382, entry for 1 July 1622, includes an epitaph in Persian; *Viaggi di Pietro della Valle il Pellegrino, descritti da lui medesimo in lettere familiari all'erudito suo amico Mario Schipano* (Rome: B. Deuersin, 1658), 2:376–77, from which Kaempfer had notes (Sloane 2912, fol. 19r). Kaempfer drew a plan of the tomb and gardens during his time in Shiraz, copying the inscription as well, BL MS Sloane 2912, fol. 37r. On fourteenth-century Shiraz, see John Limbert, *Shiraz in the Age of Hafez* (Seattle: University of Washington Press, 2004).

50. Gen'emon shared an interest in natural history and apparently thought nature represented a common, disenchanted ground between teacher and student. To systematically approach collecting and writing a natural history of Japan, Kaempfer used a popular encyclopedia by Nakamura Tekisai (1629–1702), *Kinmo zui* (preface 1666), OIOC Or 75.ff.1; a partial second copy is OIOC Or 75.ff.1*. The twenty-one parts seem to have been unbound when they arrived in the Sloane collection; see K. B. Gardner, "Engelbert Kaempfer's Japanese Library," *Asia Major* 7 (1959): 77.

51. On this wildly speculative account by Kaempfer as popular Japanese folklore, cf. Massarella and Bodart-Bailey, *Kaempfer's Encounter with Tokugawa Japan*, 62–64.

52. See the copy in the d'Anville Collection, Département cartes et plans, CPL GE DD-2987 (7461), BnF Gallica, https://gallica.bnf.fr/ark:/12148/btv1b5963197w/f1, accessed 28 July 2021.

53. On city plans generally, see Yamori Kazuhiko, *Toshizuno rekishi*, 2 vols. (Tokyo: Kodansha, 1974–75).

54. See Kazutaka Unno, "Cartography in Japan," in J. B. Harley and David Woodward, eds., *The History of Cartography* 2:2 (Chicago: University of Chicago Press, 1987), 400–404. Mary Elizabeth Berry emphasizes the fact that there are no "medieval" maps of Kyoto, despite its importance, only the more abstract early modern ones starting in the 1630s; *Japan in Print* (Berkeley: University of California Press, 2007), 54–55. On maps of Edo from the same period, starting in 1632, see Marcia Yonemoto, *Mapping Early Modern Japan: Space, Place and Culture in the Tokugawa Period* (Berkeley: University of California Press, 2003), 17–26.

55. The Japanese phrase is usually *Saigoku Sanjūsan-sho* 西国三十三所, the thirty-three referring to the number of forms of the bodhisattva Kannon. The pilgrimage stretches for six hundred miles. Kyomizu-dera is the sixteenth stop. Kaempfer had two illustrated guides to this pilgrimage: *Saigoku Sanjusanban Junreiuta* (Osaka: Nakajimaya, ca. 1680s), OIOC Or

75.g.7, and *Saigoku Sanjusan-Sho Junrei Engi* (Kyoto: Kiemon, 1680), OIOC Or 75.f.29; as well as a scroll *Saikoku Kairiku Anken Ezu* (ca. 1673–88), Or 70.bbb.9. Constantine Vaporis, *Breaking Barriers: Travel and the State in Early Modern Japan* (Cambridge, MA: Harvard University Press, 1994), describes the "secularization of pilgrimage" (236), which became play-seeking travel (*yusan tabi* 遊山旅).

56. An event known as the Purple Robe Incident of 1627; see Duncan Williams, "The Purple Robe Incident and the Formation of the Early Modern Sōtō Zen Institution," *Japanese Journal of Religious Studies* 36, no. 1 (2009): 27–43.

57. BL Add MS. 5252. For a general description, see Yu-Ying Brown, "Kaempfer's Album of the Famous Sights of Japan," *British Library Journal* (1989): 90–103

58. On the redesign of the garden, see François Berthier, *Reading Zen in the Rocks: The Japanese Dry Landscape Garden* (Chicago: University of Chicago Press, 2000), 20–25.

59. Berry, *Japan in Print*, 76.

60. Eiko Ikegami, *Bonds of Civility: Aesthetic Networks and the Political Origins of Japanese Culture* (Cambridge: Cambridge University Press, 2005).

61. On "forms," see Caroline Levine, *Forms: Whole, Rhythm, Hierarchy, Network* (Princeton: Princeton University Press, 2015), 112–18.

62. Kaempfer's observations on Siam could be productively brought into this comparison and approach.

Constructing an Authentic China

Henri Bertin and Chinese Architecture in Eighteenth-Century France

John Finlay

In the intellectual, scientific, and artistic encounters between Europe and China in the late eighteenth century, Henri-Léonard Jean-Baptiste Bertin (1720–92) played a crucial role.[1] Bertin, who served from 1763 to 1780 as a minister of state under Louis XV (1710–74) and, briefly, Louis XVI (1754–93), conceived of China as an ancient civilization ruled by an enlightened monarch and a nation from which Europe had much to learn. In a long letter dated 16 January 1765, Bertin made reference to "the correspondence that they have observed between the French and the Chinese in the national spirit and character, the two nations that can be seen as the best regulated and the most naturally civilized in the world."[2] This is Bertin's clearest statement that France and China are truly commensurate, and that they can be directly compared as civilizations on an equal footing. In order to secure comprehensive and accurate knowledge of China, Bertin began an extensive correspondence in 1765 with the French Jesuit missionaries in Beijing, themselves highly educated men who served as scientists, mathematicians, and artists in the court of the emperors of Qing (1644–1911) China. Administration of the French Jesuit mission was one responsibility of Bertin's ministry, and, after the suppression of the Jesuit order by Pope Clement XIV (1705–74) in 1773, Louis XVI guaranteed the financial support of the French missionaries still in Beijing.[3] Up to the moment when the French Revolution effectively ended official support for the Jesuit Mission française de Pékin, the missionaries sent Bertin an extraordinary number of images and a vast body of texts that dealt with many aspects of historic and contemporary China.[4]

Included in the shipments from the Jesuit missionaries in Beijing were writings and paintings that described and illustrated what the missionaries and Bertin specifically called Chinese "architecture," a broadly defined term that placed the tools and materials of construction alongside building types perceived as typical of or unique to the Chinese tradition and even included important elements of garden architecture. Taking their cue from a European Enlightenment point of view that sought accurate knowledge of technology and the arts alongside historical traditions, the French Jesuits prepared detailed descriptions to accompany paintings commissioned especially for Bertin. These included views of imperial palace buildings and temples, as well as structures in the imperial garden-palace Yuanming yuan 圓明園. Texts and pictures together highlighted what was unknown and exotic in Chinese architecture in contrast with European practice. Although in his writings Bertin himself does not seem to use an equivalent of the term "authentic," acquiring authentic knowledge was clearly his goal if France was to learn from China. Bertin believed that France could profit from a direct comparison with China, that Europeans could judge Europe by China and China by Europe, and he actively sought knowledge to be compared through the medium of texts and images.[5]

Architecture appears to have been a subject of particular interest to Bertin, and an awareness of the very real differences between Chinese and European architecture prompted the Jesuit missionaries to ask rhetorically whether Chinese architecture was indeed worth knowing. In response, the material they sent Bertin was carefully organized to deal with the forms and history of specific types of Chinese buildings, a strategy that directly implied the commensurability of European and Chinese models and standards. Illustrations and observations were typically arranged in a hierarchy that extended from simple, ordinary buildings to those that represented the most elaborate, imperial constructions. The emphasis on specifically imperial architecture appears to reflect Bertin's long service to the kings of France, a contemporary bias toward more magnificent forms of architecture, and the fact that the French Jesuit missionaries were embedded in the Qing imperial court. The texts that describe Chinese buildings contain references to the official regulations that supposedly guided Chinese construction practice, providing hints of how architecture reflected official and imperial authority, and they even contain echoes of imperial assertions of the Manchu Qing emperors' fitness to rule.

This essay analyzes a pair of extraordinary illustrated albums in Bertin's collection that presented for the first time a detailed and accurate overview of Chinese architecture. The texts and images in the albums raise questions of the differences and similarities between Chinese and European architecture. Placing the knowledge that the albums presented in a broader context then leads to

further questions. The illustrations of architecture for the most part depict individual buildings with the emphasis on the construction, not the landscape setting, while other paintings in Bertin's collection represent buildings and garden constructions as an integral part of the landscape.[6] Writings on architecture in eighteenth-century France and in traditional China produced very different concepts of what might be called "architecture." While the knowledge of Chinese architecture that Bertin acquired achieved a certain circulation in Europe, perhaps the most complex response to this encounter was a personal one—Bertin's planned construction at his estate at Chatou outside Paris of buildings and gardens in an authentic Chinese style. But not all of the questions raised here have clear answers.[7]

The Jesuit Missionaries' "Essay on Chinese Architecture"

Among the materials related to Chinese architecture in Bertin's collection, surely the most important is a pair of albums combining paintings and texts entitled *Essai sur l'architecture chinoise*, or "Essay on Chinese architecture."[8] Although the two albums themselves are undated, the manuscript that is the source for the texts copied into them provides an approximate date: the last page notes that it was written in Beijing on 3 October 1773.[9] The first album begins with a brief *avertissement*—an introduction—and each of its 135 paintings faces a caption, which usually consists of a simple title but often enough includes a short paragraph that describes what we see in the picture. The second volume follows the same format; it contains an introduction, captions or brief texts facing fifty-three paintings, and, at the very end, an article that begins "Several observations that deserve our attention."[10] The *Essai sur l'architecture chinoise* covers an astonishing range of subjects, from tools and building materials to complete structures of many kinds. These include buildings for different classes of society, from the common people (represented by a very few illustrations) to the literati, and, most especially, imperial constructions. While the paintings emphasize the depiction of architectural detail, each building is given at least a minimal landscape backdrop, and certain structures are depicted in more elaborate garden or landscape settings. The texts occasionally address issues directly related to the landscape. The effort to accurately describe and depict so many aspects of Chinese architecture is unprecedented.

太廟
照壁

Figure 3.01. "*Tchao Pei* de la grande salle ou *Miao* des Ancêtres de la famille Impériale regnante" (Screen-wall of the great hall or *Miao* of the ancestors of the reigning imperial family). In *Essai sur l'architecture chinoise* (ca. 1773), vol. 1, illus. 52, ink and color on paper, approx. 36 × 27 cm. Bibliothèque nationale de France, Paris, Département des estampes et de la photographie, Oe-13-Pet. fol.

Première partie de l'Essai sur l'architecture chinoise

The first part of the *Essai sur l'architecture chinoise* begins with illustrations of carpenters' and masons' tools. The Jesuit missionaries did not supply a detailed description of all of them but did carefully explain those that were peculiar to

China. After the illustrations of tools, the album continues with pictures of building materials: lime and mortar, bricks and tiles, and roof ornaments. The combination of texts and illustrations detailing crafts and contemporary technology is an example of a European Enlightenment strategy for the diffusion of technical knowledge in the form of writings accompanied by illustrations, of which Diderot and D'Alembert's project for the *Encyclopédie* is the best-known example.[11] Examples of the *Encyclopédie* were not part of the Jesuit libraries in Beijing, but other illustrated texts were held there, including books on architecture, among them translations of the seminal work of Vitruvius.[12] While it is unlikely that there was a direct influence from the *Encyclopédie* on the *Essai sur l'architecture chinoise*, both clearly represent an eighteenth-century spirit of inquiry that seeks to be broadly inclusive.

The *Essai sur l'architecture chinoise* then illustrates various types of walls, beginning with walls of constructions "of the people" and ending with walls associated with the most elaborate or, in many cases, imperial constructions. The *Essai* then takes up an architectural element that was surely little known in Europe, that of the screen-walls placed at the entrance to Chinese buildings or walled compounds. The screens or screen-walls, some decorated with auspicious paintings, other with sculptural decoration and colored tiles, are those of ordinary urban dwellings, of "mandarins" and important citizens, courts of law, imperial princes, Buddhist temples, imperial temples, including the ancestral temple (figure 3.01), and screen-walls within the imperial palace.[13]

The explanation that accompanies the paintings introduces an aspect of Chinese architecture to which the writer (or writers) return a number of times, that of sumptuary laws—the regulations governing official rank and its public display: "It is surely not to enlighten our Architects on the great Architecture of the ancients nor on the manner in which we could improve new [constructions] that we have had painted the *Tchao Ping* [zhaoping 照屏], *Tchao Pi* [zhaobi 照壁] and *Tchao Hiang* [zhaoqiang 照墙] in the ten following paintings as well as this one; but to provide a view of how the Chinese Government deals with these, to make visible to all the difference in ranks, and to keep each within the Realm of his status."[14] That is, the various kinds of Chinese screen-walls—which would serve no purpose in a European context—are distinguished by styles and forms that directly reflect the official rank of the occupant of a building or the status of the building itself, and the text describes this phenomenon in detail. Unknown in Europe, official regulation of architecture excited the curiosity of the Jesuit missionaries, although they never appear to state exactly why. We shall see, however, that the intimate relationship between architecture and social or official status was a question that was not unknown in eighteenth-century France.

In the first album of the *Essai sur l'architecture chinoise*, the largest group of paintings—some fifty-seven images—depict buildings identified as "Cabinets chinois." In eighteenth-century French usage, this term can mean both a collector's private study or, as here, a garden pavilion.[15] These are, of course, typical and well-known constructions in Chinese gardens, and so-called Chinese pavilions were already a feature of European garden architecture. The text that introduces these paintings states, "We would have perhaps not had so many painted if we had not felt that one might be inclined to work in this style according to the designs of the Chinese or to refine them."[16] For Bertin's project for a Chinese house at his residence at Chatou, the kind of detail presented here would be of primary importance. In describing garden pavilions, the missionaries emphasize the accuracy of what one sees in the images: "We have only three observations to make: first, that the painter has neither exaggerated nor embellished anything. We have seen in the Gardens of the Emperor many of the Cabinets that one finds here; they really are like that. The second is that the necessity of building in wood, the low price of paint and colors, and the taste of the Chinese for that which is bright and shines from afar, has led [them] to ornament and paint these Cabinets as the Painter depicts them. The final observation is that the Emperor alone may have colored Tiles or *Lieou Li* [*liuli* 琉璃]."[17]

Following the series of garden pavilions, some of which are described as temporary or "decorative" constructions, are two pavilions situated on miniature mountains, another typical kind of Chinese garden construction that was already known in Europe of the eighteenth century. A "pavilion on a mass of rocks," that is, a construction atop a *jiashan* 假山, or artificial mountain (figure 3.02), illustrates a detailed description of Chinese garden features, especially such artificial mountains.[18] The text cites the Chinese name for landscape, *shanshui* 山水 (*Chang Choui* in the original), translated literally in the text as "mountains and waters." And then the text adds that in the gardens of the emperors what at first appears as a lavish expenditure is actually a means for displaying economy and a model for everything that the emperor orders throughout the empire. The statement is not all that clear in itself, but it directly echoes the theme of frugality evoked in a number of Qing imperial writings, including the Yongzheng emperor's "Record of the Yuanming Yuan" (*Yuanming yuan ji* 圓明園記) of 1725 and the Qianlong emperor's "Later Record of the Yuanming Yuan" (*Yuanming yuan houji* 圓明園後記) of 1742. Frugality is presented as a paramount imperial virtue, and the expense of building a garden palace for the emperor's pleasure must not be an unnecessary burden on the people.[19] Qing imperial ideology is echoed here in a text written by a Jesuit missionary describing one particular feature of Chinese garden architecture.

Figure 3.02. *Cabinet sur un amas de Rochers* (Pavilion on a mass of rocks). In *Essai sur l'architecture chinoise* (ca. 1773), vol. 1, illus. 94, ink and color on paper, approx. 36 × 27 cm. Bibliothèque nationale de France, Paris, Département des estampes et de la photographie, Oe-13-Pet. fol.

The next sequence of paintings shows various kinds of bridges that are also found in *jardins de plaisance*, or pleasure gardens, a term that was usually applied to gardens of the aristocracy or imperial gardens, whether European or Chinese. The authors note that if they ever wrote a major study of Chinese architecture, the subject of bridges, dikes, levees, causeways, and locks would be an important part, but here they are content to show decorative constructions that, if examined carefully, still could provide useful models.[20] The commentary at the end of the second volume of the *Essai sur l'architecture chinoise* again describes the well-built bridges that date to earlier dynasties—testimony to the superior quality of Chinese construction.

The final paintings in the first album of the *Essai* show various forms of pagodas, identified by their Chinese name, *Ta* (*ta* 塔). Here, however, there is less to be learned, and the Jesuit missionaries state that "the Architects of Europe will not see here anything that merits their attention."[21] Pagodas are likened to pyramids, there is a clear disdain for Buddhism and other forms of idolatry and ignorance, and the only interest in these is whether they might reveal some connection between European antiquity and the history of China. This was a question that had earlier provoked intense speculation among certain Jesuits in China who attempted to link ancient Chinese texts and history with the ultimate sources of all civilizations and Christianity in particular.[22]

Seconde partie de l'Essai sur l'architecture chinoise

The second album of paintings and texts of the *Essai sur l'architecture chinoise* also begins with an introduction that seeks to clarify important elements of Chinese architecture that are distinctly different from European architecture. Although the forms of Chinese buildings are extraordinarily varied once one moves beyond the constructions of the common people, it becomes clear that this variety is essentially a series of progressions in size, elevation, and ornament or decoration. The authors note that Chinese officials have even had a book printed that specifies the dimensions and costs of buildings down to the last detail.[23] The text here provides additional details on what are effectively Chinese sumptuary laws that govern the size, plan and layout, and decoration of buildings according to the owner's rank. A comparison is made with what one sees in Paris, where the carriages of the rich merely display the trappings of wealth, while carriages of the nobility, however modest, display true social rank. In a similar way, wealthy Chinese build extravagant halls and courtyards but never at the entrance to their residences, which supposedly conform strictly to regulation. The introduction ends with the remark that since this is of little interest in

Figure 3.03. *Maison à double étage* (Two-story construction). In *Essai sur l'architecture chinoise* (ca. 1773), vol. 2, illus. 17, ink and color on paper, approx. 35 × 45 cm. Bibliothèque nationale de France, Paris, Département des estampes et de la photographie, Oe-13a-Pet. fol.

Europe, the information is included here merely to avoid errors in interpreting the various structures illustrated in the paintings.

This caveat, then, would apply to illustrations such as that of a two-story structure (figure 3.03 [plate 5]), a type that is described as only being built facing the garden behind a palace or urban residence, or in a *maison de plaisance*, a term frequently used to describe the Yuanming yuan and other imperial garden-palaces.[24] The illustration is somewhat different from most of the paintings in the two volumes of the *Essai sur l'architecture chinoise*. It shows the building not strictly from the front but from an angle, revealing details of the roof and the extensions to the rear that open onto a garden. The painting includes actual details of the landscape, including garden rocks visible over a wall. The European-style modeling in light and shade is more obvious in this illustration than in others, but the rules of linear perspective are inconsistently applied. Another building, an elaborate structure with three floors, is described as being in the gardens of the emperor of China, and it is accompanied by a short article that explains some of the environmental conditions that determine the forms of Chi-

nese architecture.[25] It appears such constructions would be dangerous, given the frequent earthquakes that supposedly oblige the Chinese to build wooden structures. The climate, too, would discourage such buildings, since they would be hot in summer and too exposed for the severe winters of the capital region. One-story buildings encourage more elaborate compounds, providing open space around them, which allows for a better circulation of fresh air. The authors note that as a result of traditional building practices in China, all types of constructions are generally oriented to the south, the most healthy direction in all seasons. This one short article effectively summarizes key elements of traditional Chinese building practice.

A group of eleven paintings in the second volume of the *Essai sur l'architecture chinoise* presents something truly novel—images of the interiors of Chinese houses and palaces. The Jesuit missionaries note that these are distinctly different from what one finds in France, and no doubt a longer text explaining the different customs and tastes of the Chinese and even the effects of weather on the arrangement of interiors would be much appreciated, but for the moment one must rely on the pictures to tell the story.[26] Throughout the *Essai sur*

Figure 3.04. *Salle chez les Gens aisés* (Room in the home of wealthy people). In *Essai sur l'architecture chinoise* (ca. 1773), vol. 2, illus. 31, ink and color on paper, approx. 35 × 45 cm. Bibliothèque nationale de France, Paris, Département des estampes et de la photographie, Oe-13a-Pet. fol.

l'architecture chinoise, the paintings are intended to provide a wealth of detail that does not specifically appear in the accompanying texts. The pictures are indeed highly detailed, revealing much about the interiors of certain types of Chinese buildings, especially wealthy upper-class or princely residences.[27] Paintings of Chinese interiors were not entirely unknown in eighteenth-century Europe—China export watercolors gave some sense of the interiors of shops or residences—but what is unique here is the goal of providing details as accurate as possible of specific types of Chinese interior spaces.

One interior is labeled "Room in the home of wealthy people" (figure 3.04 [plate 6]).[28] Like the rendering of all the interiors, the composition follows a strict, single-point perspective. The room is filled with emblems of the literati class, including, at the right, a landscape painted in ink of bare trees and distant mountains, as well as shelves filled with books at the left, and elements of calligraphy throughout the room, including a sign-board (*bian'e* 匾額) hanging in the center over the couch. It reads *Yifang shan*—房山, perhaps the equivalent of "A Room of Mountains," which would be the name of the room or the building in which it is contained, functioning as a poetic allusion to an imagined distant retreat from urban congestion. The relatively spare interior extends out through a broad opening into a garden, which includes two massive rocks—a type referred to as Taihu rocks.[29] The space ends with a view out through a circular opening to a distant garden path, and the seamless flow from interior to exterior signals the integration of garden landscapes into an upper-class Chinese residence.

A long text announces the subject of the last fourteen paintings in the second album of the *Essai*, that of constructions built on a *Tai* (*tai* 臺), or raised platform. This distinctive feature of Chinese architecture especially impressed the Jesuit authors of the album texts because it plays such an important role in both ancient and contemporary architecture. One of the paintings shows what is clearly an imperial building with red lacquered columns and multicolored tile roofs on top of a high platform or gateway that is covered with the red stucco that distinguished imperial constructions (figure 3.05 [plate 7]). The red earth that produces this special color was specifically illustrated in the first volume of the *Essai*, emphasizing a comprehensive view toward practical knowledge as well as an intimate knowledge of imperial constructions.[30] For the Jesuit missionaries, such platforms were a source of curiosity and surprise, but that surprise was tempered by their rather severe judgment of Chinese imperial builders: "Of surprise because all that we have wanted to teach so far about China does not lead one to imagine that it might have anything similar; of curiosity because the height, the beauty, and the vain magnificence of many of these *Tai* cannot be reconciled with the proclaimed Economies of their politics, and that the reason

Figure 3.05. *Tai.* Voyez la note de la *Page 39 & Suivantes* (*Tai*, [Imperial building with red lacquered columns on a high platform;] see the notes on pp. 39ff.]). In *Essai sur l'architecture chinoise* (ca. 1773), vol. 2, illus. 41, ink and color on paper, approx. 35 × 45 cm. Bibliothèque nationale de France, Paris, Département des estampes et de la photographie, Oe-13a-Pet. fol.

for this exception has much that would surprise."[31] The exception is given a detailed explanation drawn from ancient Chinese history. The missionaries proposed that so many of these were built that they became the inspiration for pagodas (or *ta,* illustrated in the first volume of the *Essai*) but had lost their original purpose. Nevertheless, such constructions were built in great numbers and at great expense, something the Jesuit missionaries felt was in direct contradiction to what they saw as the traditional economies represented in Chinese architecture. The text ends with a brief statement that, while such constructions do not reflect what European architecture might have learned from Greece and Rome, it is possible that some accommodation or adaptation of Chinese plans or designs might still prove practical. Clearly a key element of any architecture worthy of the name is the memory of a historical continuity, which the Jesuit missionaries said that the Chinese had lost in this case, in contrast to the enduring European tradition.

Writing Architecture in France and China

Besides Henri Bertin's continuing appetite for knowledge of China, we have to consider other motives for the production of the two illustrated albums of the *Essai sur l'architecture chinoise.* Why would architecture appear as a focus of study at this time? Beginning at the end of the seventeenth century and continuing into the nineteenth, the field of architecture was the subject of a remarkable number of publications in France, many with detailed illustrations, which spread knowledge of both theory and practice. For these earlier writers, theory embraced mathematics and its practical applications in building as well as more general discussions of what was fitting in terms of historical models and their relevance to contemporary architectural design.[32] This combination of the practical and the aesthetic characterized contemporary publications and pointed toward an appreciation of architecture as an art worthy of serious investigation. The foundation in 1671 of an Académie royale d'architecture, which included a school of architecture, testifies to the importance of the discipline.[33]

One key publication on the theory and practice of architecture in France in the mid-eighteenth century is the "Lecture on the necessity of studying architecture," given in 1754 by the eminent professor Jacques-François Blondel (1705–74).[34] It contains a list of books recommended for the education of architects, among them ancient texts—the foundations of European architectural theory and practice—followed by modern or contemporary publications, and includes a further list of prints that might prove useful to "architects and other artists, who make their profession from works of [good] taste."[35] First among Blondel's

choice of publications is *The Ten Books on Architecture* by Vitruvius, the ulti-
mate reference for almost all traditional writings on architecture, cited here in
Claude Perrault's (1613–88) annotated French translation of 1684.[36] Vitruvius
provides the basic format for treatises on architecture by including discussions
of fundamental principles, building materials, symmetry and proportion in de-
sign, the origins of certain forms, comments on climate and siting of construc-
tions, on tools and instruments necessary for building, and even notes on "how
the rooms should be suited to the social station of the owner."[37] Perrault's illus-
trated 1684 French translation and at least two Latin editions of Vitruvius were
held in the libraries of the Jesuits in Beijing in the eighteenth century, and surely
these along with a significant number of other books on architecture helped
serve as models for the *Essai sur l'architecture chinoise*.[38] While *The Ten Books of
Architecture* is essentially a written text whose chapters were frequently illus-
trated in later editions and the *Essai* consists of groups of illustrations with brief
but concisely written texts, the two treatises share common concerns in the de-
scriptions—the definitions—of what architecture is. The *Essai* does not include
such things as weapons and machines, but the emphasis on Chinese imperial
constructions echoes, consciously or not, Vitruvius's descriptions of temples,
villas, and other buildings, many of which were constructions of the Greek and
Roman elites.

In China, however, writings on architecture reflected very different tradi-
tions. In an article on the construction of the Qing imperial garden-palace Yuan-
ming yuan, Cary Y. Liu briefly outlines the evolution of what a Chinese
imperial architect might be—a profession that effectively did not exist in any
form comparable to historical European practice (combining the roles of de-
signer, planner, and builder) until the eighteenth century. Construction, espe-
cially of imperial buildings, was the collective responsibility of craftsmen who
did the actual labor, supervisors who administered and coordinated the crafts-
men's work, and "planners, usually well-educated ministers or imperial advi-
sors, [who] were appointed to formulate the underlying ritual design of imperial
buildings, palaces, gardens, and cities. Such planners, however, should not be
viewed as 'architects' in the modern sense; instead, their role was mainly limited
to devising schematic or ideal plans that translated imperial demonstrations of
political and dynastic legitimacy into building symbology, cosmology, numerol-
ogy, and other ritual forms that often had roots in ancient models."[39] Symbol-
ogy, the system of ritual design embodied in a Chinese structure, has no real
equivalent in European architectural practice, at least in terms of the extent to
which it determined the form, style, and decoration of Chinese buildings.

A small number of Chinese texts are usually considered the most significant
traditional writings on architecture.[40] Among these, the *Yingzao fashi* 營造法式

(Treatise on architectural methods) is the best known and most comprehensive early Chinese work on architecture. It was compiled in the late eleventh to early twelfth century for the Southern Song imperial court by Li Jie (李誠, ca. 1035–ca. 1110), the head of the imperial Department of Construction (Jiangzuo jian 將作監), who was himself effectively a practicing architect and widely knowledgeable about imperial constructions.[41] Another frequently cited work, the *Lu Ban jing* 魯班經 (Classic of Lu Ban), named for the legendary craftsman Lu Ban of the fifth century BCE, is in effect a carpenter's manual compiled in the fifteenth century. While sections of the text are concerned with magic and ritual, other sections deal directly with the practical aspects of building houses, constructing furniture and various implements. The Qing court officially commissioned the *Gongbu gongcheng zuofa* 工部工程做法 (Building methods of the Board of Works), which was completed in 1734 under the supervision of Yinli (胤禮, Prince Guo 果親王, 1697–1738). It codified existing regulations that guided imperial constructions, with a particular emphasis on economic concerns.[42] While the *Yingzao fashi* is generously illustrated, the *Gongbu gongcheng zuofa* contains only twenty-seven illustrations, all of them cross-sections of various building types with little detail—and the illustrations in various editions of these architecture manuals rarely if ever approach the level of detail seen in the paintings accompanying Bertin's *Essai sur l'architecture chinoise*.

None of these books is the equivalent of a "Chinese Vitruvius," focusing as they do on extraordinarily different concepts of what building—or architecture—might be. And as Liu further notes: "Although the Western-based Vitruvian categories of form, function, and structure are useful analytical tools, they are nevertheless inadequate for understanding Chinese architecture. Analysis of a building's symbology—including decoration, name, numerology, geomancy, calligraphy, ritual layout, and design models—is an additional lens through which to view Chinese architecture."[43] In the *Essai sur l'architecture chinoise*, it was especially the regulations that supposedly determined the decoration, scale, and layout of buildings that caught the attention of the Jesuit authors of Bertin's albums. They seem to have been unaware of the traditional symbology, the underlying ritual elements required for any substantial Chinese construction, that determined Chinese architectural forms. For Bertin and his contemporaries, "architecture" as a discursive field was broadly shaped by the Vitruvian tradition, and that tradition in many ways determined what the Jesuit missionaries in Beijing sent to Bertin as authentic knowledge of a non-Western architecture. Throughout the *Essai sur l'architecture chinoise*, the emphasis is on the contrasts between Chinese and European architecture—as seen from the European point of view.

Between the Yuanming Yuan and Chatou

The fact that a significant number of paintings in the *Essai sur l'architecture chinoise* ostensibly depict constructions found in the Yuanming yuan reminds us that the Qing emperor's garden retreat was well known in eighteenth-century Europe, where it was occasionally referred to as the "Versailles de Pékin."[44] It had been described in great detail in a letter from the Jesuit missionary-artist Jean-Denis Attiret (1702–68), which was first published in the *Lettres édifiantes et curieuses* in 1749 and translated and reprinted many times.[45] Among Bertin's own papers is a long article entitled "The *Yuanming Yuan* Garden,"[46] which, although unsigned, may have been the work of the Jesuit missionary Jean-Joseph-Marie Amiot (1718–93), who was one of Bertin's most prolific correspondents.[47]

The text, which was probably received in 1770,[48] begins with a reference to Attiret's famous letter of 1743. It accompanied a shipment to Bertin that included two versions of the "40 Views of the Yuanming Yuan," the set of forty paintings commissioned by the Qianlong emperor (乾隆, r. 1736–95) to accompany his poems on the Yuanming yuan that together formed a superb imperial album completed in 1744.[49] The first version of the "40 Views" sent to Bertin consists of simplified copies of the original forty imperial images that were painted in watercolor on Chinese paper and bound as an album in France.[50] The second was a copy of the imperially commissioned woodblock edition of the "40 Views," a publication completed in 1745 that included reproductions of the forty paintings, the Qianlong emperor's matching poems, and a massive commentary on the poems composed of citations from classical literature. The text of "The *Yuanming Yuan* Garden" describes the contents of the album and the Chinese woodblock book. While flattering in its judgments of the book's contents, the discussion is remarkably accurate and perceptive, obviously the work of someone who had paid close attention to the woodblock edition and wished to inspire a similar appreciation in his correspondent. In addition to the original Chinese prints and paintings that he possessed, Bertin was surely aware of the images of the "40 Views of the Yuanming Yuan" that had been reproduced by Georges-Louis Le Rouge (ca. 1712–ca. 1796) in portfolios XV and XVI of his series *Jardins anglo-chinois à la mode* (Anglo-Chinese gardens now in fashion), both of which appeared in 1786.[51] (The first portfolio was published in 1775, just one year before the initial volume of the *Mémoires concernant les Chinois*.) The texts that accompany the plates in Le Rouge's portfolios do not specifically identify the Yuanming yuan; the prints are simply described as "gardens of the emperor of China." Alongside illustrations based on Chinese and European sources, the portfolios contained numerous detailed plans of European gardens in so-called Chinese style. Le Rouge's *Jardins anglo-chinois* series were a key source for the design

and construction of gardens in the "Anglo-Chinese style" in eighteenth-century Europe.

Bertin's knowledge of the Yuanming yuan surely contributed to his inspiration for a project undertaken roughly a decade after receiving the various versions of the "40 Views" and one for which he made elaborate preparations. In 1762, Bertin had acquired the estates of Chatou and Montesson near Paris, where he quickly began the construction of a new chateau surrounded by extensive gardens.[52] It appears that, in contradiction to the prevailing taste for *chinoiserie* garden follies—decorative structures in a fanciful Chinese style that were all the fashion at the time—Bertin now hoped to include landscape elements in his gardens and, especially, a pavilion or even a house in what he believed to be an authentic Chinese style. Two archival documents detail his intentions. One, a letter sent to China in 1786, was apparently accompanied by a "profile and elevation view of a building to be consulted." The letter notes that on the right-hand side of the elevation was depicted a "Chinese pavilion."[53] The other document—a long, undated text—is entitled "Bertin's Chinese Cabinet at Chatou."[54] As we have seen, "cabinet" in eighteenth-century French could mean a garden pavilion—the constructions so amply illustrated in the *Essai sur l'architecture chinoise*. This text is addressed to the French Jesuit François Bourgeois (1723–92), the administrator of the French mission in Beijing and another of Bertin's frequent correspondents. In it, Bertin asks Bourgeois to consult "a number of amateurs" of Chinese architecture (the word means lovers or aficionados in its original eighteenth-century sense), or even a Chinese architect, to verify the authenticity of the style of the buildings Bertin hoped to construct. At the end of the letter, Bertin noted: "We have in addition many drawings of Chinese pavilions of all kinds, but if some architect in Peking provided us another of these, we would of course prefer to execute that."[55]

For the design of his relatively modest chateau, Bertin engaged Jacques-Germain Soufflot (1713–80), the most famous architect of his day; Soufflot is also credited with the layout of the formal gardens.[56] A postcard dated to 1910, entitled "Chatou—La Grotte du Château," shows Soufflot's famous Nympheum, or grotto, as viewed from the island in the Seine opposite Bertin's estate (figure 3.06). Part of the facade of the chateau, with the shutters closed or half-open, appears among the trees behind the Nympheum, which is itself the only part of the estate still extant. Bertin's gardens, including any Chinese-style constructions, would have been to the right of the chateau in this photograph.

Bertin's plans for a Chinese "house" or "Chinese residence" called for either authentic Chinese construction or something more in keeping with the taste of the time. He wrote at one point, "We thought, first, to arrange the roof of the house in the Chinese manner in extending it and decorating the two ends with

Chatou — La Grotte du Château

A. Fabre, imp.-édit., Chatou

Figure 3.06. *Chatou—La Grotte du Château* (Chatou—the Nympheum of the Chateau). Postcard, photo: A. Berger frères; pub.: A. Fabre, Chatou (1910). Private collection, Paris.

a few dragons."[57] The preconceived notions that he described to Bourgeois in such detail, however, are generally typical of late eighteenth-century fashions in garden design. Soufflot himself had once firmly stated his resistance to *chinoiserie* designs, although he must have modified his stance when in 1775 he presented to the Académie royale d'architecture certain unidentified drawings of Chinese subjects that belonged to Bertin.[58] At Soufflot's death in 1780, responsibility for the construction of Chatou apparently passed to his assistant, Jean-Jacques Lequeu (1757–1825?).[59] None of Soufflot's plans or drawings for the project seems to have survived, but at least three of Lequeu's designs related to Chatou are known, including a decorative sculpture crowning a Chinese pavilion (figure 3.07 [plate 8]).[60] Carefully drawn, with indications of the final measurements, the design shows a figure seated cross-legged on a cushion holding a huge parasol decorated with bells. The figure itself seems to be a heavy-set woman with large breasts clearly visible under her robes, but the figure also has a long, drooping moustache, combining in pure *chinoiserie* style vague and fantastic images of Buddhist figures with an erotically sensual, Oriental "Other."

To the end of his life, Bertin was still engaged in creating—or imagining—something authentically Chinese for Chatou. On 16 October 1790, Father Amiot wrote to Bertin that while he had promised to help with the arrangement of

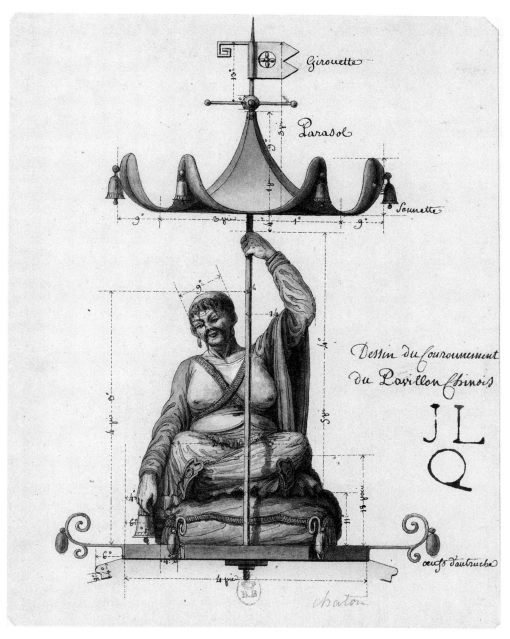

Figure 3.07. Jean-Jacques Lequeu, *Dessin du couronnement du pavillon chinois* (Design for the sculpture crowning a Chinese pavilion), ink and watercolor on paper, 21.2 × 16.6 cm, ca. 1780. Bibliothèque nationale de France, Département des estampes et de la photographie, EST VA-78 (2).

Bertin's Cabinet chinois, here meaning his Chinese-style study, he could be there only in his imagination.[61] He envisioned Bertin as a Confucian sage, reading one of the Chinese classics (*jing* 經) or the *Life of Confucius* and meditating on the principles of the things of this world.[62] Amiot himself was keenly aware of the persona of a Chinese literatus, a Confucian ideal embodied in many of the scholar-officials of the Qing court, and in this, too, it appears he wanted Bertin to be authentically "Chinese."

For Bertin's study, Amiot described a small pavilion, a private office or library, and a workshop where Bertin could amuse himself with some work with his own hands.[63] Amiot's letter accompanied several crates containing decorative objects. The most important for Amiot's image of Bertin as a Confucian scholar were a signboard, a pair of hanging scrolls with a Confucian text, and three different examples of the character *fu* 福. For the arrangement of Bertin's Chinese study, Amiot sent a drawing with extensive notes showing the character *fu*, meaning "good fortune," the signboard, the Confucian couplet, and a Chinese table set with objects for burning incense (figure 3.08). The layout of typical elements from a Chinese scholar's studio clearly echoes images of Chinese interiors presented in the *Essai sur l'architecture chinoise*.[64] To help Bertin understand what he has been sent, Amiot's notes on the drawing give the meanings of all the Chinese inscriptions, beginning with the four characters on the signboard, "Kiun-tsee pou Ki" (*junzi bu qi* 君子不器), which he translates as "A Sage is not an instrument."[65] The citation is from the *Analects* of Confucius, and it means that a true scholar is not a simple tool but rather a superior man ready for all things.[66] Amiot also explains the sense of the couplet for Bertin. Starting with the first line, at the right, taking virtue as his guiding principle is the source of a sage's true glory, and, on the left, the second line implies that benevolence will earn a sage the esteem of the whole world.[67] Through the choice of the Chinese texts, Amiot sought to position Bertin himself as an equivalent of a Confucian sage or superior man. Bertin surely envisioned his chateau and gardens at Chatou, complete with authentic Chinese constructions, as somehow a replica of a Chinese garden, perhaps even the Yuanming yuan. Father Amiot provided him with the authentic accoutrements of a Chinese scholar, including auspicious texts that proclaimed the Confucian virtues Bertin might adopt as his own.

Conclusion: Questions Answered and Unanswered

The picture of Chinese architecture presented in the two albums of the *Essai sur l'architecture chinoise* is in many ways an idealized and admiring one. The *Essai*

Figure 3.08. Joseph-Marie Amiot, *Junzi bu qi* (*Kiun tsee pou Ki* 君子不器 [A Sage is not an instrument]), ink on paper, 1790. Bibliothèque de l'Institut de France, Paris, Ms 1517, fol. 138. Photo (C) RMN—Grand Palais (Institut de France) / Stéphane Maréchalle.

repeats several times the supposed adherence of the Chinese to strict laws gov-
erning the size of buildings and other details of public display. But the Jesuit
missionary authors admit on occasion that these complex rules are not always
consistently followed. Bertin was made aware of this in a long letter from Father
Amiot dated 28 September 1777 in which Amiot remarks upon what is clearly
the *Essai sur l'architecture chinoise*:

> I had no part in all the wonderful things that were said to Your Excel-
> lency on Chinese architecture, on the tools of the mason and carpenter,
> and on these admirable regulations which have been able to preserve for
> more than 4,000 years the hierarchy of different stations by the form and
> extent of buildings which serve to house each member of society. It seems
> that these regulations are hardly observed nowadays in Peking. I have
> been in the Palace and in private houses. I have seen the accommodations
> of people of all stations, and I admit, to my confusion, that I have never
> recognized this marvelous order which would have it so that an ordinary
> citizen could not live in a house decorated with columns, that a scholar
> could only have two columns in his gallery, that a mandarin of the third
> class has four columns and so on to the leading figures of the state.[68]

The direct connection between social status and its expression in architec-
ture was a crucial concern for European elites and for writers of eighteenth-
century France. Jacques-François Blondel, author of the "Lecture on the
necessity of studying architecture" discussed above, wrote the "Architect" and
"Architecture" entries in the first volume of the *Encyclopédie* of Diderot and
D'Alembert, which appeared in 1751.[69] In the subsequent volumes of the "Plates"
illustrating the *Encyclopédie*, which began to appear in 1762, Blondel is presum-
ably the author of the "Architecture" section.[70] Part 5 consists of "General Ob-
servations on Royal Houses & Palaces, applied in particular to a grand
Residence,"[71] which describes in some detail the links between social ranks and
architectural styles:

> Hôtels [particuliers], the residences of great lords, are buildings con-
> structed in capitals, & where they normally make their residence. The
> character of their decoration demands a beauty that matches the birth
> & the rank of the persons who have them built; nevertheless, they must
> never proclaim that magnificence reserved only for the palaces of kings.
> / It is this diversity of rank, from the monarch to the great princes, &
> from these to their subjects, which must necessarily give birth to the
> different qualities of constructions; indispensable knowledge that can-

not be acquired except by the study of art, & particularly by the ways of the world Certainly, the rank of the person who orders the construction is the source from which must be drawn the different types of expression of which we speak: otherwise, how could we reach this point without knowing the ways of the world, which teach us to distinguish all the requirements & the style proper to such and such a residence erected for such and such an owner? [Should not those] persons who do not hold the same rank in society have residences of which the arrangement announces the superiority or inferiority of the different orders of status?[72]

Blondel defines the styles appropriate to a royal residence and to other kinds of buildings, insisting on the various levels of grandeur and style that must distinguish them, and he argues that such distinctions should grow out of a shared expression of what is appropriate to various levels of society. What would have struck Europeans of the period—what the Jesuit missionaries remark on several times—is that in China the customs of display are ostensibly codified in a complex set of official rules and regulations. In France, this is something that should grow out of a subtle and profound understanding of social order.

The emphasis in the *Essai sur l'architecture chinoise* on imperial buildings and imperial gardens reflects the French Jesuit missionaries' position within the Qing imperial court, where they served in many important and influential capacities. Their knowledge of, and familiarity with, imperial construction makes this prejudice understandable, and surely they assumed that it extended to their audience—those in the elite circles around Bertin who shared his fascination with China. Until the mid- to late eighteenth century, information and images of actual imperial construction—specifically the Forbidden City, the imperial palace at the heart of the capital Beijing—was remarkably limited.[73] Earlier travelers' accounts described this vast complex, but published images tended to show schematic representations based on memory, secondhand accounts, and other observations that reflected the restrictions imposed by imperial protocol and court etiquette that limited European access to all but a small number of sites. Images of the Yuanming yuan had a certain circulation in late eighteenth-century Europe, among them both Qing imperial woodblock prints and painted copies of imperial paintings of the "40 Views of the Yuanming Yuan."[74] In the late eighteenth century and, more broadly in the early nineteenth century, other Chinese sources of architectural images included so-called Export paintings showing ports, urban views, landscapes, and so on, and these had a wider popular circulation than imperial images that are documented in Europe, thus forming more of the general idea of what was

supposedly Chinese architecture. But Bertin himself derided the quality of such paintings. In the preface to the first volume of the *Mémoires concernant les Chinois,* published in 1776, he briefly discusses Chinese paintings, writing that what Europeans see are mostly the worst kinds of painting, those produced in the southern port city of Canton (modern Guangzhou). He states, however, that he has superior works in his collection that come from Beijing: "Some of them represent the magnificent interior of the palace of the Emperor and the houses of the Mandarins, cabinets of natural curiosities, etc.; others [show] charming landscapes, details of the countryside with figures of which the drawing is of an astonishing accuracy; perspective is well-observed in them, and the colors are of a brightness which we have not been able to attain up to the present."[75] Given the date of this preface, it is possible that Bertin is referring, among other paintings in his collection, to the highly detailed images contained in the *Essai sur l'architecture chinoise,* which are unique in their rendering of imperial buildings of all kinds and even princely interiors, but questions still remain as to how widely Bertin's paintings were circulated and who actually viewed them.

The first volume of the *Essai sur l'architecture chinoise* begins with a succinct note addressed to Bertin:

Chinese architecture, does it deserve to be known in Europe? The knowledge that we could give about it, would it be of any use? What we thought was best to respond to these questions was to send a collection of various paintings which we could supplement with answers that we have not given here. Time has not permitted us to expound as much as we would have wished on the different parts of the little collection we have sent, and we limited ourselves to a simple listing. In the case where you might desire further clarifications, it would be necessary to attach a quick sketch of the piece on which you have questions because we have not been able to keep a copy of what we have sent. / Since you have seemed to be well pleased to know a little of the arts and trades of China, we have begun this collection with the instruments and tools of Carpenters and Masons, who are not distinguished here from Roofers. It would be useless to enter into the details of what speaks to the eyes. We will identify only what would seem less easy to recognize.[76]

The Jesuit missionaries' main question is whether Chinese architecture deserves to be known in Europe and what the use of such knowledge would be. In answering that question, at least as far as they felt that they could, the missionaries relied on a contemporary model of providing accurate, inclusive information on

all aspects of what they understood as architecture, from humble tools and materials to the details of magnificent imperial constructions. Pictures supplemented by texts provide all the information.

The short article at the end of volume 2 of the *Essai sur l'architecture chinoise*, entitled "Several observations that deserve our attention,"[77] also does not reply directly to the question of whether Chinese architecture deserves to be known in Europe but instead concentrates on what might be characterized as the moral implications of architecture. It appeared to the Jesuit missionaries that the common people of China were for the most part badly housed, even in the capital of Beijing, with much of the effort and expense of construction concentrated in certain grand public buildings. Those that need to be solidly constructed are built with care, and a remarkable number of well-built bridges, quays, towers, and other constructions have survived from earlier dynasties, but many buildings are really only brilliantly decorated constructions, intended for magnificent display, that will last just a short time. The more the missionaries study the Chinese government, the more they realize that little is left to chance. Further answers should be left to "wise men" to fathom, but it is clear that the missionaries are expressing a deliberate censure of important aspects of Chinese architectural practice while illustrating and describing its obvious glories.

In his extended correspondence with the French Jesuit missionaries in Beijing and in the texts and images that he received from them, Henri Bertin pursued first and foremost an active, purposeful transfer of knowledge from China to France. He sought an authentic and accurate knowledge of China, and this enthusiasm was linked both to his role as a minister of state and to his personal taste for all things related to China. The detailed plans that he conceived for a Chinese pavilion or a Chinese house and the surrounding landscaping and gardens at Chatou testify to his enduring passion for China—and specifically his keen interest in Chinese architecture. Like the savants and artists with whom he was in contact, Bertin sought knowledge from the objects, texts, and images that he possessed. In the realm of architecture, much of this knowledge was new to European audiences, and the French Jesuit missionaries in Beijing clearly realized this. Texts sent to Bertin, both unpublished documents and extended comments included in the *Mémoires concernant les Chinois*, highlighted the differences between Chinese and European architectural traditions. The Jesuit missionaries active in China in the seventeenth and eighteenth centuries were ultimately the most reliable sources for information from the Chinese empire. The primary examples are the four volumes published by in 1735 by Jean-Baptiste Du Halde (1674–1743), himself a Jesuit (though he never traveled to China), which he compiled from the writings of his Jesuit colleagues. Bertin was certainly aware of this fundamental publication.[78]

Published remarks on Chinese architecture are scattered throughout the *Mémoires concernant les Chinois*, and they touch on such subjects as the antiquity of Chinese architecture, the magnificence of imperial palaces, bricks and tiles, multistoried buildings, constructions on *tai*, or platforms—many of the subjects illustrated and discussed in the two albums of the *Essai sur l'architecture chinoise*.[79] The Jesuit missionaries who wrote on architecture especially highlighted such issues as the sumptuary laws that ostensibly governed most aspects of Chinese construction, something that was unprecedented in Europe. Implicit in their observations, in both praise and criticism of Chinese architectural practice, is the assumption that China could provide a model from which Europe could learn. The commensurability of Chinese and European values is implicit throughout the narrative of the *Essai*; Chinese values can be a model for European advancement, and European principles are an appropriate standard for judging China. Pictures were key to an accurate and detailed understanding Chinese architecture, and even those buildings in the two albums of the *Essai sur l'architecture chinoise* that seem most fantastic still contained important elements of genuine Chinese architectural practice. Even if Henri Bertin never completed his own, ostensibly authentic Chinese buildings at Chatou, he still remained true to his ultimate goal of acquiring accurate knowledge of the far-off Chinese empire.

Notes

1. For an extended study of the role of Bertin in the encounters between Europe and China, see John Finlay, *Henri Bertin and the Representation of China in Eighteenth-Century France* (New York: Routledge, 2020), where material relevant to this essay appears in Chapter 3, "Constructing an Authentic China," pp. 67–106.

2. Library of the Institut de France, Ms. 1521, fol. 71 verso: "La conformité des moeurs de génie et de caractère qu'ils ont observé entre les chinois et les françois, les deux nations pouvant être considérées comme les plus policés et les plus sociables de l'univers."

3. Camille de Rochemonteix, S.J., *Joseph Amiot et les derniers survivants de la mission française à Pékin (1750–1795)* (Paris: Librairie Alphonse Picard et fils, 1915), 216ff.

4. The Jesuit mission in Beijing that was first established under Louis XIV in 1684–85 is discussed in Nathalie Monnet, "Le jeune duc du Maine, protecteur des premières missions françaises en Chine," in Marie-Laure de Rochebrune, ed., *La Chine à Versailles: Art et diplomatie au XVIIIe siècle* (Paris: Somogy Éditions d'Art, 2014), 36–43. See also Isabelle Landry-Deron, "Pour la perfection des sciences et des arts: La Mission Jésuite française en Chine sous le patronage de l'Académie royale," in Pierre-Sylvain Filliozat et al., eds., *L'oeuvre scientifique des missionnaires en Asie* (Paris: Académie des Inscriptions et Belles-Lettres, 2011), 77–96.

5. The statement appears in the *avertissement*, the introduction, to vol. 5 of the *Mémoires concernant les Chinois*, published in 1789, specifically in relation to a general overview of Europe's encounters with China written for European readers. The first fifteen volumes of

the *Mémoires concernant l'histoire, les sciences, les arts, les moeurs, les usages, &c. des Chinois: Par les missionnaires de Pekin*, based on the texts and images Bertin had received from the French missionaries, were published in Paris under Bertin's supervision from 1776 to 1791; a posthumous double volume appeared in 1814.

6. See the discussion of the "40 Views of the Yuanming yuan" and the album *Haitien: Maison de plaisance, de l'empereur de la Chine* later in the essay and in my note 50.

7. I am grateful to Stephen Whiteman for his thoughtful and constructive comments on earlier versions of this essay.

8. The albums are held in the Department of Prints and Photographs of the Bibliothèque nationale de France (BnF); they are catalogued as *Recueil: Essai sur l'architecture chinoise*, Oe-13-Pet. fol. and Oe-13a-Pet. fol. The title page of the first album reads PREMIÉRE [sic] PARTIE DE L'ESSAI SUR L'ARCHITECTURE CHINOISE. The second reads SECONDE PARTIE The first is bound in a vertical format and the second in a horizontal format, and both are emblazoned with Bertin's coat of arms in gold on the covers. A recent publication in Chinese contains all of the images; see Li Weiwen, *Lun Zhongguo jianzhu: 18 shiji Faguo chuanjiaoshi bixia de Zhongguo jianzhu* (Beijing: Publishing House of Electronics Industry, 2016).

9. The manuscript, entitled "Notices relatives à l'architecture chinoise," is contained in vol. 126 of the Fonds Bréquigny in the Department of Manuscripts of the BnF. These volumes contain the papers of Louis–Georges Oudart Feudrix de Bréquigny (1715–95), the second editor of the *Mémoires concernant les Chinois*; see my note 5. The relevant pages are Bréquigny 126, fols. 4–17, where the date "a Pe-king ce 3. oct. 1773" appears on fol. 17v (p. 28 of the ms.). For the moment, the specific author or authors among the French Jesuit missionaries in Beijing remains unknown, and I have not yet found a document that would indicate the circumstances under which Bertin requested this particular set of paintings and texts.

10. The article, on two unnumbered folios, begins with the sentence "On finira par quelques observations qui mérittent attention." See the discussion of this text in the conclusion of my essay.

11. Denis Diderot et al., comps., *Encyclopédie, ou Dictionnaire raisonné des sciences, des arts et des métiers, par une Société de gens de lettres. Mis en ordre et publié par M. Diderot, et, quant à la partie mathématique, par M. d'Alembert*, 35 vols. (Paris: Briasson, 1751–1780).

12. See my note 37.

13. *Essai sur l'architecture chinoise*, vol. 1, illus. 42–53. Captions in French face the illustrations, which have labels in Chinese pasted to them. The imperial ancestral temple lies just to the south of the Forbidden City, on the eastern side of the central axis of the imperial city; the label on the illustration in the *Essai* includes the common name *Taimiao* 太廟.

14. "Ce n'est surement point pour éclairer nos Architectes sur la grand Architecture des anciens, ni sur la manière dont on pourroit perfectionner la nouvelle que l'on a fait peindre ces *Tchao Ping, Tchao Pi & Tchao Hiang* des dix peintures suivant ainsi que celle cy; mais pour faire entrevoir comment le Gouvernement Chinois s'y prend, pour montrer aux yeux la différence des rangs, & contenir chacun dans la Sphère de son état." *Essai sur l'architecture chinoise*, vol. 1, facing illus. 42–43; there are actually twelve illustrations. The French texts here are transcribed with the spelling and punctuation as they appear in the *Essai sur l'architecture chinoise*; all translations are mine.

15. See the online version of Émile Littré (1801–81), *Dictionnaire de la langue française*, 4 vols. (Paris: L. Hachette, 1863–72): *cabinet*, no. 7: Petit lieu couvert dans un jardin; http://littre.reverso.net/dictionnaire-francais/definition/cabinet, accessed 25 February 2014.

16. "Plans et développements des Cabinets Chinois. / On n'en auroit peut-être pas tant fait peindre si l'on n'avoit songé que l'on seroit bien ais[é] d'avoir à travailler en ce genre sur les desseins des Chinois, ou a les perfectionner." *Essai sur l'architecture chinoise*, vol. 1, facing illus. 54.

17. "L'on n'a que trois observations à faire; la premiére, que le peintre n'a rien ni exagéré ni orné. L'on a vu en réalité dans les Jardins de l'Empereur plusieurs des Cabinets qu'on trouve ici; ils sont réellement comme cela. La seconde est que la nécessité de bâtir en bois, le bon marché du Vernis & des couleurs, & le gout des Chinois pour ce qui est voyant & brille de loin, à conduit a orner & peindre ces Cabinets comme la Peinture les représente. La derniére observation c'est que l'Empereur seul peut avoir des Tuiles colorées, ou de *Lieou Li*." *Essai sur l'architecture chinoise,* vol. 1, facing illus. 54.

18. *Essai sur l'architecture chinoise,* vol. 1; the text faces illus. 94, the "Cabinet sur un amas de Rochers."

19. See the citations and translations in John Finlay, "'40 Views of the Yuanming yuan': Image and Ideology in a Qianlong Imperial Album of Poetry and Paintings," Ph.D. diss., Yale University, 2011; esp. chap. 4, "Texts of the '40 Views of the Yuanming yuan.'"

20. *Essai sur l'architecture chinoise,* vol. 1, facing illus. 111.

21. "Les Architectes de l'Europe n'y verront rien qui mérite attention." *Essai sur l'architecture chinoise,* vol. 1, facing illus. 125.

22. For a detailed and well-documented discussion of the issues, see Virgile Pinot, *La Chine et la formation de l'esprit philosophique en France: 1640–1740* (Paris: P. Geuthner, 1932; facsimile ed., Geneva: Slatkine Reprints, 1971), book 2, chap. 3, part 3, "Le figurisme," 347–66. David E. Mungello has published extensively on the encounters between China and the West; on Jesuit "figurism" and related issues, see *Curious Land: Jesuit Accommodation and the Origins of Sinology* (Honolulu: University of Hawai'i Press, 1985, 1989). See also the important overview of the question in Arnold H. Rowbotham, "The Jesuit Figurists and Eighteenth-Century Religious Thought," *Journal of the History of Ideas* 17, no. 4 (1956): 471–85.

23. *Essai sur l'architecture chinoise,* vol. 2, *avertissement.* See the brief discussion of the 1734 imperial compilation, the *Gongbu gongcheng zuofa,* later in the essay; and see my note 42.

24. *Essai sur l'architecture chinoise,* vol. 2, illus. 17, and text on the facing page.

25. The article is entitled "Bâtiment à trois étages dans les Jardins de l'Empereur"; *Essai sur l'architecture chinoise,* vol. 2, facing illus. 27.

26. The text faces the first image of the series, illus. 28, with the title "Salle bourgeoise des Tartares avec une estrade échauffée par un Fourneau" (Ordinary room of the Tartars [Manchu] with a platform heated by a furnace).

27. See the brief discussion of these paintings in Gustave Ecke, "A Group of Eighteenth-Century Paintings of Beijing Interiors," *Journal of the Chinese Classical Furniture Society* 4, no. 3 (1994): 60–70. Ecke's article was originally published as "Sechs Schaubilder Pekinger Innenräume des achtzehnten Jahrhunderts," *Bulletin of the Catholic University of Peking* 9 (1934): 155–69. My thanks to Nicholas Grindley for bringing the article to my attention. Three of the paintings are also discussed in Jonathan Hay, *Sensuous Surfaces: The Decorative Object in Early Modern China* (London: Reaktion Books, 2010); see esp. illus. 16, 177, 194.

28. *Essai sur l'architecture chinoise,* vol. 2, illus. 31; the caption on the facing page reads: "Salle chez les Gens aisés."

29. The name is taken from fantastically eroded limestone rocks found at Lake Tai or Taihu 太湖 in southern China and is applied to many kinds of such stones, from miniature examples for a scholar's desk to massive garden rocks.

30. "No. 2. terre rouge qu'on mêle à la chaux pour crêpir les murailles du Palais des *Miao* &c." (No. 2. red earth one mixes with lime to stucco the walls of Palaces and *Miao* [miao 廟, temple or shrine], &c.); *Essai sur l'architecture chinoise,* vol. 1, facing illus. 18.

31. "De surprise parce que tout ce qu'on a voulu apprendre jusqu'icy sur la Chine, ne mene pas à imaginer quelle puisse avoir chez elle rien de pareil; de curiosité, parce que la hauteur, la beauté, & la vaine magnificence de plusieurs de ces Tai ne se concilie pas avec les

tant vantées Economies de sa politique, & que le motif de cette éxception a de quoi surpren-dre." *Essai sur l'architecture chinoise*, vol. 2, facing illus. 39–40.

32. See Werner Szambien, *Symétrie, goût, caractère: Théorie et terminologie de l'architecture à l'âge classique 1550–1800* (Paris: Picard, 1986); esp. the preface and *avant-propos*, 11–14.

33. See the brief discussion of the Académie royale d'architecture later in the essay; and see also my note 58.

34. Jacques-François Blondel (1705–74), *Discours sur la nécessité de l'étude de l'architecture: prononcé à l'ouverture du cinquième cours public* . . . (Paris: C.-A. Jombert, 1754); see esp. 83–89.

35. "Oeuvres d'Estampes utiles aux Architectes & autres Artistes, qui font leur profession des ouvrages de goût"; Blondel, *Discours*, 88; the citation is part of Blondel's brief note on the prints to be consulted.

36. The *De architectura* of Marcus Vitruvius Pollio (ca. 70 BCE–after 15 CE) has been translated numerous times into many languages. See Claude Perrault, *Les dix Livres d'architecture de Vitruve, corrigez et traduits nouvellement en François, avec des Notes et des Figures. Seconde Edition, reveuë, corrigée, et augmentée. par M. Perrault* . . . (Paris: J.-B. Coignard, 1684).

37. See *Vitruvius: The Ten Books on Architecture*, trans. Morris Hicky Morgan (Cambridge, Mass.: Harvard University Press, 1914; reprint, New York: Dover Books, 1960). For the suitability of rooms, see book 6, chap. 5, "How the Rooms Should Be Suited to the Station of the Owner."

38. On the contents of the Jesuit libraries in Beijing, see Mission Catholique des Lazaristes à Pékin, comp., *Catalogue de la Bibliothèque du Pé-T'ang* (Beijing, 1949). See also Noël Golvers, *Libraries of Western Learning for China: Circulation of Western Books Between Europe and China in the Jesuit Mission (ca. 1650–ca. 1750)*, Leuven Chinese Studies XXX (Leuven: Ferdinand Verbiest Instituut KU Leuven); part 1, 2012; part 2, 2013; and part 3, *Of Books and Readers*, 2015. Partial lists also appear in the appendix to Hui Zou, "The *Jing* of a Perspective Garden," *Studies in the History of Gardens and Designed Landscapes* 22, no. 4 (2002): 293–326; see esp. 317–18.

39. Cary Y. Liu, "Architects and Builders of the Qing Dynasty Yuanming Yuan Imperial Garden-Palace," *University of Hong Kong Museum Journal* 1 (September 2002): 38–59, 151–61; see esp. 38–39. (In English and Chinese.)

40. See Klaas Ruitenbeek, *Carpentry and Building in Late Imperial China: A Study of the Fifteenth-Century Carpenter's Manual Lu Ban jing*, Sinica Leidensia, vol. 23 (Leiden: E.J. Brill, 1993); see esp. 24–32 for "Technical Works" among "Chinese Sources on Building."

41. Note that various dates are cited for Li Jie's lifetime. Among the many recent publications on the *Yingzao fashi*, see Pan Guxi 潘谷西 and He Jianzhong 何建中, eds., *"Yingzao fashi" jiedu* 《营造法式》解读 (Nanjing: Dongnan daxue chubanshe, 2005). See also Jiren Feng, *Chinese Architecture and Metaphor: Song Culture in the Yingzao Fashi Building Manual* (Honolulu: University of Hawai'i Press, 2012).

42. See the printed book referred to in the *avertissement* of vol. 2 of *Essai sur l'architecture chinoise*; it is almost surely this imperial publication; see also my note 23.

43. Liu, "Architects and Builders," 48n7.

44. Construction of the Yuanming yuan began in 1707 with the gift from the Kangxi emperor (康熙, r. 1662–1722) of a garden site to the prince who would reign as the Yongzheng emperor (雍正, r. 1723–35). The garden-palace just northwest of Beijing was the favorite residence of the Qing emperors until its destruction in 1860 by British and French troops in the wake of the Second Opium War (1856–60). For one citation of the term "Versailles de Pékin," see my note 48.

45. "Lettre du frère Attiret, de la Compagnie de Jésus, peintre au service de l'Empereur de la Chine, à M. d'Assaut," *Lettres édifiantes et curieuses* (1749), 27:1–61. The thirty-four volumes of published correspondence of the Jesuit missionaries, *Lettres édifiantes et curieuses, écrites des Missions étrangères, par quelques missionnaires de la Compagnie de Jésus* (Paris: Nicolas Le Clerc and others, 1703–76), are a crucial source of accurate knowledge of China.

46. "Jardin de *yuen-ming-yuen*;" BnF, Fonds Bréquigny, vol. 123, fols. 243–46.

47. Chinese name: Qian Deming 錢德明, active in China after 1749. Amiot is also the author of a long biography and obituary of Jean-Denis Attiret, in a letter dated 1 March 1769. See Henri Bernard, S.J., "Le Frère Attiret au service de K'ien-long (1739–1768)," *Bulletin de l'Université Aurore* 1943, series 3, 4, no. 1 (13): 30–82; and 4, no. 2 (14): 435–74.

48. Documents contained in Ms. 1524 in the library of the Institut de France include lists of objects sent from China. On fol. 136r, a list dated 1770 includes "une boëte de carton où sont diverses peintures. au dessus sont les vües de *ge ho eul* plus bas sont les 40 peintures du Versailles de Péking &c." (The name "ge ho eul" is a transcription of Jehol, and the subject here is surely a version of the Kangxi emperor's 1712 "36 views of the Bishu shanzhuang.") Another list, fol. 133v, also dated 1770, includes an entry for "41 [*sic*] dessins maisons de l'Empereur ou du Versailles de PéKing." Other, similarly brief entries indicate the approximate date at which Bertin received the various versions of the "40 Views."

49. The album is entitled *Yuanming yuan sishi jing tuyong* 圓明園四十景圖詠; taken by a French officer in 1860, it was acquired by the BnF in 1862 and held in the Department of Prints and Photographs, B 9 rés. (ft. 5). See Nathalie Monnet, *Chine: L'empire du trait: Calligraphies et dessins du Ve au XIXe siècle* (Paris: Bibliothèque nationale de France, 2004), 225.

50. The album is entitled *Haitien. Maison de Plaisance, de l'Empereur de la Chine* (Haidian, pleasure palace of the emperor of China); it was acquired by the BnF in the nationalization of Bertin's collections in 1792 and is kept in the Department of Prints and Photographs, Oe 21 rés. (40). Haidian 海淀 is the town northwest of Beijing that is the location of the Yuanming yuan. For a detailed discussion of images of the Yuanming yuan in Henri Bertin's collection, see John Finlay, "Henri Bertin (1720–1792) and Images of the Yuanmingyuan in Eighteenth-Century France," chap. 8, 123–37, in Louise Tythacott, ed., *Collecting and Displaying China's "Summer Palace" in the West: The Yuanmingyuan in Britain and France* (London: Routledge, 2018).

51. See Véronique Royet et al., *Georges Louis Le Rouge: Les jardins anglo-chinois* (Paris: Bibliothèque nationale de France; Connaissance et Mémoires, 2004); see esp. 202, 207–21. This invaluable volume reproduces all of Le Rouge's illustrations with an extensive commentary.

52. See http://chatou.fr/chatou/ch060702.asp, accessed 28 May 2013. The chateau was eventually demolished in 1910, and all that remains is the "Nympheum," a riverside grotto decorated with multicolored tiles.

53. Library of the Institut de France, Ms. 1524, fol. 191r. The document is probably a copy of the letter actually sent to China. It has also been published twice, with minor variations in transcription; see Henri Bernard, S.J., "Catalogue des objets envoyés de Chine par les missionnaires de 1765 à 1786," *Bulletin de l'Université l'Aurore*, 1948–III, 9 (January–April): 197–98 (Shanghai); and see Henri Cordier, *La Chine en France au XVIIIe siècle* (Paris: H. Laurens, 1910), 84–85.

54. "Le cabinet chinois de Bertin à Chatou." The document is in the Library of the Institut national d'histoire de l'art (INHA), Ms. 131, fols. 91ff.

55. "Nous avons au surplus beaucoup de dessins de pavillons Chinois et de toute espèce, mais si quelque architecte de PeKin nous en donnoit un, nous pourrions volontiers l'exécuter de préférence"; "Le cabinet chinois de Bertin à Chatou."

56. For a brief introduction to Soufflot's career, see Michel Gallet, *Les architectes parisiens du XVIIIe siècle: Dictionnaire biographique et critique* (Paris: Mengès, 1995), 449–61. Soufflot's exact role in designing the residence at Chatou remains unclear. Another architect, Jean Chalgrin (1739–1811), himself linked to Soufflot, supposedly did extensive work on the chateau. See Charles-François Viel, *Notice nécrologique sur Jean-François-Thérèse Chalgrin, architecte, lue à la Société d'architecture, dans sa réunion du 26 novembre 1813* (Paris: Tilliard frères, 1814), esp. 17. See also my note 52.

57. "On a imaginé 1° d'arranger le toit de la maison à la chinoise en le prolongeant, garnissant les 2 bouts de quelques dragons." See "Le cabinet chinois de Bertin à Chatou," INHA Ms. 131; the spelling and punctuation have been updated here.

58. Société de l'histoire de l'art français, comp., *Procès-verbaux de l'Académie royale d'architecture, 1671–1793,* 10 vols. (Paris J. Schemit; E. Champion; A. Colin, 1911–1929); see esp. vol. 8 (1768–79), 241–42, for the very brief note. One of the most detailed sources on Soufflot's role in the construction of Chatou is Jean Mondain-Monval, *Soufflot, sa vie, son oeuvre, son esthétique (1713–1780)* (Paris: A. Lemerre, 1918); for his contributions to Chatou, see esp. 419–21.

59. Lequeu, sometimes written Le Queu, is a strange and controversial figure. See Philippe Duboÿ, *Jean-Jacques Lequeu: Une énigme* (Paris: Hazan, 1987); references to Lequeu's role at Chatou appear on 68–70, 339, 353, 360.

60. Entitled "Dessin du couronnement du pavillon chinois," the drawing bears Lequeu's monogram JLQ; it is held in the BnF, Department of Prints and Photographs, EST VA-78 (2). See also Kee Il Choi Jr., "Ornament from China: Sources for a Garden Folly Design by Jean-Jacques Lequeu," Shorter notices on drawings in *Burlington Magazine* 162 (March 2020): 216–19.

61. See Georges Bussière, "Henri Bertin et sa famille. Troisième partie. Les Ministère de Bertin, Bertin à la Cour, Bertin chez lui . . .," in *Bulletin de la Société historique et archéologique du Périgord* 36 (1909): 159–60. Bussière transcribes the opening paragraphs of the letter, citing the *Fonds Nepveu*, vol. 21 of Amiot's letters to Bertin. This document is Ms. 1517 of Bertin's documents in the library of the Institut de France. See Constance Bienaimé and Patrick Michel, "Portrait du singulier monsieur Bertin, ministre investi dans les affaires de la Chine," in Rochebrune, *La Chine à Versailles,* 150–77; see esp. 156–57, fig. 6.

62. An illustrated life of Confucius written by Amiot takes up most of vol. 12 of the *Mémoires concernant les Chinois,* published for Bertin in 1786. An abbreviated version, which cites Amiot's text of the life of Confucius and Bertin's collection, was published independently by Stanislas Helman as *Abrégé historique des principaux traits de la vie de Confucius . . .* (Paris, ca. 1782–92).

63. See Bussière, "Henri Bertin et sa famille."

64. See esp. *Essai sur l'architecture chinoise,* vol. 2, illus. 37, showing the ceremonial hall of an imperial prince, where a landscape scroll flanked by couplets hangs behind a table with an incense burner and other emblems of a scholar.

65. "Le Sage n'est pas un instrument."

66. See James Legge, trans., *Confucius: Confucian Analects, The Great Learning and The Doctrine of the Mean,* The Chinese Classics, vol. 1 (Oxford: Clarendon Press; reprint, New York: Dover Publications, 1971), 150, *Analects,* book 2, chap. 12. Legge's comments clarify the broader role of a superior man, that is, a *junzi.*

67. On the right, 德政口碑盈四�053, "En prenant la vertu pour règle générale de sa conduite, il érige à sa propre gloire autant de trophées (de Pei) qu'il y a de bouches dans les quatre parties du monde." And on the left, 仁壽身承冠一球, "Le jin étant en particulier le principal mobile qui le fait agir, il jouit de la récompense qui lui est due, dans le contentement de soi-même, dans une longue vie, et dans l'estime de l'univers entier."

68. Library of the Institut de France, Ms. 1515, letters from Amiot to Bertin, fols. 108–95; the date appears on the first page, and the text here is on fol. 172: "Je n'ay aucune part à toutes les belles choses qu'on a dites à votre grandeur sur l'architecture chinoise, sur les instruments du maçon et du charpentier, et sur cette police admirable qui a sû conserver depuis plus de 4000 ans la hiérarchie des états différents par la forme et l'étendue des bâtiments qui servent à loger chaque membre de la société. Il paroît que cette police n'est guère observée aujourd'huy à Péking. J'ay été dans des Palais et dans des maisons particulières. J'ay vû les logements des personnes de tous états, et j'avoue, à ma confusion, que je n'y ay point reconnu cet ordre merveilleux qui veut qu'un simple bourgeois ne puisse pas habiter dans une maison décorée avec des colonnes, que le lettré ne puisse avoir que deux colonnes à sa gallérie, le mandarin du troisième ordre, quatre colonnes et ainsi jusqu'aux premiers personnages de l'état."

69. Diderot et al., *Encyclopédie*; see vol. 1, 616–18. The author is indicated by the initial (P) at the end of the entries; the *avertissement*, xlvi, identifies (P) as Blondel.

70. *Recueil de planches, sur les sciences, les arts libéraux et les arts méchaniques: Avec leur explication . . .*, vol. 1 (Paris: David Briasson, Durand Le Breton, 1762); the contents of the volume are not numbered consecutively. Illustrations are accompanied by notices on the various sections (*parties*) and detailed entries on each of the engraved plates.

71. *Recueil de planches*, "Observations générales sur les Maisons royales & les Palais, appliquées en particulier à un grand Hôtel."

72. *Recueil de planches*, vol. 1 (1762), "Architecture," section 5: "Les hôtels, demeures des grands seigneurs, sont des bâtimens élevés dans les capitales, & où ils font habituellement leur résidence. Le caractere de leur décoration exige une beauté assortie à la naissance & au rang des personnes qui les font bâtir; néanmoins ils ne doivent jamais annoncer cette magnificence réservée seulement pour les palais des rois. / C'est de cette diversité de rang, du monarque aux grands princes, & de ceux-ci aux sujets, que doivent naître nécessairement les différens caracteres d'édifices; connoissances indispensables qui ne peuvent s'acquérir que par l'étude de l'art, & particulierement par l'usage du monde Certainement le rang du personnage qui fait bâtir, est la source où doivent se puiser les différens genres d'expressions dont nous voulons parler: or comment y arriver sans l'usage du monde, qui nous apprend à distinguer tous les besoins & le style convenable à telle ou telle habitation érigée pour tel ou tel propriétaire? [Should not those] personnages qui ne tenant pas le même rang dans la société, doivent avoir des habitations dont l'ordonnance annonce la supériorité ou l'infériorité des différens ordres de l'état?"

73. For a broad selection of seventeenth- and eighteenth-century illustrations, see Hendrik Budde et al., eds., *Europa und die Kaiser von China (1240–1816)*, exhibition catalogue (Frankfurt am Main: Insel, 1985); see esp. Peking (images), 76–79, and Kapital 7 (cat. entries), 252–69.

74. See John Finlay "Between France and China in the Late 18th Century: Henri Bertin and the Commerce in Images," in Petra Chu and Ning Ding, eds., *Qing Encounters: Artistic Exchanges Between China and the West* (Los Angeles: Getty Institute, 2015), 79–94; see also the discussion of Bertin's copies of the "40 Views" earlier in the present essay.

75. "Nous avons sous les yeux des peintures à la gouache de Peking: elles représentent les unes, l'intérieur magnifique des palais de l'Empereur & des maisons des Mandarins, des cabinets de curiosités naturelles, &c. d'autres, des paysages charmants, des détails champêtres avec des figures dont le dessein est d'une correction étonnante; la perspective y est bien observée, & les couleurs sont d'une vivacité à laquelle nous n'avons pu atteindre jusqu'à présent." *Mémoires concernant les Chinois*, vol. 1 (1776), preface, xi–xii.

76. "L'Architecture Chinoise mérite t'elle d'être connüe en Europe? Les connaissances qu'on pourroit en donner y seroient-elles de quelque utilité? Ce qu'on a imaginé de mieux

pour répondre à ces questions a été d'envoyer un Recueil de différentes Peintures sur lesquelles on pourra suppléer à des réponses qu'on n'est pas en état de donner. Le tems n'as pas permis de s'étendre autant qu'on auroit voulu sur les différentes parties du petit Recueil qu'on envoye, & on se bornera à une simple nomenclature; dans le cas où l'on désiraît quelques Eclaircissements, il seroit nécessaire de joindre un petit croquis de la Piéce [*sic*] sur laquelle on fera des questions parcequ'on n'a pas été en état de garder une Copie de ce qu'on a envoyé. / Comme on a paru bien aise de connoître un peu les Arts & metiers de la Chine, on a commencé ce Recueil par les instruments & outils du Charpentier & du Maçon qui n'est pas ici distingué du Couvreur. Il seroit inutile d'entrer dans les détails sur ce qui parle aux yeux. On ne nommera que ce qui seroit moins aisé a reconnoître." *Essai sur l'architecture chinoise*, vol. 1, n.p.

77. See the brief reference earlier in the essay to the article at the end of vol. 2 of the *Essai sur l'Architecture Chinoise*; see also my note 10.

78. Jean-Baptiste Du Halde, *Description géographique, historique, chronologique, politique et physique de l'Empire de la Chine et de la Tartarie chinoise . . .*, 4 vols. (Paris: P.-G. Le Mercier, 1735). For a superb study of Du Halde's achievement, see Isabelle Landry-Deron, *La preuve par la Chine: La "Description" de J.-B. Du Halde, jésuite, 1735* (Paris: Éd. de l'École des hautes études en sciences sociales, 2002).

79. The cumulative index, the *Table générale des matières* in vol. 10 (1784), lists architectural subjects in detail. Much of this discussion figures in an article in vol. 2 (1777) entitled "Remarques sur un Écrit de M. P** . . .," a text that was sent from Beijing in 1775. The article is a long and acerbic refutation of the *Recherches philosophiques sur les Egyptiens et les Chinois* by Cornelius de Pauw, published in 1773 (Berlin: C. J. Decker) and severely criticized at the time, especially by the Jesuits.

PART II

Constructing Identities

Landscape and the Articulation of the Imperium

Safavid Isfahan

Seyed Mohammad Ali Emrani

Isfahan, the great city of the Safavid (1501–1722), was among the major cosmopolitan centers of the early modern era. When Shah Abbās I (r. 1588–1629) designated Isfahan as the Safavid's new capital in 1598, he immediately began expansion beyond the old city's bounds, imagining a grand city to the south that would run alongside the Zāyandahrūd River. Isfahan's rapid transition from a closed-in medieval city to a vast, global metropolis of diverse inhabitants was not only a turning point in the history of urban development but also a significant moment for landscape design.

Shah Abbās I's extraordinary planning and implementation of building projects in Isfahan has attracted a great deal of scholarly attention and a rich variety of studies concerning the city's art, architecture, and urbanism, including its many monuments, royal gardens, and palaces. While there is still much to learn about Safavid Isfahan, Shah Abbās I's unique urban concept is an especially ripe subject for further consideration.[1] This essay reconsiders the imperial master plan and in so doing differs from prevailing scholarly opinion that locates the physical center of urban development at the great public square, or Maydān-i Naqsh-i Jahān, suggesting instead, through the lens of urban-scale landscape design, a new theory for the conceptualization of Safavid Isfahan anchored by the tree-lined avenue of Chahārbāgh (Khiyābān-i Chahārbāgh).[2]

By undertaking a morphological analysis of the city's development, this study aims to elucidate the ways in which principles of garden and landscape design served as devices to articulate imperial ambitions. Early maps and contemporary chronicles of the city, both Persian and European, are utilized to

form a reconstruction of Shah Abbās I's master plan, and the resulting focus on royal gardens demonstrates the centrality of landscape in the development of Isfahan during this period.

Isfahan's reinvention was significant in the history of urban design, as it was a precursor to a general transition from the traditional walled and fortified medieval city toward the model of an open, planned city of geometric patterns and tree-lined streets that was later adopted across much of the early modern world—a major example of which is Louis XIV's (1643–1715) Paris. As discussed in the Introduction to this volume, we can attribute the dissemination of such concepts to the increasing mobility and cultural exchange of the early modern world, a concern that is pursued further in this essay. In Isfahan's case, however, the large number of immigrants and foreign travelers in this period, and their translocation from an array of different cultures, not only influenced the visual and spatial articulation of the imperium's power but was integral to the aims of the imperium itself, particularly its desire to create a cosmopolitan city.

Shah Abbās I, or Shah Abbās the Great (r. 1588–1629), had become the fifth shah at a time of instability and factionalism among Safavid militant groups, the Qizelbāsh tribes.[3] Prior to Shah Abbās's ascension to the throne, his father, Sultān Mohammad Shah, suffering from poor eyesight, had been unable to manage the land or control the rebels, prompting rival emirs to use Abbās and his brothers as pawns for their own agendas. Foreign enemies played this situation to their advantage and occupied many parts of the Safavid territories. When Shah Abbās was appointed ruler at the age of seventeen, he decided to make revolutionary reforms to the structure of the state and the Safavid armed forces with the intention of reconstituting the royal authority.[4] During the first decade of the young shah's reign, he established a base of power and managed domestic and foreign threats. After his conquest in the war with the Uzbeks in 1598, Shah Abbās determined to transfer his capital to Isfahan. This was a major step toward the shah realizing his imperial ambitions, his dream of creating an ideal capital city reflecting an earthly image of kingship that he was to cultivate over a forty-one-year reign. One of Shah Abbās I's major reforms was a policy of tolerance toward other ethnicities and religious groups. Welcoming and accepting minorities helped Shah Abbās I to populate his capital city, and his leveraging of a diverse pool of skills and knowledge accelerated Safavid military and economic goals. Migrants and travelers from different cultures and nations played an important part in this successful and splendorous age, a part reflected in their central place in the shah's imperial plan that ultimately led to the formation of an innovative landscape design in the early modern period.

Alongside its future inhabitants, the location of this new cosmopolitan center was influential in its design. The first Safavid capital city, Tabriz, lay near the

Ottoman borders, and even Qazvin, the second Safavid capital city, faced the Ottoman threat. Isfahan lay in the central area of the Safavid territory, far from borders with foreign enemies. This central position also provided relatively good access to the Persian Gulf, a proximity well matched to the shah's commercial and territorial goals.[5] Beyond its strategic locale, Isfahan was chosen by the shah for its access to water, its benign climate, the abundance of land, and the natural beauty around the Zāyandahrūd River, among other reasons. The city's vast area was a key requirement for settling the migrants who came with the royal administration or whom the administration forced to relocate to help the shah build his new capital. For example, many skilled Armenian artisans were transferred from Jolfā in Azerbaijan to "New Jolfā" in Isfahan, one of the migrant suburbs of the shah's master plan illustrated in the pages ahead. A wide variety of luxury items were produced in Isfahan as a result of these forced migration policies, with merchants from as far off as China, India, Central Asia, Turkey, and Europe flocking there to buy a range of items produced by Safavid craftsmen.[6]

There was much at stake in the transformation of Isfahan, and a detailed review of its design and development reveals just how significantly Shah Abbās I benefited from innovative landscape and urban-design ideas as he sought to articulate his imperium and realize his vision of kingship. In the mining of this material, as local and foreign impressions are tracked and codified elements of nature are reconstructed to unlock their symbolic purpose, a key question surfaces: Could traditions of Safavid garden design have influenced the city's design as a whole? Shah Abbās I's careful construction of paradise, as articulated through trees, avenues, waterways, and bridges, goes some way to answering this question and enables us to delve further into the principles of Safavid imperial rule in the process.

From Medieval City to Metropole: Early Modern Accounts of Isfahan Under Shah Abbās I

Isfahan experienced several periods of political centrality in its early history. Yet in the century before Shah Abbās I, the city also suffered from prolonged periods of stagnation, neglect, and destruction.[7] Like many other medieval cities of the time, it was surrounded by defensive walls, fortifications, and several monumental gates (figure 4.01). A great citadel, Qal'eh Tabarak, lay on the southeast side of the medieval city wall. A vast *maydān*, or public square, known as the Maydān-i Hārun valāyat (later Maydān-i Kuhne, or the Old Maydān), occupied the center of the city, bringing together a magnificent congregational mosque, a

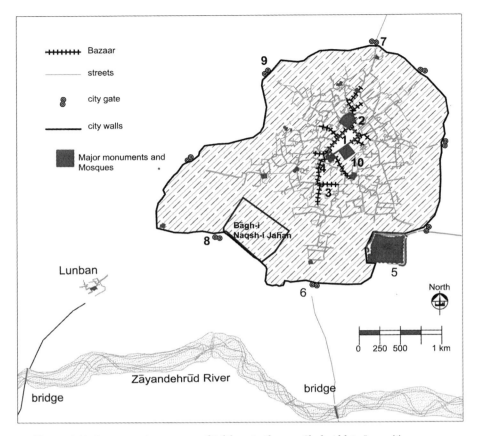

Figure 4.01. An approximate map of Isfahan in the pre-Shah Abbās I era. (1) Maydān-i Kuhnah (Old Square); (2) Masjid-i Jameʿ (Jameʿ Mosque); (3) Maydān-i Mir (Mir Square); (4) Masjid-i Ali (Ali Mosque); (5) Tabarak Fortress (Qalʿeh-yi Tabarak); (6) Hasanābād Gate; (7) Toqchi Gate; (8) Dawlat Gate; (9) Dardasht Gate; (10) Old royal palace. Map by Seyed Mohammad Ali Emrani.

shrine, a madraseh, and bazaars, which surrounded its open area and contributed to its particularly compact urban texture. The minarets and domes of mosques and shrines dotted the urban vistas, while defensive structures loomed over the cityscape, dominating the skyline. The medieval city, which mostly took shape during the Seljuq period (eleventh to thirteenth centuries), sat well north of the Zāyandahrūd River, while the farmlands and orchards of its hinterland lay still farther north, outside the city walls and without an arterial connection to the city structure. Those extra-urban sites included several significant gardens, some of which adjoined the city walls—the largest and most important among them, the garden of Naqsh-i Jahān (Image of the World Garden), would

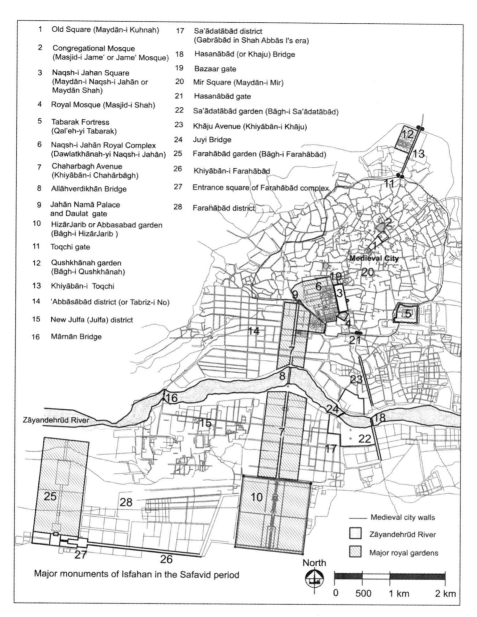

1	Old Square (Maydān-i Kuhnah)
2	Congregational Mosque (Masjid-i Jame' or Jame' Mosque)
3	Naqsh-i Jahan Square (Maydān-i Naqsh-i Jahān or Maydān Shah)
4	Royal Mosque (Masjid-i Shah)
5	Tabarak Fortress (Qal'eh-yi Tabarak)
6	Naqsh-i Jahān Royal Complex (Dawlatkhānah-yi Naqsh-i Jahān)
7	Chaharbagh Avenue (Khiyābān-i Chahārbāgh)
8	Allāhverdikhān Bridge
9	Jahān Namā Palace and Daulat gate
10	HizārJarib or Abbasabad garden (Bāgh-i HizārJarib)
11	Toqchi gate
12	Qushkhānah garden (Bāgh-i Qushkhānah)
13	Khiyābān-i Toqchi
14	'Abbāsābād district (or Tabriz-i No)
15	New Julfa (Julfa) district
16	Mārnān Bridge

17	Sa'ādatābād district (Gabrābād in Shah Abbās I's era)
18	Hasanābād (or Khaju) Bridge
19	Bazaar gate
20	Mir Square (Maydān-i Mir)
21	Hasanābād gate
22	Sa'ādatābād garden (Bāgh-i Sa'ādatābād)
23	Khāju Avenue (Khiyābān-i Khāju)
24	Juyi Bridge
25	Farahābād garden (Bāgh-i Farahābād)
26	Khiyābān-i Farahābād
27	Entrance square of Farahābād complex
28	Farahābād district

Figure 4.02. Map of major monuments of Isfahan in the Safavid period. Map by Seyed Mohammad Ali Emrani.

later serve as the main Safavid royal palace garden ensemble adjoining a vast new square.

Shah Abbās I reorganized and developed Isfahan into one of the largest cities of the early modern world, the seat of the Safavid throne. Within a short period, he developed the city, establishing four new districts adjoining the south side of the medieval city and extending Isfahan beyond the river toward Suffa Mountain. The main pieces of Shah Abbās I's master plan were the huge rectangular square, the Maydān-i Naqsh-i Jahān (figure 4.02, number 3), and the long, straight avenue (*khiyābān*) known as Khiyābān-i Chahārbāgh (figure 4.02, number 7). These two most important public spaces provided a unifying structure for the later developments that took place on both sides of the river. Among other important components of this plan were new residential districts, bridges, a large network of canals, bazaars, and many new buildings and palaces.[8]

Morphological analysis of the city's growth through early modern accounts reveals the significant role played by landscape and garden concepts in the shah's realization of an appropriately imperial capital city. A closer examination of his master plan and its subsequent expansions point to a new era of urban design with landscape seen as an organizing principle, a design tool, and an integral part of the artistic, architectural, and engineering aspects of urban development. Before discussing its wider ramifications for urban design, or the shah's ability to create an inimitably vast city befitting his absolutist kingship and his territorial ambitions, we must first reconstruct Isfahan's grand overhaul through the local and foreign impressions that remain.

No pictorial documents or drawings of a master plan have survived. Valuable information has, however, emerged from Persian chronicles and European travelogues from this time, which can help us to reconstruct the shah's overall vision. The Maydān-i Naqsh-i Jahān served as an aesthetic and functional joint between the medieval city and the new city, offering a large open space that stood at the center of the main religious, economic, royal, and administrative institutional structures. Yet, as the sources I mention below illustrate, the Khiyābān-i Chahārbāgh formed the key organizational element in the shah's plan for the new urban districts. Royal gardens and palaces lay at both ends of this avenue, representing an innovative use of garden design principles to portray the symbolic and political presence of royal authority within the urban landscape.

Three Safavid chronicles from the Shah Abbās I era describe the creation of the khiyābān.[9] Jalā al-Din Muhammad Munajjim, Shah Abbās I's astronomer, reports briefly that in December 1596 the shah entered Isfahan and began the design of the Chahārbāgh. Munajjim does not give us any detail, describing only the construction of a large irrigation canal from the Zāyandahrūd River to a

royal garden, ʿAbbāsābād, and the gardens of various elites that lined the Chahārbāgh.[10] Iskandar Beg Munshi (1560–1634), Shah Abbās I's official chronicler, offers a more thorough description.[11] He writes that the construction of Khiyābān-i Chahārbāgh occurred in two parts, north and south of the river. To the north, a khiyābān was built from the Dawlat Gate, located in a precinct of the Naqsh-i Jahān garden, to the edge of the river. Flanking this khiyābān were *chahārbāgh*, or large gardens (*chahārbāgh-i dar har du taraf-i khiyābān*), their entrances marked by sublime buildings. The khiyābān continued across the river and through to the foot of the mountains on the southern side of the city, and the land alongside this southern stretch was divided among the emirs and nobles of the state to create their own gardens, which were similarly distinguished by impressive buildings at their entrances.[12] Munshi also tells of the construction of a well-designed and brilliant bridge, the Allāhverdikhān Bridge, that spanned the Zāyandahrūd River to connect the two parts of the khiyābān. Munshi describes a canal made from stone that extended down the middle of the khiyābān, while two narrower canals lined with cypress, juniper, pine, and plane trees ran along the sides of the khiyābān. Large basins faced each main building of the khiyābān.[13] Munshi also notes the vast terraced garden, the garden of ʿAbbāsābād (or HizārJarib), that was created for the shah himself at the south end of the khiyābān. In 1616, as Munshi finished his chronicle, all of Shah Abbās I's projects around the khiyābān were complete, and to its west a new district known as ʿAbbāsābād had been developed to house migrants from Tabriz (figure 4.02, number 14).[14]

In the third of the Safavid sources, Mirzā Beg Hasan Junābadi describes the creation of the new khiyābān much as Munshi does.[15] Writing several years after Munschi, Junābadi adds details about the urban environment that sprang up around the shah's new boulevard, including taverns (*maykhānah-ha*), hostels (*jāhā*), and hermitages (*zāwiyah-hā*) for the poor and the dervishes, as well as coffeehouses constructed along the khiyābān itself.[16] Like Munshi, Junābadi mentions the creation of the new district for Tabriz migrants, which he calls Tabrizābād, while also referring to other quarters, including New Julfa and Shamsābād, which Shah Abbās I ordered to be built for the city's migrant groups.[17] These migrant districts were created for people who came to the new capital with the royal administration or were forced to migrate to Isfahan so that their skills might help the new city flourish.

Contact between Persia and Europe increased during Shah Abbās I's reign as a result of the religious, political, and commercial incentives of the Safavid period. Voyagers traveled from European countries to Persia, and vice versa, many of whom were ambassadors or diplomats, missionaries or representatives of various religious orders, or officers of the East India Companies (English,

Dutch, and later French).[18] Various members of these groups, as well as individual merchants, craftsmen, and scholars, published their observations and travel reports upon their return home.[19] Almost all European travelogues of Persia in the seventeenth century have at least a short description of the new monuments of Isfahan, including the Khiyābān-i Chahārbāgh, and several augment the information on Shah Abbās I's plan that the Safavid accounts provide. Among them, the descriptions by the Italian Pietro della Valle (1586–1652) are especially important, as he visited Isfahan twice between 1617 and 1621, at the time of the completion of Shah Abbās I's projects. Della Valle's observations in letters he wrote to his friend Mario Schipano of Naples are particularly valuable, as he recorded his experience of Isfahan as an eyewitness; one thus presumes that his descriptions are more reliable than those written by European travelers who sought to recollect their experience of the city long after they had departed.[20]

Della Valle's descriptions place particular emphasis on the role of the Khiyābān-i Chahārbāgh in the master plan for the capital (figure 4.03). In a letter from Isfahan in 1617, he names Khiyābān-i Chahārbāgh and Maydān-i Naqsh-i Jahān as the two most marvelous structures in the city. At the center of the planned city lay the Khiyābān-i Chahārbāgh, which, as he explains several times in his letters over the course of his stay, played a fundamental role in Shah Abbās I's plan. Della Valle describes the four separate suburban districts around this central axis: the old city, consisting of the medieval city and its new adjoining development, including Maydān-i Naqsh-i Jahān in the northeastern quarter, and three new suburban districts for specific migrant groups—ʿAbbāsābād or Tabriz-i Nu, for migrants from Tabriz; Gabrābād, for Zoroastrian migrants; and New Julfa, for Armenian migrants from Julfa.[21] Della Valle states that the shah provided many facilities, allowing for the quick expansion of these suburbs and their merging together as a united city. He underlines the shah's urban development policy that provided essentials, such as land and money, for migrants and others who wished to settle there. Anticipating the continued growth of the three new suburban quarters and their increased connection with the old city, della Valle recognizes the central position of the Khiyābān-i Chahārbāgh in future development.[22]

Two other European accounts of Isfahan under Shah Abbās I come from the travelers Garcia de Silva Figueroa (1550–1624) and Thomas Herbert (1606–82). Figueroa, ambassador from the court of Philip III (r. 1598–1621), king of both Spain and Portugal, portrays the khiyābān as a straight, tree-lined avenue joining the new districts on opposite sides of the river, with a canal made of white stone extending along its center.[23] Herbert, a member of the mission of Sir Dodmore Cotton (1600–1628), the English ambassador of King Charles I (1600–1649)

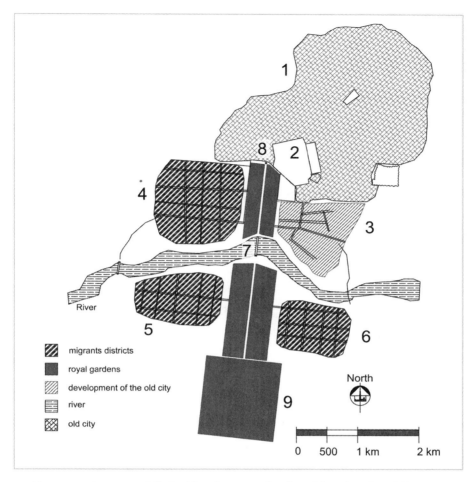

Figure 4.03. Diagram of Shah Abbās I's master plan for Isfahan, based on della
Valle's description. (1) The old city; (2) Dawlatkhānah-yi Naqsh-i Jahān; (3)
continuous growth of the old city; (4) Tabriz-i Nu, or ʿAbbāsābād; (5) Julfa; (6)
Gabrābād; (7) Allāhverdikhān Bridge; (8) Dawlat Gate; (9) ʿAbbāsābād garden
(Bāgh-i HizārJarib). Map by Seyed Mohammad Ali Emrani.

to Persia, who visited Isfahan late in Shah Abbās I's reign, also highlights the
avenue's significance. Herbert describes the khiyābān as a large street lined with
garden walls and summer houses, for which plane trees were planted. He notes
that the trees served both practical and decorative purposes.[24]

Adam Olearius (1599–1671), a member of the diplomatic mission sent by
Duke Friedrich of Holstein (1597–1671), visited Isfahan in 1637, eight years after
the reign of Shah Abbās I had ended. In his writings, he declares the Khiyābān-i
Chahārbāgh to be one of the world's noblest avenues, describing the whole of it

as "the King's Garden." Surrounding it, the city was, according to Olearius, divided into four sections:

> The Parts adjacent to the Citie, are not unsuitable to the sumptuousness of its structures, and the greatness of so famous a Metropolis, The Kings Garden which they call Tzarbagh [Chahārbāgh], is, no doubt one of the noblest in all the World. It is above half a League in a perfect square, and the River Senderut [Zāyandahrūd], which hath Spacious Walks on both sides of it, divides it into a cross, so as that it seems to make four Gardens of it. At one of its extremities, towards the South, there is a little Mountain, divided into several Alleys, which have on both sides steep precipices, in regard that the River, which they have brought up to the top of the Mountain, does thence continually fall down, by Chanels [canals] into Basins, which are cut within the Rock. The Chanels were about three foot broads and were cut upon every side, so as that the water falling directly down, and, with a great noise, into the Basin, extremely delighted both the ear, and the eye. No Basin but the water fell into it, and upon every Alley, there was a Basin of white Marble which forced the water into divers figures. All the water about the Garden fell at last into a Pond, which in the midst of it, cast up water forty foot high. This Pond, had, at the four corners of it so many large Pavilions, whereof the apartments were gilt Within, and done with fueillage, there being a passage from one to another by Walks, planted with Tzinnar-Trees [plane trees], whereof there being Millions, they made the place the most pleasant and delightful of any in the World.[25]

Sir John Chardin (1643–1713), a French traveler who lived in Isfahan during the Safavid era, describes many features of the Khiyābān-i Chahārbāgh's northern section, such as the royal gardens and their gateway building and the basins, canals, and waterfalls that lay at the center of the khiyābān, declaring: "This avenue is the most beautiful avenue I have ever seen or heard of."[26] Chardin was in Persia between 1666 and 1677, during which time he was mostly in Isfahan and able to collect a vast amount of information regarding the capital, its people, and its monuments. His descriptions of the Khiyābān-i Chahārbāgh provide more detail and help us to develop a comprehensive image of its form and functions as they stood approximately forty years after the era of Shah Abbās I (figure 4.04). Chardin tells us that the khiyābān was two miles and two hundred paces long and one hundred paces wide; a water canal ran the entire length of its center, and the canal's edges were made of stone. These edges were raised nine inches above the avenue's surface and were so wide that two men on horseback could

Figure 4.04. Khiyābān-i Chahārbāgh based on Chardin's description. (1) Maydān-i Naqsh-i Jahān; (2) Dawlatkhānah-yi Naqsh-i Jahān; (3) 'Emārat-i Jahān Namā; (4) Khiyābān-i Chahārbāgh; (5) Bridge; (6) Bāgh-i HizārJarib; (7) Bāgh-i Musamman; (8) Bāgh-i Khargāh; (9) Bāgh-i Takht; (10) Bāgh-i Bulbul (Bolbol); (11) Bāgh-Mu (le Jardin des Vignes); (12) Bāgh-i Tūt (le Jardin des Meuriers); (13) Bāgh-i Tikiyeh Nematollahi (l'Hôtellerie des Derviches des Neametolahy); (14) Bāgh-i Tikiyah Heidari (l'Hôtellerie des Derviches de Heider); (15) Bāgh-i Shirkhānah (la Volière du Roi); (16) Bāgh-i Tāvuskhānah (la Maison des Lyons); (17) gardens belonging to emirs and courtiers, with seven gardens on each side of the khiyābān (Chardin does not record their names); (G-1) Dawlat Gate; (G-2) gate to royal complex (harem); (G-3) gate to harem; (G-4) gate toward the suburbs of the city; (B-1) to (B-7) basins at the center of the Khiyābān recorded by Chardin; (W) waterfall. Map by Seyed Mohammad Ali Emrani.

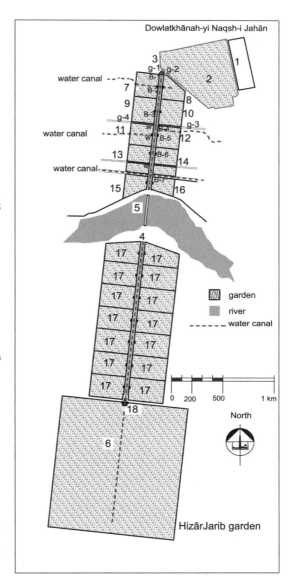

ride next to each other on the same side. Beautiful and spacious gardens bordered this lovely avenue, and each of them featured two types of pavilion. The first of these structures was a very large building in the middle of the garden, consisting of a hall open on all sides. These center pavilions also housed cabinets and chambers at their corners. The other pavilions were located at garden gates and were also partially open, in front and on the sides, providing a pleasant view of the khiyābān. Chardin reports that the pavilions had different forms and figures, but almost all were of equal size, painted and gilded, and aesthetically

pleasing. He further recounts that the garden walls were created with lattice-work so that people could see the gardens without going into them. He notes that the several intersecting streets, which crossed at various intervals along the avenue's length, also had large water canals and two rows of plane trees. The avenue ended at one of the shah's suburban palaces, which Chardin recounts was so great that it was called "Thousand Acres" (*Maison de mille arpens*, i.e., Bāgh-i HizārJarib).

Chardin's account also offers a detailed breakdown of the khiyābān's basins, revealing that they varied in size and shape. He mentions the seven basins in the khiyābān between Jahān Namā Pavilion and the river, of which three were small and four were large:

> The first one was a quadrant with an area of 15 paces squared.
> The second was also a quadrant with a perimeter of 120 paces, and the gardens flanking it were Bāgh-i Moṣamman and Bāgh-i Khargāh.
> The third basin had an octagonal shape with a perimeter of 108 paces, and the gardens of Bulbul and Takht flanked it.
> The fourth basin was small with a perimeter of 20 paces and lay above a waterfall (or adjoined to a waterfall).
> The fifth basin was a small basin near another waterfall and the Mulberry garden [Bāgh-i Tūt], and a vineyard [Bāgh-i Mu] flanked it.[27]
> The sixth basin was a quadrant and had the gardens of dervishes on either side.[28]
> The seventh basin had a perimeter of 124 paces and was used to divide the water to the surrounding alleys.

Chardin provides even further detail:

> The third waterfall on the khiyābān lay between these last two basins and had an alley on both sides. The Allāhverdikhān Bridge was on the other side of the seventh basin and there were gardens on either side of the khiyābān, just before the river. One of these was a garden for royal birds [*La Volliere du Roi*] with cages made of gold, and the other was a garden for lions [*La Maison des Lyons* or *Bāgh-e Shirkhāneh*].

Chardin mentions several gardens on the bank of the Zāyandahrūd and also counts fourteen gardens lining the Khiyābān-i Chahārbāgh to the south of the river, which were named after the men who built them. He writes that the basins were surrounded by flowers and that people used the platforms of the gateway buildings to rest and smoke shisha.[29]

Just seven years after Chardin departed, another distinguished visitor to Is-fahan, Engelbert Kaempfer (1651–1716), not only wrote about the city but also created drawings of its streets.[30] As German secretary and physician for the Swedish embassy to Persia from 1684 to 1685, Kaempfer visited and studied many of the Safavid royal gardens and palaces of Isfahan. He, like others, noted the contrast between the medieval and Safavid quarters, noting that the latter were filled with tree-lined streets.[31] Though the Gabrābād Quarter was removed before Kaempfer's visit, della Valle had earlier confirmed that its streets were as wide and straight as New Julfa's, and even more beautiful.

Whether these impressions of Isfahan from European travelers and Safavid writers are brief or detailed, when taken together they give us a better under-standing of Isfahan's development during this period. While most of these ac-counts simply praise the main urban spaces of the city, like the maydān and the khiyābān, Chardin's descriptions and Kaempfer's drawings reveal many of the landscape characteristics and details of the main Khiyābān and royal gardens. Della Valle's eyewitness text should be considered the most accurate, and it is also valuable for its description of the shah's master plan in its early stages. Compared and contrasted, these accounts allow us to reconstruct and examine the master plan for Isfahan, and lead us to a better understanding of the role of landscape in this period.

Shah Abbās I's Master Plan: From Garden Design to Urban Development

Having reviewed the accounts of travelers and chroniclers, I have drafted two plans of Isfahan in the Safavid era based on a comparison and collation of the textual and pictorial evidence from these early modern sources and later docu-ments.[32] An analysis of such reconstructed plans of Isfahan shows that several main spatial components constituted the backbone of the Safavid capital under Shah Abbās I (figures 4.05 and 4.06 [plates 9 and 10]). Comparing Isfahan before and after Shah Abbās I's open and ordered revision of the city's structure illus-trates that the medieval city of Isfahan was mostly the product of gradual, organic growth, with very densely populated land and winding, narrow streets and ba-zaars (figure 4.07). This traditional urban fabric is still visible in the old quarters around the Jāme' Mosque. The main architectural landmarks of the medieval city were located around the irregular geometric form of the Maydān-i Kuhnah, which was the most important public open space at that time.

The Safavid eventually used open urban spaces and straight streets and ave-nues in many parts of their urban development. The center of the new Isfahan

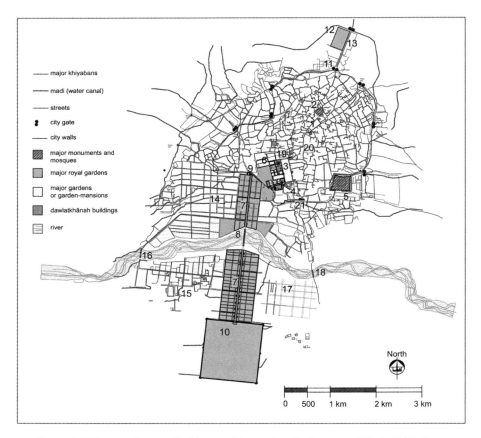

Figure 4.05. Restored plan of Isfahan and its gardens in the time of Shah Abbās I.
(1) Old Square (Maydān-i Kuhnah); (2) Masjid-i Jameʿ (Jameʿ Mosque); (3)
Maydān-i Naqsh-i Jahān; (4) Royal Mosque (Masjid-i Shah); (5) Tabarak Fortress
(Qalʿeh-yi Tabarak); (6) Dawlatkhānah-yi Naqsh-i Jahān; (7) Khiyābān-i
Chahārbāgh; (8) Allāhverdikhān Bridge; (9) ʿEmārat-i Jahān Namā and Dawlat
Gate nearby; (10) HizārJarib garden; (11) Toqchi Gate; (12) Qushkhānah garden; (13)
Khiyābān-i Toqchi (or Khiyābān-i Bāgh-i Qushkhānah); (14) ʿAbbāsābād district;
(15) New Julfa district (Julfa); (16) Mārnān Bridge; (17) Gabrābād district; (18)
bridge; (19) bazaar gate; (20) Maydān-i Mir (Mir Square); (21) Hasanābād Gate.
Map by Seyed Mohammad Ali Emrani.

city plan was the Maydān-i Naqsh-i Jahān, a large, rectangular public square
that also served as a stage for royal games and ceremonies. A third major public
open space, the Maydān-i Chāhārhoz, was created as part of the royal palace
precinct of Naqsh-i Jahān. The most recognizable change in the Shah Abbās I
period, even more immediately apparent than an expansion of public spaces, is
the geometric pattern that becomes visible at different parts of new urban devel-
opment, and that contrasts distinctly with the organic fabric of the medieval
city. A pattern of wide, straight streets characterized the new districts of Shah

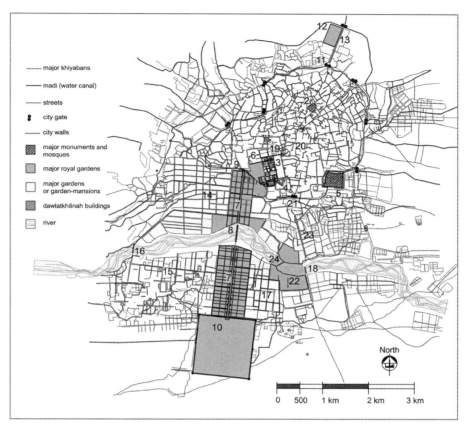

Figure 4.06. Restored plan of Isfahan and its gardens in the era of Shah Abbas II. (1) Old Square (Maydān-i Kuhnah); (2) Masjid-i Jame' (Jame' Mosque); (3) Maydān-i Naqsh-i Jahān; (4) Royal Mosque (Masjid-i Shah); (5) Tabarak Fortress (Qal'eh-yi Tabarak); (6) Dawlatkhānah-yi Naqsh-i Jahān; (7) Khiyābān-i Chahārbāgh; (8) Allāhverdikhān Bridge; (9) 'Emārat-i Jahān Namā and Dawlat Gate nearby; (10) HizārJarib garden; (11) Toqchi Gate; (12) Qushkhānah garden; (13) Khiyābān-i Toqchi (or Khiyābān-i Bāgh-i Qushkhānah); (14) 'Abbāsābād district; (15) New Julfa district; (16) Mārnān Bridge; (17) Sa'ādatābād district; (18) Hasanābād Bridge (Khāju Bridge); (19) bazaar gate; (20) Maydān-i Mir (Mir Square); (21) Hasanābād Gate; (22) Sa'ādatābād royal garden; (23) Khiyābān-i Khāju; (24) Juyi Bridge. Map by Seyed Mohammad Ali Emrani.

Abbās I's Isfahan—visitors can still see these today in the Abbāsābād Quarter, while della Valle reports that other quarters Shah Abbās I created, including New Julfa and Gabrābād, shared this design.[33]

As Isfahan expanded and new quarters were created beyond the original city walls, the fortifications of the medieval city lost their defensive roles. As a powerful emperor realizing his vision of kingship, Shah Abbās I decided that his capital city did not require such defensive structures. Moreover, larger houses,

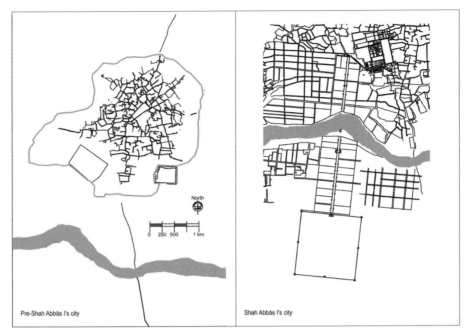

North

0 250 500 1 km

Pre-Shah Abbās I's city

Shah Abbās I's city

Figure 4.07. Comparison of the city fabric of Isfahan before Shah Abbās I and after its development. Map by Seyed Mohammad Ali Emrani.

garden-mansions, and royal palace gardens were no longer segregated but integrated into the fabric of the city. As the city moved southward, the river and its banks and bridges all became a part of the new metropolitan city's open public space. The vast scale of this development in such a short period also reveals the shah's power in shaping his imperium.

One can summarize Shah Abbās I's ideal capital city, an integral part of his vision of kingship, as an earthly paradise created by him as the shadow of God, the absolute power of the land. The concept of this vision is considered further in the following section, but what of its construction? How did Shah Abbās I physically shape his capital city into a unique earthly paradise? Of particular import to the transformation of Isfahan under Shah Abbās I and his successors were design elements associated with Safavid-era royal gardens, including khiyābāns, central pavilions or palaces, canals and basins, and rows of trees.[34] In considering how the shah constructed a notion of paradise, the question arises: Does a relationship exist between concepts of Safavid gardens and the urban development of Isfahan in this period? The idea of the paradisiacal garden and the layout of chahārbāgh are two central concepts in the formation of Safavid gardens that we see reflected in Safavid Isfahan.

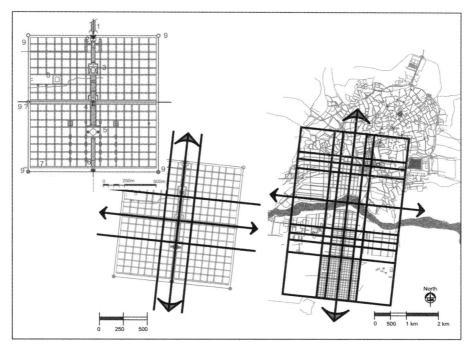

Figure 4.08. Comparison of the layout of 'Abbāsābād garden with Shah Abbās I's master plan for Isfahan. Left: restored plan of Bāgh-i HizārJarib. Right: the Khiyābān-i Chahārbāgh forms a quadripartite division with the Zāyandehrud River. (1) Khiyābān-i Chahārbāgh; (2) gateway building and starting point of the main spatial axis with a water channel and basins; (3) first large octagonal pool; (4) central pavilion; (5) second large octagonal pool and two pavilions; (6) building at the end of the main axis; (7) one of the main water canals from the river that ran parallel to the south wall; (8) harem building and a maydān (playing field) for polo created by Shah Suleiman; (9) pigeon tower. Map by Seyed Mohammad Ali Emrani.

Since the ancient era, Persian gardens have been recognized as a metaphor for paradise. In the Safavid era, Qur'anic notions of paradise were used in texts and poems not only to describe Isfahan's gardens but also to admire the beauty and quality of the new capital city. Both European travelers and Safavid chroniclers used such allusions: Kaempfer used the expression "irdische Paradiese" (earthly paradises) in his description of the Khiyābān-i Chahārbāgh.[35] Thomas Herbert invoked similar language: "Which at a little distance from the city you would judge a forest, it is so large; but withal so sweet and verdant that you may call it another paradise."[36] Munshi, the official chronicler of Shah Abbās I, frequently employed literary references in comparing Isfahan to paradise, using phrases like "a city like a paradise" (*baladah-i Jannat-neshān*) and "the second paradise" (*Khuld-i Sāni*) in his texts. Munshi further describes Shah Abbās I's

Isfahan as a city with excellent buildings and houses, splendorous and aromatic gardens, and streams and flowers, which one might find in paradise,[37] and refers to the expression of paradise in the Qur'an, arguing that the city of Isfahan embodies the paradise expressed in two verses from the Holy Book.[38] Such examples in official Safavid writing show that the metaphoric and symbolic invocations of paradise were used to describe and admire the Safavid city as well as its gardens and indicate the inspiration of the Qur'anic and Persian notion of paradise in the planning of the capital city.

Of all the new city's structural developments, the main longitudinal axis, or khiyābān, was the most important spatial component, and so it was in Safavid urban gardens. Particularly in large gardens, transversal and lateral khiyābāns articulated the primary spatial structure (figure 4.08). An examination of Shah Abbās I's design of Isfahan demonstrates that he applied this same spatial organization for other urban areas as well. In the city at large, the Khiyābān-i Chahārbāgh constituted the main longitudinal axis, while transversal khiyābān were constructed to cross the new quarters, including 'Abbāsābād, New Julfa, and Gabrābād.

Having surveyed the gardens along the Khiyābān-i Chahārbāgh, Kaempfer recounts that two perpendicular axes, the khiyābān and the river, divided the area into four parts, and that the whole comprised thirty gardens, some of which nobles received as gifts, while others were for public use; moreover, his valuable drawings show us the layout of many of these gardens.[39] Not all of the royal gardens of Isfahan in the Safavid era possessed a quadripartite division, but some did. In a chahārbāgh layout of a garden in the Safavid era, a central khiyābān formed the backbone of the spatial structure and possessed a symmetrical design. We have already seen that the Khiyābān-i Chahārbāgh played a key role in the master plan of Isfahan as an urban thoroughfare and the organizer of the metropolitan city-garden area. This city's arterial thoroughfare cannot be called a garden itself, since a garden and a khiyābān differ considerably. Likewise, a khiyābān is but one element in a garden, surrounded by other garden components. An examination of the shape, architecture, and surrounding constituents of this khiyābān, however, discloses it as having the quality of the main khiyābān of a garden, albeit on the scale of a city.

In almost all Safavid gardens, as well as in theoretical models of Persian gardens based on the *Irshād al-Zirā'a*,[40] a treatise composed by Qasim ibn Yusuf Abu Nasr Haravi in the early Safavid period, a monumental building such as a pavilion, kiosk, or palace with a *tālār* (semi-open pillared hall) sits at the center of the garden along the main longitudinal axis.[41] In Isfahan, the Allāhverdikhān Bridge (figure 4.05 [plate 9], number 8), located in the middle of the Khiyābān-i Chahārbāgh, occupied this important position in both design and function. Un-

der Shah Abbās II (r. 1642–66), another bridge, the Hasanābād or Khāju Bridge (figure 4.05, number 18), was built with the same purpose in mind, though it also served as a dam, creating a lake in the middle of the royal gardens and the city.[42] In both cases, the bridges took their places within the urban plan just like axis-sited central garden pavilions, with monumental architecture and semi-open spaces gracing all four sides. For this city-garden, the river and its banks played the role of the transversal axis. Pavilion-like bridges offered places for visitors to sit, listen to the sound of running water, and take pleasure from a cool summer breeze. Indeed, European travelers reported that the bridges served social functions similar to those of garden pavilions and that they also served as the location for many public feasts and ceremonies.[43] Finally, as with a pavilion or a semi-open pillared hall in the middle of a garden, from within the bridge's structure one could enjoy a view of the river or city, while from the outside the view was reversed so that if you were standing at various points along the riverbank, you could appreciate a bridge as a monument in a way comparable to how one would view a garden's primary architectural feature.

Garden design's influence in Isfahan goes beyond the Khiyābān-i Chahārbāgh and its surrounding area. Another example is the creation of large rectangular maydāns with rows of trees and water canals. In Shah Abbās I's era, tree-lined rectangular maydāns were constructed not only in Isfahan but in other cities as well, such as Qazvin and Farahābād. A comparison of the geometry and features of these maydān with the open spaces of Safavid gardens uncovers some similarities. In most Safavid gardens, a vast open space sits in front of the central pavilion, decorated with basins and canals along its central axis, while trees and further canals line its border; an example still visible today may be found in Bāgh-i Fin, near Kashan.[44]

Water's application as an architectural element in Safavid gardens is also echoed in many aspects of the open public spaces designed for the shah's garden-city. A major development of the new Isfahan was its vast and infrastructural water system consisting of a network of large water canals (*mādis*) that drew from the river. The canals, waterfalls, and basins functioned as both practical and aesthetic components in the creation of this city-garden, and the river itself played a central role in the overall design, acting as the city-garden's main water canal (*shāhjuy*), but once again operating on an urban scale (figure 4.08).

The growth of the shah's city did not always conform with his garden-based design, but the design's influence remained. More recent accounts now show that when della Valle was looking ahead to the era after Shah Abbās I, his prediction was correct: the four districts of the shah's master plan, separated by the intersection of the khiyābān with the river, developed individually but eventually combined to create a single continuous metropolitan area (figure 4.06 [plate

10]). An important functional change occurred during the reign of Shah Abbās II, however: a new large royal palace and garden complex replaced one of the suburban districts (figures 4.05 and 4.06 [plates 9 and 10], number 17). A new bridge, the Hasanābād, and a large avenue, the Khiyābān-i Khāju (figure 4.06 [plate 10], numbers 18 and 23, respectively), were created, together with adjoining districts. Yet the concept and function of the four divisions of Shah Abbās I's plan may still be observed, though their original pure layout becomes somewhat obscured by this development.[45]

In the early modern era, Isfahan became a pioneer city, employing novel garden-design ideas to represent the imperial ambitions of the monarch through the urban landscape. The ambitious and open Isfahan of Shah Abbās I was not only a city orchestrated to reflect the design values of a large paradisiacal garden but also a metropolitan city embodying many innovative urban architectural and landscape ideas, which all served to represent the splendor of the imperium, an integral part of the Shah Abbās I's notion of kingship as the shadow of God on earth.

Safavid Kingship and the Formation of the City-Garden

Safavid kingship drew on the interlaced principles and practice of a two-pronged understanding of cultural authority. As Sussan Babaie writes, "The Persianate tradition of kingship and the ancient notions of the king's aura of splendor or farr, on the one hand, and the Imami Shi'i extractions from the Qur'an and the hadith (sayings and deeds attributed to the Prophet) on the points of legal- or shari'a-based legitimacy of authority, on the other."[46] This noble and legally authorized shah represented the absolute power of the land, and he sat at the apex of the pyramid of power, whose base was the common people.[47] The middle layers of power in this pyramid experienced some change, but the position of the shah, praised as the shadow of God and invested with divine authority, remained consistent during this long period.

An examination of Shah Abbās I's development of Isfahan shows that his design reflected these Safavid doctrines of kingship. From one side, the city's primary axis, the Khiyābān-i Chahārbāgh, constituted the main urban connection between the medieval city and the new Safavid districts, forming a symbolic connection between past and present, while on the other side it gave order to the new neighborhoods and communities the shah desired to build. Two vast royal gardens also sat at either end of this axis, symbolically manifesting the shah's absolute power and authority. The large royal garden of 'Abbāsābād (or

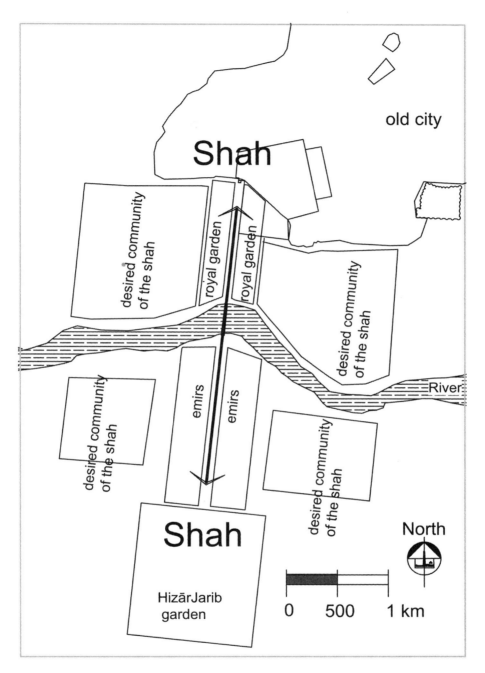

old city

Shah

desired community of the shah

royal garden

royal garden

desired community of the shah

River

desired community of the shah

emirs

emirs

desired community of the shah

Shah

HizārJarib garden

North

0 500 1 km

Figure 4.09. Diagram of arrangement of layers of society and desired community of the shah on both sides of the Khiyābān-i Chahārbāgh. Map by Seyed Mohammad Ali Emrani.

HizārJarib) lay at the southern end, while the garden of Dawlatkhānah-yi Naqsh-i Jahān, which housed the main palace complex of the shah and his administration, sat at the northern tip of the khiyābān. The khiyābān joined the old city to the new via Shah Abbās I's great public open space, the Maydān-i Naqsh-i Jahān, with its surrounding bazaars, mosques, and other urban areas. The dawlatkhānah's position, therefore, located the shah's physical seat of power between the two most important public open spaces of his new city, the maydān and the khiyābān.

The significance of the dawlatkhānah was marked most prominently by the 'Imārat-i Jahān Namā. Designed as a monumental pavilion, it was the representative entrance of the dawlatkhānah at the beginning of the Khiyābān-i Chahārbāgh. On the maydān side stood the Imarat-i 'AliQapu, a magnificent gateway with a vast tālār offering a view of the public square. On either side of the Khiyābān-i Chahārbāgh, in the southern, court members, ministers, and governors created their own gardens. The boundaries of these gardens, which Kaempfer incorporates into his drawings along with their names, remained until the nineteenth century, when Colonel Chirikov and his team surveyed the plan of Isfahan in 1851.[48] Several gardens Shah Abbās I created for different functions and occasional public use also stood along the northern end of the khiyābān. Located beyond the gardens of the court elite on either side of the axis were properties ordered according to the social status and class of their owners, including separate or adjoining quarters. 'Abbāsabad, New Julfa and Gabrābād had their own centers.

The layout of urban open spaces found a new importance and function in the hands of the shah's designers as an inseparable part of the city's royal architecture. The landscape design of the khiyābān, with its symmetrical rows of trees and well-designed gateways, water canals, and basins, created for the shah a unique royal view, which all surviving foreign accounts have praised.[49] The symbolic conformation of the gardens, gateway buildings, and landscape monuments on both sides of this urban axis of authority to the shah's vision of social order and kingly power demonstrates the absolute authority of the ruler over his people and his rivals. Moreover, the layout of the khiyābān, together with the variety of urban quarters arrayed around it, both projected on a city scale and made manifest the shah's vision for an ordered society and the successful integration of his desired communities (figure 4.09).

The shah utilized the two main open public spaces of the city, the khiyābān and the maydān, as places for the performance of kingship. There, he sought to convey political legitimacy, displaying his might and splendor to ambassadors, foreign travelers, and his subjects.[50] In this interpretation, the divine authority of the shah, as the shadow of God on earth, provided for his people a "paradise on

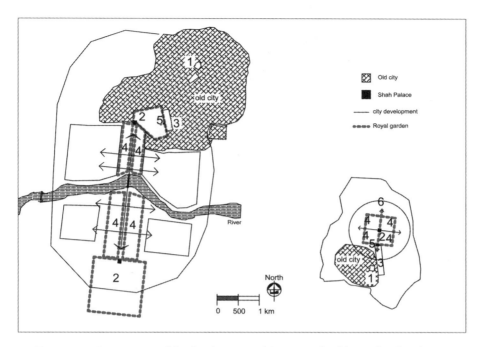

Figure 4.10. Comparison of the development of Qazvin and Isfahan related to the shift in military and administrative powers and policies on religious and ethnic minorities. Left: Isfahan of Shah Abbās I's development. Right: Qazvin of Shah Tahmasp I. (1) Jameʿ Mosque in the old city; (2) main royal palace; (3) main maydān; (4) gardens of emirs and courtiers; (5) main royal gate (Ali Qāpu). Map by Seyed Mohammad Ali Emrani.

earth" as a reward for their belief in his divinity. From this perspective, one might also understand the public use of the royal garden as a symbol of the shah's generosity and a demonstration of his ability to create an earthly paradise.

Considering the capital cities of Persia from the late medieval to the Safavid era, we can see a change in the location and function of the royal gardens within the urban vicinity. For instance, Isfahan of the Seljuk (1040–1194), Samarqand of the Timurid (1370–1506), and even Tabriz of Aq Qoyunlu (1396–1508) had many royal gardens in their suburbs without any relation to the urban fabric. In Isfahan of the Safavid era, the royal gardens were woven into the urban fabric at the outset, and they served as political and theatrical devices for the shahs.[51] Having been integrated into the capital city's urban architectural structure and opened for public use, many gardens served new functions in the city's social and political life, something both European travelers and Safavid chroniclers describe.[52]

The evolution of royal gardens from their isolated suburban function to gardens integrated into the city's fabric occurred during the Timurid and Safavid

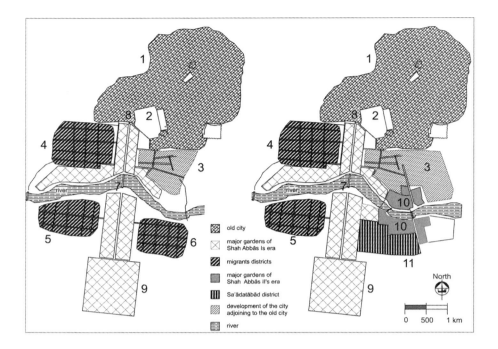

Figure 4.11. Shah Abbās I's policies regarding religious minorities and ethnic groups were reflected in his city plan. Left: Shah Abbās I's era. Right: Shah Abbas II's era. (1) Old city; (2) Dawlatkhānah-yi Naqsh-i Jahān; (3) development of the city adjoining the old city; (4) 'Abbāsābād district; (5) New Julfa; (6) Gabrābād; (7) Allāhverdikhān Bridge; (8) Jahān Namā; (9) 'Abbāsābād royal garden; (10) royal gardens of Shah Abbas II; (11) Sa'ādatābād district. Map by Seyed Mohammad Ali Emrani.

eras. Samarqand and Herat served as early examples, as they had numerous gardens in their suburbs. Several of those early gardens also functioned as main royal residences, yet they were built as isolated complexes outside the city walls.[53] Ruy González de Clavijo, the Spanish ambassador who arrived in Samarqand in 1404 and visited many of these gardens, describes them in telling us about the ceremonies of Timur and his court. He writes, "A traveler who approaches the city sees only a great mountainous height of trees and the houses embowered among them remain invisible."[54] Samarqand had a suburban network of gardens, mostly on its eastern and northern sides, as seen in Donald Wilber's plan.[55] Herat of this era had a similar plan and many suburban gardens, as Babur (1483–1531), a descendant of Timur and the founder of the Mughal Empire in India, reports.[56] The plan of Herat that Allen and Gaube published in 1988 shows that many of Herat's gardens lay in the northern and northeastern outskirts of the city.[57] In the time of Shah Abbās I, the city of Herat had a quadripartite divi-

sion within its walls but lacked any significant public gardens. Shah Abbās I lived there before coming to power, so its layout may have played a role in his master plan for Isfahan.[58] Tabriz of the Aq Qoyunlu dynasty (r. 1453–78) also had a garden-palace complex set on its outskirts.

Shah Tahmasp I (1524–76) transferred the Safavid capital city from Tabriz to Qazvin in 1555–56, and under his rule the city inherited many characteristics from the royal complex in Tabriz (figure 4.10). Qāzi Ahmad Qummi, Shah Tahmasp I's historian, reports that the royal palaces and gardens, the khiyābāns, and the dawlatkhānah buildings were completed in 1558.[59] A new urban district was created adjoining the medieval city, with a vast maydān surrounded by a royal gateway, a bazaar, caravanseries, and other urban spaces. In the royal garden of Sa'ādatābād, which stood at the middle of this development, the centrally located main palace of the shah was surrounded by gardens and palaces that were arranged around it in a rectangular design. The overall design of the complex was structured around two main khiyābāns. Shah Abbās I's development of Isfahan benefited from the Qazvin's model but was also innovative in several important ways. The design of Shah Abbās I's Isfahan reflected the sociopolitical changes of the time, for instance, the shah's military and administrative reforms and policy on religious and ethnic minorities.[60] Shah Tahmasp I's Qazvin was developed around a central arrangement of the royal district, with the shah's garden and pavilion at its center. In Isfahan, however, the core of the metropolis was shaped by its central axis and reflected the new policy and structure of power.

Mainly for reasons of military and economic advantage, Shah Abbās I's migration policy underlined tolerance for various ethnic and religious minorities, especially Christians and Zoroastrians.[61] His city plan also reflected this policy. The shah's respect for these communities as well as his aim to profit from their abilities led him to position them near the royal gardens, linked to the Khiyābān-i Chahārbāgh, but far enough from the old city to avoid potential conflicts with the native people or negative sentiments within existing neighborhoods. In other words, the gardens acted as a filter or green belt between these quarters. The change of this policy in the reign of the next Safavid shahs influenced the rearrangement of the new districts on the south side of the river. The Zoroastrians were forced to leave their quarter, Gabrābād, and go outside the city (figure 4.11).[62] The area was replaced by a new royal garden and the palaces of Sa'ādatābād and its adjoining neighborhood, which was completed under Shah Abbās II. The urban development of Shah Abbās II and the subsequent Safavid shah still require scholarly attention.

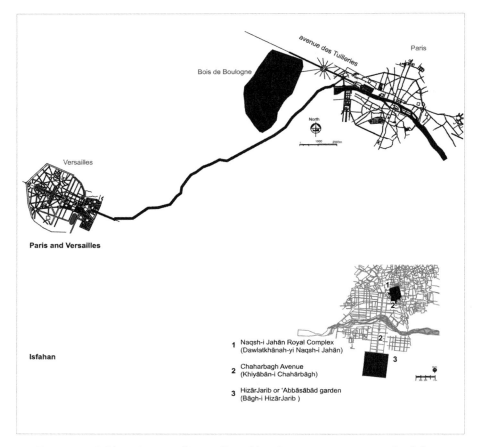

Figure 4.12. Isfahan, Paris, and Versailles: a khiyābān, or avenue, was a splendid link between the royal complex in the city and the royal garden in the suburbs. Map by Seyed Mohammad Ali Emrani.

Epilogue

An examination of the development of Isfahan by Shah Abbās I, the most authoritative emperor of the Safavid, reveals how he employed landscape architecture and urban-design ideas to strengthen his base of power and articulate his imperium. He used many natural and human-made landscape architectural elements and garden-design ideas to create his perfect capital city and represent his vision of the shah as the shadow of God on earth. Magnificent public open spaces articulated a capital city without any walls or fortifications, a pioneering and noble idea to represent the supremacy of the imperium and one that defined a new concept for the artistic and architectural epoch that followed in many other cosmopolitan cities of the early modern world.

With increasing contact between cultures, objects and ideas traveled easily across the early modern world via craftsmen and artists, diplomatic envoys and merchants, and large trade companies. Each played a major role in shaping intercultural exchanges that influenced urban design and imperial landscape related to court authority. The descriptions and writings of travelers in the early modern era represent various moments of exchange, including the sources of inspiration that would become common ideas and concepts in landscape design and the development of cities near and far.

Great royal gardens were created in relation to major cities later in this period. For example, Agra and Shahjahānābād (old Delhi) of Mughal India were shaped by major imperial gardens. Far from Isfahan, in Europe, similar practices transformed medieval cities in comparable ways in the late seventeenth century. Tree-lined imperial avenues with an axial design appeared around several European cities outside city walls and fortifications. A map of Berlin in 1648 shows such an avenue, Unter den Linden, which is comparable in relative design to the Khiyābān-i Chahārbāgh.[63] On the west side of the medieval city of Berlin, the avenue lay outside the city walls, extending toward a suburban royal garden. It was later developed as an integrated tree-lined boulevard in a newly developed district of Dorotheenstadt, as a map of the city from 1688 shows.[64]

The well-known avenue of the Tuileries in Paris (which would become the avenue des Champs-Élysées) was created a decade later using a similar design. Christian Schneider declares the Khiyābān-i Chahārbāgh of Isfahan to be the direct model for the Champs-Élysées in Paris and either the direct or indirect models of the axial designs (*Achsenplanungen*) in Germany during the Third Reich (1933–45).[65]

A comparison of the city development of Louis XIV's Paris and Versailles with Shah Abbās I's Isfahan reveals many common features.[66] One could view this as the result of intercultural contacts and increasing mobility across the early modern world, of which diplomatic delegations should also be considered an influential part. Kurt Würfel in his book on Isfahan writes: "The Chahārbāgh Avenue was in its time so unique, that it induced the French minister de Troy, who was accustomed to living in luxury and temporarily staying at the court of the shah in Isfahan, to give an exact description to the architect André Le Nôtre with the advice to use his description as stimulation for planning a boulevard between the Tuileries and the Bois."[67] A morphological analysis of the form, design, and layout of this boulevard and the Khiyābān-i Chahārbāgh of Isfahan reveals major resemblances. The medieval city of Paris was, like many other European medieval cities of this era, formed around a central core, with organic growth and narrow and irregular streets and paths. The city had many farms and orchards inside its walls but lacked any gardens or allées with architectural

or urban significance. In the 1560s, the first substantial gardens were created beyond the city walls; after the extension of the walls in the time of Louis XIII (1600–1643) around 1635, however, several of these gardens came to lie inside the walls, although still without any architectural connection to the spatial structure of the city. A major transformation occurred when Louis XIV began to govern France, following the death of his chief minister Cardinal Mazarin in 1661. Like Isfahan of Shah Abbās I, Paris became a metropolis without walls or fortifications, with many tree-lined allées in its peripheries. The reconstruction of the Tuileries garden by Le Nôtre (1613–1700), who also extended the avenue's spatial axis beyond the garden, was a significant milestone in the city's history. An analysis of the modification of the Tuileries garden revealed the way in which this garden changed from being a classic isolated Renaissance garden to a French baroque garden with architectural links to the palace and its surrounding environment. The shape of the garden changed to a complete rectangle with a rigid symmetry, and water basins were installed along the central axis. Beyond the basins, the axis continued into the countryside to form the avenue of the Tuileries. This visual axis was an important and splendorous avenue by which the king could approach the Tuileries or visit the suburban royal gardens (figure 4.12).

In Versailles, as in Isfahan, the concept of a garden inspired the ruler's creation of a new imperial city. Le Nôtre integrated the tree-lined streets of Versailles into the fabric of the city, modifying and enlarging the small garden of Louis XIII to create an enormous royal garden-city for Louis XIV and a *patte d'oie* layout of tree-lined axes on both sides of the old chateau as the main spatial structure for the new development.[68] The new city was ordered by an extension of the garden scheme out of its gate much like the Safavid development of Isfahan in the time of Shah Abbās I. In Versailles, the concept of garden and city were interwoven, and one could not understand the city without the garden. These two vast imperial garden designs rendered on the scale of cities demonstrate the splendor and power of their monarchs as they used landscape to strengthen their political legitimacy and articulate their imperia in the early modern period.

Notes

I would like to express my appreciation to Sussan Babaie, for reading an early draft of this text and for her helpful comments and editorial guidance.
1. See for example: Sussan Babaie, *Isfahan and Its Palaces, Statecraft, Shi'ism and the Architecture of Conviviality in Early Modern Iran* (Edinburgh: Edinburgh University Press, 2008); Robert D. McChesney, "Four Sources of Shah Abbās's Building of Isfahan," *Muqarnas*

5 (1988): 103–34; Mahvash Alemi, "Princely Safavid Gardens: The Stage for Rituals of Imperial Display and Political Legitimacy," in Michel Conan, ed., *Middle East Garden Traditions: Unity and Diversity: Questions, Methods and Resources in a Multicultural Perspective* (Washington, DC: Dumbarton Oaks Research Library and Collection, 2007), 113–37. Also see Lutfallah Hunarfar, *Ganjineh-yi Āsār-i Tarikhi-yi Isfahān* (Isfahan: Ketāb forushi-yi Saqafi, 1965/1344).

2. Because of the key role of this term in this work and the lack of an exact synonym in English, I use the Persian terms *khiyābān* for the singular and *khiyābāns* for the plural of this urban space to distinguish it from similar forms, as I did in my doctoral dissertation. *Khiyābān* in the Safavid era referred to a straight pathway in a garden or a city similar to an alley or avenue, flanked with rows of trees and water canals. Sometimes along the middle of the pathway it had a waterfall and basins.

3. Turkmen tribal groups known as the Qezelbāsh.

4. The main part of this reform was the creating of a third force, the *gholams*, with the aim of increasing the shah's opportunity to maneuver between the rival Qezelbāsh and Tājik (Persian) elements in the state, leading to a considerable reorganization of the Safavid administrative system. R. M. Savory, "'Abbās (I)," *Encyclopædia Iranica* 1, no. 3: 71–75; http://www.iranicaonline.org/articles/Abbās-i, accessed 8 August 2021.

5. Masashi Haneda and Rudi Matthee, "Isfahan vii. Safavid Period," *Encyclopædia Iranica*, 13, Fasc. 6: 650–657; http://www.iranicaonline.org/articles/isfahan-vii-safavid-period, accessed August 8, 2021.

6. Savory, "'Abbās (I)."

7. For medieval Isfahan, see Mafarrukhi al-Mufaddal ibn Sa'd, *Tarjumah-yi mahāsin-i Isfahān: az Arabi bi-Fārsi. Biqalam Husain ibn Muhammad ibn Abi al-Ridāāvi, dar sāl-i 729 Hijri. Bi-ehtimām 'Abbās Iqbāl* (Tehran: Shirkat-i Sahāmi-yi Chāp, 1949/1328); and Abū-Nu'aim al-Isfahāni and Ahmad Ibn-i 'Abdallāh, *Zekr-i akhbār-i Isfahān*, trans. Norollah Kassa'i (Tehran: Sorush, 1998/1377). For a local historiography of Isfahan before the twentieth century, see Jürgen Paul, "Isfahan v. Local Historiography," *Encyclopædia Iranica*, 13, Fasc. 6: 638–641, https://iranicaonline.org/articles/isfahan-v-local-historiography, accessed 8 August 2021. See also Lutfallah Hunarfar, *Isfahan* (Tehran: Shirkati Enteshārat-i Elmi va Farhangi, 2007/1386); Heinz Gaube, *Iranian Cities* (New York: New York University Press, 1979); and Lisa Golombek, "Urban Patterns in Pre-Safavid Isfahan," *Iranian Studies* 7 (1974): 18–44.

8. For architectural projects of the Shah Abbās I era, see Hunarfar, *Ganjineh-yi Āsār-i Tārikhi-yi Isfahān*, and McChesney, "Four Sources."

9. For the Safavid chronicles on in the time of Shah Abbās, see McChesney, "Four Sources." His work is a textual analysis of the four Safavid chronicles, namely, *Nuqāwat al-āthār fī Dhikr al-Akhyār*, by Afushtah-i Natanzi, *Tārikh-i 'Abbāsi yā Ruznāmeh-yi Molāa Jalāl*, by Munajjim, *Tārikh-i 'Ālamārā-yi 'Abbāsi*, by Iskandar Beg Munshi, and *Rauzat al-safawiyeh*, by Junābadi, and aims to determine the sequence of Shah Abbās I's projects in Isfahan. See also Mulla Muhammad Jala al-Din Yazdi Munajjim, *Tārikh-i 'Abbāsi yā Ruznāmeh-yi Molāa Jalāl*, ed. Seyfollah Vahidnia (Tehran: Enteshārat-e Vahid, 1987/1366), and Iskandar Beg Munshi, *Tārikh-i 'Ālamārā-yi 'Abbāsi* (Tehran: Kārkhān-yi salālat al-sādāt, 1896/1314).

10. Munajjim, *Tārikh-i 'Abbāsi.*

11. He reports that the design of Khiyābān-i Chahārbāgh took place in the same year that the capital was moved from Qazvin to Isfahan in 1597–8 (Munshi, *Tārkh-i 'Ālamārā-yi 'Abbāsi*, 372–73). For a diagram of Khiyābān-i Chahārbāgh and its gardens based on Iskandar Beg Munshi's description, see Seyed Mohammad Ali Emrani, *The Role of Gardens and Tree-Lined Streets in the Urban Development of Safavid Isfahan (1590–1722): A Comparative Approach (Paris and Versailles in the 17th Century)* (Munich: Dr. Hut, 2013).

12. In this era, *chahārbāgh* was a common term and was sometimes used as a synonym for the Persian style of garden or for large gardens. Therefore, the phrase "chahārbāgh-i dar har du taraf-i Khiyābān" in the original Persian text means "a chahārbāgh on each side of the avenue."

13. The traces of such basins were still visible in the nineteenth century when Pascal Coste visited Isfahan and recorded his drawing of the chahārbāgh. Pascal Xavier Coste, *Monuments modernes de la Perse, mesurés, dessinés et décrits par Pascal Coste Publiés par ordre de son excellence le ministre de la maison de l'empereur et des beaux-arts* (Paris: Morel, 1867). See the detailed plan of Khiyābān-i Chahārbāgh by Pascal Coste in 1840: Pascal Coste, "*Voyage en Perse 3ième partie. Ispahan: Plan général de l'avenue Tschar-Bag*," Bibliothéque municipale de Marseilles MS 1132, F 47 b. See also the photos by Ernst Höltzer, *Persienvor 113 Jahren: Text und Bilder (Irān dar yaksad wa sizdahsāl-i pīsh) zusammengestelt und übersetzt von Mohammad Assemi* (Tehran: Publ. d. Kultur u. Kunstministeriums, Zentrumfür d. Pers. Ethnologie, 1975).

14. Munshi, *Tārikh-i ʿĀlamārā-yi ʿAbbāsi*, 372–73.

15. Mirzā Beg b. Hasan Junābadi, *Rauzat al-safawiyeh / be kushesh-i Gholamrez Tabātabāei Majd* (Tehran: Bunyād-i Mauqufāt-i Duktur Mahmud Afshār Yazdi, 1999/1378). For a translation of his text about Shah Abbās I's projects in Isfahan, see McChesney, "Four Sources."

16. Junābadi, *Rauzat al-safawiyeh*, 761–62.

17. Junābadi, *Rauzat al-safawiyeh*, 761–62.

18. Among the European travelers who visited Isfahan of the Shah Abbās I era and published their accounts are the Shirley brothers from England, Henri de Feynes, a French traveler, Don García de Silva Figueroa, the ambassador to Persia of Philip III, king of Spain and Portugal (r. 1598–1621), Pietro della Valle (1586–1652), an Italian traveler, and Thomas Herbert (1606–82), a member of the mission in 1634 of Sir Dodmore Cotton, the English ambassador to Persia of King Charles I. For a list of major European travelers to Persia, including the dates their travels and a short introduction, see Seyed Mohammad Ali Emrani, "The Role of Gardens and Tree-Lined Streets in the Urban Development of Safavid Isfahan (1590–1722): A Comparative Approach (Paris and Versailles in the 17th Century)," Ph.D. diss., Technische Universität München, 2012, appendix 3.

19. Sibylla Schuster-Walser and Olivier H. Bonnerot, for example, listed more than twenty travel reports of the European travelers to the east and Persia who published their texts from 1598 to 1660 (between Shah Abbās I's development of Isfahan and Louis XIV's creation of Versailles); see Olivier H. Bonnerot, *La Perse dans la littérature et la pensée françaises au XVIIIe siècle* (Paris: Champion, 1988), 331–32; and Sibylla Schuster-Walser, *Das safawidische Persien im Spiegel europäischer Reiseberichte (1502–1722)* (Baden-Baden: Grimm, 1970), 110–16. For the European contacts with Persia in the Safavid period see Laurence Lockhart, "European Contacts with Persia, 1350–1736," in Laurence Lockhart and Peter Jackson, eds., *The Cambridge History of Iran, Volume 6: The Timurid and Safavid Periods* (Cambridge: Cambridge University Press 1986), 373–411; also, Willem Floor and Farhad Hakimzadeh, *The Hispano-Portuguese Empire and Its Contacts with Safavid Persia, the Kingdom of Hormuz and Yarubid Oman from 1489 to 1720* (Leuven: Peeters, 2007). For French travelers to Persia, see Anne-Marie Touzard, *France vii: French Travelers in Persia, 1600–1730*, Encyclopaedia Iranica, online edition, https://iranicaonline.org/articles/france-vii-french-travelers-in-persia-1600–1730, originally published December 15, 2000. See also Schuster-Walser, *Das safawidische Persien*.

20. Schipano's travelogue was published in four volumes in 1650, 1658, and 1663 in Rome under the title *Viaggi di Pietro della Valle il pellegrino: Con minuto ragguaglio. Di tutte le cose notabili osseruate in essi* (Rome: Appresso Vitelo Mascardi).

21. Pietro della Valle, *Petri della Valle, Eines vornehmen Römischen Patritii, Reiß-Beschreibung in unter schiedliche Theile der Welt* (Geneva: Widerhold, 1674), 17–19. He writes: "Was nun bei Grösse dieser Stadt, nehmlich allein, was eigentlich Hisphahan [Isfahan] genennet wird, anbelangt, so wird dieselbe eben so groß, oder nicht viel kleiner als Neapolis seyn: es hat aber der könig nicht weit davon noch dery andere neue Plätze umb dieselbe erbauen lassen. Einer ist das neue Tauris [Tabriz-Nu], welche von denen Völckern, die von ihme von Tauris dahin versetzt worden, bewohnet wird; jedoch wird dieselbe anjetzo nicht mehr Tauris, sondren nach seinem Nahmen Abbās-Abad, das ist, die Pflantzstadt Abbās genennet. Der andere ist das neue Ciolfa, worinnen lauter Armenische Christen, welche alle reiche Kauffleuthe sind, wohnen, und gleichfals von Ciolfa dahin versetzt worden seyn . . . der dritte Platz ist der jenige, den bei Gauren, das ist, die Unglaubige, und Abgöttische innen haben; und ist der König, wie aus dem jenigen, so man allbereits, siehet zu schliessen, willens diese drey Plätze mit Hisphahan zu vereinigen, und eine Stadt daraus zu machen; woran dann eyfrig gearbeitet wird, und ist auch schon so weit damit kommen, daß wenig mehr hieran fehlet, weil er einem jeden, was er zu Grund und Boden, wie auch an Geld zum bauen bedarf, reichen lässt: Wenn nun diese Werck wird vollendet werden, so wird sonder Zweiffel Hisphahan in ihrem Umbkreiß grösser als Gonstantinopel und Rom seyn" (17).

22. Della Valle, *Petri della Valle*, 17–18, 22, 41.

23. Garcíade Silva y Figueroa, *L'ambassade de D. Garcias de Silva Figueroa en Perse, cont la politique de ce grand empire, les moeurs du Rey Schach Abbās etc.* (Paris: Du Puis, 1667), 191.

24. Thomas Herbert, *Some Years Travels into Divers Parts of Africa and Asia the Great* (London: J. Best, 1665), 173.

25. Adam Olearius, *The Voyages and Travels of the Ambassadors sent by Frederick Duke of Holstein, to the Great Duke of Muscovy, and the King of Persia* (London: Printed for Thomas Dring and John Starkey, 1662), 301.

26. Jean Chardin, *Voyages de Mr. Le Chevalier Chardin, En Perse, Et Autres Lieux De L'Orient: Contenantune Description particuliere de la Ville d'Ispahan, capitale de Perse* (Amsterdam: De Lorme, 1711), 168–79. A view of Khiyābān-i Chahārbāgh in the seventeenth century is published in his travelogue.

27. "Le Jardin des Vignes and le Jardin des Meuriers." Chardin, *Voyages*, 168–79.

28. "Les Jardins qui sont vis-à-vis sont nommez l'Hotellerie des Derviches de Heider, & L'Hotellerie des Derviches des Neametolah."

29. Chardin, *Voyages*, 168–79.

30. See Robert Batchelor's essay in this volume (chapter 2) for further discussion of Kaempfer's travels to Isfahan.

31. Engelbert Kaempfer, *Am Hofe des persischen Großkoenigs (1684–85): Das 1. Buchdt. Amoenitates exoticae. Eingel. u. in dt. Bearbeitghrsg. v. Walther Hinz* (Leipzig: K. F. Koehler Verlag, 1940), 154. Most of his drawings of Isfahan gardens were studied and published by Mahvash Alemi, "The Royal Gardens of the Safavid Period: Types and Models," in Attilio Petruccioli, ed., *Gardens in the Time of the Great Muslim Empires: Theory and Design* (Leiden: Brill, 1997), 72–96. See also Alemi, "Princely Safavid Gardens," and Emrani, *The Role of Gardens.*

32. These two plans (my figures 4.05 and 4.06 [plates 9 and 10]) show us the two important periods of city development in the Shah Abbās I and Shah Abbās II eras. A third plan shows the city at the end of the Safavid period. See Emrani, *The Role of Gardens.* There are several other restored plans of Safavid Isfahan. Most of them are either just plans of a few main urban streets without the surrounding fabric of the city or plans for Safavid monuments and gardens on a twentieth-century background plan, without any information regarding most of the destroyed quarters. For this reason, I restored three plans for the

significant period of Safavid development based on Safavid and later documents and evidence.

33. He describes these quarters with wide and straight streets in 1619: "Solchem nach begab ich mich, wie gedacht, Tebriz-abad zu besehen, und befande, daß es eine zimblich schöne, und grosse Stadt, und grösser als Ciolfa [Julfa] war, und in ihrem Umbkreiß ein Meil begriffe, wie auch viel volckreichere, und schönere, geradere und längerer Gassen, als Ciolfa, im übrigen aber nichts Anmerckens würdiges, und nur nidrige, eines Stockwercks hoch von der Erden gebauete Häuser, gleich wie anderswo, oder gar wenig Stiegen und Aufgänge, und einen Garten in der mitten hatten"; della Valle, *Petri della Valle*, 17. He reports that the streets of Gabrābād were straighter and wider—even better than Julfa's: "Diese Wohnung der Gauren hat, so viel mir bewust ist, keinen andern Nahmen, als Gauristan [Gabrābād]. . . . Es ist, dieselbe sehr schön gebaut, und hat breite und gerade Gassen, viel schöner als die zu Ciolfa seyn" (41).

34. For recognition of the major gardens of Isfahan in the Safavid period, see Emrani, *The Role of Gardens*, chap. 3.

35. Kaempfer, *Am Hofe*, 159.

36. Herbert, *Some Years Travels*, 173.

37. Munshi, *Tārkh-i 'Ālamārā-yi 'Abbāsi*, 372, 578. For Isfahan and the idea of paradise in the Safavid period, see Heidi A. Walcher, "Between Paradise and Political Capital: The Semiotics of Safavid Isfahan," *Middle Eastern Natural Environments* 103 (1998): 330–48. The comparison of Isfahan to "paradise" was seen in poems even before the Safavid era. For instance, Jamal al-Din Isfahani (d. 1192/588), a poet from Isfahan, writes: "Didi tu Isfahan ra an shahr-i khold-i Paikar"—"Have you seen Isfahan, that city like Paradise?" (translation in Walcher, "Between Paradise and Political Capital," 330). See Vahid Dastgirdi, ed., *Divan-i Kamil* (Tehran: Enteshārat-i Vahid, 1941/1320), 410.

38. "Of Iram, known for their lofty columns, the like of whom no nation was ever created in the lands of the world?" (Qur'an, 89:7 and 8). Translation by Abul A'la Maududi, https://tanzil.net/#trans/en.maududi/89:7, https://tanzil.net/#trans/en.maududi/89:8, accessed 8 August 2021. *Iram* (or *eram*) refers to a garden that was created as an earthly paradise by Shaddad ibn-i Ad. See Persian dictionary of Aliakbar Dekhoda, https://dehkhoda.ut.ac.ir/fa/dictionary?DictionarySearch%5Bword%5D=%D8%A7%D8%B1%D9%85+&DictionarySearch%5Bdefinition%5D=, accessed 8 August 2021.

39. For Kaempfer's drawings of Khiyābān-i Chahārbāgh, see Engelbert Kaempfer, *Drawings and Plans of Engelbert Kaempfer, Unpublished Manuscripts*, 1684–86, British Library, Sloane 5232.

40. A medieval Persian agricultural manual at the early Safavid period in 1515. This treatise by Qasim ibn Yusuf Abu Nasr Haravi focuses on vegetation and agricultural issues, but in its last chapter deals with the layout and planning of a chahārbāgh. Haravi explains the theoretical model of a typical garden without any drawings. See Qasim ibn Yusuf Abu Nasr Haravi, *Irshād al-Zirā'a: Be ehtemām-i Muhammad Mushiri* (Tehran: Tehran University Press, 1967/1346); and Maria Eva Subtelny, "Agriculture and the Timerud Chahargagh: The Evidence from a Medieval Persian Agricultural Manual," in Attilio Petruccioli, ed., *Gardens in the Time of the Great Muslim Empires: Theory and Design* (Leiden: Brill, 1997), 116. Some also suggested a reconstruction after him; see Ralph Pinder Wilson, "The Persian Garden: Bagh and ChaharBāgh," in Richard Ettinghausen and Elisabeth B. Macdougall, eds., *The Islamic Garden: Papers Presented to the Fourth Dumbarton Oaks Colloquium on the History of Landscape Architecture* (Washington, DC: Dumbarton Oaks, 1976), 69–85; Mahvash Alemi, "Chahar-Bagh," *Environmental Design: Journal of the Islamic Environmental Design Research Centre* 1 (1986): 38–45; and Maria Eva Subtelny, "Mīrak-i Sayyid Ghiyās and the Timurid Tradition of Landscape Architecture," *Studia Iranica* (1995): 19–60.

41. A *tālār* is a semi-open pillared hall or roofed porch on columns. In Safavid architecture it was usually a wooden pillared hall.

42. Mohammad Tahir Vahid Qazvini, *Abbāsnāmah yā Sharh-i zindagāni-yi 22 sāli-yi Shāh 'Abbās Sāni* (Arak: Ketābforushi Dāvudi, 1950/1329), 233–34.

43. These bridges were the place of several ambassadorial receptions and ceremonies. Feasts and ceremonies like *Abpashān* took place here as well. See, for instance, Garcia de Silva y Figueroa, *Safārnāmah-i Dun Garsiya de Silva Figueroa* (Tehran: Nashr-i No, 1984/1363). Pietro della Valle also describes such feasts and ceremonies and the reception of ambassadors by Shah Abbās I in the pavilion under the Allāhverdikhān Bridge; Pietro della Valle, *Safarnāmah Pietro della Valle (Cose e parole neiviaggi di pitro della valle)*, Persian translation by Shujaedin Shafa, 4th ed. (Tehran: Shirkat-i Intishārāt-i Elmi va Farhangi, 2005/1384).

44. See Hamidreza Jayhani and Seyed Mohammad Ali Emrani, *Bagh-i Fin* (Tehran: Research Center of Iranian Cultural Heritage, Handicrafts and Turism Organization, 2007/1386).

45. Later, in the Shah Sultan Hussein era (1694–1722), a large royal garden and the adjoining suburban city of Farahābād were created, which shifted the city's development toward the southwest (see fig. 4.02, numbers 25 and 28).

46. Babaie, *Isfahan and Its Palaces*, 258.

47. Roger Savory, "Notes on the Safavid State," *Iranian Studies* 1 (1968): 96–103.

48. See the 1851 plan by Capitan Proskuryakov and ensign Ogranovich under the guidance of the Colonel Chirikov, reproduced in Mohammad Mihryar et al., *Asnād-e Tasviri-e Shahrhā-ye Irani doreye Qajar* (Tehran: Shahid Beheshti University and Iranian Cultural Heritage Organization, 1378/2000), 169–84; see also Kaempfer's drawings, British Library, Sloane 2910 and 5232. See also Mahvash Alemi, "Safavid Royal Gardens and Their Urban Relationships," in Abbās Daneshvari, ed., *A Survey of Persian Art* (Costa Mesa, CA: Mazda, 2005), 18:1–24.

49. After the Safavid era, the ruins of this khiyābān were surveyed and studied by many scholars. Among them, Pascal Coste surveyed a detailed plan of Khiyābān-i Chahārbāgh in 1940; see Coste, "Voyage en Perse 3ième partie. Ispahan: Plan général de l'avenue Tschar-Bag," Bibliothéque municipale de Marseilles MS 1132, f. 47b.

50. Alemi, "Princely Safavid Gardens."

51. Alemi, "Princely Safavid Gardens."

52. Della Valle reports that the people had free access to most of the royal gardens flanking the Khiyābān-i Chahārbāgh. He tells us that people could use the entrance buildings and were even permitted to eat the gardens' fruits. Della Valle, *Petri della Valle*, 18. Junābadi, the Safavid chronicler, writes that even the poor and the dervishes had places set aside for them in some of these gardens. Junābadi, Rauzat al-safawiyeh, 761–62.

53. Babaie, *Isfahan and Its Palaces*, 41–42.

54. González de Clavijo, *Embassy to Tamerlane: 1403–1406*. Translated from the Spanish by Guy Le Strange with an Introduction (New York: Harper, 1928), 286.

55. Donald N. Wilber, *Persian Gardens and Garden Pavilions*, 2nd ed. (Washington, DC: Dumbarton Oaks, 1979).

56. Wilber, *Persian Gardens and Garden Pavilions*, 32–37.

57. Terry Allen and Heinz Gaube, *Das Timuridische Herat: Erhaltene oder hinreichend sicher lokalisierbare Orte, Lagen und Gebäude* (Wiesbaden: Dr. Ludwig Reichert, 1988).

58. The old city of Herat has had, from at least the tenth century, a quadripartite division, which is still visible today. Maria Szuppe, "Herat iv. Topography and Urbanism," *Encyclopedia Iranica*, 12, Fasc. 211–217; originally published 15 December 2003, https://iranicaonline.org/articles/herat-iv.

59. Qāzi Ahmad Qummi, *Khulāsat at-tawārikh* (Tehran: Intishārāt-i Dānishgāh-i Teh-ran, 2004/1383), 399–400. Qummi reports that the shah ordered engineers and architects to design and build a square garden with palaces, tālārs, pavilions, and basins (*'emārāt-i 'Āli, tālār-hā-ye mot'āli va ayvān-hā va hoz-hā*), as well as a lofty gateway (*Darvāzeh-yi be ghāyat mortafa' va 'Āli*) and a pigeon tower at the end of the garden. They divided the area of the garden geometrically into square plots (*Gozar-hāyi moraba'*) and triangular and hexagonal compartments or lawns (*chaman*) and created a big water canal (*nahri 'azim*) running down the middle of its khiyābān. They planted white poplar and plane trees along its borders and various flowers and trees on its plots. Qummi, *Khulāsat at-tawārikh*, 312–13.

60. See Rudi Matthee, "Safavid Dynasty," *Encyclopædia Iranica*, online edition http://www.iranica.com/articles/safavids, accessed 8 August 2021.

61. Matthee, "Safavid Dynasty."

62. See Mary Boyce, *Zoroastrians: Their Religious Beliefs and Practices* (London: Routledge and Kegan Paul, 1979), 182.

63. Johann Marius Friedrich Schmidt, *Historischer Atlas von Berlin* (Berlin: Simon Schropp und Kamp, 1853).

64. Schmidt, *Historischer Atlas von Berlin.*

65. Christian Schneider, *Stadtgrundung im Dritten Reich* (Munich: Moos, 1978).

66. See Emrani, *The Role of Gardens*, chap. 7.

67. Kurt Würfel, *Isfahan, nisf-i dschahan: Das ist die Hälfte der Welt* (Küsnacht-Zürich: Raggi: 1974); also Emrani, *The Role of Gardens*, chap. 7.

68. Emrani, *The Role of Gardens*, chaps. 6 and 7.

Bridges into Metaphorical Space

Hideyoshi's Imperial Landscapes at Osaka

Anton Schweizer

The long sixteenth century in Japan was dominated by bloody wars waged among provincial warlords for wealth and supremacy.[1] The imperial court in Kyoto, the highest ceremonial seat in the country, was powerless and destitute. Control had also slipped away from the shogunate, the samurai government that had held de facto rule since the late twelfth century, causing the country to fragment into dozens of largely independent domains. A resolution to the chronic turmoil came only toward the end of the century during a period that is commonly called Momoyama (1568–1615). During this short half century, three successive hegemons, Oda Nobunaga 織田信長 (1534–82), Toyotomi Hideyoshi 豊臣秀吉 (1536/37?–98), and Tokugawa Ieyasu 徳川家康 (1543–1616), forced their peers, one by one, into submission. These three "unifiers," however, all faced a similar problem: the urgent need to manifest their still contested authority and legitimize their more or less questionable claims to rule. At the heart of their responses to this need were vast architectural and urbanistic projects. This essay investigates one case in point, Toyotomi Hideyoshi's formation of Osaka on the Kansai Plain in the 1580s and 1590s, and argues that the city and its landmarks should not be reviewed in isolation but rather be understood as pivotal constituents of a symbolic landscape. Hideyoshi's project responded to Kyoto, an ancient city located on the same plain (figure 5.01). Kyoto, the seat of the imperial institution, had been Japan's principal ceremonial and cultural center for almost eight centuries. Soon after his ascension to military power in 1583, Hideyoshi began restoring and largely remodeling war-torn Kyoto in an effort to present himself as a loyal servant to the court. He complemented the restoration of Kyoto with a concurrent transformation of the sur-

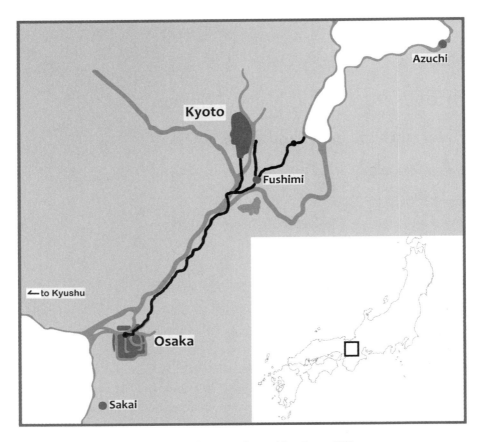

Figure 5.01. Map of the Kansai Plain. Map by Lachlan James Hill.

rounding region, founding new castle towns at Osaka (1583) and Fushimi (1592).[2]

This essay chiefly addresses works of architecture in Osaka, first and fore-most the city's enormous castle. The main focus is not, however, on the build-ings per se but rather on the question of how the castle and its surrounding city were designed to an overall brief of creating, revealing, and performing a greater symbolic landscape. I use the term "landscape" here in a very broad sense that comprises the physical as well as the conceptual. This allows for a variety of con-stituents and media to be addressed, be they natural (topography) or human-made (site planning, architecture, and landscaping), real (a physical place) or virtual (a painterly or literary representation of the place), present (an existing place) or historical (memories of places past).[3] The term "landscape" is also de-fined by two further and essential characteristics: it denotes a vista that can be regarded as a whole from a distance and a spatial matrix that can be entered and transited, experienced from within. Hideyoshi's symbolic landscape encom-

passed all aspects of this broad notion as it engaged in dialogues with places real and imagined, ancient and contemporary, domestic and foreign, thus creating a multilayered system of spatiotemporal references.

The essay begins with a brief description of Osaka Castle at the time of its founding and, in particular, a crucial reorientation of its landscape in the early 1590s. The subsequent section discusses a number of spectacular "landmark buildings" that embodied in their architectural style and material substance a pervasive notion of fantastic novelty and splendor. A third section identifies compelling referents for these structures in the textual and visual cultures of dynastic China and Buddhism. The concluding section applies the gathered findings to the concept of an imperial landscape, including a discussion of the monumental visual axes that anchored the castle within the city and the wider context of the Kansai Plain. The resulting portrait of Osaka's landscape reveals a unique matrix and new political context in which urban vistas were mobilized, performed to various audiences, and proliferated through painted representations.

Osaka: Authority Constructed

On 22 September 1615 Ralph Coppendale (?–1617?), a British merchant and captain of the ship *Hozeander*, reached Osaka. Most of the city and its large fortress lay in ruins, since Tokugawa Ieyasu had three months prior wiped out the last supporters of the long-deceased Hideyoshi. Despite the signs of carnage and destruction that surrounded him, Coppendale still managed to be fascinated by "many handsome wooden bridges over the great river towards Miaco [Kyoto], and likewise over smaller streams within the city, all of them richly ornamented with carved work, while the main posts of the railing were mounted with thick copper. In the whole course of my life, I never saw anything equal to the ruins of these bridges, for they had been not all consumed [by fire]."[4] Osaka, located at the estuary of the Yodo River flowing into the Japanese Inland Sea, boasted countless large and small bridges over canals and streams (figure 5.02 [plate 11]). It is therefore difficult to identify the specific bridges Coppendale saw or to describe their appearance beyond his recordings. It is, however, clear that the Englishman was profoundly impressed, despite the fact that what he saw were only scant fragments of the place's former glory. In all likelihood, he was not aware that sculpted decoration on bridges as well as other buildings was at the time a recent and even then still quite uncommon addition to Japanese architecture. Osaka's ornate bridges were, in fact, only one group among many anomalous structures that inscribed the urban landscape with a dense amalgam of associations intended to bolster Hideyoshi's authority.

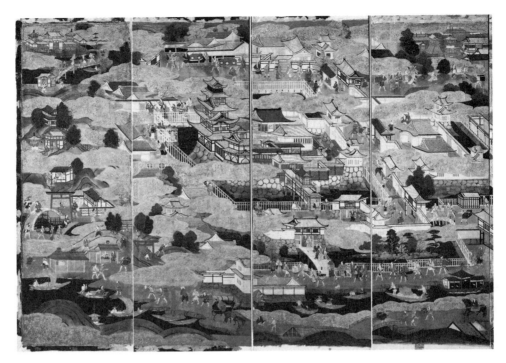

Figure 5.02. Anonymous, *View of Osaka*, second quarter of the seventeenth century. Virtual assembly of individually mounted panels. Eight-panel folding screen, ink,

Hideyoshi began the construction of Osaka in the fall of 1583, little more than a year after the death of his overlord, Oda Nobunaga. Nobunaga had been within reach of becoming the de facto lord of Japan but was assassinated halfway by one of his own commanders.[5] Nobunaga had in many respects set new standards for manifesting power through works of architecture. Rather than basing his court at an existing castle, he erected a new ceremonial, administrative, and military base at the edge of Lake Biwa in Azuchi (see figure 5.01). Despite its exceedingly short existence—completed in 1579 and destroyed in the chaotic weeks after Nobunaga's murder in 1582—Azuchi became instantly famous for its grandeur and innovative architectural design. This novel design consisted, notably, of a fusion of the previously distinct typologies of wartime fortress and peacetime palace. Azuchi Castle was located on a promontory surrounded by the lake and overlooking a commoner town. The slopes of the castle hill were molded into terraced sections that contained the mansions of Nobunaga's leading retainers. These terraces were reinforced by massive ramparts (*ishigaki* 石垣) built from large stones in dry masonry and topped with plastered clay walls. The hill's summit was occupied by Nobunaga's own palatial

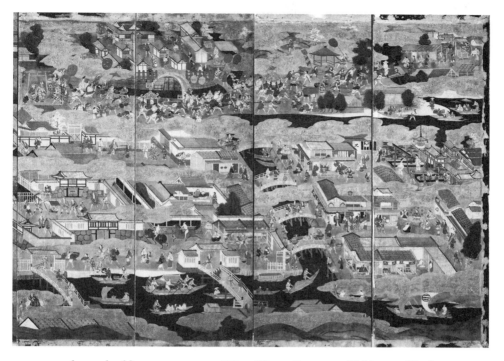

color, and gold on paper, approx. 182 × 480 cm. Courtesy of Schloss and Park Eggenberg/Universalmuseum Joanneum, Graz.

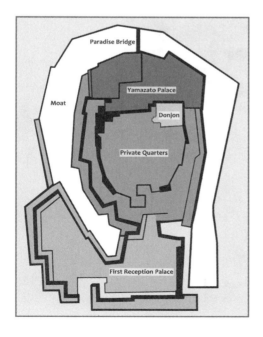

Figure 5.03. Plan of Toyotomi-era Osaka Castle, inner enceinte. Map by Lachlan James Hill, adapted from Miyakami, *Ōsaka-jō*, 17-18, unnumbered fig.

mansion and crowned with the castle's most iconic feature, a five-story donjon, or *tenshu* 天守, of previously unseen height and sophistication.[6]

When Hideyoshi founded Osaka he followed the precedent established by Nobunaga in many key ways. Like Azuchi, Osaka was conceived as a new "capital" and consisted of a commoner settlement that was adjoined and surmounted by a castle. In marked contrast to Azuchi, Osaka was built on flat terrain near the estuary of a river. The position and design of Hideyoshi's castle still echoed its model, however, as an artificial hill structured by terraced enceintes. These enceintes were reinforced with dry-stone ramparts and surrounded by a system of dry and water-filled moats. Strategic points were secured by turrets (*yagura*

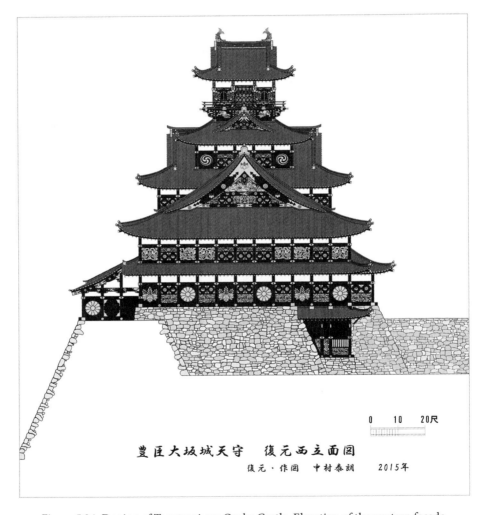

豊臣大坂城天守　復元西立面図
復元・作図　中村泰朗　2015年

0　10　20尺

Figure 5.04. Donjon of Toyotomi-era Osaka Castle. Elevation of the western facade. Reconstruction with hypothetical coloring by Nakamura Yasuo and Miura Masayuki. Courtesy of Miura Masayuki.

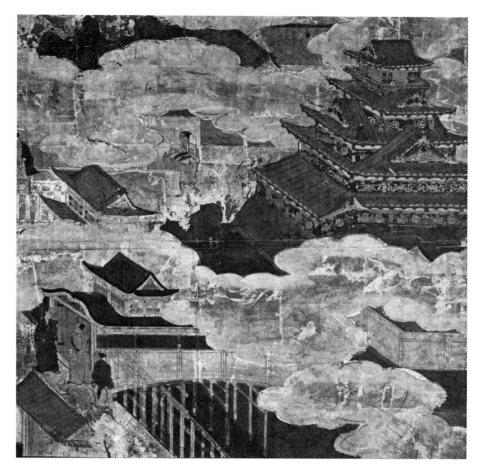

Figure 5.05. Anonymous, *Osaka Castle*, early seventeenth century. Detail of a two-panel folding screen, ink, color, and gold leaf on paper, approx. 130.0 × 53.2 cm. Osaka Castle Museum (formerly Kawakami Collection, Tokyo). Photograph by Anton Schweizer, courtesy of Osaka Castle Museum.

櫓) and heavily fortified gateways. As at Azuchi, Osaka Castle's focal point was a soaring donjon erected on the highest terrace.

Osaka's impressive formation suggests that Hideyoshi's ambition was to surpass the bar set by Nobunaga in every possible respect, but particularly speed of erection, scale, and sumptuousness. The construction proceeded with stunning rapidity. By 1588, just three years after completion of the inner enceinte (*honmaru* 本丸), a second enceinte had been added, followed by a gargantuan outer bulwark (*sōgamae* 総構え) that was finally completed in 1596. The latter enclosed almost the entire commoner city, a vast area of roughly nine square kilometers.[7] The castle's centerpiece, the inner enceinte, measured an enormous five hundred by three hundred meters (figure 5.03). The inner enceinte was further

divided into three major sections. The southern section contained an extensive reception palace (the "First Reception Palace," called *omote goten* 表御殿 in modern writing). Located in the central section were Hideyoshi's private quarters (*oku goten* 奥御殿) and the donjon.[8] The northern section contained storehouses and the "Mountain Village" (Yamazato 山里), a garden with tea huts that was designed to evoke a remote mountain setting.[9]

The donjon was one of the tallest buildings in Japan at the time, soaring approximately forty meters above the floor level of the inner enceinte, which was itself elevated some twenty-five meters above the waterline of the surrounding castle moat.[10] The donjon's appearance is largely undisputed (figures 5.04 and 5.05 [plate 12]). It was erected upon a tall rectangular stone foundation with sloping walls. The stone foundation supported a wooden structure that had the rough shape of a stepped pyramid. Each one of the five exterior tiers of this stepped pyramid was provided with its own roof of ceramic tiles with a bluish glaze.[11] The top tier featured a balcony that wrapped around all four sides and was crowned with a hip-and-gable roof. The ridge of this main roof was furnished with sculptural finials in the form of fish-and-dragon composite creatures (*shachihoko* 鯱 or 鯱鉾).[12]

The original layout of the inner enceinte, with the main entrance in the south and the private section in the north, followed long-standing Japanese convention that had also been observed at Azuchi. Around 1591 or 1592, however, Hideyoshi had significant modifications made to this original layout. These modifications included, most importantly, the erection of a new reception palace in the northern Yamazato enceinte, directly adjacent to the garden with tea buildings. Distinct from the "first" Reception Palace in the southern section, this new compound is commonly called the Yamazato Palace (Yamazato *goten* 山里御殿; see figure 5.03).[13] The Yamazato Palace was provided with its own access over the castle's inner moat (*uchibori* 内堀) in the form of an elaborate structure dubbed the "Paradise Bridge" (*Gokuraku no hashi* 極楽橋) in period sources.[14] The erection of the new reception palace and its bridge entrance had profound effects on the spatial organization of the castle and the greater landscape around it, discussed further in a following section. In short, the Paradise Bridge and the Yamazato Palace shifted the castle's principal facade from south to north.

It is very likely that this dramatic reorientation was meant to open a visual and symbolic dialogue with the imperial capital of Kyoto, with the aim of better manifesting Hideyoshi's role as a loyal protector and minister of the court. The timing of this modification was not, it would appear, random. The year 1592 coincides with the transfer of the title of imperial regent (*kanbaku* 関白) from Hideyoshi to his nephew Hidetsugi 秀次 (1568–95). This ceremonial office, one of the most exalted that existed at court, had been bestowed upon Hideyoshi in

1585 at his own urging—a process that, in view of his humble origins, would previously have been unheard of. Hideyoshi's passing of the title to his nephew by no means meant a withdrawal from power. Rather, it brought further promotion, since the title of retired regent (*taikō* 太閤) was traditionally regarded as even higher in rank. In addition, 1592 is the year in which Hideyoshi began a large-scale invasion of Korea. The undertaking was aimed at toppling the Chinese Ming (1368–1644) dynasty and making Hideyoshi the ruler of a vast East Asian empire. After some initial success the campaign stalled, and Hideyoshi turned to negotiations.[15] In 1596, the year in which the Paradise Bridge was completed, a high-ranking Chinese mission was expected in Osaka.[16] The very same year also saw a heavy earthquake hit the Osaka-Kyoto region and inflict severe damage to numerous buildings. Hideyoshi took this setback as an opportunity for further enhancing the castle's grandeur, for instance through rebuilding the donjon with one additional story.[17]

The timing of these events suggests that the modifications to Osaka's layout and the further escalation of the castle's ornamental and architectural splendor were intended to better manifest Hideyoshi's grandeur and claim to legitimacy, versus both domestic and foreign audiences. Hideyoshi based this claim on his self-portrayal as a superior military leader, which he soon downplayed in favor of the more cultured persona of loyal servant to the emperor and benevolent minister of the people. He communicated these identities through a set of strategies that his former overlord and predecessor, Oda Nobunaga, had introduced only years before: the appropriation, transformation, and reinterpretation of iconographic formulae from the contexts of ritual and ceremonial architecture, specifically, of Chinese palace and Buddhist temple architecture.

Exceptional Structures

One of the largest structures at Osaka Castle, the Yamazato Palace complex, was centered around an audience hall of such unprecedented size that it earned the name "Hall of One Thousand Mats" (Senjōjiki 千畳敷).[18] The erection of this hall on top of a massive dry-masonry terrace proved difficult and constituted a technical feat. The acquisition of top-quality timber in sufficient quantity alone was a major accomplishment.[19] The typology of the "grand audience chamber" (*ōhiroma* 大広間), a vast hall for holding formal receptions, was a novelty that had been first introduced with Osaka's old reception palace. Art historian Ōta Shōko has demonstrated that the introduction of this architectural typology was directly connected to Hideyoshi's development of regular ceremonies during which his retainers and allies confirmed their allegiance.[20] As was common,

Figure 5.06. Karamon Gateway, Kannon Hall of Hōgonji Temple, late sixteenth century. Chikubushima, Shiga Prefecture. Photograph by Anton Schweizer.

the interior of this hall was subdivided with sliding doors. By removing these interior partitions, one continuous room of stunning size could be created. With the erection of this monumental audience hall, Hideyoshi continued Nobunaga's strategy of dramatically escalating the dimensions of his buildings beyond those of previous shogunal mansions.[21]

Another distinguishing feature of the Yamazato Palace was its principal access via a bridge. This structure, the Paradise Bridge, was likewise highly unusual and deserves special attention.[22] A variety of material, pictorial, and textual sources corroborate each other to a degree that allows for well-grounded discussion. Furthermore, this bridge is in all likelihood the only building of Hideyoshi's castle that survives today, at least in part. Textual documentation indicates that the Paradise Bridge was dismantled in 1600, two years after Hideyoshi's death, and converted into a gateway that would stand at the center of the ruler's posthumous cult, the Toyokuni 豊国 Shrine in Kyōto. Only two years later, in 1602, it was relocated once more, this time to the island of Chikubushima in Lake Biwa, where part of it survives as a ceremonial gateway (*karamon* 唐門), a curious structure that is attached to the Kannon Hall of the temple Hōgonji 宝厳寺 (figure 5.06 [plate 13]).[23] The original appearance of the bridge

at Osaka Castle can be glimpsed from a description provided by the Portuguese Jesuit Luís Fróis (1532–97):

> He [Hideyoshi] ordered the making of a magnificent bridge over the castle moat which leads to this aforementioned Hall of One Thousand Mats. [The bridge is] covered on top with gilded [roof] tiles, and in the middle of the bridge rises a small tower of two tiers, which has in each corner a kind of banner, of which there are four, with each corner having its own. [Each banner] is eight or nine palms long and four [palms] wide,[24] made of gilded brass, with a thousand multiples of figures,[25] birds, and trees, placed there in a cut-out fashion [i.e., openwork decoration]. After having been hung up, [these banners] remain there glistening in the sun, and they give great luster to the aforementioned tower [i.e., the donjon]. And the wooden beams that are crossing through above, on one side and the other, as if they were meant for reclining oneself [i.e., handrails], are gilded with Naxinji (*nashiji*), and the very same ground of the bridge [is filled] with so many ornaments [made] in masonry, and plates [manufactured] of various types and manners gilded with quite artful works by master goldsmiths, that the governor of Sakai[26] told a priest of ours, while speaking with him about this whole work, that the expense that had been made in the bridge, which would be of ten *braças*[27] [in length] more or less, especially due to the much gold and grand craftsmanship that was put onto it, would be valued at more than 15,000 ducats.[28]

Further information on the structure's appearance and decoration is provided by a Japanese source, the diary of Gien 義演 (1558–1626), who was the abbot of the Sanbōin 三宝院, a sub-temple of Daigoji 醍醐寺. Gien's account describes the bridge in its reincarnation as a gateway on the grounds of the Toyokuni Shrine:

> Further, a two-storied gateway, about twenty *ken* [ca. 39.40 m] in width, was built to the West of the shrine entrance (*torii*) of the [precinct of the] Toyokuni Luminous Deity. [In order to build this gateway,] the Paradise Bridge was brought from Osaka. The rafters of the upper story protrude slightly, and the upper story is taller in the central bay than in the others. From the pillars downwards, everything is [decorated with] gold-sprinkled lacquer (*makie*). The round pillars of the lower [story] are completely [coated with] black lacquer. The bracket complex [above the pillars that support the roof] is rendered in polychromy. It profoundly dazzles eyes and ears.[29]

These two accounts serve as a basis for several conclusions. First, it can be inferred from Fróis's account that the Paradise Bridge was indeed conceived as a ceremonial entrance to the Yamazato Palace, and second, that bridge and hall were built to complement the donjon in order to create a coherent architectural ensemble. Of fundamental significance for the subsequent discussion is the orientation of this ensemble's main entrance—that is, the Paradise Bridge—toward north. This is very unusual for an official building, since northern areas were usually associated with the rear or private parts of a compound. Third, it is clear that this bridge entrance was extraordinary not only in its location but also in its design, even in the context of the Momoyama period's eclectic taste. Abbot Gien, in his account, seems to search for the right words to describe a largely unprecedented construction—a bridge covered with a roof and crowned by a pavilion-like ridge turret. A last observation is that the architectural decoration, of gilded roof tiles and railings, copious metal fittings, and accents of polychrome painting, was equally exceptional and thus worthy of detailed description. Implied by Fróis's mention of intense gloss, and explicitly stated by Gien, is architectural lacquering, a very rare and extremely expensive decoration technique discussed shortly.

The accounts by Father Fróis and Abbot Gien are corroborated by several painted representations of Osaka (although these do not seem reliable in all details). Of special note is a folding-screen fragment that was formerly in the Kawakami Collection in Tokyo (the "Kawakami Screen"; see figure 5.05 [plate 12]).[30] This screen fragment dates to the Momoyama period and was thus produced during or in short temporal distance from the bridge's existence. Two other paintings, a single screen in Eggenberg Castle in Graz, Austria (the "Eggenberg Screen"; see figure 5.02 [plate 11]),[31] and a pair of folding screens in the Osaka Museum of History (the "Museum of History Screens"),[32] have a later date but are commonly assumed to be copies of compositions that were created during the Momoyama period.[33] All three of these painted representations conform in their depiction of an almost level, corridor-like structure that is covered with a roof over its entire length. Also consistently represented are a small, pavilion-like ridge turret with a hip-and-gable roof in the bridge's center and a billowing gable pediment (*kara hafu* 唐破風) over its entrance, which must be the part surviving at Hōgonji in Chikubushima (see figure 5.06 [plate 13]). The Hōgonji gate, as it is today, is entirely coated with plain black lacquer. Based on the accounts by Fróis and Gien, it seems likely that these lacquered expanses were originally further embellished.

Turning away from the Paradise Bridge, it is possible to make corresponding observations for other buildings in the castle compound, where a similar apparatus of style and decoration was employed. In all three aforementioned repre-

sentations of Hideyoshi's Osaka—the Kawakami Screen, the Eggenberg Screen, and the Museum of History Screens—as well as in other paintings, the donjon is consistently shown as entirely or partially black.[34] This suggests the donjon was also coated with pigmented lacquer to a considerable extent (see figures 5.04 and 5.05 [plate 12]).[35] Lacquer, or *urushi* 漆, is a substance gained from the sap of trees and an expensive material. To lacquer entire buildings necessitates tremendous quantities of the substance. Lacquering is, in addition, highly labor intensive. Even the simplest type of coating cannot be applied in a single step but has to be built up in a complex and time-consuming process that involves a textile lining, repeated priming, and at least two top layers of pigmented lacquer. As if this were not enough, there survive several buildings erected with Hideyoshi's sponsorship that feature sophisticated decoration via the lacquering techniques of *makie* 蒔絵 and *nashiji* 梨地. These two related techniques both essentially consist of sprinkling metal particles into still-wet lacquer. Makie is made with fine and uniform metal particles and typically employed for pictorial subjects that are set off in gold against a black background. *Nashiji*, in contrast, is made with coarser metal particles of irregular shape that are embedded into red-brown lacquer. The nashiji technique can be used both for creating pictorial subjects and for imbuing large surfaces with a sparkling copper glow.[36]

Makie is attested to in Gien's description of the Paradise Bridge at its second location, the Toyokuni Shrine in Kyoto. Nashiji is, in turn, explicitly mentioned for one last building that Hideyoshi erected in the Yamazato Palace at Osaka, a theater stage. Luís Fróis describes it as follows:

> In front of this Hall [of One Thousand Mats], in a beautiful open field, he ordered the erection of a stage for theatrical plays[37] to be performed on it. It had from one part to the other, somewhat set apart, two towers with three or four tiers. One [tower] was ruined by the rain and killed three or four people [when it collapsed]. Taiko [*taikō*, i.e., Hideyoshi] got so involved[38] in this work for theater, that he wished it to exceed all other buildings that he had erected until then in terms of beauty, perfection, and [monetary] expenses. The columns, which are made of wood, and the pavement or [board] flooring are all covered with a black varnish, which is called here vruxi [*urushi*], whereby they are left as very shiny mirrors; and all of this is gilded with Naxinji (*nashiji*), which is gold ground into powder, impressed there [upon the varnish] with great artifice. The coffered ceiling[39] is filled with figures and large amounts of gold leaf, made with various crafts; and alongside [all of] this, they are making other houses of very rich and lustrous craft all around that very same fortress.[40]

Irrespective of the still unknown location of this stage, this account echoes key decorative features of other buildings in the vicinity of the Yamazato Palace and the inner enceinte discussed earlier.[41] Fróis's description suggests a design that must have departed considerably from convention. Flanking "towers" were absolutely unprecedented features for a noh stage, and one can only speculate about their purpose as venues for accommodating an elite audience.[42] Fróis's description of them as multistoried and towerlike raises the intriguing possibility that these were indeed pavilion-like edifices, maybe of similar character to that of the Paradise Bridge's ridge turret. Hideyoshi's stage impacted the viewer with a stunning array of colors and surface textures, which can be gleaned from some rare surviving buildings of the period: timber frame and wall panels were coated with black lacquer and accentuated in some way with glittering gold particles applied in the nashiji technique. Gilded metal fittings, chased and engraved with delicate ornamentation, were mounted to joints, corners, and post endings. The zone between the lintel and the eaves was filled with copious woodcarvings, likely polychromized and accentuated with gold leaf.[43]

"Exuberant" decoration, exemplified by gilded roof tiles, extensive lacquering, bright polychromy, and sumptuous woodcarvings, is often pointed out as a stylistic hallmark of Momoyama-period ceremonial architecture. The same notion applies to "flamboyant" constructive details, which are also found at Osaka, such as curving eaves, swerving roof corners, ornamental gables, and cusped windows. The motivation for employing such stylistic features is often explained as a predilection for ostentation by nouveau-riche rulers. The temporal coincidence of this new architectural language with the project of national unification, however, urges a reconsideration of this association and of the messages that were inscribed into such stylistic features.

Invented China and Earthly Paradise

The conceptual model for and direct predecessor of Osaka was Oda Nobunaga's "capital" of Azuchi. At Azuchi, Nobunaga had set a new paradigm for manifesting and communicating authority. The complex architectural and painterly program of Azuchi Castle's famous donjon cannot be discussed here for limitations of space; however, at the heart of its overall iconography were multilayered references to legendary Chinese sage kings and philosophers evoked by Nobunaga to support his claim of possessing a heavenly mandate to rule.[44] Compared to Azuchi, our knowledge about the specifics of Osaka Castle's iconographic program is limited. If archeological evidence is combined with textual and pictorial sources, however, there is sufficient material for making a case that Hideyoshi

also heavily relied on associating his regime with ancient Chinese precedent. This predominantly Chinese—that is, foreign—point of reference was encoded first and foremost in the architecture of the donjon.

Today the Japanese castle donjon, or tenshu, belongs firmly to Japan's architectural inventory and constitutes an iconic embodiment of samurai culture. These modern associations, however, obscure the fact that the first castle donjons were experienced by targeted Japanese audiences as revolutionary in construction and decidedly foreign in style. Initial experiments with multistory watchtowers that were more permanent and refined in character than their precursors—improvised wooden platforms for archers and sentries—date to the 1560s.[45] The donjon of Azuchi, completed in 1579, was the first example of a fully developed tenshu. When Osaka was erected in the mid-1580s, the donjon was still perceived as a profoundly novel and outlandish typology. This is evident from several textual sources.

In late May 1586, Ōtomo Sōrin 大友宗麟 (1530–87), Lord of Bungo in Kyushu, was received in audience by Hideyoshi at Osaka. Directly after the event, he wrote a long letter home to a group of leading retainers. "The donjon," he states, "has a layered (=multistory) appearance. It is difficult to explain and words cannot fully describe it. It has nine [layers; *sic!*] above the ground level. It is an absolutely unique wonder and one has to say that there is nothing comparable in the Three Countries [of India, China, and Japan]."[46] Sōrin was not in any way inarticulate or uncultured but rather a well-versed patron of the arts. He seems, however, to have been somewhat at a loss for adequate terminology in the face of this highly anomalous structure. What struck him as the single most notable feature of the donjon was its "layered appearance" (*jūjū no yōsu*), that is, the building's composition from multiple units that were stacked on top of one another.

Another eyewitness account comes from Chōsokabe Motochika 長宗我部元親 (1539–99), Lord of Tosa in Shikoku. Motochika came to Osaka early in 1586 to offer New Year's compliments and thereby signal his submission to Japan's new strongman. A record of Motochika's visit states, "[The donjon] soars up nine [*sic!*] stories tall. [It comes] close to the sky. Yanmen and the palace of Xianyang must have been just like this."[47] This quote is notable for likening Osaka to two lofty locales in ancient China. The first of these, Yanmen 雁門, is a pass in modern Shanxi Province that constituted a key strategic position along the famous Great Wall. The second place, Xianyang 咸陽, in modern Shaanxi, was the capital of the kingdom of Qin in the third century BCE. It was from Xianyang that the eventual first emperor, Qin Shihuangdi 秦始皇帝 (259–210 BCE; r. 221–210 BCE), set out to forcefully unite the "Warring States" and establish the first in a long series of imperial dynasties.[48] One might speculate that the two specific Chinese places were not Motochika's own, random associations but rather were suggested to

him by his host. Both are very apt references for an empire builder. The first, a pass near the most formidable defensive structure in China, makes perfect sense as a conceptual model for a defiant fortress. The second, Xianyang, is of particular significance for a much-celebrated palace in its immediate vicinity, Epang 阿房 (also pronounced Ebang or Afang, late 3rd c. BCE).

Epang holds a distinguished place in Chinese architectural history and was often cited as the epitome of grandeur and material opulence.[49] Sima Qian 司馬遷 (135?–86 BCE), considered the father of Chinese historiography, describes the never-finished palace in his work *Shiji* 史記 (Historical records, ca. 91 BCE). Sima Qian's account provides some detail, but with the dispassionate tone of the chronicler.[50] Epang's paramount fame is owed to a much later and entirely fictitious poem by the Tang (618–907) dynasty poet Du Mu 杜牧 (803–53?). His *Epang gong fu* 阿房宮賦 (*A Rhapsody on Epang Palace*) glorifies the site as a phantasmagoric imperial abode boasting "a tower every five paces / and a pavilion every ten," "hallways twisting around like silk / eaves like teeth, gaping high," and buildings embellished with "golden bricks and pearl tile bits."[51]

This vision of Epang as an enormous and luxuriant palace was well known in late sixteenth-century Japan. The poem's fame is attested to, most significantly, by a poetic composition that stands in direct relationship with Osaka Castle's immediate predecessor, Azuchi. This composition, a panegyric on the castle entitled *Azuchiyama no ki* 安土山記 (Record of Mount Azuchi, ca. 1576–82) and written by the Zen monk Nanka (also pronounced Nange) Genkō 南化玄興 (1538–1604), was commissioned by Nobunaga in an effort to maximize the impact of his architectural image politics.[52] The first part of Genkō's text is written in prose and relates the landscape around Azuchi to various scenic locations in China, such as the Xiaoxiang 瀟湘 region in what is today Hunan Province.[53] The second part is a poem that unleashes a cascade of sublime images, each more hyperbolic than the one before. In this part, Azuchi is praised as having "a palace even taller and larger than the halls of Epang."[54]

Nanka Genkō, the author of the panegyric, swiftly geared his allegiance after Nobunaga's death toward Hideyoshi, a move that proved helpful for his career. Having presided over several well-known temples in Kyoto, he became in 1591 the founding abbot of Shōunji 祥雲寺, the mortuary temple of Hideyoshi's early deceased first son, Sutemaru 棄丸 (Tsurumatsu 鶴松; 1589–91). In this function, Genkō contributed significantly to construing Sutemaru's posthumous memory.[55] The combined facts—that Epang is directly invoked in Genkō's Azuchi panegyric, a work commissioned by Nobunaga; that Hideyoshi had been one of Nobunaga's most important retainers and as such was certainly familiar with the panegyric, and subsequently took Azuchi as the principal model for Osaka; and that Genkō served Hideyoshi as a close adviser in matters of political ico-

nography and self-promotion during the early 1590s—suggest we might benefit from a closer look at the strategies through which Osaka Castle could have been stylized as an reincarnated Epang.

The aforementioned account in *Shiji* describes the first emperor's palace at Epang as vast in scale, large enough to seat an enormous retinue. While Sima Qian's own wording makes it unclear whether he speaks about an open space or a building, virtually all later authors assumed that Epang had a mammoth reception hall. After describing the palace, Sima Qian writes that the first emperor's builders "were going to make a raised way (*fudao* 復道) from Epang across the Wei [River], connecting it to Xianyang, in order to emulate how [the constellation] *gedao* 閣道 (literally, "Raised Way") cuts across *han* 漢 [the Milky Way] to reach [the constellation] *yingshi* 營室 in the firmament."[56] This description reflects long-standing concerns in China with geomancy and the idea that ceremonial architecture should be reflective of universal and celestial ordering principles.[57] While it is imperative not to overinterpret, a couple of striking correlations between the portrayals of Epang in Sima Qian's account and Du Mu's poem, on the one hand, and Osaka after the reconfiguration of 1591/92, on the other, spring to mind. Osaka was, like Epang, a new "palace" erected outside a much older capital. Like Epang, Osaka was located to the south of the old capital (Kyoto) and across a river (the Yodogawa). The principal structures of the new capital included a venue fit for entertaining a vast assembly (the Hall of One Thousand Mats) as well as a spectacularly tall and large palace building (the donjon). Osaka was "connected" to the old capital (Kyoto) through a "raised way" (the Paradise Bridge) constructed over the inner castle moat, replicating the way in which Epang was linked to the old capital of Xianyang over the Wei River. The analogy would have hinged, especially, on the unusual shape of the Paradise Bridge, which was essentially a covered corridor on stilts. This shape would have functioned as a translation into architecture of the word *gedao* (Jap. *kakudō*), which is not only the name of an astrological constellation but literally means "raised way" or "pavilion way."

Further research is needed to clarify the hypothesis of a specific allusion to Epang through the Paradise Bridge. On a more general level, however, there is no doubt that the architecture of Osaka Castle was pitched to a "Chinese" key. The Paradise Bridge's pavilion-like ridge turret, the "towers" flanking the theater stage, the soaring donjon and the defensive corner towers (*yagura*) clearly resonated with text passages from Du Mu's fictional praise of Epang such as "a tower every five paces / and a pavilion every ten." The looming gables of the donjon and the large palatial halls would, in turn, have recalled the line "eaves like teeth, gaping high." Not least, gilded roof tiles, polychromized woodcarvings, and lacquered wall panels would have conjured up the fantastic image of "golden

bricks and pearl tile bits." Above all, the "layered," that is, multistoried, donjon with its shachihoko fish-dragon ridge sculptures must have evoked painted representations of Chinese palace compounds—a random but representative example being a fourteenth-century hanging scroll that depicts the summer palace of the Tang dynasty emperor Minghuang 明皇 (also Xuanzang 玄宗; 685–762; r. 712–56), a figure often quoted in legend and historical fiction for his penchant for luxury and sensual pleasures (figure 5.07 [plate 14]).[58]

A further, complementing layer of meaning emerges from the name and decoration of the Paradise Bridge, or *Gokuraku no hashi. Gokuraku* 極楽 (literally, "supreme bliss)" is the name of Buddha Amida's paradise, the Western Pure Land. Several sutras describe this land as made entirely from precious substances and permeated by supernatural radiance, and a place of boon and carefree joy.[59] The connotation transported by the bridge's name was subtly reinforced by a decorative detail that Luís Fróis mentions: "a kind of banner . . . made of gilded brass, with a thousand multiples of figures."[60] These metal banners were suspended from the four corners of the pavilion-like ridge turret and clearly fashioned after ritual implements (*bandō* 幡幢) that adorn Buddhist altar spaces (figure 5.08).[61] The resulting message was that to approach Hideyoshi's castle meant to enter a dream-like landscape that rivaled the splendor of Amida's paradise.

It is important to note that such references to dreamlands from Chinese and Buddhist visual culture were not limited to the castle but could be found all over the city. This becomes clear, for instance, from a sculptural roof application in the shape of a shachihoko that likely belonged to the mansion of an elite retainer (figure 5.09)[62] and is further corroborated by Coppendale's observation of "many handsome wooden bridges . . . richly ornamented with carved work." Clearly, Osaka's resemblance to well-known representations of China's imperial past and Amida's paradise imbued Hideyoshi's castle with the decorum befitting the center of a reborn empire.

Pertinent to this discussion of architectural iconography is our understanding that Osaka Castle was not construed as an ethereal vision accessible only to a privileged few who could enter the castle walls. In fact, Hideyoshi went to great lengths to intertwine the castle with the surrounding city and connect it to the wider environment of the Kansai. The principal means for constructing this greater landscape was the gaze of those for whom it was intended.

Construing and Performing a Landscape of Symbols

Historian of urbanism Miyamoto Masaaki has identified Hideyoshi's Osaka as an early example of what he describes as Japan's paradigmatic early modern castle town. One main characteristic of this urbanistic typology is zoned settle-

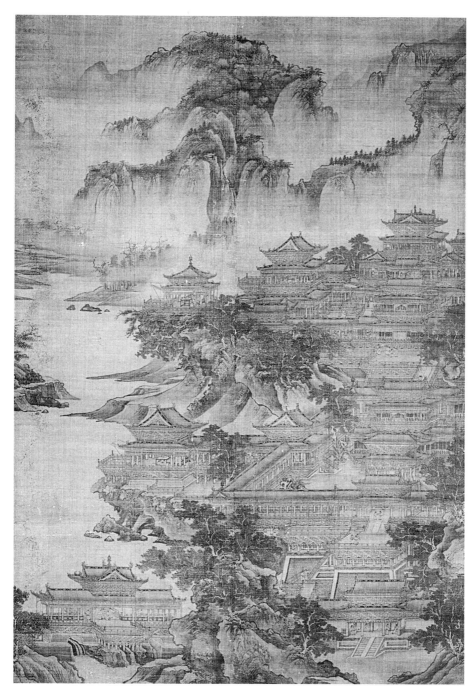

Figure 5.07. Attributed to Guo Zhongshu, *Emperor Minghuang's Palace of Escaping the Heat*, second half of the fourteenth century. Hanging scroll, ink on silk, 161.5 × 105.6 cm. Abe Collection, Osaka City Museum of Fine Arts.

Figure 5.08. Ritual banner, dated on wooden container to 1517. Shanain, Nagahama City, Shiga Prefecture. One of a pair, openwork and engraved gilded copper, 105.5 × 13.2 cm. Courtesy of Shanain, Nagahama City (Shiga Prefecture), and Nara National Museum.

Figure 5.09. Decorative roof application in the shape of a composite creature, late sixteenth to early seventeenth century. Fired clay with black and red lacquer and gold leaf. Courtesy of Osaka City Cultural Properties Association.

ment, which differentiates spatially between high-ranking retainers, middle-class samurai, low-class foot soldiers, specialized craftsmen, merchants, and religious institutions. These dedicated residential areas palpably visualized social hierarchies (proximity to the center denoted a high rank) and the ruler's authority to enforce them. A second major characteristic is what Miyamoto calls "lines of sight" (*mitōshi sen* 見通し線), executed via one or sometimes several visual axes along large streets that were oriented towards the principal manifestation of the ruler's authority—usually, the donjon. At Osaka, the configuration of these axes is particularly compelling. The donjon was positioned in such a way that it served as vanishing point for two visual axes in the urban grid (figure 5.10).[63] The first of these axes was formed through Kōraibashi-dōri 高麗橋通り, an urban thoroughfare issuing westward from the castle. The street was named

after its crossing of the canal Higashi Yokobori 東横堀 at Kōraibashi 高麗橋, or "Korea Bridge." This name was aptly chosen, since the street merged at the city's western border with the main overland artery to western Japan and its thriving harbors, gateways of overseas trade with Korea, China, and Europe. The second visual axis at Osaka issued from the castle's donjon toward the northeast, traversing two castle moats and the Ōkawa River. On the other side of the Ōkawa it aligned with the Kyōkaidō 京街道, the principal road connection between Osaka and Kyoto.

Straight procession alleys had been a feature of Japanese cities for many centuries before their installation at Osaka. The original urban grid of ninth-century Kyoto (then called Heiankyō 平安京), for instance, had featured an enormously long and wide ceremonial approach to the Imperial Palace as its center axis.[64] Furthermore, shrine and temple precincts were often equipped with straight procession routes leading toward their main gateways. There are, however, obvious differences between such conventional applications and their late sixteenth-century variants, the most crucial being the latter's emphasis on verticality.[65] The urban axes in this and other contemporary cities were invariably oriented toward dramatically elevated landmarks inserted within urban landscapes, which were often centrally positioned as a culminating point for one or more radiating main streets.[66] Where traditional urban patterns typically featured an axis that ended at a gateway of some sort, that is, a more or less peripheral marker of an otherwise visually inaccessible, sanctified architectural complex, the Momoyama-period axes were oriented toward towering structures, which also constituted the most private and hallowed parts of their respective complexes but were visible from the exterior because of their height. Where the interior buildings of elite residences had formerly been kept well concealed from the gazes of commoners, they now enjoyed maximum visibility.

This new approach also allowed for the axes to extend beyond the city limits. The two visual axes at Osaka significantly imposed the vista of the castle, an artificial hill crowned by the soaring donjon, on travelers. Everybody approaching Osaka from the north—merchants, pilgrims, courtiers, and elite samurai on their way to see Hideyoshi in audience—would have been confronted with the architectural embodiment of his power long before they entered the city. The same is true for the road from western Japan: all travelers would have been exposed to the donjon's monumental silhouette for considerable time as they advanced toward it. The donjon was even visible from the sea and used as a navigation point by ships approaching the harbor. The imposition would, all the more, have been relevant for Osaka's inhabitants on a daily basis. Kōraibashi-dōri was one of the most thriving commercial streets, with numerous shops,

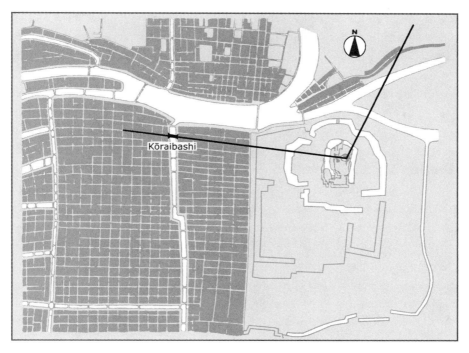

Figure 5.10. Map of Toyotomi-era Osaka with visual axes. Map by Lachlan James Hill, adapted from Miyamoto, *Toshi kūkan no kinseishi kenkyū*, 295, fig. 7–4.

inns, and offices of licensed money changers. Anyone who had business in the city would perform their activities in plain view of the donjon and, implicitly, its master.

The final distinction between traditional axes and their reinvention at Osaka can be identified in this kind of function. Traditional axes were mostly reserved for ceremonial or ritual activity and therefore somewhat excluded from everyday life. Their centrally located early modern counterparts, however, were inextricably woven into the fabric and function of their cities. The unprecedented height of Osaka's donjon, combined with the considerable length and bustling industry of the urban axes leading to it, created a monumental vision of the ruler's power that remained inescapably present to everybody who moved along the city's main streets.[67]

While Osaka's commoners were forced to perform an upward gaze in their daily lives, their ruler would orchestrate reciprocal gazes on manifold occasions, most significantly, after formal receptions. A number of eyewitness accounts by elite retainers and guests allow us to identify patterns in Hideyoshi's ceremonial practices.[68] The most detailed of these accounts is given by Ōtomo Sōrin in the previously mentioned letter to his retainers.[69] After a formal audience with

Hideyoshi and some close advisers in the (First) Reception Palace, Sōrin was led into a stunning, entirely gilded tea room, where he was served first by the tea master Sen no Rikyū 千利休 (1522–91) and then by Hideyoshi himself. This famous Golden Tea Room (*ōgon no zashiki* 黄金の座敷) was demountable and most likely had been commissioned by Hideyoshi for use at the Imperial Palace, where he had offered tea to the emperor earlier in the same year.[70] At the time of Sōrin's visit, it is thought to have been set up within a room of the reception palace.[71] After the tea gathering, Sōrin was invited to see the donjon. In what must have been a highly surprising move, Hideyoshi himself acted as the guide. Within the donjon, Sōrin was shown a series of storage rooms that were filled with vast stockpiles of raw silk, costly brocades, weapons, and gold. The tour climaxed with a visit to the viewing deck at the donjon's top story. There, the party sat down while Hideyoshi took his time pointing out in detail famous places in the Kansai Plain and around the Bay of Osaka. Upon descending from the donjon, Sōrin was led into ostensibly private rooms with more staggering displays of material wealth. Tellingly, Hideyoshi withdrew at that point and delegated the political negotiations—the actual reason for Sōrin's trip to Osaka—to his half-brother Hidenaga 秀長 (1540–91) and tea master Rikyū.[72]

Sōrin's account is closely mirrored in a letter by Luís Fróis that describes the visit of a Jesuit delegation.[73] Again, once the formal audience had been concluded, Hideyoshi proceeded to guide the group through his residence "just as if he were a private person."[74] Although the tour was conducted, this time, somewhat in reverse, with the private quarters first and the donjon as crowning finale, many details are similar. The Golden Tea Room was by then dismantled and stored away in large boxes, but Hideyoshi made a point of having the boxes opened to afford his guests a glimpse. At the donjon's top story the ruler, once again, discussed the surrounding panorama in detail and pointed out various locales and current construction projects that as he spoke were being executed by an army of laborers below. Back in the private quarters, the delegation enjoyed refreshments that Hideyoshi insisted he personally serve.

Looking down on a stretch of land from an elevated position virtually always implies a privileged and dominant position. In Japan, this concept had a long tradition. Among the most significant annual observances at the imperial court was a rite of "viewing the land" (*kunimi* 国見), in which the emperor climbed a hill, visually inspected the surrounding country, and then celebrated its fecundity and beauty with a poem.[75] The Kansai Plain that surrounds Osaka is part of the old heartland of Japanese culture. Many of the places that Hideyoshi pointed out to his guests were "famous places" (*meisho* 名所), locales that were long renowned for their scenic beauty or legendary events and had therefore become codified subjects for poems. For an educated audience, the mere

mention of place names like "Sumiyoshi" and "Naniwa" would have triggered rich poetic associations.[76] Those visitors who had the privilege of having this view introduced by Hideyoshi would doubtlessly have understood his gesture as taking visual possession of the surrounding landscape and appropriating its cachet of cultural capital.

Looking down on an urban landscape from a position at its center was, in addition, a very rare experience in early modern Japan. Since recreational hiking was as yet unknown and most tall buildings remained inaccessible to the common populace, such occasions were exceedingly uncommon.[77] For Hideyoshi's guests at Osaka this seminal and awe-inspiring experience was further enhanced by their host's relaxed attitude. Hideyoshi's behavior is described in both aforementioned accounts as confusingly casual. During the entire informal part of the Jesuit visit, for instance, Hideyoshi's sword was carried ahead not by the customary male page but by a lavishly costumed girl of thirteen or fourteen years.[78] It has been estimated that about three hundred women served in the inner enclosure.[79] Most of them can be assumed to have been ladies-in-waiting to Hideyoshi's principal wife, Nene 寧々 (1548?–1624), or his various concubines.[80] A Buddhist nun seemingly acted as keeper of the donjon's keys.[81] With the exception of Hideyoshi's bodyguard, no men were allowed to live permanently in the inner enclosure. All male servants and specialists such as falconers, carpenters, and gardeners were admitted only during daytime and had to leave before sunset.[82]

It was in fact customary to have women's quarters in samurai residences that were off limits for male outsiders. More notable, however, is that the donjon at Osaka—the center of the fortified castle and prime manifestation of Hideyoshi's authority as a ruler—seems to have been included in such a female-gendered space.[83] While Hideyoshi's habit of staffing his surroundings predominantly with women can be explained both as a security measure and as the attempt to offset his masculinity with a sort of harem, it stands to reason that a further aspect of his careful persona making also played a significant role. A gradual deemphasis of martial identity aligned perfectly with Hideyoshi's self-portrayal as a cultivated ruler, a propagandistic image he largely based on depictions of ideal "sage kings" from throughout China's history. While Hideyoshi essentially emulated Nobunaga, who had employed a similar strategy for legitimizing his regime, Hideyoshi downplayed the role of a military usurper and emphasized that of a generous supporter of the imperial court and a benevolent father figure providing wealth and stability to his subjects. This is manifest even in the family name that Hideyoshi had himself granted by the emperor—Toyotomi 豊臣 (literally, the "Bountiful Minister"). Hideyoshi's self-proclaimed role as a catalyst for economic growth is also highlighted in an often-quoted passage from his

semiofficial biography. There, it is claimed that "ever since the advent of the Retired Regent Hideyoshi, gold and silver have gushed forth from the mountains In the old days, no one as much as laid an eye on gold. But in this age, there are none even among peasants and rustics, no matter how humble, who have not handled gold and silver aplenty."[84]

The urban landscape at Osaka, with its lacquered and gilded castle buildings, ornately carved bridges, busy markets, and wide, straight thoroughfares, perpetuated this claim for everyone who visited. The erection of Osaka was a pivotal step in advertising for a new order. This order pictured a utopian society in which hierarchies were stable, loyalties unshakable, and public safety always granted. That the landscape of Hideyoshi's castle was presented as a reincarnation of the most magnificent places from Chinese history enabled Hideyoshi's self-presentation as a ruler who fashioned himself on and perhaps even claimed to surpass the exemplars of good government from Chinese history. Osaka was built in proximity to the imperial capital of Kyoto, the ceremonial and cultural heart of the realm, thereby ostensibly protecting, yet not interfering with, imperial rule. The view down from Osaka Castle's donjon was performed by Hideyoshi as if to claim in its vista a flourishing city full of bustling commerce and construction projects, enlivened by shrine and temple festivals all year round, and dotted with numerous landmarks that were to be immortalized by poets for centuries to come.

It is perhaps unsurprising that this meticulously premediated view of the landscape of Osaka finds its complement in the painterly genre of city vistas (see figure 5.02 [plate 11]).[85] It is not by chance that panoramas of Osaka are among the earliest monumental representations of cities other than Kyoto. In fact, it is thought that many of the surviving Osaka screens were once paired with counterparts depicting the imperial capital. Together, these painted screens actualized and proliferated the notion of a vibrant symbolic landscape that encompassed the cities of Osaka, Kyoto, and the entire Kansai Plain, furthering Hideyoshi's careful political positioning in their panoramas.

Notes

I would like to thank Elizabeth Lillehoj, Morgan Pitelka, Jonathan Hay, and an anonymous reviewer for their extremely helpful comments on earlier versions of this essay.

1. For historical background, see John Whitney Hall, Nagahara Keiji, and Yamamura Kōzō, eds., *Japan Before Tokugawa: Political Consolidation and Economic Growth, 1500–1650* (Princeton: Princeton University Press, 1980); Pierre François Souyri, *The World Turned Upside Down: Medieval Japanese Society*, trans. K. Roth (London: Pimlico, 2002); Mary Elizabeth Berry, *The Culture of Civil War in Kyoto* (Berkeley: University of California Press, 1994).

2. On Hideyoshi's rebuilding of Kyoto, see Nihonshi Kenkyūkai, ed., *Toyotomi Hideyoshi to Kyōto: Jurakudai, odoi to Fushimi* (Kyoto: Bunrikaku Shuppan, 2001).

3. For related approaches, see W. J. T. Mitchell, ed., *Landscape and Power* (Chicago: University of Chicago Press, 1994); Kitty Zijlmans, ed., *Site-Seeing: Places in Culture, Time, and Space* (Leiden: CNWS Publications, 2006), and the thematic issue "Tokushū: Toyotomi no fūkei to rakuchū rakugai zu," *Shūbi* 11 (April 2014): 68–79.

4. "Fragment Journal by the Cape Merchant of the *Hozeander*," entry 22 September 1615. Quoted after M[ontague] Paske-Smith, ed., *History of Japan: Compiled from the Records of the English East India Company . . .*, 2 vols., reprint of the original edition London 1822 (London: Curzon Press and New York: Barnes and Noble, 1972), 2:11. The notation given by Paske-Smith is obviously anachronistic. I want to thank Timon Screech and Edward Town for their kind, but so far unsuccessful, help in locating the original manuscript in the British Library. Ralph Coppendale's name turns up in documents under numerous spellings, including Raphe Copingall, Coppindale, Copendall, or Coppindall.

5. On Hideyoshi's biography, see Kuwata Tadachika, *Toyotomi Hideyoshi kenkyū* (Tokyo: Kadokawa Shoten, 1975); Mary Elizabeth Berry, *Hideyoshi*, Harvard East Asian Monographs 146 (Cambridge, MA: Harvard University Press, 1982).

6. For a discussion of the scholarship on Azuchi, see Mark Karl Erdmann, "Azuchi Castle: Architectural Innovation and Political Legitimization in Sixteenth-Century Japan" (Ph.D. diss., Harvard University, 2016). Especially, see Naitō Akira, "Azuchi-jō no kenkyū," part 1, *Kokka* 987 (1976): 7–117; part 2, *Kokka* 988 (1976): 7–63 and unpaginated appendix; Miyakami Shigetaka, "Azuchi-jō tenshū no fukugen to sono shiryō ni tsuite: Naitō Akira-shi 'Azuchi-jō no kenkyū' ni tai suru gimon," part 1, *Kokka* 998 (1977): 7–26; part 2, *Kokka* 999 (1977): 5–26; Miura Masayuki, ed., *Yomigaeru shinsetsu Azuchi-jō: Tettei fukugen, haō Nobunaga no maboroshi no shiro*, Rekishi gunzō shirīzu derakkusu 2 (Tokyo: Gakushū Kenkyūsha, 2006); Shiga-ken Azuchi Jōkaku Chōsa Kenkyūjo, ed., *Azuchi-jō: Nobunaga no yume: Azuchi-jō hakkutsu chōsa no seika* (Hikone: Sanraizu Shuppan, 2004).

7. The precise extent of the *sōgamae* is disputed. See Watanabe Takeru Kanchō Taishoku Kinen Ronshū Kankōkai, ed., *Ōsaka-jō to jōkamachi* (Kyoto: Shibunkaku Shuppan, 2000), 9, fig. 1.

8. See Okamoto Ryōichi, *Ōsaka-jō* (Tokyo: Iwanami Shoten, 1970), 55–66; Sakurai Narihiro, *Toyotomi Hideyoshi no kyojō*, 2 vols. (Tokyo: Nihon Jōkaku Shiryōkan Shuppankai, 1970–71), vol. 1; Miyakami Shigetaka, "Hideyoshi chikuzō Ōsakajō honmaru no fukugen," *Kikan Ōbayashi* 16 (1983): 3–21; Miyakami Shigetaka, *Ōsaka-jō: Tenka-ichi no meijō*, Nihonjin wa dono yō ni kenzōbutsu o tsukutte kita ka 3 (Tōkyō: Sōshisha, 1984).

9. Saitō Hidetoshi, "Yamazato to sōan," in Nobuo Tsuji et al., eds., *Shiro to chashitsu: Momoyama no kenchiku, kōgei*, vol. 14 of *Nihon bijutsu zenshū* (Tokyo: Kōdansha, 1992). The name Yamazato references a poem by the Kamakura-period courtier Fujiwara no Ietaka 藤原家隆 (1158–1237). See Miyamoto Kenji, *Kenchikuka Hideyoshi: Ikō kara suiri suru senjutsu to kenchiku, toshi puran* (Kyoto: Jinbun Shoin, 2000), 65.

10. These rough estimates are taken from Miyakami, "Hideyoshi chikuzō Ōsakajō," 9–10 and 17–18, unnumbered figs. The donjon of Azuchi is commonly agreed to have been about 32.5 meters tall above the floor level of the inner enceinte. See Erdmann, "Azuchi Castle," 193n97.

11. Five exterior tiers above the stone base are consistently shown in pictorial sources. Textual sources disagree, counting seven or nine. This may be reasoned in (1) counting floors contained in the stone base that would not have been visible from the exterior; (2) a discrepancy between the number of interior floors and exterior tiers, which is frequent at other donjons; (3) modifications to the donjon after earthquake damage in 1596. See Luís Fróis, letter Miyako 18 September 1596 (through Nagasaki 28 December 1596), in *Quaderno q̃ ua*

separado De la Annua En q̃ se trata del successo de las cosas y Estado de Japon seglar (Archivium Romanum Societatis Iesu ARSI Jap. Sin. 52), fols. 231–50v. I am profoundly indebted to Patrick Schwemmer for sharing his transcription of the manuscript with me. For an annotated translation of a Latin version into Japanese, see Matsuda Kiichi and Engelbert Jorissen, *Jūroku, nana seiki Iezusu-kai Nihon hōkokushū*, 3 vols. (Tokyo: Dōhōsha, 1987–98), vol. 2, 275–306. For an attempt to synthesize the information about the donjon, see Satō Taiki, "Toyotomi Ōsaka-jō tenshu no fukugenteki kenkyū," *Shigaku kenkyū* 270 (February 2011): 34–55.

12. Archeological evidence for the shachihoko of Osaka's donjon is so far missing. Their existence is, however, generally accepted, based on the following reasons: (1) ceramic shachihoko are assumed for Azuchi and Gifu and evident for virtually all later donjons, implying an unbroken tradition; (2) Osaka Castle's donjon is consistently shown with shachihoko in the three earliest pictorial representations—the Kawakami Screen, the Summer Campaign Screens, and the Winter Campaign Screens (a later copy of an early seventeenth-century work). Compare my notes 30–34; (3) shachihoko fragments have been excavated from residences of some of Hideyoshi's high-ranking vassals (see figure 5.09). It stands to reason that if they used such distinguishing decoration, Hideyoshi would certainly have done so too.

13. The location of the Yamazato Palace was long disputed. Sakurai assumed that it replaced the First Reception Palace on the identical plot; see Sakurai, *Sengoku meishō no kyojō*, unpaginated/unnumbered illustration [corresponding to 13, pl. 16, of the unpaginated section]. Miyakami Shigetaka first argued for a location in the northern section, which is now commonly accepted. See Miyakami, *Ōsaka-jō*, 79.

14. Historian Kitagawa Hiroshi has brought forward evidence for the Paradise Bridge's location, appearance, and subsequent relocations; see Kitagawa Hiroshi, "Ōsaka fuyu no jin zu byōbu, natsu no jin zu byōbu ni egakareta Ōsaka-jō," in Wakayama Kenritsu Hakubutsukan, ed., *Tokubetsuten: Sengoku kassen zu byōbu no sekai* (Wakayama: Wakayama Kenritsu Hakubutsukan, 1997).

15. On the Korean campaign, see Ike Susumu, ed., *Tenka tōitsu to Chōsen shinryaku*, vol. 13 of *Nihon no jidaishi* (Tokyo: Yoshikawa Kōbunkan, 2003); James B. Lewis, ed., *The East Asian War, 1592–1598: International Relations, Violence, and Memory* (London: Routledge, 2015).

16. The delegation was headed by Yang Fangxiang 楊方享 (dates unknown) and Shen Weijing 沈惟敬 (1540?–1597?). For more, see Jurgis Elisonas [George Elison], "The Inseparable Trinity: Japan's Relations with China and Korea," in John Wittney Hall and James L. McClain, eds., *Early Modern Japan*, vol. 4 of *The Cambridge History of Japan* (Cambridge: Cambridge University Press, 1991), 281–85.

17. This information is from Fróis, letter Miyako 18 September 1596, fol. 232v.

18. To indicate the number of straw mats (*tatami* 畳) needed to cover a room's floor was one method of calculating size. For a Jesuit account of the Hall of One Thousand Mats, see Michael Cooper, trans. and annot., *João Rodrigues's Account of Sixteenth-Century Japan*, Works Issued by the Hakluyt Society, 3rd series, 7 (London: Hakluyt Society, 2001), 150. There is little known of the actual appearance. For more information, see Matsuoka Toshirō, *Ōsaka-jō no rekishi to kōzō* (Tokyo: Meicho Shuppan, 1988), 86. For hypothetical reconstructions of the hall, see Sakurai Narihiro, *Sengoku meishō no kyojō: Sono kōzō to rekishi wo kangaeru* (Tokyo: Shin Jinbutsu Ōraisha, 1981), 128–29; Miyakami, *Ōsaka-jō*, 79. Also, see Miyamoto, *Kenchikuka Hideyoshi*, 67.

19. Luís Fróis relates that the dry-stone platform on which the hall was erected collapsed mid-construction due to heavy rain. Fróis, letter Miyako 18 September 1596, fol. 232.

20. Ōta Shōko, "Fukuzoku girei to jōkaku no shōhekiga," in Ike Susumu, ed., "Tenka tōitsu to Chōsen shinryaku", vol. 13 of *Nihon no jidaishi* (Tokyo: Yoshikawa Kōbunkan,

2003), 261–307. Thanks to Mark Erdmann for alerting me to Ōta's essay. For more, see Futaki Ken'ichi, *Buke girei kakushiki no kenkyū* (Tokyo: Yoshikawa Kōbunkan, 2003), 218–82.

21. This claim is based on Miyakami's hypothetical reconstruction of Azuchi Castle's donjon as a structure of 12 × 11 *ken*. Miyakami, "Azuchi-jō tenshū no fukugen," part 1, 7. For context, see Erdmann, "Azuchi Castle," 216–18.

22. On the Paradise Bridge, see Kitagawa, "Ōsaka fuyu no jin zu byōbu," 13–15; Kitagawa Hiroshi, "Ōsaka-jō zu byōbu," *Ōsaka tenshukaku kiyō* 35, no. 3 (2007): 12–13. The name of this bridge may be older than Hideyoshi's Osaka Castle. The site had been occupied by the Ishiyama Honganji, the fortified headquarters of the True School of the Pure Land, who resisted Oda Nobunaga for years. See Miyamoto, *Kenchikuka Hideyoshi*, 66. This does not, however, speak against a metaphorical use of this name in Hideyoshi's times.

23. This identification is supported by ink inscriptions on the rear of some of the metal fittings of the *karamon* that were detected during conservation work. See Hirai Kiyoshi, "Hōgonji karamon," in Suzuki Kakichi, ed., *Kenzōbutsu*, vol. 5 of *Kokuhō daijiten* (Tokyo: Kōdansha, 1985), 388. The architectural historian Satō Taiki has investigated the structural characteristics of the karamon gateway and concluded that its conversion from a bridge is technically possible and plausible. See Satō Taiki, "Hōgonji karamon," *Nihon Kenchiku Gakkai taikai gakujutsu kōen kōgaishū: Kyūshū* (August 2008): 21–22.

24. One *palmo* is about 22 cm. The dimensions are therefore about 176–198 cm × 88 cm.

25. Literally, "sculptures" (*esculturas*).

26. Likely, Konishi Josei 小西如清 (dates unknown).

27. One *braça* is approximately 2.2 m, making the bridge about 22 m long.

28. "Mando hazer vna magnifica Puente sobre la caua de la fortaleza que va para esta sobredh̃a sala de mil tatamis cubierta ꝑ ensima cõ las tejas doradas, y en el medio de la Puenta se eleuanta vna torre zita de dos so brados, la qual tiene en cada canto vna manʳᵃ de estandartes q̃ son quatro en cada canto el suyo de ocho v nueue palmos de ⁺ cumplido y quatro de ancho de ⁺ latõ dorado cõ mil quentos de esculturas, Paxaros, y aruoles, ally cortados que quedando colgados está resplandeçiendo al sol, y dã grande lustre a la mesma torre, y los palos q̃ atrauiessẽ por sima de vna parte y della otra ⁺ como para ⁺ en cuesto, está dorados de Naxinji, y el mesmo saelo de la puẽ ⁺ te cõ tantos ornamẽtos de ⁺ Masoneria, y laminas de uarios modos y maneras doradas cõ obras muy primas de grandes oficiales Plateros, q̃ afirmo el gouer nador del Sacay a vn padre nr̃o hablandole desta Obra que el gasto que se a uia hecho en la puente, q̃ sera de diez braças poco mas o menos especialmᵗᵉ ꝑ el mesmo Oro y grande hechura q̃ ally se metio, ymportaua mas de 15000. ducados." Fróis, letter Miyako 18 September 1596, 232v. Transcription by Patrick Schwemmer. Translation by Bebio Amaro, edits by the author.

29. "次豊國明神ノ鳥井ノ西_、廿間斗ノ二階門建立・大阪極楽橋ヲ被引了・二階ノ垂木少々出来了、中間ノ二階ハ猶自余ヨリモ高キ也、柱以下悉蒔繪也、下ノ重圓柱悉黒漆也、組物採色也、結構驚目耳." Iyanaga Teizō et al., eds., *Gien jūgō nikki*, 4 vols., *Shiryō sanshū, Kokiroku-hen* 48, 65, 71, 145 (Tokyo: Zoku Gunsho Ruijū Kanseikai, 1976), 1:170, entry Keichō 5/5/12. The last phrase, "it profoundly dazzles eyes and ears," is a frequently used statement of astonishment that incorporates a synesthetic aspect. Cf. the discussion in Andrew M. Watsky, *Chikubushima: Deploying the Sacred Arts in Momoyama Japan* (Seattle: University of Washington Press, 2004), 188.

30. From here on, "Kawakami screen." Illustrated in Ōsaka-jō Tenshukaku, ed., *Ōsaka-zu byōbu: Keikan to fūzoku o saguru: Tokubetsuten* (Osaka: Ōsaka-jō Tenshukaku Tokubetsu Jigyō Iinkai, 2005), 6, no. 1. The surviving two panels once belonged to a larger vista of Osaka. My thanks to Kitagawa Hiroshi for making the screen accessible for inspection.

31. This screen can be dated on stylistic grounds to the second quarter of the seventeenth century. The screen was taken apart and its individual panels mounted to the walls of a chi-

noiserie interior during the eighteenth century. See Franziska Ehmcke and Barbara Kaiser, eds., *Ōsaka Zu Byōbu: Ein Stellschirm mit Ansichten der Burgstadt Ōsaka in Schloss Eggenberg* (Graz: Universalmuseum Joanneum, 2010).

32. These screens, showing Kyoto and Osaka, respectively, can be dated to the eighteenth century on stylistic grounds. Illustrated in Ōsaka-jō Tenshukaku, *Ōsaka-zu byōbu*, 10–11, no. 2.

33. This assumption is based on (1) style; (2) internal evidence, such as buildings that were not in existence after the period's end; and (3) the fact that visual celebration of Toyotomi monuments became a risky dissident view after the Tokugawa regime's consolidation. It is therefore more likely that Toyotomi loyalists would rather have old paintings copied than new compositions made.

34. A well-known pair of six-panel folding screens in the Osaka Castle Museum depicts the final battle of the 1615 Summer Campaign. This pair of screens is thought to date from before 1644. The donjon is represented entirely in black. Illustrated in Kuwata Tadachika et al., eds., *Sengoku kassen-e byōbu shūsei*, 6 vols. (Tokyo: Chūō Kōronsha, 1980–81), 4:31–34. Another pair of six-panel screens in the Tokyo National Museum depicts the Winter Campaign of 1614–15. These screens date from the nineteenth century but are likely copies of preparatory sketches for a documented (now lost) pair of screens made by Kano Tan'yū in 1616. The castle is only sketched with light color washes, as is the entire screen. The donjon is notated with "black color" (*sumi no gu* スミノグ), however. Illustrated and discussed in Kuwata et al., *Sengoku kassen-e byōbu shūsei*, 4:2–5.

35. For more on architectural lacquering, see Watsky, *Chikubushima*; Anton Schweizer, *Ōsaki Hachiman: Architecture, Materiality, and Samurai Power in Seventeenth-Century Japan* (Berlin: Dietrich Reimer, 2016), 137–51. The pervasive use of lacquer at the Toyotomi-era Osaka Castle has been confirmed by archaeology. For lacquered and partially gilded roof tiles excavated in the *honmaru*, see Ōsaka-shi Bunkazai Kyōkai, ed., *Ōsaka jōseki*, VI (2002), 25–26, figs. 18 and 19. For lacquered and polychromized ridge tiles excavated at vassal residences in the southwest of the castle proper, see Ōsaka-shi Bunkazai Kyōkai, ed., *Ōsaka jōseki*, IV (1999), 81 and 85–86, figs. 62–63.

36. The two techniques differ mostly in the type of metal particles used. For more, see Taishū Komatsu and Katō Hiroshi, *Shitsugeihin no kanshō kiso chishiki* (Tokyo: Shibundō, 1997).

37. The meaning of the word "comedias" is discussed in Patrick Schwemmer, "Ōsaka-jō honmaru o Iezusu-kai Nihon hōkoku no genpon kara yomitoku," *Nō to kyōgen* 13 (2015): 153–65, here 157.

38. Literally, "stuck his hand so much [in it]."

39. *Gōtenjō* 格天井. Literally, "the revetments on the above [part]" (*aforros por ensima*).

40. "Delante desta sala en vn hermozo Campo mando hazer vn teactro para en el se reprezentar comedias. tenia de vna parte y de otra alguntanto a partado dos torres de tres v. quatro sobrados una sea rruyno cõ la lluuia y mato tres v. quatro pᵃs. metio tanto la mano Tayco en esta obra del teatro q̃ quezo exediese a todas las otras fabrias q̃ hasta agora tenia hechas en lindeza, per feiçiõ, y gasto, las columnas q̃ son de palo y el pauimiento v. tablado esta todo ⁺ cubierto de un varniz ⁺ prieto, q̃ aca se llama vruxi, q̃ quedan como espejos muy reluzientes y todo esto dorado de Naxinji, q̃ es Oro molido em poluo cõ grande ⁺ artificio alli estampado. ⁺ Los aforros por ensima llenos de Esculturas y grande copia de laminas doradas hechas cõ uarias lauores, y juntamᵗᵉ se uã haziendo otras casas de muy rica y lustrosa hechura al derredor de la mesma fortaleza." Fróis, letter Miyako 18 September 1596, fols. 232r–232v. Transcription by Patrick Schwemmer. Translation by Bebio Amaro, edits by the author.

41. The precise location of this stage remains unclear. Miyakami suggests a position in the north and outside of the inner enceinte, so that an audience seated in the Hall of One Thousand Mats would have gazed at the stage across the castle moat. See Miyakami, *Ōsaka-jō*, 78–79. Evidence for this hypothesis is, however, lacking.

42. Schwemmer speculates about one (or even two, in an unprecedented doubling) of the towers containing the dressing room(s) (*kagami no ma* 鏡の間). See Schwemmer, "Ōsaka-jō honmaru o Iezusu-kai Nihon hōkoku no genpon kara yomitoku," 156. This would, however, necessitate a connection to the stage through a covered corridor (*hashigakari* 橋掛り), which is not mentioned in Fróis's account. Hideyoshi himself seems to have intended to perform in a lead role for the Ming envoys. It is uncertain if these plans were realized. See Steven T. Brown, *Theatricalities of Power: The Cultural Politics of Noh* (Stanford: Stanford University Press, 2001), 128.

43. A similar ensemble survives at the Main Hall of Tsukubuma Shrine 都久夫須麻神社 at Chikubushima. See Watsky, *Chikubushima*.

44. For more, see Naitō, "Azuchi-jō no kenkyū"; Miyakami, "Azuchi-jō tenshū no fukugen"; Erdmann, "Azuchi Castle."

45. The earliest true tenshu is assumed to have been built by Oda Nobunaga between 1569 and 1570 at the first Nijō Castle in Kyōto; see Takahashi Yasuo and Matthew Stavros, "Castles in Kyōto at the Close of the Age of Warring States: The Urban Fortresses of the Ashikaga Shoguns Yoshiteru and Yoshiaki," in *Japanese Capitals in Historical Perspective: Place, Power and Memory in Kyōto, Edo and Tokyo*, eds. Nicolas Fiévé and Paul Waley (London: Routledge Curzon, 2003), 56–57. Cf. Erdmann, "Azuchi Castle," 246–330.

46. "天主重ゝ之様子、是又言説か及ましく候、書載などハ隙を明候、橋敷以上九ツ。寄特神變不思議との申事候、三國無雙とも可申候哉." See Ōita-ken Kyōikuchō Bunkaka, ed., *Ōtomo Sōrin shiryōshū*, 5 vols. (Ōita: Ōita-ken Kyōiku Iinkai, 1994), 5:215. Sōrin, also known as Sōteki 宗滴, Yoshishige 義鎮, or Francisco, was received in audience at Osaka in Tenshō 14 (1586)/4/5.

47. "九層高く聳え、天に近く、雁門を立て、咸陽宮も、是程にこそありけめ." Kurokawa Mamichi, et al., eds., *Tosa monogatari*, 2 vols. (Tokyo: Kokushi Kenkyūkai, 1914), 1:484. The entry for Motochika's reception is dated to Tenshō 14 (1586)/1. On Yanmen 雁門 (J. Ganmon), see Victor Cunrui Xiong, *Historical Dictionary of Medieval China*, Historical Dictionaries of Ancient Civilizations and Historical Eras, 19 (Plymouth: Scarecrow Press, 2009), 615. On the inconsistency of text sources regarding the number of stories, see my note 11.

48. For background, see Maria Khayutina, *Qin: The Eternal Emperor and His Terracotta Warriors* (Bern: Bernisches Historisches Museum and Zürich: Neue Zürcher Zeitung, 2013), 118–29. I am indebted to Lukas Nickel for pointing me to this publication.

49. Charles Sanft, "The Construction and Deconstruction of Epanggong: Notes from the Crossroads of History and Poetry," *Oriens Extremus* 47 (2008): 160–76.

50. For the Chinese text, see Zhonghua Shuju, ed., *Shiji*, vol. 1 of *Ershisi shi* (Beijing: Zhonghua Shuju, 1997), 69 (256). For English translations, see Sanft, "Construction and Deconstruction," 164, and Burton Watson, trans., *Records of the Grand Historian by Sima Qian: Qin Dynasty* (Hong Kong: Research Center for Translation, Chinese University of Hong Kong and New York: Columbia University Press, 1993), 56. It is not entirely clear from the text if this large venue is a building or rather a terrace or square.

51. "五步一樓，十步一閣 . . . 廊腰縵迴，簷牙高啄 . . . 金塊珠礫." For the Chinese text, see Ouyang Zhuo, annot., *Du Mu ji* (Changsha: Yuelu Shushe, 2001), 1–2. The English translation is adjusted from Sanft, "Construction and Deconstruction," 169. A more literal translation of the last four characters is "gold bullion and pearl pebbles."

52. Text and annotated translation in Erdmann, "Azuchi Castle," 493–501; see also 71.

53. On the Eight Views of Xiaoxiang, a celebrated group of vistas in poetry and painting, see Alfreda Murck, *Poetry and Painting in Song China: The Subtle Art of Dissent* (Cambridge, MA: Harvard University Press, 2000).

54. "宮高大似阿房殿." Erdmann, "Azuchi Castle," 499.

55. On Nanka's biography see Watsky, *Chikubushima*, 133–36 and 287n89.

56. "爲復道、自阿房渡渭、屬之咸陽、以象天極閣道絶漢抵營室也." Zhonghua Shuju, *Shiji*, 69 (256). English adjusted from Sanft, "Construction and Deconstruction," 164. Interpolations in square brackets are mine. Watson translates gedao as "Heavenly Apex star" and yingshi as "Royal Chamber star." See Watson, trans., *Records of the Grand Historian*, 56. Sanft identifies gedao as six stars belonging to Cassiopeia and yingshi as part of Pegasus.

57. On the symbolism employed by Qin Shihuangdi, see Mark Edward Lewis, *The Construction of Space in Early China* (Albany: State University of New York Press, 2006), 171. For a reconstruction of the actual palace at Epang, see Kinoshita Hiromi, "Qin Palaces and Architecture," in Jane Portal, ed., *The First Emperor: China's Terracotta Army* (Cambridge, MA: Harvard University Press, 2007), 83–93. Geomantic considerations played a significant role far into the seventeenth century, though alignment with the cardinal directions was observed far less consequently in Japan in comparison with China.

58. I am not claiming that this particular painting was known in Momoyama-period Japan. On the transmission of Chinese architectural paintings to Japan and their role in the formation of China-related imagery, see Shane McCausland, "The Dublin Chōgonka Scrolls by Kano Sansetsu," in Shane McCausland and Matthew P. McKelway, eds., *Chinese Romance from a Japanese Brush: Kano Sansetsu's Chōgonka Scrolls in the Chester Beatty Library* (London: Scala, 2009), 39.

59. For background, see Inagaki Hisao and Harold Steward, trans. and annot., *The Three Pure Land Sutras: A Study and Translation from Chinese* (Kyoto: Nagata Bunshodo, 2000); Mimi Hall Yiengpruksawan, "The Phoenix Hall at Uji and the Symmetries of Replication," *Art Bulletin* 77, no. 4 (December 1995): 647–72.

60. See my note 28.

61. Money L. Hickman, "Notes on Buddhist Banners," *Boston Museum Bulletin* 71, no. 363 (1973): 4–20; Okazaki Jōji, *Butsugu daijiten* (Tokyo: Kamakura Shinsho, 1995), 105.

62. The fragment was excavated in two pieces in 1977 and 1993 in Hōenzaka, a neighborhood southwest of the castle where residences of some of Hideyoshi's highranking vassals were located. See Ōsaka-fu Bunkazai Chōsa Kenkyū Sentā, ed., *Naniwa to Ōsaka-jō: Hakkutsu sokuhō ten* (Minami Kawachi: Ōsaka Furitsu Chikatsu Asuka Hakubutsukan, 2001), 30.

63. Miyamoto Masaaki, "Kinsei shoki jōkamachi no wisuta ni motozuku toshi sekkei—sono jittai to imi," *Kenchiku shigaku* 4 (March 1985): 69–91; Miyamoto Masaaki, *Toshi kūkan no kinseishi kenkyū* (Tokyo: Chūō Kōron Bijutsu Shuppan, 2005), 295, fig. 7/4, and 381, fig. 8/22. Miyamoto suggests that even some shorter streets and individual buildings were oriented toward the donjon. Precursors include the castle town of Ōmi Hachiman and, in less pronounced form, Azuchi. On the latter, see Miura, ed., *Yomigaeru shinsetsu Azuchi-jō*, 42–43 and 48–49.

64. See Matthew G. Stavros, *Kyōto: An Urban History of Japan's Premodern Capital* (Honolulu: University of Hawai'i Press, 2014), 8.

65. For further comparison, see what Mark Erdmann calls the "discovery of verticality" in the sixteenth-century development of the *yagura* watchtower. Erdmann, "Azuchi Castle," 246–247.

66. See Miyamoto, *Toshi kūkan no kinseishi kenkyū*, 458, fig. 10–1, and 466–67.

67. On the implications of monumentality, see Susan A. Stewart, *On Longing: Narratives of the Miniature, the Gigantic, the Souvenir, the Collection* (Baltimore: Johns Hopkins University Press, 1984), 70–103.

68. In addition to the visits of Ōtomo Sōrin, Chōsokabe Motochika, and the Jesuit group discussed in the main text, early audiences include: in Tenshō 12 (1584)/4/26, two emissaries of Kennyo 顕如, abbot of Honganji temple. See Watanabe Takeru, *Toyotomi Hideyoshi o saihakkutsu suru* (Tokyo: Shin Jinbutsu Ōraisha, 1996), 88; in Tenshō 13 (1585)/12, two retainers of the Mōri family, Kobayakawa Takakage 小早川隆景 (1533–97) and Kikkawa Mo-

tonaga 吉川元長 (1548–87). See Theodore M. Ludwig, "Chanoyu and Momoyama: Conflict and Transformation in Rikyū's Art," in Paul Varley and Kumakura Isao, eds., *Tea in Japan: Essays on the History of Chanoyu* (Honolulu: University of Hawai'i Press, 1989), 86; in Tenshō 16 (1588)/9/11, Mōri Terumoto 毛利輝元 (1553–1625). See Sakurai, *Toyotomi Hideyoshi no kyojō*, 1:109.

69. Ōita-ken Kyōikuchō Bunkaka, ed., *Ōtomo Sōrin shiryōshū*, 5:213–19.

70. On the Golden Tea Room, see Kuwata, *Toyotomi Hideyoshi kenkyū*, 511–12; Saitō, "Yamazato to sōan," 180. Hideyoshi served tea to the emperor at the imperial palace in Tenshō 14 (1586)/1/16. The Golden Tea Room was subsequently employed at the Great Kitano Tea Gathering of 1587; see Louise A. Cort, "The Grand Kitano Tea Gathering," *Chanoyu Quarterly* 31 (1982): 32. A golden tea room was employed, moreover, to entertain a Chinese emissary in Bunroku 2 (1593)/5/25 at Nagoya Castle in Hizen, but it is disputed if this was the identical room. See H. Paul Varley and George Elison, "The Culture of Tea: From its Origins to Sen no Rikyū," in George Elison and Bardwell L. Smith, eds., *Warlords, Artists and Commoners: Japan in the Sixteenth Century* (Honolulu: University of Hawai'i Press, 1981), 218–19.

71. Miyakami hypothesizes that the Golden Tea Room was set up in the so-called Kuroshoin wing of the reception palace; see Miyakami, *Ōsaka-jō*, 57.

72. See Beatrice Bodart, "Tea and Counsel: The Political Role of Sen Rikyu," *Monumenta Nipponica* 32, no. 1 (Spring 1977): 49–74, here 56–57.

73. The letter, Shimonoseki 17 October 1586, is published in Tenri Daigaku, *Cartas*, vol. 2, 175v–177v. For this essay I have consulted the slightly longer version in Fróis's *History of Japan*; see Jose Wicki, ed. and trans., *Luís Fróis: Historia de Japam*, 5 vols. (Lisbon: Biblioteca Nacional, 1976–84), 4:229–233; for a selective translation in English, see Michael Cooper, *They Came to Japan: An Anthology of European Reports of Japan 1543–1640* (London: Thames and Hudson, 1965), 136–38. I thank Mark Erdmann and Bébio Amaro for granting me access to their new translation. Also cf. Miyakami, *Ōsaka-jō*, 63.

74. "[C]omo se fora hum homem particular." Wicki, *Historia de Japam*, 4:230.

75. On the *kunimi* rite, see Gary L. Ebersole, *Ritual Poetry and the Politics of Death in Early Japan* (Princeton: Princeton University Press, 1989), 23–28; Jacqueline Pigeot, *Michiyuki-bun: Poetique de l'Itinéraire dans la Litterature du Japon Ancien* (Paris: Maisonneuve et Larose, 1982), 42–47. Obviously, Hideyoshi was inspired by Nobunaga's similar visual strategies at Azuchi; see Matthew P. McKelway, *Capitalscapes: Folding Screens and Political Imagination in Late Medieval Kyoto* (Honolulu: University of Hawai'i Press, 2006), 169–70. Also, cf. Schweizer, *Ōsaki Hachiman*, 283–99.

76. For background, see Edward Kamens, *Utamakura, Allusion, and Intertextuality in Traditional Japanese Poetry* (New Haven: Yale University Press, 1997).

77. The gaze from a raised observation deck was a rare attraction still in the nineteenth century. See Timon Screech, "The Strangest Place in Edo: The Temple of the Five Hundred Arhats," *Monumenta Nipponica* 48, no. 4 (Winter 1993): 407–28, here 419.

78. Sōrin records two or three girls of twelve or thirteen years; see Ōita-ken Kyōikuchō Bunkaka, *Ōtomo Sōrin shiryōshū*, 5:217. Motochika saw several female attendants and estimates their age at about seventeen to twenty years; see Kurokawa et al., eds., *Tosa monogatari*, 1:484.

79. The estimate is from Kuwata, *Toyotomi Hideyoshi kenkyū*, 403.

80. Nene is also known under her official title, Kita no Mandokoro 北政所, and her later monastic name, Kōdaiin 高台院. Hideyoshi's concubines Chacha 茶々 (Yodo-dono 淀殿, 1567/69?–1615) and Matsu no Maru 松の丸 (Kyōgoku no Tsubone 京極局, ?–1634) resided in the second and fourth enclosure, respectively. See Kuwata, *Toyotomi Hideyoshi kenkyū*, 403.

81. Fróis specifies the woman as *huma só bicunin*, that is, a Buddhist nun (*bikuni* 比丘尼). Wicki, ed., *Historia de Japam*, 4:229.

82. Kuwata, *Toyotomi Hideyoshi kenkyū*, 407. Besides female attendants there is evidence only for the presence of Buddhist clergy and tea masters, the latter of which belonged, at least ostensibly, to the ranks of the Buddhist monks too. See Miyakami, *Ōsaka-jō*, 65.

83. This may have been modeled on practices initiated by Nobunaga at Azuchi. Cf. Erdmann, "Azuchi Castle," 41.

84. The English translation is George Elison's; see "The Cross and the Sword: Patterns of Momoyama History," in George Elison and Bardwell L. Smith, eds., *Warlords, Artists and Commoners*, 55. "さるほとに、大閤ひてよしこう、御しゆつせより此かた、日ほんくにくに、きんぎん、さんやにわきいて . . . むかしは、わうこんを、まれにもはひけん申事、これなし。とうしは、いかなるでんぶやじんにいたるまで、きんきん、たくさんにもちあつかはずといふものなし。" Keiō Gijuku Daigaku Fūzoku Kenkyūjo Shidō Bunko, ed., *Taikō-sama gunki no uchi*, 2 vols. (Tokyo: Kyūko Shoin, 1975), facsimile 1:3–4 and transcript 2:3–4.

85. On panoramic paintings as political devices, see McKelway, *Capitalscapes*, passim and in particular 164–77. Suzuki Hiroyuki, "Byōbue ni okeru 'shajitsu:' Naizen-bon 'Toyokuni saireizu' to chūkū no shikaku," in Kokusai Kōryū Bijutsushi Kenkyūkai, ed., *Tōyō bijutsu ni okeru shajitsu*, Kokusai Kōryū Bijutsushi Kenkyūkai Shinpojiamu, 12 (Osaka: Kokusai Kōryū Bijutsushi Kenkyūkai, 1994), 75. On the folding screen panels in Eggenberg Castle (Graz, Austria) depicting Toyotomi-era Osaka, see Ehmcke and Kaiser, eds., *Ōsaka zu byōbu*.

PART III

Defining Margins

Views of Victory

The Landscapes of the Battle of the Boyne

Finola O'Kane

The River Boyne is not Ireland's longest river, nor does it flow through any of Ireland's five cities, as currently designated (figure 6.01).[1] Neolithic sites, medieval towns, castles, houses, and great demesnes line the river's banks, as they do all of Ireland's rivers. Yet, arguably, no Irish river so connects events and sites of such significance to Ireland's history. Rising at Newbury in County Wicklow, the river then draws a broad arc to reach the sea at the port of Drogheda, where Oliver Cromwell (1599–1658) won victory from royalist forces in 1641. Some fifty years later, on the morning of 12 July 1690, King William III (1650–1702) rode down the cleft of King William's Glen to ford the Boyne at Old-bridge and meet the Catholic armies of James II (1633–1701) on the opposite bank. As the one and only time that Ireland was an arena of European war, the Battle of the Boyne led to the definitive victory of the Protestant William III over the Catholic James II. Other battles followed before the Glorious Revolution's English throne and Protestant religion were definitively established, but the Battle of the Boyne has continued to hold the most commemorative power.

In the sixteenth century the Dissolution of the Monasteries, instigated by Henry VIII (1491–1547) in England, saw the mass of Great Britain's population convert from Catholicism to Protestantism. The same mass conversion did not occur in Ireland, where the vast majority of the population remained Catholic, leading to the correlation of Protestant with English and Catholic with Irish. A constituent kingdom of the English Crown since medieval times, Ireland's Parliament sat in College Green, Dublin, retaining considerable administrative independence until the Act of Union of 1800.[2] Yet the financial and political control of London increased inexorably, and by the late seventeenth century the kingdom of Ireland was very much a part of the great empire that was being

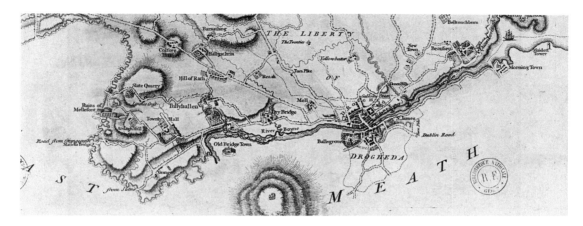

Figure 6.01. Detail of the Boyne Valley from Matthew Wren, *A Topographical Map of the County of Louth* (London: Printed and sold by Andw. Drury, 1766). 65 × 49.5 cm. Bibliothéque nationale de France, Département cartes et plans, GE DD-2987 (2658, 1). Beaulieu is in the top right corner of the image.

slowly accumulated. Oscillating between province, home country and colony, in Ireland the British Empire developed many of its most successful and disastrous imperial strategies, from plantation to governance, in this edge country of the British Isles.

As the site of these two great cataclysms—the siege of Drogheda and the Battle of the Boyne—the valley became the spatial crucible of ascendancy Ireland, and its subsequent design development was intended to cast both the eye and the mind back to these formative events. In the case of Drogheda, the town's existing medieval gates and ruins became the foci for designed prospects. Employed initially by the military to visually survey the site, these prospect points were then repurposed to represent its novel reworked geometry in maps and paintings while also structuring the designed landscapes and their buildings. For the large, low, and complex battle site, an obelisk built in 1736 structured the sightlines of the many designed landscapes that spun around it. Catholic or suspect convert houses often betrayed other loyalties by looking elsewhere for their foci, with many of the valley's older ruins and impressive Neolithic mounds pressed into service, being demonstrably not those of the new order.

An imperial landscape, such as that of Versailles or Hampton Court, has no need to displace the center, as Drogheda's ruins and the obelisk did for the many landscapes that used it as a point of origin. At an empire's core, all spins unquestionably about the house, and there is no need to strengthen its position by reference to a military and alternative point of consequence. Yet at the edge of empire—as Ireland was in 1690— the central nodes are not sufficiently powerful to act in isolation. History, site, and aspect must all be marshaled together to

Figure 6.02. View of Beaulieu House and its church, County Louth. Photograph by Finola O'Kane, 2016.

form a convincing survey, a calculated accumulation of bearings to incontrovertibly position a conquest. Individually weak, their cumulative strength lies in a profligate use of time, purpose, orientation, and seductive imagery. Such massed views of victory together created a court landscape at the edge, which is arguably where its vocabulary was at its most ingenious, contrived, and manipulative. Families who lived along the Boyne's banks chose to represent the battle in various artistic practices, the overarching one being landscape design. The vocabulary and tone of military engineering affected such designed landscape features as moats, terraces, grassed inclines, eye-catchers, and choice of axes. Because of such efforts, the power lines of the battle persisted.

The Protestant hero Sir Henry Tichbourne (1581–1667) had successfully withstood the long siege of the town of Drogheda by Catholic rebels in 1641. In recognition of this exceptional service to the Protestant cause, Oliver Cromwell granted him land at Beaulieu, County Louth, in the 1650s. In 1660 he began building Beaulieu House, one of Ireland's earliest houses of a non-defensive nature (figure 6.02).[3] Turned eastward to face the town of its owner's military victories, Beaulieu has Drogheda as its place of origin and allegiance—a relationship vividly described in an overmantel painting in Beaulieu's hall (figure 6.03 [plate 16]). There, the town and its ruins frame Drogheda's principal villa, each pos-

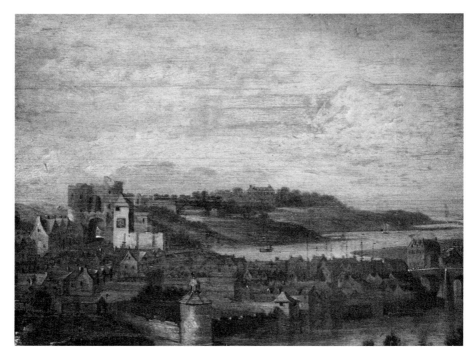

Figure 6.03. Detail of Johann van der Hagen, *Overmantel view of Drogheda, Co. Louth with Beaulieu House in the background*, ca. 1740. Beaulieu House, Drogheda, County Louth, Ireland. Photograph by Finola O'Kane, 2016.

sessing the other from a discrete yet visible distance. Above the hall door a plasterwork semicircular frieze of Williamite weaponry proclaims both the family's loyalty to William III's Crown and the military service that had won them the estate. Exiting the house, the Tichbournes' Protestant church flanks the central avenue, subjugated geometrically to the master axis of house, town, and family (see figures 6.01 and 6.02), and replicating spatially Henry VIII's subjugation of church to crown. Caught within the confines of this villa landscape, the church's position explains the sequence of events that brought the Tichbournes' ascendancy, and that of their religion, to pass.

The landscape's key bearings were further reinforced in Beaulieu's interior, where the central upper windows fix the ruins of Drogheda's high Magdalen Tower carefully on the western horizon (figure 6.04). Henry Tichbourne's grandson, also called Henry, was half brother to the distinguished gardener Robert Molesworth (1656–1725) of Breckdenston, County Dublin.[4] Prospects, and what could be seen strategically from houses and gardens, dominated design discussions between Molesworth and Tichbourne, with the "pleasantest part of ye ground" consistently assessed as that which boasted a "fine prospect." Beaulieu's geometry was laid out with reference to Drogheda and its ruins, phys-

Figure 6.04. View of Drogheda's Magdalen Gate viewed on axis from the central window of Beaulieu's west elevation. Photograph by Finola O'Kane, 2016.

Figure 6.05. Beaulieu's west boundary castellated brick wall and the public road leading down to the Boyne. Photograph by Finola O'Kane, 2016.

ical remnants of the siege that Henry Tichbourne had successfully withstood. Views of the landscape from without were as important as views from within, and, as at Breckdenston, "fine palisades" were combined with a "great gate" to ensure that the landscape's design was perceived to be "very grand & magnificent to ye country for some miles" (figure 6.05).[5] The landscape's extension by axial projection was a driving design intention. Point bearings, when combined with axes, could dramatically extend the garden's lines of power far into the countryside. To the south, terraces stepped down to the Boyne's banks, while the adjacent kitchen garden benefited from their extension into its walled enclosure. Beaulieu's landscape design, like that of Breckdenston, also employed water features of some hydraulic complexity in its design. West of the public road that ran across the grounds the Tichbournes constructed an artificial lake surrounded by a semicircle of stepped grass terraces (see figure 6.01). This grass stage surrounding a central pond lay on the same axis that led visually to the ruin of Drogheda's Magdalen Tower, the remnant of a Dominican friary destroyed by Cromwell's forces (see figures 6.01 and 6.04). Jonathan Swift's (1667–1745) 1726 response to the same ruins as distressing evidence of "the modern way of planting colonies—*et ubi solitudinem faciunt, id imperium vocant* [They make it a desert and call it an empire]"—reveals the potential of such prospect points to harshly focus and divide opinion, even between those of the same religion. Arriving in Drogheda, Swift's "first mortifying sight was the ruins of several churches batter'd down by that usurper Cromwell." Leaving the town itself, Swift "cast [his] eyes around from the top of a mountain, from whence [he] had a wide and a waste prospect of several venerable ruins."[6] Standing where he could survey the scene, as military men had done before him, Swift's interpretation of the past through its physical prospect points diverged utterly from the Tichbourne family's point of view.

Prints depicting the Battle of the Boyne were engraved rapidly in its aftermath. The cartographer George Story (1664?–1712) produced a topographical plan of the battle that was published as an illustrative plate in his rather less than *Impartial History of the Wars of Ireland*.[7] Bearing a legend to key both the landscape's geographical features and the strategic movements of the Jacobite and Williamite forces, it was oriented south upward so as to adopt the Williamite point of view, with "S" locating the point closest to the viewer as the "hill from whence his Majesty (William III) first saw the Irish camp" (figure 6.06). Two routes were proposed: a faint dotted road leading to the walled town of Drogheda (A) or the insistent cleft of King William's Glen; this drew the eye toward (F), marking the place where the battle's most dramatic and potentially traumatic incident occurred, "the place where his Majesty was in danger of being killed." Clearly dividing the two camps into "Irish" and "English," the legend had none

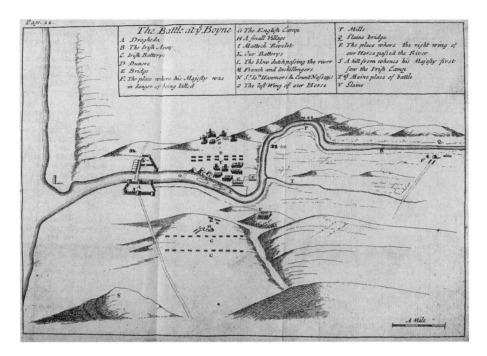

Figure 6.06. "Ye Battle at ye Boyne," from George Story, *An Impartial History of the Wars of Ireland . . .* (London: Richard Chiswell 1693), 22.

of the ambiguity of later interpretations, and the personal specificity of (K), for "Our Batterys," revealed an openly partisan agenda. The wider frame of reference was fixed by the walled town of Drogheda (A) to the east and "Slaine bridge" (Q) to the west. The "Maine place of Battle" (T) on the south bank of the river is placed at the center of the print, with the tower of Donore church (D) on the horizon above it. The profiled line of hills above the bend of the Boyne and the careful inclusion of minor rivulets and key outcrops, prospect points, spires, and houses all fix the landscape from this viewpoint, providing the viewer with a set of landscape features with which to correctly survey the scene.

These "survey features" were then carefully transferred into early paintings of the battle, of which Jan Wyck (1645–1702), the Dutch artist, was the most prolific creator.[8] One such painting describes the precise events of the 11th and 12th of July 1690, where the actions and directions of the participants are palpable, heightened by the aural impressions created by the guns, the powder, and the invariably rearing and charging horses (figure 6.07 [plate 17]). Battle paintings of the Boyne all depict a landscape setting structured by the same strategic topographical features, such as the town of Donore, the glen of approach, the spires of Drogheda, and the various bridges, fords, and roads. These images of victory all typically take the same point of view, evoking that of King William ap-

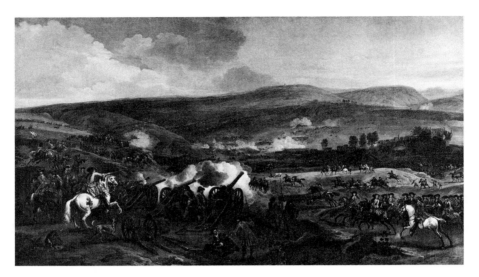

Figure 6.07. Jan Wyck, *The Battle of the Boyne, 12 July, 1690,* 1693. Oil on canvas, 223 × 386.5 cm. The National Gallery of Ireland, NGI.988.

proaching the Boyne from the north. Structurally they follow the ideal plan formation of the battle so clearly expressed in the topographical plan. Arrayed on a height overlooking the massed infantry fording the river, William and his officers cast their gaze beyond the river toward the town of Donore, the mountain pass to the south, and the road to Dublin. Painted from a point west of King William's Glen, the topographical prospect points, those from the battle itself and those toward which the victors proceeded, give the painting a directional momentum from foreground to horizon.

As Chandra Mukerji has pointed out, topographical "prints seemed designed to be sold to members of a military culture that located pleasure in surveying and taking the measure of lands."[9] This practice of surveying, of viewing landscapes from a height while accurately noting the position of landmarks relative to one another, is also a fundamental precursor to the accurate measured survey, confiscation, and redistribution of land.[10] This had taken place in Ireland during the period 1640–60, reducing the Catholic (typically conflated with Irish, not always accurately) share of profitable land from 59 percent to between 8 and 9 percent of the total, with most of the Catholic share located in the west of Ireland.[11] The Catholic total was increased to 20 percent by the Acts of Settlement and Explanation in the 1660s but reduced again by the confiscations and redistributions that took place in the aftermath of the Williamite campaign, when parts of the Boyne Valley were parceled out to the professional generals and soldiers who had fought there for the Glorious Revolution, a Protestant ascendancy, and the land survey, confiscation, and redistribution that followed.[12] Be-

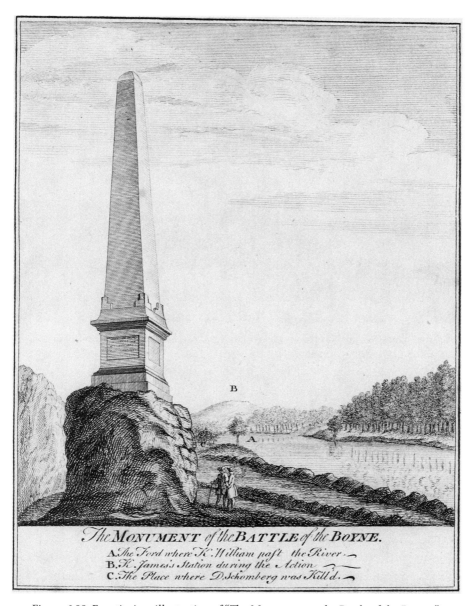

Figure 6.08. Frontispiece illustration of "The Monument to the Battle of the Boyne," from Thomas Wright, *Louthiana, or an Introduction to the Antiquities of Ireland* (London: W. Faden, 1748).

low the outcrop where King William had caught a stray bullet, subscribers paid for the construction of a great obelisk in 1736 (figure 6.08). Commemorating where the Williamite foot had forded the river, the obelisk also focused and reduced a field of battle to a precise place, its upward projection compensating for its lowly location. The pleasure that Mukerji describes is derived not only from

Figure 6.09. The author climbing the Wonderful Barn, Castletown demesne, County Kildare. Photograph by Neil Crimmins, 2010.

the military gentleman's practice of military power but also from the pleasure and power of landownership, and Protestant families soon employed the new obelisk as a strategic bearing from their demesnes.[13]

Prints of the obelisk followed its construction with an advertisement in April 1745 announcing the speedy publication of "The Obelisk at the Boyne and the adjacent country, with references where the most remarkable actions happened."[14] An obelisk in the Irish landscape typically comes to constitute a pivot around which many landscapes turn. The greatest of all Irish obelisks is the Conolly obelisk, an abstract, arched composition that ties together many landscapes across the plains of Kildare. In 1719 Henry Tichbourne's half brother Robert Molesworth had "acquainted our two Lord Chief Justices," one of whom was William Conolly (1662–1729), "and some other gentlemen with Mr. Switzer's ability & his design to visit Dublin."[15] Stephen Switzer (1682–1745), principal landscape designer of the early eighteenth century, probably advised both Molesworth and Conolly, who had acquired substantial estates by speculating in land in the years following the Williamite victory. The Conolly obelisk in turn derived to another folly of strange and compelling design—the spiral form of the Wonderful Barn of Castletown House (figure 6.09). Both built to terminate avenues extending from the house, they were also substantial public works pro-

jects. Commissioned as a benevolent response to the severe winters and famines of 1739–43, they were both built by Katherine Conolly (ca. 1662–1752), William Conolly's widow. The Wonderful Barn, like the Boyne and Castletown obelisks, is a manmade prospect point and was identified as such on a 1744 map that included "A Table of Bearings of several Gentleman's Seats and Eminent Places" with the "Mighty [Wonderful] Barn" located at twenty-four degrees to the southeast.[16] Providing bearings for the design of all the large-scale landscape axes, the table indicated how Kildare's natural (hills) and human-made prospects (obelisks, etc.) were laid out. The fixed bearings also grounded the fey spiral form of the Wonderful Barn, as the disorienting spiral motion of ascending the structure is balanced by distant prospects of fixed structures, framed by alternately circular and triangular windows.[17]

Carefully fixing the battle's position by obelisk also ensured that the north-south vector of the battle could be replaced by views looking along the river. While Beaulieu had looked to Drogheda for its bearings, later Boyne houses positioned themselves by obelisk, with Oldbridge House taking up a fashionably oblique relationship (figure 6.10). Placed to address both the obelisk and the field of battle, the house carefully stepped clear of the battle's exact footprint. Its con-

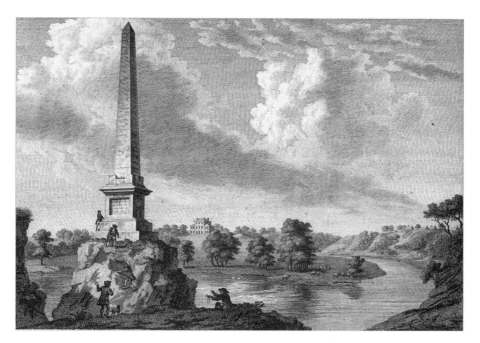

Figure 6.10. William Angus and William Walker, "Obelisk in Memory of the Battle of the Boyne," after Paul Sandby, *The Virtuosi's Museum* (London: George Kearsley, 1778 [–81]), Plate XVIII. Etching, 15.6 × 19.9 cm. The British Museum, London, 1870,1008.544.

struction also replaced the unseemly huddle of Oldbridge town, depicted by Jan Wyck at the riverside (see figure 6.07 [plate 17]), with the smooth contours and artful clumps of a Brownian landscape garden. Publishing it as Plate XVIII of *The Virtuosi's Museum*, Paul Sandby took care to reproduce the inscription that appeared on the fourth face of the obelisk's base:

> IV Sacred to the glorious memory of King William the III who, on the 1st [*sic*] of July, 1690, passed this river near this place, to attack James II, at the head of a popish army, advantageously posted on the south side of it, and did on that day, by a successful battle, secure to us, and to our posterity, liberty, laws, and religion. In consequence of this action, James II. left this kingdom, and fled to France. This memorial of our deliverance was erected in the 9th year of the reign of George the II. the first stone being laid by Lionel Sackville, duke of Dorset, lord lieutenant of the kingdom of Ireland, 1736.[18]

In landscape design a river makes a pleasant boundary that blurs the rude lines of property into a fluid meander, and borrowed vistas of other people's properties proliferate when no walls disturb the view. The alternative river orientation also brought the extraordinary prehistoric landscape of the Bend of the Boyne into play, with its many passage graves, mounts, embanked enclosures, barrows, and standing stones judiciously employed to suggest a preordained aspect to the more recent history. "Druidic" monuments, when imported into the landscape garden, finessed an imperfectly understood past into a triumphalist present. Further upstream from Oldbridge stood Dowth demesne, where a modest eighteenth-century house lay caught between western vistas of the Netterville family's old church and castle and the northeastern obelisk and distant spires of Drogheda (figure 6.11; also figure 6.01). Home to a family of pronounced ambivalence toward both Oliver Cromwell and the Glorious Revolution, Dowth's loyalties are not as easily unpicked as those of Beaulieu, although the family's survival implies some degree of compromise with the Williamite victory.[19] Carefully flanked by two passage tombs and the great prehistoric Neolithic mound of Dowth to the west and by the great embanked enclosure now called Site Q to the east, Dowth's prominent earthen monuments, together with those of Knowth and Newgrange, today make the Boyne Valley a prehistoric World Heritage Site. Knowledge of such sites was at a very preliminary stage in the mid-eighteenth century, yet the site's design indicates that such large earthworks did not escape the eighteenth-century affinity for large-scale landscape design. In the eighteenth century, landscape was understood as a changing sequence of views or tableaux, marked and emphasized by

Figure 6.11. Dowth Hall, County Louth, ca. 1915. The Irish Architectural Archive, 024_003_X_001. Reproduced courtesy of the Irish Architectural Archive.

exceptional stages along these routes, which formed the highlighted vistas. A visitor to Dowth was drawn through the parkland before glancing off the ancient embankment. At this point of compression, between mound and river, the house came into view (figure 6.12). Drogheda's spires were carefully caught at this vantage point, with the obelisk structuring other views along the route.

The antiquarian artist Gabriel Béranger (ca. 1729–1817) completed two drawings of Dowth's archaeological monuments. His circa 1775 watercolor of Lord Netterville's teahouse on top of Dowth Mound suggests the eighteenth-century taste for building small leisure buildings or miniature viewing platforms near sites of "Druidic" activity (figure 6.13 [plate 18]).[20] Omitted from the 1766 Matthew Wren map of the Boyne Valley (see figure 6.01), the Boyne's great henges were carefully depicted by the antiquarian and eye surgeon Sir William Wilde (1815–76), father of the more famous Oscar, in an interesting palimpsestic map of the Boyne battle landscape for his book, *The Beauties of the Boyne, and Its Tributary, the Blackwater*, in 1849.[21] He took the battle plan, marked in the military maneuvers, changed it to the standard north-up orientation and superimposed the valley's Neolithic and medieval monuments (figure 6.14). Later analyses of the Boyne Valley have tended toward the political by omitting dis-

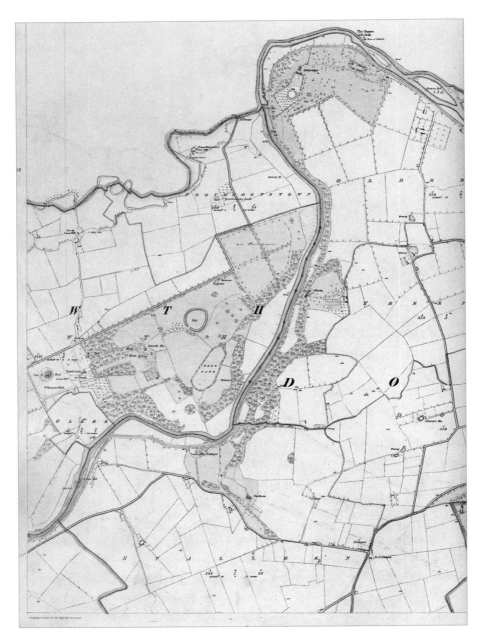

Figure 6.12. Ordnance Survey map of County Meath, scale 1:10560, sheet 20 (Surv 1935), first edition, engraved 1837. Showing Dowth demesne, its complex approach route, and the Boyne obelisk. Reproduced courtesy of Trinity College Dublin.

Figure 6.13. Gabriel Béranger, *View of Dowth Neolithic mound, with Lord Netterville's summerhouse*, ca. 1775. From the Béranger Sketchbooks, the Royal Irish Academy, 3C 30 F5.

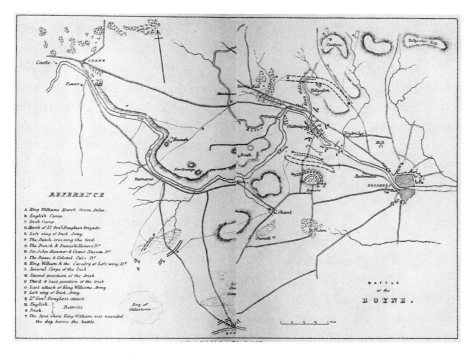

Figure 6.14. Plate of "The Battle of the Boyne" from William Wilde, *The Beauties of the Boyne, and its tributary, The Blackwater* (Dublin: James McGlashan, 1849), ["to face page 248"].

Figure 6.15. Thomas Mitchell, *A View of the River Boyne with Gentlemen and Horses by a Statue to William III in the Foreground, the Boyne Obelisk beyond*, 1757. Oil on canvas, 106.8 × 175.5 cm. National Museums Northern Ireland, BELUM.U4813.

cussion of the landscape's redesign in the battle's aftermath and the role of the obelisk in that process.[22]

Views of the victory shifted focus over time. The battle paintings looked southward to emphasize the route to Dublin via the town of Donore (see figure 6.7). While the river and the distant sea feature, the action is turned toward the site of battle and the precise events of the 11th and 12th of July 1690. Later paintings abandoned the strategic geography of the battlefield for the more charming setting of the river valley. Looking eastward and seaward in the direction of England, Thomas Mitchell's (1735–90) painting of the Boyne obelisk is "an elaborate composition incorporating Grinling Gibbons' transposed equestrian statue of William III, which in reality stood on College Green, Dublin," site of the eighteenth-century Irish Parliament before the Act of Union of 1800 (figure 6.15 [plate 19]).[23] Projected backward in time to become an antique Roman general crowned in laurel, William sits in the shade of a "sacred" grove. Lance in hand, he stares stoically toward England, his throne there secured by the battle here. By making the event archaic—with the real William long departed, leaving a stone replica in his stead—the "monument" attains the stature of a more distant past. Turned to the same orientation as Oldbridge House, William directs his own gaze and that of the viewer toward the obelisk. This point of view is then redirected toward the spires of Drogheda and the high Magdalen gate at

Figure 6.16. The stump of the Boyne obelisk with tricolor. Photograph by Finola O'Kane, 2010.

the upper left of the silhouette, the same gate that fixes the eye along the main axis of Beaulieu. Positioned firmly on the left, northern bank, William's position approximates that of Townley Hall, seat of the loyal Balfour family, while to the right, the mound of Newgrange draws Neolithic antiquities into the narrative. Pointing hands command the direction of view, and William's viewpoint is

echoed by the many gentlemen leading horses, remnants themselves of the battle's military equestrianism.

Sight survey combined with sober land measurement to create a new network of state power. The Boyne Valley landscapes "were not just marvels to transfix the viewer," they also acted as laboratories for demonstrating the victor's "capacities to use the countryside as a political resource for power."[24] Carefully caught into the new web were the older prospect points of ruins, churches, and burial mounds woven together with the new master node of the Boyne obelisk. Begun as the reinforcement of a war-torn landscape, the early villa of Beaulieu connected axially with the town of Drogheda. Mimicking the preference of battle paintings to document a carefully edited sequence of events, Beaulieu's new landscape design echoed the overt geometry of siege warfare. Other landscapes, such as those of Oldbridge and Dowth, refigured that geometry by placing the Boyne obelisk in a more oblique relationship to the house and by seductively linking the ancient with the new in the design of both route and vista. Once constructed, the obelisk became a favored frontispiece. Employed to introduce Ireland's earliest book of antiquities, Thomas Wright's (fl. mid-18th c.) *Louthiana or an Introduction to the Antiquities of Ireland* of 1748 (see figure 6.08), it was also the leading image for George Taylor and Andrew Skinner's 1778 *Maps of the Roads of Ireland*, thereby becoming a key bearing for all those traveling through Ireland by road.[25] The built memorial to King William's crossing of the Boyne became an emblem for the Protestant Ireland of his victory, contriving to compress a country's identity into one battle and its legacy.

Landscape interpretation in Ireland tends to give marks and emblems of ownership precedence. This arises from the fact that the legal title to land was typically in dispute between one section of the community and another. As ownership of land became conditional upon loyalty to the Crown of England and thence to the Protestant religion, questions surrounding the identity of the owner of a property and the manner of its acquisition could overwhelm any ancillary intentions. Owning land invariably overpowered beautifying land, and the many veils of progressive land "improvement" parted only to reveal the naked power of "mine." Edge territories are places where the ownership of land remains perceptually contested, even if the armored men with guns have long disbanded. Court landscapes at the center of empire have little need of the contorted spatial transfers from battle site to obelisk, military road to winding river, real site to landscape painting, reality to representation that this history describes. If they do engage in such transfers, aesthetic motives may dominate the design intent. At the edge, past events, and the memory of those events, have to be carefully controlled and often manipulated. Changing and altering how land

is perceived, both by the conquered and by the conquerors, is essential for any imperial project.

At its most fundamental, much landscape design, and some of its representation, is concerned with the correct identification of ownership, whether by boundary wall, map, or estate portrait. The route by which a real battle site is progressively reimagined by topographical map, obelisk, landscape garden, and landscape painting serves to reinforce the essential legal title to the land that each artistic practice represents, if at progressively more distant removes. These "re-moves," and the twists, turns, and reorientations that take place, distract both mind and eye from the naked power dispute between two kings that took place at the battle site. Distracting attention from the real site to its spatial, architectural, and pictorial representation, the more cumulative the removes the more convincing the process.

The many paintings of the battle continued to transcend and manipulate, through landscape, the overt expression of political victory, with Dutch, French, English, and Irish identities invoked to create a smoother transnational narrative, an objective that continues to the present day. Ireland continued to be reoriented in painted views with the oppositions between north and south, east and west, closely correlated with English and Irish, newcomer and native. With both William's equestrian statue at College Green in Dublin's city center and the Boyne obelisk destroyed by bombs in the 1920s, the political power of such artifacts has carried down the centuries, and the refusal to consider them as purveyors of aesthetic narratives alone, a factor in the Irish public's acceptance of "public" art and "designed" landscape.[26] The obelisk's stump now typically boasts the Republic of Ireland's tricolor, and its symbolic territorial power continues, albeit in ruin (figure 6.16 [plate 20]). A lodge of the Protestant Orange Order from Northern Ireland has recently acquired both site and stump, with the express intention of reconstructing the obelisk. While this would restore the legibility of the Boyne's designed landscape, it would also add overtones of triumphalism, which neither time nor subsequent history have muted, that complicate its restoration. For the Boyne's landscape continues to be a homeland of Irish identity and the bearings people choose to follow in that valley, a precise ground map of its slow and contested formation.

Notes

1. Drogheda was arguably a city in the past but under the Local Government Act 2001 it became a town.

2. The Kingdom of Scotland was amalgamated with the Kingdom of England (which encompassed Wales) to form the Kingdom of Great Britain in 1707. The Kingdom of Ireland

was amalgamated with the Kingdom of Great Britain by the Act of Union in 1800 forming the United Kingdom.

3. Terry Clavin, "Tichbourne (Tichborne), Sir Henry," in *Dictionary of Irish Biography* (Cambridge University Press, online edition), https://www.dib.ie/biography/tichbourne-tichborne-sir-henry-a8553, accessed 2 August, 2021.

4. For Robert Molesworth's influence over Irish landscape design, see Finola O'Kane, *Landscape Design in Eighteenth-Century Ireland; Mixing Foreign Trees with the Natives* (Cork: Cork University Press, 2004), chap. 1.

5. Letter from John Tichborne to Robert Molesworth, 23 July 1710. National Library of Ireland, Molesworth Ms. P 3753.

6. James Wooley, ed., *Thomas Sheridan and Jonathan Swift, the Intelligencer* (Cambridge: Cambridge University Press, 1992), 87–88.

7. George Story, *An Impartial History of the Wars of Ireland with a continuation thereof from the time that Duke Schonberg landed with an army in that kingdom, to the 23rd of March, 1691/2 when their majesties proclamation was published, declaring the war to be ended. Illustrated with copper sculptures describing the most important places of action. Together with some remarks upon the present state of that kingdom by George Story, Chaplain to the regiment formerly Sir Tho. Gower's, now the Earl of Drogheda's; An Eye-witness of the most remarkable passages* (London: Richard Chiswell, 1693), 22, "Ye Battle at ye Boyne." This was also sold as a print; for example, "The Battle of ye Boyne, Drogheda (Plan)," National Maritime Museum, Greenwich, London, PAD 1465.

8. In the sense of the word "survey's" older meaning from the French "surveier," or overlook.

9. Chandra Mukerji, *Territorial Ambitions and the Gardens of Versailles* (Cambridge: Cambridge University Press, 1997), 86.

10. For a description of the physical survey methods employed in Ireland in this period see John Harwood Andrews, *Plantation Acres* (Omagh, Co. Tyrone: Ulster Historical Foundation, 1985).

11. Sean Connolly, *Religion, Law, and Power: The Making of Protestant Ireland 1660–1760* (Oxford: Oxford University Press, 1992), 13.

12. On the increase of the Catholic total to twenty percent, see Connolly, *Religion, Law, and Power*, 15.

13. The website The Down Survey of Ireland, TCD (http://downsurvey.tcd.ie, accessed 2 August 2021), allows for the interrogation of the valley's 1641 and 1670 ownership patterns on an interactive GIS map platform. While much of the valley was in Protestant hands in 1641, some families visibly expanded their landholdings in the 1641–1670 period, notably the Tichbournes.

14. Walter Strickland, *A Dictionary of Irish Artists* (Shannon: Irish University Press and Hacker, 1968), 107: "John Brooks Line Engravings and Etchings by Brooks The Obelisk at the Boyne. *I. Tudor Pinx. J. Brooks & Crofts scul.* A folio print with lettered references to the localities, and a dedicatory inscription in Latin to the Duke of Dorset, Lord Lieutenant 1731–37. An advertisement in April, 1745, announces the speedy publication by Brooks of 'The Obelisk at the Boyne and the adjacent country, with references where the most remarkable actions happened.' The only impression of this print met with belongs to Mr. B. R. Balfour of Townley Hall, Drogheda."

15. Edward Malins and the Knight of Glin, *Lost Demesnes: Irish Landscape Gardening, 1660–1845* (London: Barrie and Jenkins, 1976), 16.

16. "A Table of Bearings The Mighty Barn SE 24," in Charlie Baylie and John Mooney, *A Map of the Demeasne of Carrtown Together with a map of the Adjacent Lands intended for a Deer-park*, February 1744. National Library of Ireland, Ms. 22,500.

17. For an analysis of the Wonderful Barn's design and its connection to eighteenth-century military theory and dance theory and practice, see Finola O'Kane, "Military Memory Manoeuvres in Dublin's Phoenix Park 1775–1820," in Anatole Tchikine and John Dean Davis, eds., *Military Landscapes* (Washington, DC: Dumbarton Oaks Research Library and Collection, 2021), 311–30.

18. Paul Sandby, *The Virtuosi's Museum* (London: G. Kearsly, 1778 [–81]), plate XVIII.

19. For the Netterville family's political and religious allegiances, see Jane Ohlmeyer, *Making Ireland English: The Irish Aristocracy in the Seventeenth Century* (New Haven: Yale University Press, 2012), appendix 2.

20. Peter Harbison, *Beranger's Rambles in Ireland* (Bray: Wordwell, 2004), 26, 48.

21. William Wilde, *The Beauties of the Boyne, and its tributary, The Blackwater* (Dublin: James McGlashan, 1849).

22. The most recent of these is the conversion of Oldbridge House and Demesne into The Battle of the Boyne Interpretative Centre. The archaeological dig that informed the museum's design brought a sustained focus to the immediate battlefield and the various military maneuvers. See Conor Brady, Emmet Byrne, Gabriel Cooney, and Aidan O'Sullivan, "An Archaeological Study of the Battle of the Boyne at Oldbridge, Co. Meath," *Journal of Conflict Archaeology* 3, no. 1 (2008): 53–77, https://eprints.dkit.ie/265. The museum's interpretation strongly suggests that Louis XIV was extremely significant in this history, in turn deflecting political attention away from the battle's Catholic and Protestant protagonists, namely, James II and William III, respectively, both of whom have long and problematic commemorative legacies in the North of Ireland in particular.

23. Anne Crookshank and Desmond FitzGerald, the Knight of Glin, *Ireland's Painters* (New Haven: Yale University Press, 2002), 73–74

24. Mukerji, *Territorial Ambitions*, 2.

25. George Taylor and Andrew Skinner, *Taylor and Skinner's Maps of the Roads of Ireland* (Dublin: W. Wilson, 1778).

26. Wout Troost, "William III," *Dictionary of Irish Biography*, https://www.dib.ie/biography/william-iii-a9044, accessed 2 August 2021. On 1 July 1701, the Dublin corporation had unveiled an equestrian statute of William, by Grinling Gibbons, on College Green. This became the focal point for both public celebration and political protest, in the latter case as early as 1710, when it was defaced by Trinity College, Dublin, students with Tory or Jacobite sympathies. The statue was blown up in 1836 but subsequently reerected, surviving until 1929, when it was destroyed by a bomb.

Delineating the Sea

Maritime Law and Painting in Willem van de Velde the Elder's Sea-Drafts

Caroline Fowler

In his 1609 treatise on the rights of commonwealths over the expanse of the sea, the Dutch legal scholar, humanist, and theologian Hugo Grotius (1583–1645) wrote that "a ship sailing over the sea no more leaves behind itself a legal right than it leaves a permanent track."[1] Grotius's comparison between a "legal right" and a "permanent track" introduces one way in which questions about property law at sea fundamentally differ from property law on land. While property owners on land may establish their territory through borders and fences, the ability to claim ownership on the fluid, nearly formless waves remains less tangible. Moreover, as Grotius's choice of the word "track" illustrates, the sea connects (and separates) landmasses. Yet, unlike the ability to build fences and other visible claims of ownership on land, at sea, for Grotius, it is nearly impossible to demarcate territory. The inability to claim property rights over the dominion of the sea made it a common pathway for emerging nations in the seventeenth century to explore and exploit. As Grotius asked: "Can the vast, the boundless sea be the accessory of one kingdom alone, and that not the greatest? Can any one nation have the right to prevent other nations, which so desire, from selling to one another, from bartering with one another, actually from communicating with one another?"[2] To these rhetorical questions, Grotius's treatise answered a resounding no. The sea cannot, by its boundless nature, be the accessory of a territorial power. The sea must exist as a shared ground on which all nations may build their capital. Nevertheless, the nature of the sea was a subject of debate in the seventeenth century as emerging nation-states sought to govern the passageways across this undefined space. In order to

argue against the ability of a single state (such as the Dutch Republic or England) to control the passage of ships across the sea, Grotius and other jurists sought to define the nature of this body of water on which it remains impossible to "leave a permanent track."

While an essay on water may seem out of place in a volume dedicated to landscapes and gardens, the development of landscape as a construction of imperial identity can only be understood in the context of the oceans, the expansive conduits of trade and travel described by Grotius. In recent histories of mobility and trade across the oceans, the physical presence of water as a space for passage, domination, trade, and death is beginning to be considered.[3] As a study of early marine painting in the context of maritime law demonstrates, the idea of an abstracted, dematerialized oceanic space served emerging nation-states seeking to dominate and form an imagined ease of exchange. While the correlation between "ways of seeing" and landscape painting has been explored by geographers and art historians, there has been little consideration of how the simultaneous development of seascape painting intersects with and diverges from the previous models presented in relationship to land.[4] Drawing on the concept that landscape acts as a catalyst in the construction of national identities, an idea developed in the work of W. J. T. Mitchell in *Landscape and Power* and Denis Cosgrove in *Social Formation and Symbolic Landscape*, seascape too must be considered in the formation of national identities.[5] Both landscape painting and seascape painting expanded as independent genres separate from history painting in the sixteenth and seventeenth centuries, often painted by artists who specialized in both land and sea, such as the Dutch painter Jan van Goyen (1596–1656). Yet there has been increased attention among scholars about the divergences between conceptualizing the emergence of early modern globalism in relationship to the sea as opposed to the land.[6] James Elkins described landscape as "something we inhabit without being different from it; we are in it, and we *are* it."[7] In contrast, the sea resists inhabitation.[8] For Grotius, the sea cannot be occupied, and for this reason legal jurists presented the sea as a common ground for trade and commerce in the seventeenth century.[9]

The legal and written discourses on maritime law by Grotius and other seventeenth-century legal theorists contextualize the seventeenth-century development of marine painting and its increasing popularity as a genre, particularly as both the Dutch and the English governments were key patrons of seascapes.[10] To consider how legal writings surrounding the rights of nations over waterways come to bear on marine painting, this essay looks at the career trajectory of a central innovator of this genre, Willem van de Velde the Elder (1611–93), who immigrated to England from the Dutch Republic. Known as a consummate "sea draftsman," van de Velde the Elder and his son Willem van de Velde the Younger

(d. 1707) established themselves in England as painters of seascapes and maritime battles. In the discipline of art history, the van de Veldes are considered the main pictorial influence for establishing marine painting as a genre in England.

This chapter limits itself to a discussion of van de Velde the Elder, who is celebrated for his *penschilderijen*, monochromatic paintings on a prepared panel that simulate engraving.[11] In contrast to the father's monotone palette, the son is remembered for his attention to color, light, and water. While the Elder concentrated on the accurate portrayal of ships' construction and their strategic placement on the sea, the Younger focused on atmosphere, light, and the reflection of the water itself. Scholars trace the development of marine painting in England to the latter tradition formed through the study of fluctuating meteoric conditions in the Younger's work. Yet a consideration of the Elder's career shows a different perspective to maritime painting's development in the seventeenth century, particularly the Elder's inventive use of penschilderijen, in which he mimicked the linear black and white tones of engraving with drawings on canvas in ink. Picturing the ocean as an uninhabited void contrasts to landscape painting in this period, in which the genre engages with the specificity of territorial demarcations and borders. When seen from the viewpoint of the Elder's monochromatic palette and bare delineation of water, the seascape emerges as an articulation of an empty space on which ships could journey unhindered from port to port, carrying goods, passengers, and enslaved persons. This space has no markers or characteristics of a geographic locality, as it is the common space of the emerging capitalist markets.

A Common "Ground"

During the first Anglo-Dutch War (1652–54), van de Velde the Elder sailed in his own *galjoot* (a small ship) with the Dutch Navy.[12] From the deck of his vessel, he captured in rapid strokes on paper the movements and positions of Dutch squadrons across the waters. He made drawings while sailing with the Dutch Navy as studies for his painted compositions, which were completed later in the studio. The drawings themselves were also collectors' objects and could be touched up later in the studio with light brushes of gray wash. Throughout this war and the two subsequent Anglo-Dutch Wars (1652–54, 1665–67, 1672–74) van de Velde used wide blank sheets of paper to pictorially recount famous battles, such as the Battle of Scheveningen in 1653, the epic losses of the Dutch in the Battle of Lowestoft in 1665, the Four Days' Battle in 1666, and the Battle of Solebay in 1672, among other engagements.

Figure 7.01. Willem van de Velde the Elder, *Episode from the Four Days Battle, 11–14 June 1666*, 1666. Pencil and brush on paper, 21.5 × 172.7 cm. Rijksmuseum, Amsterdam, RP-T-1886-A-715.

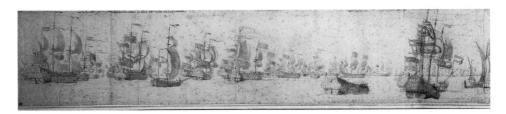

Figure 7.02. Willem van de Velde the Elder, *The English and Dutch Fleets on the Day After the Battle of Solebay*, 1672. Graphite and gray wash on paper, 68.2 × 246 cm. National Maritime Museum, Greenwich, PAJ3045.

While van de Velde first documented the naval battles at sea from the perspective of the Dutch Republic, he immigrated to London in the early 1670s at the behest of the English royals and began to work from the English perspective.[13] He left the company of the Dutch Navy for the English, moving from a declining maritime power to an emerging maritime nation. From London, he recounted the end of the Anglo-Dutch Wars from a different point of view, creating compositions for the English court and capturing images of the naval battles that memorialized the English gains and losses.[14] The documentation of the Anglo-Dutch Wars from the perspective of both the Dutch and the English—the fluidity of his patrons and alliances, and his transition from Amsterdam to London—points toward a relationship to state and sea formed by a perception of the sea as an open site for commerce and trade.

The van de Veldes, father and son, produced works for prominent patrons in the Dutch Republic, England, and Italy, including the Dutch naval hero Cornelis Tromp (1629–91) and his family, the Dutch Council of State, Cardinal Leopold de Medici (1617–75), Charles II (1630–85), and the Duke of York (1633–1701).[15]

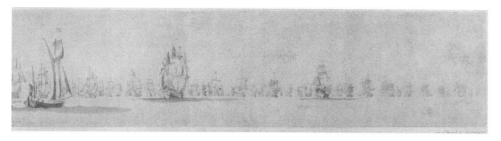

Figure 7.01. (*continued*)

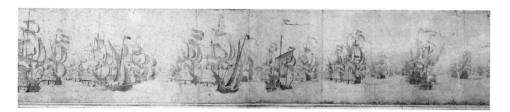

Figure 7.02. (*continued*)

As stated, the Elder first sailed with the Dutch Navy and drafted the movements of the fleet. He later sold these drawings to the Dutch Council of State.[16] He then became the navy draftsman for the English after he moved to London. His arrival in England no doubt aided Lord High Admiral James Stuart, Duke of York, later James II, who was seeking to establish the Royal Navy and place it "on a permanent and increasingly professional footing."[17] The Elder's stipend from the king was paid by the navy treasurer, demonstrating the close interrelationship between van de Velde's work and the navy's conscious attempt to fashion itself in line with its developing maritime policy.[18] The pictorial capabilities of the Elder helped the Stuart monarchy shape a vision of the new Royal Navy as a rising maritime force. Nevertheless, the tools, craft, and seascapes that he employed for the Stuart monarchy to shape a vision of the Royal Navy were no different from those that he used to depict the Anglo-Dutch Wars for Dutch patrons from a "Dutch" point of view.

By comparing the drawings that van de Velde completed while working under the patronage of the Dutch and English navies, it may be seen that his style, palette, and delineation of sea and ships remained unchanged from Amsterdam

to London. In a study of the strategic placement of ships on open waters during the Four Days' Battle (figure 7.01), he drafted the wooden bodies casting their shadows, soft reflections in gray wash, against the white ground of paper. There is an absence of water and atmosphere (the formal characteristics of a seascape). The Elder's drawings are structured by monochromatic gray line and white paper as a background for the detailed construction of ships. This monotone palette and drawing style, fastidious attention to ship detail and rigging, and weightless swathes of gray wash continues in his work for the English Navy, as may be seen in *The English and Dutch Fleets on the Day After the Battle of Solebay* (figure 7.02). The indefiniteness of the gray wash marks the unshaped representation of the ocean's uninhabitable space. Yet the stylistic or particularization of a "point of view" from the Dutch to the English does not exist in the Elder's work. The sea is neither "Dutch" nor "English." This diverges from the development of landscape painting in the seventeenth century, a genre that became increasingly devoted to topographical specificity.[19] Drafted for the Dutch and English navies (at different points in time), the Elder's drawings reveal that the documentation, which was relevant to both sides, was to capture how ships temporarily occupied an empty space embodied in the white sheets of paper. The drawings stand as singular testaments and accounts of the temporary passage of these nations across the uninhabitable waters.

In a recent volume of essays that frames the centrality of the ocean in early modern expansion, globalization, and the discipline of art history, scholars defined the sea as a "social space" as opposed to an "uninhabited empty space."[20] This construction of the sea as a social space offers a lens through which to consider the work of van de Velde, who captured with pen, ink, and wash the interactions that occurred over the open waterways. He drafted the battles between the Dutch and the English during the Anglo-Dutch Wars and the diplomatic journeys that ensued in the Channel between the Dutch Republic and England. He recorded Charles II's departure from Scheveningen to England to take the throne. He also captured on paper Mary of Modena's (1658–1718) journey across the Channel to marry James II. Nevertheless, the events that he represented are passageways, interactions defined by a terminus, whether naval victory, defeat, or royal coronation. While it is fundamental not to view the ocean as empty, it is also necessary to appreciate the liminal qualities of this social space.

As Philip Steinberg has argued, in the seventeenth century maps began to use "a grid over an essentially featureless ocean." There are no "discernible topographical ocean features on these figures," unless they are "a utilitarian and beneficial landmark."[21] For Steinberg, the imaging of the ocean as "an empty space to be crossed by atomistic ships" was crucial to an "ocean-space construction (and the scientific outlook) that was to predominate during the following

centuries of industrial capitalism."[22] Van de Velde's representation of the sea as a navy draftsman for the maritime nations of the Dutch Republic and England mirrors this development in mapmaking. Like the cartographic ocean devoid of topographical features, his ocean is a vacant space for the movement of ships. The sea in van de Velde's work becomes a no-place space defined by its lack of individual qualities that might denote a geographic site. While contemporary scholarship on the maritime is re-historicizing, materializing, and temporalizing ocean space, the concept of the ocean as an ahistorical, atemporal, empty space may be traced not only to mid-seventeenth-century cartography but also to the drawings and paintings of van de Velde, one of the foremost innovators in the genre of marine painting.[23]

His seas are fluid, atemporal, and ahistorical. These qualities of ahistoricity present the sea as the background for the unfolding of social interactions among emerging nations pursuing hegemony over this supposed "common ground." As one recent historian of the sea remarked, for much of Western history the sea has been seen "as empty: a space not a place. The sea is not somewhere with 'history,' at least not recorded history."[24] The sea is "a space without ruins or other witnesses to the events which may have taken place on its surface."[25] This stands in contrast to landscape painting, which embeds history in the land with ruins, monuments, and markers of human existence. In the absence of the sea's ability to provide witness through footprints, tracks, or monuments on its surfaces, van de Velde acted as witness. With his drawings and paintings, he marked and noted the disappearing tracks left by the Dutch and the English as they sought supremacy (and paradoxically also legal common space) over this vast and boundless waterway.

The Elder's Draftsmanship

Van de Velde's drawings served several purposes. He made delicate and detailed studies of famous ships, known as ship portraits, which were later integrated into larger compositions. After sailing with the Dutch Navy in the first Anglo-Dutch War, he documented the events he witnessed at sea. These works on paper were material for larger panels and were also sold to the Dutch Council of State.[26] The drawings were shown to patrons too, as when Dutch Lieutenant Admiral Jacob van Wassenaer Obdam (1610–65) showed a sketch of a battle by van de Velde to the king and queen of Denmark, reporting, "It has pleased their Majesties exceedingly."[27] Influential English artists also collected the drawings of the van de Velde studio, artists such as Paul Sandby (1731–1809), Joshua Reynolds (1723–92), and J. M. W. Turner (1775–1851).[28]

Looking at the Elder's famous penschilderijen, monochromatic *grisaille* paintings on panel that give the effect of an engraving, in relation to his drawings, one can see how the drawings provide the basis to understanding his paintings. He composed his sketches along a horizon, making a straight line from edge to edge of the paper. He delineated the positions of flutes, frigates, galleys, and yachts in relation to one another and the horizon. The sky stays a blank space of white paper, a background for ships' masts and flags. As with the sky, in the arena of the sea van de Velde shows little interest in the natural elements of wind and water. Working with graphite and wash, he measures out a wide unarticulated space signifying water. In contrast to this minimal attention to atmosphere, his work illustrates an observed knowledge of ships' construction, rigging, sails and winds, tacking and warfare.

His drawings—linear and monochromatic—accompany the style van de Velde developed in painting known as penschilderij. These paintings, valued both by contemporaneous and by later collectors, show a precise attention to the structure of ships. In contrast to this nautical detail, there is an abstraction to the water itself. In both his drawings and his penschilderijen, van de Velde's pictorially realized body of water in which the ships sail is a gray, fluid amorphous space defined by the indefinite smoothness of his wash on paper or his patterned rippling waves on panel. This non-particularized water plays against the presence of the intricate, almost obsessive portrayal of the ship's bodies. The details to which van de Velde attended were the construction of the ships, leaving the sea as an ornamental rippling of waves. The sea remains common in his bare attention to its description of ships. Instead the minutiae of the atomistic ships briefly crossing over that pathway signify "Dutch" or "English."

This imaging of the sea as an empty space for the positions of ships resonates with a commemorative poem on a naval battle by the poet Edmund Waller (1606–87), who entitled the verse "Instructions to a Painter." Waller told the artist to construct a composition as van de Velde the Elder would have, a "formless portion" on which warring navies may meet: "First draw the sea, that portion which between / The greater world and this of ours is seen; / Here place the British, there the Holland fleet, / Vast floating armies, both prepar'd to meet!"[29] Written after the Second Anglo-Dutch War in 1665, Waller's opening stanza invokes the sea as a "portion" on which the Dutch and British sea armies are placed to battle out their commercial rivalries for Baltic herring and Eastern spices. The poet advised the artist to "draw the sea," leaving the image of the sea blank. It exists as that portion which opens onto the greater world, a seemingly infinite expanse on which an artist places, as though pawns on a chessboard, warring naval fleets.

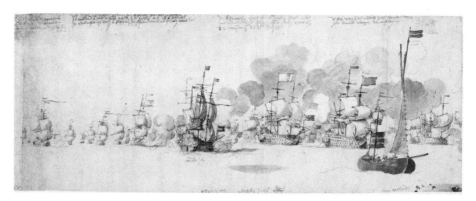

Figure 7.03. Willem van de Velde the Elder, *The English Engage Tromp's Squadron, 11–14 June, 1666*, 1666. Graphite and gray wash on paper, 35 × 86.4 cm. Museum Boijmans van Beunigen, Rotterdam, MB 1866/T 81 a (PK).

Van de Velde's written marks inscribed on the drawings contribute to the absence of atmospheric attention in his drawings. He does not visualize meteoric or temporal conditions. Instead he noted the weather in script. In his drawing of the engagement between the English and Captain Tromp's squadron of 1666 (figure 7.03), he designated the ships' names, including his own galjoot— *mÿn galliodt*. He also registered the positions of the Dutch and English ships in relation to the wind: "No 1 In which position the enemy, being to windward engages us . . . on Friday about midday at one o'clock . . . the 11th June 1666."[30] Van de Velde evoked the chaos of battle with gray clouds of smoke, shaded pencil, and variations of gray wash. Against the formless expanse of the sea and the cannon smoke, he provided order for this unstructured space through recording the time, the weather, and the position of the ships. The conditions of weather and time are not inscribed into the visualization of the sea itself. They remain marginalia, notes in a sparse language for the historic record.

What was a blank space or spread of gray wash in van de Velde's drawings becomes in his monochromatic paintings an area filled in with patterned rippling lines of waves.[31] In one of his large penschilerijen at the Rijksmuseum, *Four Days Battle* (figure 7.04 [plate 21]), mannered pastures of waves provide the background against which the ships fight for control over this indeterminate passageway. Van de Velde focuses on the ships and their placement in relation to one another. The waves and clouds could describe any sea. They are visual signs of a seascape. Against his fastidious attention to the ships from their sculptural programs to their rigging and masts, van de Velde used preestablished repetitions to represent the sea itself. This is a ground that may be

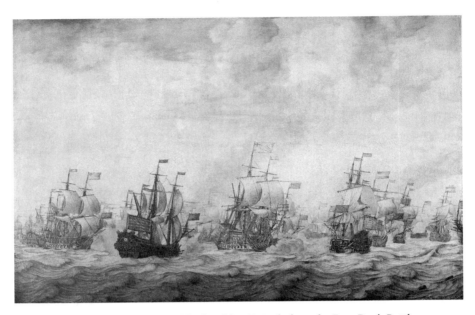

Figure 7.04. Willem van de Velde the Elder, *Episode from the Four Day's Battle, 11–14 June 1666*, 1668. Ink on canvas, 119 × 182 cm. Rijksmuseum, Amsterdam, SK-A-840.

controlled by any land or country, a viewpoint that would have been obvious to him from his tiny galjoot tracking the movements of both the Dutch and the English navies. Against the non-particularized sea, van de Velde placed in juxtaposition to one another the detailed embodiment of emerging nations as displayed in their flags, regalia, arms, and ship heads. It is not the transitory aspects of nature that he captured but the ephemera of history as it unfolded in the no-place space of the ocean. The sea, unlike the land, does not carry monuments on its surface. It is within his drawings and paintings that van de Velde provided documents to testify to the events that occurred over these blank waterways.

The Sea as Common Ground

This image of the ocean as an arena for the placement of ships has been overlooked in discussions of the rise of maritime painting in the seventeenth century. A 2008 exhibition catalogue on marine painting characterizes the primary challenge to sea painters as learning to master "the unstructured elements of air, light and water."[32] Certainly the evocation of these mutable phenomena became

part of the seascape tradition. Yet the preference for masters of "air, light and water" neglects van de Velde maritime work, which displays little attention to these unstructured elements for their own sake. Instead the sea draftsman concentrated on the structure of ships and the placement of warring fleets.

The draftsmanship of van de Velde and his documentation of battling squadrons demonstrate an affinity with the legal discourses in this period. These debates asked whether the ocean was capable of dominion by one state or whether the ocean was a common space. Conceptions of ocean space changed in the seventeenth century as politicians and theorists sought to "craft a governance system appropriate for the emergent era of merchant capitalism."[33] Van de Velde's approach to his craft and the sea complemented the seventeenth-century debates about the status of the ocean in discourses on trade, commerce, and property. Necessary to contextualizing the importance of van de Velde's work for both the Dutch and the English is the debate about the ocean as either *mare liberum* (an unregulated highway for emerging nations) or *mare clausum* (resources controlled by a dominant power).

In 1609, Grotius anonymously published a booklet entitled *Mare liberum* (*On the Freedom of the Seas*).[34] This sixty-eight-page work set off a dispute among jurists, theologians, and mathematicians on fishing rights in the North Sea, piracy, overseas booty, and empire.[35] Written at the request of the VOC (Verenidge Oostindische Compagnie), or Dutch East India Company, Grotius's tract defended the seizure of prize booty (raw silk, damask, gold thread, linen, cotton, sugar, and spices) by the Dutch captain Jacob van Heemskerk (1567–1607) from the Portuguese merchant ship the *Santa Catarina*.[36] Overtaking the *Santa Catarina* in the Straits of Singapore, Heemskerk allowed the Portuguese crew and captain to live, but he sailed back to Amsterdam with a cargo that grossed more than three million guilders after auction.[37] Although the VOC determined that the vessel was seized "in an act of war" and was therefore legitimate, this piratical profit troubled the consciences of certain members of the Company.[38]

Beyond defending Heemskerk's actions and the confiscation of booty, Grotius's treatise proved influential for its engagement with the issue of sovereignty on the open seas and whether or not a king, Parliament, or States-General could claim ownership (*dominium*) over open water. Grotius argued that the sea is a *res communes omnium* (common to all humankind) and therefore cannot be any one person's (or state's) property.[39] Grotius described the sea as infinite like the cosmos, making it impossible to rule: "The question is concerning the whole ocean, which antiquity calleth unmeasurable and infinite, the parent of things bordering upon heaven, with whose perpetual moisture the ancients supposed not only fountains and rivers and seas, but also the clouds and the very stars themselves, in some sort to be maintained, which finally compassing the earth

(this seat of mankind) by the reciprocal courses of tides can neither be kept back nor included and more truly possesseth than is possessed."[40] In short, "the sea is incomprehensible, no less than the air, it can be added to the goods of no nation."[41] Nature does not acknowledge boundaries, borders, or occupation. Only people recognize these demarcations through contract.[42] As property, borders, and contractual obligations developed in early agrarian societies, commerce and trade increased. This gave rise to the Law of Nations, which early modern jurists placed in juxtaposition with the Law of Nature. The Law of Nations is the right to free trade, and it was this that Grotius defended.[43]

Grotius's first opponent was the Scottish mathematician-cum-jurist William Welwood (1578–1622), who wrote *An Abridgement of All Sea-Lawes* (1613). Welwood was concerned not with Dutch trade in the East Indies but with the dominant presence of Dutch herring fleets in the Baltic, and he challenged the rights of the Dutch to fish in Scottish coastal waters. Although Grotius maintained that the resources of the sea (such as herring) were inexhaustible and common to all, Welwood stated that the assets of the ocean were not limitless.[44] The other influential response to Grotius came from the English jurist John Selden (1584–1654), in his 1618 *Mare clausum* (The closed sea). Like Welwood, Selden argued that the sea and its reserves were not inexhaustible.[45] Quoting Seneca, Selden challenged Grotius's conception of the boundless, fluid nature of the Sea: "The *Sea stands without Motion, as it were from dull heap of matter that nature could not bring to perfection.*"[46] Just as the land may be surveyed and framed by ditches, hedges, trees, and mounds, so the sea should be considered finite.[47] "We have high Rocks, Shelves, Promontories opposite to each other, and Islands dispersed up and down, from whence as well direct Lines, as crooked windings and turnings, and angles, may bee made use of, for the bounding of a Territorie in the Sea."[48]

Sir Philip Meadows (1626–1718), once Latin secretary to Oliver Cromwell, carried forward the debate about the sea: closed or open, finite or infinite. His treatise argued against England's pretensions to sovereignty of the seas, while maintaining that coastal waters for fishing should remain within territorial regulations.[49] Meadows, like those before him, described the "Natural State of Things" when "the whole Earth was common and undivided unto all Mankind. Property arose with the developments in 'Arts and Industry.'"[50] Nevertheless, unlike terra firma, the sea is incapable "of Cultivation, or Improvement, by Art or Industry; it may therefore be reasonably supposed, never to have been impropriated by consent, but left to its Primitive and Natural Communion."[51] Meadows compared the sea to the public pathway that cuts through the private field: "The Sea, say we, is the publick Property of the Crown of *England*; but yet as 'tis a Way, 'tis common to the peaceable Traders of all Nations. A Path over a Field is

of some damage to the Soil, though compensated with a greater utility, but a way over the Sea is of no damage to the Water." He concluded that the sea is "a common Highway from one Nation to another."[52]

Although the authors taking sides in the battle of the books restricted themselves to opposing views, they all argued for a stewardship of the ocean, regulating the highways of trade and commerce and keeping them free from piracy.[53] While these juridical debates about the sea's status as mare liberum or mare clausum might seem removed from the sphere of a sea draftsman, the battle of the books provides the historical background by which to understand the stakes in many of the battles that van de Velde documented. Moreover, it contextualizes the abstraction of van de Velde's waters, which would have appealed to two separate navies that both sought to defend a "common sea."

In his penschilderijen van de Velde depicted the sea as a symbolic space pictorialized with model-book waves. This commonness of the sea within the visual choices of his work shaped a national image at sea for both the Dutch and the English. Against the clearly drawn signs of states from the ships' flags to starboards, the sea remains indefinite. Van de Velde conceptualized the fight over this shared space between the Dutch and the English with no identifiable characteristics of land, monuments, or place.[54] The emergence of maritime painting in seventeenth-century England under his stewardship contextualizes his success in both Amsterdam and London. This was a sea that connected two countries as much as it formed a boundary between them. The influence of van de Velde's work in both the Dutch Republic and England demonstrates that the sea was a shared interest (rather than a cultural difference) between England and the Dutch Republic, founded in maritime trade, a commonality that allowed for his success in both emerging nations.[55]

The concept of an ahistorical, atemporal, no-place-space ocean may be seen in the work of van de Velde, which was collected by the leaders of the same nations that hired the jurists to define an image of the ocean for their developing maritime policies. His draftsmanship and documentation of warring fleets reveals the necessity of studying the rise of maritime trade in relationship to the genre of sea painting. Legal discourses in this period explored the ocean as a space capable of dominion by one state or government versus the ocean as a common space. In their debates over the ocean, jurists offered different descriptions, from Grotius's "unmeasurable and infinite" to Selden's "dull heap of matter." Ultimately, van de Velde's drawings and penschilderijen leave this space blank, defining it as neither sublime nor dull. Instead it is the shared-scape of the emergent forces of globalization that would come to make both the Dutch and the English dominant world forces. Unlike land, the watery, mutable, and inhospitable nature of the open waterways tested the ability of early maritime

powers to claim ownership or dominion. This challenge paradoxically allowed both the Dutch and the English to dominate the passageways across the seas with their claims to common ground. The blank depiction of van de Velde the Elder's water expressed a vision of ocean space suited to both emerging nations. A study of his work and the voids in the paper or uniform sweeping semicircles of lines representing water demonstrates that the roots of British maritime painting and its imperial visions may be traced to those trackless waters, where temporally fleeting ships fought for sovereignty over that empty, infinite portion between the greater world and ours.

Notes

1. Hugo Grotius, *Mare liberum, 1609–2009*, ed. Robert Feenstra (Leiden: Brill, 2009), 85.

2. Grotius, *Mare liberum*, 15.

3. See Jennifer Roberts, *Transporting Visions* (Berkeley: University of California Press, 2014); Daniela Bleichmar and Meredith Martin, "Objects in Motion in the Early Modern World," *Art History* 38, no. 4 (2015): 604–19.

4. Recently historians have begun to consider how the relationship between "territory" and the nation-state differs significantly between land and water; see John Mack, *The Sea: A Cultural History* (London: Reaktion Books, 2011), 20–22; Philip E. Steinberg, "Lines of Division, Lines of Connection: Stewardship in the World Ocean," *Geographical Review* 89, no. 2 (1999): 254–64; David Lambert, Luciana Martine, and Miles Ogborn, "Currents, Vision and Voyages: Historical Geographies of the Sea," *Journal of Historical Geography* 32, no. 3 (2006): 479–93.

5. W. J. T. Mitchell, ed. *Landscape and Power* (Chicago: University of Chicago Press, 2002); Denis Cosgrove, *Social Formation and Symbolic Landscape* (Madison: University of Wisconsin Press, 1998). Similarly, Quilley has pointed out that Mitchell's conceptualization of landscape as "the 'dreamwork' of imperialism, as a genre that encapsulates the cognitive and physical assimilation of territory through imperial expansion and which developed at precisely the moment of the growth of European empires," also applies to seascapes. Nevertheless, critical studies remain fixed on the land as opposed to the sea. Geoff Quilley, "Art History and Double-Consciousness: Visual Culture and Eighteenth-Century Maritime Britain," *Eighteenth-Century Studies* 48, no. 1 (2014): 24.

6. Geoff Quilley, "Missing the Boat: The Place of the Maritime in the History of British Visual Culture," *Visual Culture in Britain* 1, no. 2 (2000): 79–92.

7. James Elkins, "Writing Moods," in Rachael Ziady DeLue and James Elkins, eds., *Landscape Theory* (New York: Routledge, 2008), 69.

8. This chapter is considering the specific "history of the sea" in the seventeenth century before the invention of the steamship, the submarine, or the growing consciousness today of the oceans' fragile ecologies. It is also considering a specific "Western" perspective on the sea, and acknowledges that these assumptions and viewpoints would be different if seen from any number of vantage points outside the seventeenth-century Western European continent.

9. The tension continues today between conceptualizing the ocean as an immaterial space to allow for the easy transport of materials, resources, and peoples and an ocean that must be regulated, governed, and enclosed. For an overview of this play between "the ten-

dency to enclose ocean space with lines of division and the tendency to construct it as a friction-free surface characterized by lines of connection," see Philip E. Steinberg, "Lines of Division, Lines of Connection: Stewardship in the World Ocean," *Geographical Review* 89, no. 2 (1999): 254–64.

10. Jan Brueghel the Elder (1568–1625) was one of the first Netherlandish painters to explore the representation of the sea apart from the composition of history paintings in the sixteenth century, but the scope of this chapter limits itself to a particular development in marine painting in the seventeenth century and its corresponding development in England. For an overview of marine painting in the Low Countries, see Jenny Gaschke, ed., *Turmoil and Tranquility: The Sea Through the Eye of Dutch and Flemish Masters, 1550–1700* (London: National Maritime Museum, 2008). The chapter uses interchangeably the terms "marine painting," "maritime painting," and "seascape," although there are subtle differences. Marine and maritime paintings indicate works that are involved with the maritime world broadly, taking as the subject ports, harbors, ships, beaches, and so on. In turn, seascape seems to suggest a work in which the primary focus in the shaping of the sea, in relationship either to land, ships, or itself. Roger Quarm draws attention to a shifting definition of marine painting whereby marine painting in the nineteenth century meant any work "in which the sea was a major element." In contrast, in the eighteenth century marine painting specifically denoted a precise category defined by "the accurate portrayal of nautical detail (in its broadest sense) as well as historical fact." Roger Quarm, "The Art of Marine Drawing," *Masters of the Sea: British Marine Watercolours* (Oxford: Phaidon Press, 1987), 9.

11. On the particularity of this technique, see David Freedberg, Aviva Burnstock, and Alan Phoenix, "Paintings or Prints? Experiens Sillemans and the Origins of the Grisaille Sea-piece: Notes on a Rediscovered Technique," *Print Quarterly* 1, no. 3 (September 1984): 149–68.

12. Born in Leiden, van de Velde the Elder was the son of a transport-vessel master, and his artistic training remains obscure. The painter Liefrinck was the van de Veldes' neighbor in Leiden, and it is hypothesized that he may have trained the young boy. W. V. Cannenburg, "The Van de Veldes," *Mariner's Mirror* 36, no. 3 (1950): 185.

13. Under the stress of the French invasion, van de Velde the Elder and the Younger accepted the invitation Charles II extended to Dutch artists to immigrate to London. For an overview of the Van de Veldes' motivations for moving to England, see Cannenburg, "The Van de Veldes," 185–204. While there are different forces that historically have impelled immigration, from the economic and the political to the religious, the van de Veldes fall into the category of the economic, seeking greater financial opportunity in a rising economy. Unlike artists traveling to Italy, which provided not only lucrative papal and courtly sites of patronage but also the opportunity to study works of antique and modern masters (such as Michelangelo), artists migrating to England seem to have done so primarily for economic advantage, not to further the study of their craft or antiquity. Nevertheless, the move of the van de Veldes from the Dutch Republic to England seeking more profitable circumstances can be understood as part of a broader pattern of trade relations and rivalries between the two territories that provides an explanatory framework for the appearance of their work. Peter Hecht and G. M. G. Rubinstein also argue that Dutch artists immigrated to England primarily for economic reasons; see Peter Hecht, "Dutch Painters in England: Readings in Houbraken, Weyerman and Van Gool," in Simon Groenveld and Michael Winte, eds., *The Exchange of Ideas: Religion, Scholarship and Art in Anglo-Dutch Relations in the Seventeenth Century* (Zutphen: Walburg Institute, 1994), 155; G. M. G. Rubinstein, "Artists from the Netherlands in Seventeenth-Century Britain: An Overview of Their Landscape Works," in Groenveld and Winte, eds., *The Exchange of Ideas*, 186. See also Eric Jan Sluijter, "The English Venture: Dutch and Flemish Artists in Britain 1550–

1800," in Juliette Roding et al., eds., *Dutch and Flemish artists in Britain, 1550–1800* (Leiden: Primavers, 2003), 21.

14. After moving to London, the Elder was not present for the majority of the battles between England and the Dutch Republic. The "perspective" in his drawings, drafted as though he was amid the warships during battle (as he had been while working for the Dutch Navy), were most likely assembled from eyewitness accounts and other reports. Michael Robinson, *The Willem van de Velde Drawings in the Boymans–van Beuningen Museum, Rotterdam* (Rotterdam: Museum Boymans–van Beuningnen Foundation, 1979).

15. Robinson notes two separate occasions in which the Elder attempted to sell his drawings of battles to the states of Holland and West Friesland; M. S. Robinson, *Van de Velde: A Catalogue of the Paintings of the Elder and the Younger Willem van de Velde* (Greenwich: National Maritime Museum and London: Sotheby's, 1990), xv, xviii.

16. Robinson, *Van de Velde*, xv, xviii.

17. Daniel A. Baugh, "Maritime Strength and Atlantic Commerce: The Uses of a 'Grand Marine Empire,'" in Lawrence Stone, ed., *An Imperial State at War: Britain from 1689 to 1815* (London: Routledge, 1994), 192.

18. M. S. Robinson, *Van de Velde Drawings: A Catalogue of Drawings in the National Maritime Museum Made by the Elder and the Younger Willem van de Velde* (Cambridge: Cambridge University Press, 1958–74), 12.

19. This also stands in marked contrast to the necessity of "topographical specificity" that defined marine painting as British and patriotic in the later eighteenth century. Geoff Quilley, *Empire to Nation: Art, History and the Visualization of Maritime Britain 1768–1829* (New Haven: Yale University Press, 2011), 189–90.

20. Tricia Cusack, "Introduction: Framing the Ocean, 1700 to the Present: Envisaging the Sea as Social Space," in Cusack, ed., *Framing the Ocean, 1700 to the Present: Envisaging the Sea as Social Space* (Farnham, Surrey: Ashgate, 2014), 1–20.

21. Philip E. Steinberg, *The Social Construction of the Ocean* (Cambridge: Cambridge University Press, 2001), 105.

22. Steinberg, *The Social Construction of the Ocean*, 105. "The sea was fought over not as a space to be possessed, but to be controlled, a special space within world-society but outside the territorial states that comprised its paradigmatic spatial structure," ibid., 109.

23. An important example of this shift in scholarship may be seen in Bernhard Klein and Gesa Mackenthun, eds., *Sea Changes: Historicizing the Ocean* (New York: Routledge, 2004). As the introduction states: "The essays in this volume all take issue with the cultural myth that the ocean is outside and beyond history, that the interminable, repetitive cycle of the sea obliterates memory and temporality, and that a fully historicized land somehow stands diametrically opposed to an atemporal, 'ahistorical' sea." Bernhard Klein and Gesa Mackenthun, "Introduction: The Sea is History," in *Sea Changes: Historicizing the Ocean*, 2.

24. Mack, *The Sea*, 16. An important addendum to the lack of ruins for the sea is shipwrecks; see Cusack, "Framing the Ocean," 10.

25. Mack, *The Sea*, 17.

26. Robinson, *Van de Velde Drawings*, 20.

27. Cited in Robinson, *Van de Velde Drawings*, 6.

28. Quarm, "Art of Marine Drawing," 16.

29. Edmund Waller, "Instructions to a Painter," in George deF. Lord, ed., *Poems on Affairs of State: Augustan Satirical Verse, 1660–1714* (New Haven: Yale University Press, 1963–75), 21.

30. "No 1 In wat postuier den vÿant ons / boven de wint zÿnde aenvaltt / op vrÿdach ontent middach ten een urren / . . . 11en Junÿ 1666." M. S. Robinson, *Van de Velde Drawings in*

the Boymans–van Beuningen Museum, Rotterdam (Zaltbommel: Koninklijke Drukkerij Van de Garde, 1979), 44–45.

31. For the complete catalogue of the penschilderijen, see Robinson, *Van de Velde: A Catalogue of the Paintings of the Elder and the Younger Willem van de Velde*, 1:2–124.

32. Gaschke, ed., *Turmoil and Tranquility*, 1.

33. Philip E. Steinberg, "The Maritime Mystique: Sustainable Development, Capital Mobility, and Nostalgia in the World-Ocean," *Environment and Planning D: Society and Space* 17, no. 4 (1999): 408.

34. Grotius, *Mare liberum*; for the translation, see David Armitage, ed., *The Free Sea*. Translated by Richard Hakluyt with William Welwood's critique and Grotius's reply (Indianapolis: Liberty Fund, 2004).

35. Grotius penned *Mare liberum* as part of a larger work, *De iure praedae* (On the Law of Prize and Booty), that would not be published in his lifetime.

36. On the *Santa Catarina* incident and its incitement of Dutch trade and Portuguese strife in the Indies, see Peter Borschberg, "The Seizure of the *Sta. Catarina* Revisited: The Portuguese Empire in Asia, VOC Politics and the Origins of the Dutch-Johor Alliance (1602–c.1616)," *Journal of Southeast Asian Studies* 33, no. 1 (2002): 31–62.

37. C. R. Boxer, *Portuguese Merchants and Missionaries in Feudal Japan, 1543–1640* (London: Variorum Reprints, 1986), 14–15.

38. Peter Borschberg, "Hugo Grotius, East India Trade and the King of Johor," *Journal of Southeast Asian Studies* 30, no. 2 (1999): 226.

39. On Grotius and the legal history of *res communes omnium*, see Martin J. Schermaier, "*Res Communes Omnium*: The History of an Idea from Greek Philosophy to Grotian Jurisprudence," *Grotiana* 30 (2009): 20–48.

40. Armitage, ed., *The Free Sea*, 32.

41. Armitage, ed., *The Free Sea*, 34.

42. For the problems of contract between European and non-European powers, see Andrea Weindl, "Grotius's *Mare Liberum* in the Political Practice of Early-Modern Europe," *Grotiana* 30 (2009): 131–51.

43. Armitage, ed., *The Free Sea*, 51.

44. "For whereas aforetime the white fishes daily abounded even into all the shores on the eastern coast of Scotland, now forsooth by the near and daily approaching of the buss-fishers the shoals of fishes are broken and so far scattered away from our shores and coasts that no fish now can be found worthy of any pains and travails." Armitage, ed., *The Free Sea*, 74.

45. In response to Welwood's treatise, Grotius wrote *Defensio capitis quinti* (ca. 1615) and *De dominio maris* (1615). Grotius never publically responded to Selden's work. Other important contributions to the *Battle* include the Portuguese Serafim de Freitas's *De justo imperio Lusitanorum asiatico* (1625) and the Spanish response represented by Juan Solórzano Pereira's *De Indiarum* (1629).

46. John Selden, *Of the dominion, or, ownership, of the sea* (London, 1552), 127.

47. Selden, *Of the dominion*, 135.

48. Selden, *Of the dominion*, 137.

49. Thomas Fulton, *The sovereignty of the sea: A historical account of the claims of England to the dominion of the British seas, and of the evolution of the territorial waters* (Edinburgh: W. Blackwood, 1911), 524–25.

50. Philip Meadows, *Observations concerning the dominion and sovereignty of the seas* (London: Printed by Edw. Jones and sold by Samuel Lowndes, 1689).

51. Meadows, *Observations*, 2.

52. Meadows, *Observations*, 7.

53. While these treatises might seem at odds with one another—*Mare liberum, Mare clausum,* or some compromise in between—Selden's work has been described, nevertheless, as "deeply Grotian." Richard Tuck, *Philosophy and Government, 1572–1651* (Cambridge: Cambridge University Press, 1993), 213.

54. Traditionally, scholars have argued that mercantile competition and rivalry was the primary cause for the seventeenth-century Anglo-Dutch wars; see: Charles Wilson, *Profit and Power: A Study of England and the Dutch Wars* (The Hague: M. Nijhoff, 1978); C. R. Boxer, *The Dutch Seaborne Empire, 1600–1800* (New York: Knopf, 1965); Jonathan Israel, *Dutch Primacy in World Trade, 1585–1740* (Oxford: Oxford University Press, 1989). Other scholars have suggested that the wars developed out of courtly machinations at the court of Charles II; see: J. R. Jones, *The Anglo-Dutch Wars of the Seventeenth Century* (London: Longman, 1996); N. A. M. Rodger, *The Command of the Ocean: A Naval History of Britain 1649–1815* (New York: W. W. Norton, 2005). Also, scholars have argued that the wars arose out of ideological and religious debates; see: Steven Pincus, *Protestantism and Patriotism: Ideologies and the Making of English Foreign Policy, 1650–1688* (Cambridge: Cambridge University Press, 1995). Most recently Gijs Rommelse has taken a nuanced stance, accommodating these various viewpoints; see Gijs Rommelse, *The Second Anglo-Dutch War (1665–1667): Raison d'état, Mercantilism and Maritime strife* (Hilversum: Verloren, 2006). For an overview of the literature, see Rommelse, "The Role of Mercantilism in Anglo-Dutch Political Relations, 1650–1674," *Economic History Review* 63, no. 3 (2010): 591–611.

55. The relationship was paradoxical: "Grotian oceanic space was realized through the exercise of naval power, and the free ocean was able to serve as a conceptual dominant only during times of single-power—primarily British—oceanic hegemony." C. L. Connery, "Ideologies of Land and Sea: Alfred Thayer Mahan, Carl Schmitt, and the Shaping of Global Myth Elements," *Boundary* 2, no. 28 (2001): 182.

Dutch Representations of Southeast Asia

Larry Silver

D uring the early modern period the Dutch Republic never formally held territory as a proper empire. But in Asia the Dutch East India Company (Verenigde Oostindische Compagnie, or VOC) did hold tightly to a trade monopoly for the Spice Islands and Japan, and it exerted territorial control over significant portions of Southeast Asia, especially in the region that would become modern Indonesia.[1] Like its near contemporary in England, the East India Company, this joint-stock, limited liability company, charted by the States-General of the Dutch Republic but ruled by city representatives, dominated the Indian Ocean with all the force of a national fleet. Across the entire region, it first attacked and then supplanted rival Portuguese merchants (then ruled by King Philip II [r. 1580–92] of Spain, the Dutch arch-nemesis and object of the Dutch Revolt for political independence). Though supervised by a board of directors, the Heeren XVII, who embodied powerful urban regents in the loose confederation of the Dutch Republic, the VOC had authority to build forts, maintain armies, and even conclude treaties with Asian rulers, and it often exploited the safety of overseas distance (some twenty months at sea to receive a reply to a missive) to act with virtual impunity in its region.[2] Its fortune was founded on spices—especially cloves, nutmeg, and mace from the Moluccas, as well as pepper—in a zealously guarded monopoly of harvest and transport.

C. R. Boxer's term "the Dutch seaborne empire " and Holden Furber's "thalassocracy," or empire at sea, seem particularly apt as an analytical category for a VOC that simultaneously operated both as a wholesaler and as a military power and ruler, or what Jurrien van Goor duly characterizes as *koopman en konig* (merchant and king).[3] And we shall see how Dutch self-confidence as a

world trade center, with outreach to the entire globe, found visual expression around the mid-seventeenth century in the new Amsterdam city hall.

Reflecting the concerns of this volume, these Dutch territorial claims constituted a version of the Indian Ocean as a new *mare nostrum*, akin to the Mediterranean for ancient Rome, now part of a worldwide, seaborne network of power based on shipping and trade. But the administration of the new Dutch East Indies depended equally on knowledge, particularly on mapping, whose apex of seventeenth-century delineation flowed from the great Amsterdam publishing houses of Hondius and Blaeu. And that world dominion was inscribed graphically back home in the very nerve center of Dutch trade, onto the very floor of Amsterdam's Town Hall, built in the wake of Dutch independence after 1648 on the main city square, the Dam. On the city hall's western tympanum a sculpted relief by Artus Quellinus (1650/55) depicts the four continents bringing their bounty to the central personified figure of Amsterdam, a ship behind her, as her foot rests on a globe with an astrolabe below; on the east side marine creatures under the vigilant protection of Peace bring her both bounty and homage.[4] A figure of Atlas also appears with the celestial globe atop the Town Hall pediment.

A physical administrative capital of Dutch colonial authority overseas was firmly established in 1619 on the island of Java (near modern Jakarta) at the newly built port of Batavia, whose Dutch-based plan of a walled, grid-planned city with canals provided a firm geographical center and distant capital for the new Dutch geographical landscape, centered around the Indian Ocean.[5] Symbolically, this new geo-imperial center adopted its name from the legendary outer province of imperial Rome in the Netherlands, Batavia, which rebelled against Rome itself in the first century CE, as described in the *Histories* of Tacitus. This founding event by their Germanic tribal ancestors also decorated the seventeenth-century Amsterdam Town Hall in a series of commissioned paintings by Rembrandt (1606–69) and his circle.[6] So a heroic Dutch past lends the name to an assertive new global Dutch present. Batavia's governor-general headed a highly centralized administration, overseeing a regional empire of sea trade that stretched from the Persian Gulf to Japan.

This chapter examines the visual culture of that newly conceived Dutch imperial landscape in Asia—maps, views, and representations of that large foreign domain—prepared locally for Dutch merchants and commanders but also, chiefly, for VOC leaders back at headquarters in Amsterdam during the seventeenth century.[7] Printed images emerge from travel books, which mushroomed in the city, especially with the publishing initiative of Jacob van Meurs (ca. 1617/18–ca. 1680) after mid-century, and from the margins of maps and atlases, a

noted Amsterdam specialty, led by the house of Joan Blaeu (1596–1673).[8] But other unique images feature paintings and watercolors of those faraway Southeast Asian ports that hosted Dutch merchant ships of the VOC; most of these were retained closely in the possession of the company headquarters as privileged views of the VOC's territories abroad. Taken together, both the public and the private images of Southeast Asia—as well as published accounts of intermediate regions—provided Dutch readers and viewers the same sensation provided by the possession of an atlas: to hold the world in their hands. As a result of the images at home and the depicted reality of Dutch possessions abroad in Batavia as well as pictures of the exotic foreign trading ports of Asia, Amsterdam truly felt like the center of a worldwide trading empire, with a true regional capital for the VOC in Java at Batavia.

The founding of the VOC in 1602 marked the first national body for foreign trade in the Dutch Republic. A crucial opening salvo in Dutch-Portuguese relations in the Indian Ocean appeared in the form of an earlier travel book, the *Itinerario* (1596; Amsterdam: Cornelis Claesz) by Jan Huygen van Linschoten (1563–1611), a Dutchman who traveled from Lisbon to Portuguese Goa on the west coast of India.[9] The Portuguese had already sailed to Java and the Moluccas in 1511, and they established Goa as their fortified base for Indian Ocean voyages. There, Linschoten worked for the archbishop of Goa, Vicente da Fonseca (1530–ca. 1587), from Linschoten's arrival in 1579 to his return to his hometown of Enkhuizen in 1592. While most of Linschoten's accounts and images focus on Goa and its environs, his book begins with a wider exploration of Asian sites. Significantly, the book also included maps with sailing instructions about sea lanes from the port of Cape Town to India, as well as a map of Goa and surroundings—his publisher Cornelis Claesz (1551–1609) was the dominant map printer in the Netherlands between 1592 and 1609, in partnership with leading mapmakers.[10] Indeed, those same Claesz maps were used by the first Dutch fleet to sail to the East Indies in 1595 (and soon afterward by the English). Linschoten's Dutch text, soon translated into several European languages, was accompanied by etchings as well the maps; both printed works were realized by Joannes van Doetecum the Elder (1530–1605) and his sons.

Linschoten's initial engraving (figure 8.01) about Malacca shows a characteristic pair of Malays, "who outstrip all other Indians in language, fine manners, and amorousness." It presents a typical, representative couple, a male trader with a female, and its text notes that Malay is the indispensable lingua franca of commerce. These two figures are balanced by a pair of [East] Javans, with the male clad only in a loincloth; they are said to trade with the Malaccans and to receive linen for spices.[11]

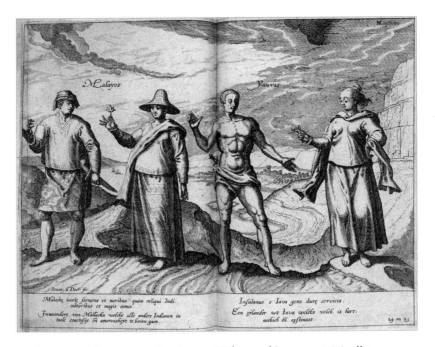

Figure 8.01. Joannes van Doetecum, *Malays and Javanese*, originally published in 1596 in Jan Huygen van Linschoten, *Itinerario* (Amsterdam: Cornelis Claesz). Etching, published in *John Huighen van Linschoten, his Discours of voyages into ye Easte & West Indies*, London: John Wolfe, 1598. Library of Congress, DS411.1.L735.

Because of the importance of their own merchant communities in Southeast Asia, the Chinese are described in the next Linschoten engraving; their costumes feature colorful silks for figures of rank but are restricted to cottons for commoners. Chinese women are noted for their enforced seclusion and prized small bound feet, which necessitated transport by litters or chairs, covered with silk curtains for privacy. Malaccans are described as "yellow in color," like the people of Brazil. Chinese, seen "near Macao and Canton, toward the coast," are noted for being fat, with round faces and small eyes but with notably thin, if well-tended, beards. Cultural relativism also enters into this ethnography: "The character of the people can easily be seen in their very salutary ability to rule in peace and wartime, their excellent morals, and their exceptional proficiency in all kinds of handiwork [T]here is hardly any reason to doubt that such a level of civility exists among those whom we call barbarians."[12]

Another engraving depicts Mandarins, "the principal authorities of government," delighting to cruise in riverboats. China is characterized as fully centralized rather than feudal but bound by oath to the king and separated from their native regions: "There is no one who claims an area of authority as a private

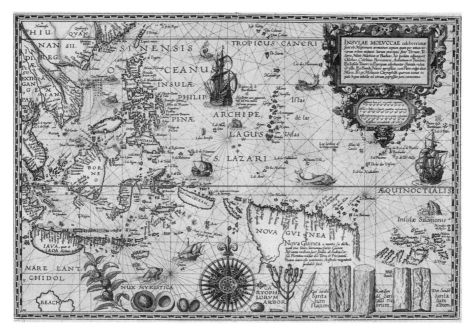

Figure 8.02. Joannes van Doetecum, *Map of Southeast Asia*, designed by Petrus Plancius, originally published in 1594 (Amsterdam: Cornelis Claesz). Etching, 36.7 × 53 cm, printed in Amsterdam by C. J. Vischer, 1617. State Library of New South Wales, SAFE/M2 470/1617/1.

ruler, no count, no baron, no duke." Linschoten also takes note of China's meritocracy: "The king's servants, dignitaries who hold honorary positions, are selected not from the wealthier and higher aristocracy but from the most highly educated, and are experienced in all the sciences."[13] Those mandarin notables also travel on litters covered in silks but are "prone to pleasure and luxury and are self-indulgent, which is a quality of all Chinese." Moreover, "the Chinese are idolators, without adulteration by the Mohammedan sect. They worship the devil . . . make sacrifices to the sun and moon as man and wife, and believe in immortality of the soul."[14]

A final Linschoten illustration about China shows the coastal boats of China and Java, "with reed sails and wooden anchors." The kingdom of China is noted for its fertile fields and numerous rivers, which (like Holland's) stimulate trade, especially around the harbor of Canton. China even has sailed wagons with wheels.[15] Finally, appropriately, China is credited for historic inventions, recently so prized in early modern Europe: "The art of printing was also in use among the Chinese before all times, as were the cannon and gunpowder, to our great surprise. What we claim to be specific to our world was already passé to them."[16]

Petrus Plancius (1552–1622), a minister of the Dutch Reformed Church as well as a skilled geographer and pupil of Gerard Mercator (1512–94), consulted on and invested in the initial Dutch voyage to Southeast Asia (1595–97) by Cornelis de Houtman (1565–99), who had obtained confidential Portuguese sea charts in Lisbon made by the cartographer Bartolomeu Lasso.[17] This initial company, the Compagnie van Verre (Long-Distance Company), would merge with the Nieuwe Compagnie (New Company) in 1598 as the forerunner organization of the VOC. Plancius in turn received a license from the States-General in 1592 to publish the Lasso sea charts, which appeared in 1594, engraved by the same professional, Joannes van Doetecum the Elder, and published by Claesz. That landmark map of Southeast Asia, *Moluccan Islands* (*Insulae Moluccae*; all labels in Latin), by Plancius (figure 8.02 [plate 22]), marked the shift from domination of the Indian Ocean coastline by the Portuguese to the emerging hegemony of the Dutch. It situates Pegu (modern Burma) and Siam (modern Thailand) at the upper left but features the island archipelagoes from Java in the west to the project of "Nova Guinea" and the Solomons in the east across the bottom of the map; the Philippines extend northward to the top left of the map, and the Marianas to the top right (still bearing their Spanish name, *Islas de las Velas*, or Islands of the Sails). Accessory decorations include three-masted European vessels with smaller regional coastal vessels, including one ship near the wind rose with lateen sails. Along the bottom of the map Plancius inserts the real treasure of the region—commodities, given their Latin names: nutmeg (*nux myristica*), cloves (*Caryophilorum arbor*), and three varieties of sandalwood (*Santalum*), gold, red, and white. At the conclusion of Linschoten's volume, several pages and four images also itemize the native flora of India and their potential for food or utility.[18]

Houtman's pioneering 1595–97 voyage with four ships from the Netherlands was reported by an expedition participant, the merchant Willem Lodewijcksz (who had already sailed the African coast), in a 1598 volume, *Historie van Indien*, published by Claesz with van Doetecum engravings. Lodewijcksz's book featured seventy-four illustrations: maps and profiles of Indonesian archipelago coastlines, especially Java and Bali; plans of the port and town of Bantam in Java; a double-sheet view of Bantam market; and numerous prints of scenes of daily life.[19] Both the account and the images by Lodewijcksz along with those of Linschoten were swiftly republished that same year by the German firm of Theodore de Bry (1528–98) in Frankfurt as part of his *Petits voyages*, the Asian complement to his successful *Grandes voyages* about New World discoveries.[20]

Among the illustrations of Java, music and dance are carefully described, with pictorial attention given to the distinctive local art forms of gongs (described as "sounding like our clock towers") and gamelans.[21] Dancers appear

beside a bamboo xylophone, and both males and females are described for their arm and leg movements, while females in the image show a synchronized sway with elaborate hand movements.[22] Local leaders are also pictured, distinguished by their turbans and parasols from surrounding figures in sarongs. Soldiers appear with armor and weapons—spears, blowguns, and curved blades (*kris*); they are characterized as "the most militant people in all East-India . . . very steadfast and grim, sly and quick . . . but not to be trusted and trusting no one."[23] In similar fashion, an image of Java's local merchants calls them "untrustworthy" retailers who apply big markups in Bantam.[24] Among foreign merchants in Bantam both image and text label Persians ("who deal in jewels"), Arab sea traders, and "cunning" Peguans (Burmese), who trade for pepper.[25] Malay tradesmen and Chinese receive separate illustrations, and all representative individuals appear in characteristic costumes, as in Linschoten. A Chinese "temple or chapel" shows two individuals prostrating themselves and making a fruit offering before an idol in a niche, described as "the devil with the triple crown" (an imitation papal tiara).[26]

Portuguese men are shown in Lodewijcksz (as in Linschoten, and they are depicted as well on a series of condescending contemporary Japanese *nanban*, or "Southern Barbarian" folding screens). The Portuguese wear their own distinctive costume, baggy pants with side sword, and they often travel under sheltering parasols, carried by slaves. Also as in Linschoten, local Asian sea craft are carefully described and illustrated. These single-masted war vessels feature four small bronze cannon and galley slaves, but they also pilot junks with lateen sails on monsoon winds and ride outrigger canoes along the coast.[27] A Bali image shows the nobility carried on a litter by slaves and led by bodyguards; another shows the king of Bali under a parasol in a royal chariot drawn by two white water buffalo.[28]

A final figural image in Lodewijcksz represents a scene that had already both fascinated and horrified Linschoten in India: the Hindu custom of *sati*, where a widow casts herself onto the funeral pyre of her dead husband, described by Lodewijcksz as follows: "Here one sees how women according to the custom of East-India burn themselves alive after the death of their husband together with the dead body. They do this accompanied by all manner of string music and dance, and encouraged by their closest friends. They say that the woman goes to attend her husband in the other world. She takes her most beautiful jewelry into the fire to carry into the other world."[29] Just as Linschoten had observed the flora of India, Lodewijksz illustrates the exotic flora of the archipelago, especially those plants with commercial or practical value, such as coconut palms, bananas, and peppers.[30] He gives less attention to fauna but does feature the Javanese elephant, along with crocodiles, turtles, and rhinos; another image shows

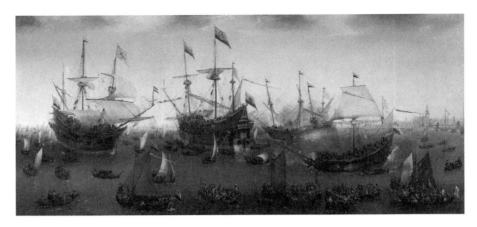

Figure 8.03. Hendrick Cornelisz Vroom, *The Return to Amsterdam of the Second Expedition to the East Indies*, 1599. Oil on canvas, 102.3 × 218.4 cm. Rijksmuseum, Amsterdam, SK-A-2858.

the civet cat and describes local cockfights, while a third describes (but does not name) the emu, "a strange Javanese bird as big as an ostrich, with a long neck, no tongue, minimal wings and tail."[31]

Where Lodewijksz planned to insert a map of Java and Sumatra, a supplement of 1598 was printed by Claesz. A "hydrographic description," it centers on the Indian Ocean (Oceanus Orientalis); some versions replace text inserts to represent both peoples and sea vessels, drawn from the illustrations to the Lodewijksz text.

Celebratory marine images of successful Dutch overseas expeditions became a staple of large-scale painting, particularly by the pioneer of the genre, Hendrick Cornelisz Vroom (1566–1640). His *Return of the Second Dutch East India Fleet in 1599* (figure 8.03 [plate 23]), features portraits of the triumphant vessels set against the horizon, welcomed in the foreground by smaller craft while anchored before the profile of the harbor of Amsterdam, at right.[32] This massive canvas, measuring 110 x 220 cm, demonstrated the energy and enthusiasm for East Indies trade that would soon culminate in the 1602 foundation of the VOC. Its original frame bears an inscription that describes the voyage and names the four ships that returned laden with profitable cargo.

Dutch prints also celebrated distant naval battles involved in the Dutch Republic's accumulation of trade and territory in the East Indies. Such prints could be taken as documents and new reports of noteworthy events but also as examples of maritime art. One oversized print of three plates (ca. 1610, figure 8.04) shows *The Naval Battle at Bantam* (30 December 1601) in panoramic bird's-eye perspective before a high horizon.[33] It commemorates a Dutch victory over a

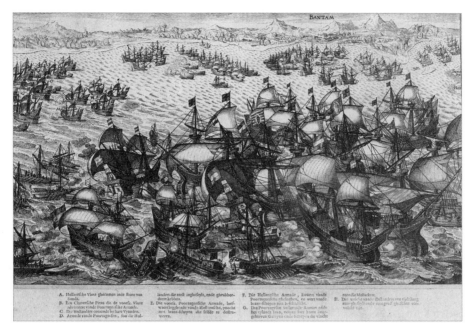

Figure 8.04. Bartholomeus Willemsz. Dolendo, attr., *Naval Battle at Bantam, 1601*, ca. 1610. Engraving on three plates, 260 × 365 cm. Rijksmuseum, Amsterdam, RP-P-OB-75.315.

larger fleet of Portuguese vessels, which led directly to the Dutch takeover of the city of Bantam on the island of Java, which they soon established as their regional capital. Ultimately, this naval triumph assured hegemony over the entire Indonesian archipelago and its lucrative spices. The sequence of events, described in a legend below the image, unfolds in the print across from the upper right, where the Dutch ships enter the strait; their eventual success is evident from the burning Portuguese ships in the top center. At the left edge of the image the Portuguese sail away from Bantam and Java.

In some impressions, the engraving also includes an inset map, seen from the north and indicating the strategic geographical site of the Sunda Strait, used instead of the Strait of Malacca by pioneering Dutch voyages to access this region from India. At the top left a cartouche features the heraldry of the Dutch *stadholder*, or appointed national ruler, Prince Maurice of Nassau, along with the heraldry of the Dutch Republic itself. The arms of the VOC appear above the map, flanked by sea gods, located just above Bantam on the map. Together, both map and battle establish claims for Dutch supremacy in the region. Soon afterward the 1605 Dutch naval conquest of Amboina in the Moluccas Islands also received a commemorative print, "a true and memorable depiction of the con-

quest of the island and castle of Amboina" (1606).[34] Many such images were re-printed or sold in Amsterdam by Cornelis Claesz, indicating their newsworthy topicality as well as their importance as extensions of Dutch claims from the capital to the new provinces.

As that latter print suggests, the newly formed VOC did not take long to assert its territorial might and to exploit its new outposts for both rare goods and local labor.[35] Already in 1605 the Company conquered parts of Amboina in the Spice Islands, followed by the conquest of Banda Neira in 1609. The new regional capital, named Batavia after the ancient Roman province that included Holland, took definitive form ten years later under the regime of the most assertive VOC regional director, the fourth governor-general, Jan Pietersz Coen (r. 1619–29). He applied the current war-party outlook of the home country to its new Asian colony.

Coen brutally subjugated the spice island of Banda after 1621 with all the callousness of later nineteenth-century imperialists in Africa.[36] He strove to establish an unchallenged Dutch monopoly in three rare spices: nutmeg, cloves, and mace. His hand-picked eventual successor, Anthony van Diemen (r. 1636–45), continued these commercial and administrative policies of the VOC from Batavia and opposed the Portuguese as well as the English with force in the region at every turn.

Eventually the Company added more possessions taken from the Portuguese—Formosa (now Taiwan), the settlement around Cape Town in South Africa, and Ceylon (modern Sri Lanka). Thus (like the later British East India Company in India, 1757–1858) the VOC became imperial in all but name almost from its earliest phase.[37] Ultimately Dutch commercial exchange formed a triangle centered on Batavia, whence textiles from India's west coast were exchanged for spices and Japanese copper in the east; then spices, indigo, coffee, and saltpeter went back to the homeland along with an increasing cargo of Chinese porcelains and silks, ultimately to be exchanged for silver and gold from Holland.[38]

Nevertheless, Dutch historians still debate whether those commercial interests were sufficient to motivate territorial conquest and political domination over local elites within the East Indies region.[39] They point to the model of factory and fortress settlement rather than real inland penetration by the Dutch seaborne empire. But as van Goor notes, VOC territories included regions administered with considerable Dutch authority. Company rule spanned regions with various degrees of independence: regions with real local sovereignty; regions where local rulers acknowledged suzerainty; regions with local rulers as dependable allies; and, finally, regions where the VOC was merely a merchant

resident.[40] Even the founding charter of the VOC from the States-General of the Dutch Republic, as noted, granted it the authority to wage "defensive war," negotiate treaties of peace and alliance, and build fortresses. Thus the VOC operated simultaneously as both a wholesaler and a military power and ruler or, in van Goor's characterization, as "merchant and king."[41]

Mapmaking of the region was actively sponsored by the VOC administration, regularly updated to incorporate accumulated new information (such as the new southern landmass of Australia) drawn from both logbooks and charts of merchant ships as it was acquired. Officially the Company first entrusted Hessel Gerritsz (1581–1632) with that responsibility in 1617 under condition of strict secrecy, since such knowledge literally was power.[42] After Gerritsz's death, however, his VOC post passed to the Blaeu firm in Amsterdam, led first by Willem Blaeu (1571–1638) and then by his son Joan, atlas publishers active between 1630 and 1670, so the policy of secrecy waned toward something closer to private exclusivity.[43]

With the assistance of Gerritsz and with a florid dedication in the lower left corner to Laurens Reael (1583–1637), the VOC director in Amsterdam (since 1625), Willem Blaeu produced a large map (figure 8.05), *India, Called the Eastern, and the Adjacent Islands*. It first appeared in his 1635 atlas, after which a more public presentation of cartographical information pertained. The entire map is centered on the Indonesian archipelago, with Borneo and Java at the core of the emerging empire, as small galleons patrol the open ocean spaces of the map. Batavia is clearly marked as the regional capital, and Bantam occupies the Sunda Strait. At this moment, island shapes and locations throughout the region are quite accurate, though several anomalies of scale or contour remain. Based on Gerritsz's updates, the notable recent discovery by Dutch explorers of the edges of Papua New Guinea (Iriyan Jaya) protrudes tentatively into the southeast corner of the map.[44] While offering improvements in both accuracy and detail over the Plancius map of 1594, these features still lack the later refinements added by Dutch explorer Abel Tasman (1603–59) on voyages organized by Antony van Diemen (1593–1645), governor-general of the Dutch East Indies (1636–45), in 1642.[45] In fact, this territory conforms to the private VOC chart compiled in 1623 by Arent Martensz de Leeuw aboard the *Pera*.[46] Thus what had once been the secret possession of the VOC alone was now available to a purchasing public through the Blaeu firm's atlas maps.

Willem Blaeu's atlas follows that regional East Indies map with a detailed map of the *Moluccas* (figure 8.06), purchased from his chief Amsterdam rival as atlas publisher, Jodocus Hondius the Younger (d. 1629). Characteristically, however, Blaeu inserted the map directly into his atlas and replaced Hondius's name

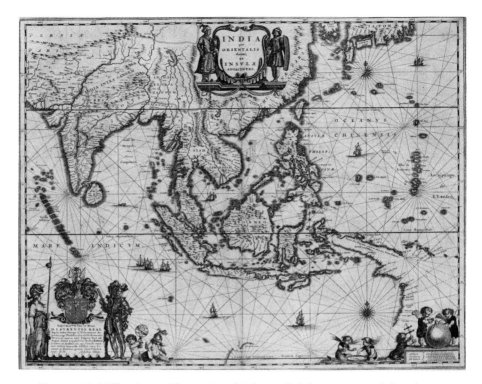

Figure 8.05. Willem Jansz. Blaeu, *Map of India, Called the Eastern, and the Adjacent Islands*, 1635. Engraving, 39.5 × 48.3 cm, published in Blaeu, *Grand Atlas* (Amsterdam: Blaeu). John R. Borchert Map Library, University of Minnesota, G8000 1635.B5.

on the plate with his own.[47] This anomalous close-up of the precious spice islands, led by Ternate and Tidore, indicates their critical importance to the entire overseas VOC enterprise. In this cartographic representation the ocean spaces are filled with a variety of ships, both regional and European, and in the top center a battle rages between a galleon and an oared vessel.

The ultimate evidence of Dutch self-consciousness as a world imperial power by the mid-seventeenth century lies in the inlaid marble world map in two hemispheres, placed in the middle of the giant central Burgerzaal (Citizens' Hall) of Amsterdam's new city hall (completed in 1655).[48] Based on a mural-sized world map published by Joan Blaeu in 1648, the city hall floor features the globe in two hemispheres—now including much more of Australia's newly explored coastline as well as the coast of South and Central America, the area served by the ill-fated Dutch West India Company (WIC).[49] It even included the latest mapped discovery, 1642–44, by Abel Tasman, already called New Holland, or Van Diemen's Land (Cape York in northeast Australia on modern maps).

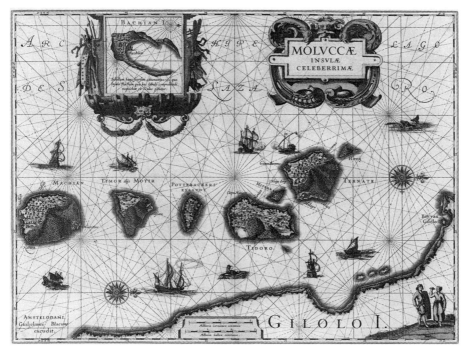

Figure 8.06. Willem Jansz. Blaeu, *Map of Moluccas*, originally published in 1635 in Blaeu, *Grand Atlas*. Engraving, 37 × 48 cm, likely published in Blaeu, *Appendice de la I & II partie du Théâtre du monde, ou, Nouvel atlas*, Amsterdam: Blaeu, 1638–40. Historic Maps Collection, Princeton University Library, HMC01.6386.

Moreover, the western facade relief sculpture on the Town Hall (1650–55) by Artus Quellinus (1609–88) clearly articulates the notion of Amsterdam as the center of the world, toward which the riches of the world are brought from the corners of the globe.[50] Figures from the other continents approach the personification of the metropole, a central female figure with her foot on the globe and an astrolabe at her feet, with two male river gods before her; behind her the mast of a ship forms a halolike crown, with its crow's nest perch and its rigging expanding outward like rays. She welcomes the continents as they bestow their treasures.

Europe, wearing the imperial crown of the Holy Roman Empire and holding a cornucopia in her hand, stands to the left of the female personification of Amsterdam (i.e. the favorable heraldic right), at a position of seniority and privilege. Children with grapes and books alongside domesticated animals point to Europe's superior civilization. Asia, also mature and civilized, brings a camel and incense, and a child carries a tulip. In the corners of the pediment the stooping figures of Africa and America represent savagery and wear only loincloths and

head coverings. Behind Europe, Africa is surrounded by a lion and an elephant, as a serpent winds around her exposed leg. Her ivory and bales and barrels of treasure fill out the corner. America arrives after Asia, with slaves and a crocodile; feathers form her head covering, and a second Indian figure reclines at the back, smoking a pipe of tobacco. At the opposite corner, New World silver miners struggle with their axes as monkeys scramble amid fruit. Thus, this allegory does not feature the continents as separate zones of the world but now instead as common contributors to Dutch prosperity through trade, centripetally focused on Amsterdam.

Wall maps by Blaeu and Hondius also filled the walls of contemporary Dutch houses, such as that of VOC director and former governor-general Jacques Spex (1585–1652), which featured a globe, a world map, and hand-drawn maps of the Spice Islands, Amboina and Banda, and Banda Nera.[51] A most notable individual instance of Dutch world consciousness is the luxury edition (1660–63; Vienna: Österreichische Nationalbibliothek) of the Blaeu *Atlas Major*, eleven volumes with some 600 maps. Blaeu's maps in turn formed the core of the forty-six volumes of Dutch world images, supplemented with watercolor reproductions of exclusive Company depictions of distant VOC ports, gathered together in the sumptuous Atlas de Hem, owned by Laurens van der Hem (1621–78).[52] Van der Hem, a lawyer from a wealthy family of merchants, lived in grand style on Amsterdam's Herengracht (the city's most important canal) and certainly cannot be taken as typical, but his upper-end consumption of maps and watercolor port profiles indicates his lively curiosity for knowledge of Dutch discoveries and his pride in the nation's worldwide maritime domination. In his massive collection of volumes, he assembled separate volumes dedicated to the VOC and the lands that it either controlled, explored, or traded with: *India Orientalis* (four vols., nos. 38–41, and a separate volume, no. 36, devoted to the Cape of Good Hope). One page of the Van der Hem Atlas uses his portrait, pictured before a naval battle, to commemorate Admiral Michiel de Ruyter (1607–76), who sailed the West Coast of Africa in the 1660s and also was a national hero of naval conflicts, especially for his famous raid up the Medway during the Anglo-Dutch Wars.[53] The Atlas volumes read continuously as if they were an ongoing voyage: from Cabo Blanco to the Cape of Good Hope (36); from the Cape of Good Hope to Malabar (38); from Sri Lanka, Coromandel, and Malacca to the Straits of Sunda and Batavia (39); around the Spice Island group and the Philippines (40); and the final voyage from Batavia to Taiwan, China, Japan, and the newly discovered coast of Australia.[54] The Atlas de Hem's most famous watercolor maps and drawings represent VOC territories and appear chiefly in the VOC volumes of the Atlas; they replicate original sketches made for the VOC on its voyages,

and they were already in place when van der Hem received a visit in 1668 from Duke Cosimo III de' Medici (1642–1723) in 1668.[55]

Since Willem Blaeu was also the principal cartographer of the VOC, he doubtless could provide access to the Company's private drawings of ports, many of them provided by painter-cartographer Johannes Vingboons (1616–70) and his workshop.[56] Blaeu had originally planned to publish a 1659 atlas of VOC territories based on these drawings, but the VOC never authorized their publication, so he must have sold them to private individuals, including Laurens van der Hem. Some of them turned up in the collection of Cosimo III de' Medici (now in the Bibliotheca Laurenziana, Florence), others in the monumental, three-volume atlas of Christina of Sweden (as early as 1650; now in the Vatican, Reg. Lat. 2105–2107) as well as an atlas in The Hague (Rijksarchief, ARA, VEHL 619).[57] The contents and character of the Vingboons drawings are amply signaled by the title of the Christina Atlas: "Worldly Display of the Seacoasts and Various Adjoining Regions in Africa, America, and Part of Europe. Showing the Foremost Harbors, Cities, Fortifications, and Extensions of the Two Parts of the World. From Discoveries of Many Experienced Seamen, Gathered and Assembled by Johannes Vingboons."

One of the principal measures of the imperial outlook of the VOC toward its Asian territories is the representation for its leaders, the Heeren XVII, of its overseas possessions. Working closely alongside Blaeu, Vingboons produced around two hundred views, often in watercolors, plus maps and plans of specific sites—a chorographic, that is, close-up, view to complement the wider geography of territorial overviews found in Blaeu's atlases. For the most part, Vingboons produced skyline profile or low-level, bird's-eye views of Asian ports, from Ceylon to Formosa, as seen from the viewpoint of an arriving vessel. This distinctive viewpoint differs from the higher aerial perspective more common in atlases of cities, such as the celebrated Georg Braun-Frans Hogenberg *Civitates orbis terrarum* (published in Cologne between 1572 and 1617). Thus these images had a more practical layout, oriented toward seafaring, closely resembling the private coastline profiles provided to sea captains to assist them in recognizing landmarks from the ocean.

An important suite of seven oil paintings, based on Vingboons's watercolors of overseas cities and forts which the Dutch traded with rather than owned (ca. 1662–63; now Rijksmuseum, Amsterdam), decorated the meeting room of the ruling committee of the VOC, the Heeren XVII, in East India House, Amsterdam.[58] Visitors recorded additional topographic paintings created for the directors: "In the room where the Directors of the East India Company meet, you see Japanese and Chinese paintings. In the same room you can admire the great city

Batavia with its mighty castle. There you also see the royal court of Japan with its incomparable beauty, size, and strength. You see the islands of the Moluccas (with their trees full with spices), harbors, and cities: all the islands which we possess on the other side of the globe. You will also see places close to China. All these paintings illustrate our favorable contacts with faraway nations."[59]

When we examine the range of surviving images, several characteristics consistently emerge. These views are taken from sea approaches with low horizons, just above the level of ships depicted in the foreground, often expressly flying Dutch tricolors.[60] Consequently, they also focus on harbors and fortifications, carefully observed by the VOC for its own marine safety as well as trading access.

The principal Spice Island locality for nutmeg, Banda Neira (labeled "Neyra," figure 8.07 [plate 24]), is seen from higher up. The island bears the clear, cruel marks of actual Dutch possession after the 1621 conquest by Coen: its land is now cleared of all trees except for a cultivated grove at right; two large forts (one of them named Fort Nassau after the ruling Dutch house) dominate and protect the small coastal township laid out at left. *Neyra* still retains its elaborate original frame for the delectation of VOC leaders.

A different painted view, by Andries Beeckman (1628–1664), for the India House great hall (figure 8.08 [plate 25]) shows the market in the Dutch regional capital, Batavia, with its massive, fortified walls and warehouse at the background right horizon, all built by Coen in the 1620s. A cavalcade of officials proceeds out of the fortress. The diagonal river waterway provides a site for ship carpenters. At left, palms tower above a row of houses built for the Chinese population. Underneath, the market crowd features a wide range of figures and costumes: Chinese fishmongers, Javanese natives, and Portuguese visitors. In addition, a prominent foreground couple walk with a parasol while dressed in both European and Asian fashion. The artist derived his image from his own on-site drawing, made for the VOC.[61]

Besides Laurens van der Hem, other Amsterdam patricians, led by burgomaster and VOC director Nicolaas Witsen (1641–1717), avidly collected imagery and exotic imported objects for their cabinets of curiosity (*Wunderkammern*).[62] Fueled by returning Dutch shipments from Asia, the wealthy Witsen in particular supported ongoing Dutch exploration of Australia at the end of the seventeenth century, just as his father, Cornelis, had sponsored those pioneering discoveries by Abel Tasman in the previous generation. Witsen supported artistic and scientific imagery of Dutch overseas locations, including the important insect fauna and flora watercolors and engravings made in Surinam (1699–1701) by Maria Sibylla Merian (1647–1717). He particularly sponsored travel books and

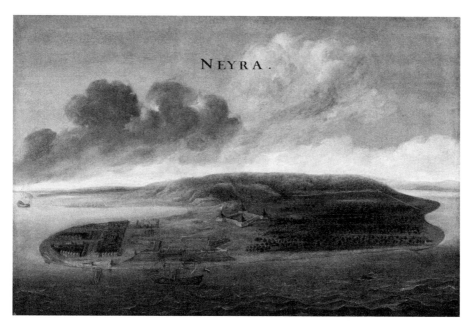

Figure 8.07. Johannes Vingboons, *Neyra* (Island of Banda Neyra), ca. 1662–63. Oil on canvas, 97 × 140 cm. Rijksmuseum, Amsterdam, SK-A-4476.

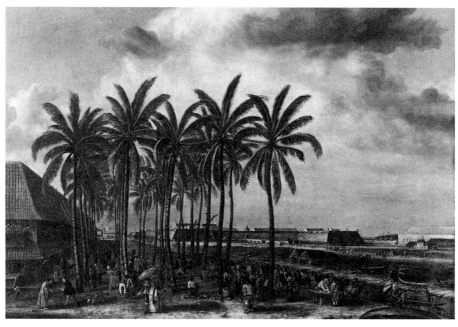

Figure 8.08. Andries Beeckman, *Castle of Batavia*, ca. 1661. Oil on canvas, 108 × 151.1 cm. Rijksmuseum, Amsterdam, SK-A-19.

images by the artist Cornelis de Bruijn (1652–1727), based on his extended passage across Russia, Persia, and the East Indies (published Amsterdam, 1711; English ed. London, 1737). De Bruijn's illustrations of plants, animals, natives, and views of sites were owned by Witsen, whose collection also included Asian weapons and such prized items as shells, corals, fossils, and minerals, all arranged in a museum display in Amsterdam.[63]

Of course, van der Hem's special connection to Blaeu as official cartographer of the VOC and Witsen's directorial position made both of them particularly interested in VOC outreach to Southeast Asia and also gave them privileged access for their personal collections to such images as the Vingboons port depictions. Most contemporary map collections, by contrast, followed Blaeu's own greater focus on nearer geography, Europe.

While such maps and views doubtless certify (or make claim to) possession of the represented lands, their site-specific geography and topography do not record the people and events that made possible these proud possessions. Commemorative portraits of the governors-general and directors-general of the VOC provide celebratory imagery of the personalities who led the Company. While portraits of most governors-general, such as Coen, that hung in the administration council chamber of the Batavia fort hold no great artistic merit, they were copied for wide distribution to various local VOC chambers in Holland.

Such homeland portraits, however, could occasionally be distinguished works. Finest of them is the portrait by the prominent Amsterdam artist (and Rembrandt associate) Govert Flinck (1615–60). It depicts Gerard Hulft (1621–56), first councilor and then director-general of the VOC, who sailed to Batavia in 1654 to take up his duties and had his portrait made on that occasion (figure 8.09 [plate 26]).[64] The Amsterdam patrician sitter appears before the dawn of a rising sun over the ocean in an oval frame, a Dutch portrait convention established by Frans Hals (1582–1666). Atop the frame a pair of angels hold an anchor before a dove of peace to suggest Hulft's VOC identity and aspirations. Around that fictive frame numerous attributes elaborate Hulft's personal interests and talents: scholarly tomes and writing instruments, above; loose documents of his city council secretarial and merchant career, below, as well as papers from distant European cities. At left sits a treaty with England from the First Anglo-Dutch War, in which he served, plus his "secret" VOC commission. In the lower left a globe, bamboo cane, and Japanese samurai sword stand beside charts and plans for fortifications, while at right nautical instruments cluster, including a compass and an astrolabe. Before an hourglass at the foreground, which serves as a memento mori, a more personal device appears in the bottom center—a drawing of a caterpillar transforming into a butterfly, accompanied by a Latin motto,

Figure 8.09. Govert Flinck, *Gerard Hulft*, 1654. Oil on canvas, 130 × 103 cm. Rijksmuseum, Amsterdam, SK-A-3103.

Nil adeo fuit unquam tam dispar sibi ("Nothing was so unlike itself"). Metamorphosis thus defines the sudden change of career and fortune of this young VOC leader, who would die a mere two years after this likeness was made, but not before successfully attacking the Portuguese at Colombo in Ceylon in 1655.

Finally, a printed image commemorates a major Dutch military conquest in the East Indies. The VOC army in the seventeenth century rivaled any other regional power, and its ultimate victory in the East Indies was achieved at last with

the conquest of the sultanate of Makassar on the Indonesian island of Sulawesi in 1669. Governor-General Johan Maetsuycker (1606–78) sought to capture that crucial regional trade center in order to secure his spice monopoly. So he dispatched a fleet commanded by Cornelis Speelman (1628–84), along with native military support on land, headed by the Buginese leader Arung Palakka (1634–96), who was returning from exile to take possession of his native land. Victory by land and sea was achieved in two campaigns (1666–69), and Arung Palakka was established as the loyal local ruler and ally, while the major Macassarese fort was renamed Rotterdam, after Speelman's birthplace.[65]

To commemorate this vital conquest, an etching was produced in Holland by Romeyn de Hooghe (1645–1708) in 1670, commissioned by the VOC directors (figure 8.10).[66] In addition to its pictorial documentation, the print is accompanied by an extensive text beneath, reporting the glorious news to the Dutch homeland like a modern newspaper. In the lower corners, verses, including lines penned by leading author Joost van den Vondel (1587–1679), offer praise to Speelman. Beside the cartouche that proclaims the subject appear the portraits of both Speelman and "Raja" Palakka, respectively, with the latter depicted topless, crowned, and carrying a spear.[67] Across the top and flanking a central laurel wreath with symbolic figures of sea and land victory appear two vignettes of other campaigns, a naval battle on the side of Speelman and a land assault on the court capital, Sambopo, by Arung Palakka.

The main battle scene, surely imagined by the Dutch etcher, features only a few markers of the tropical locality, chiefly tall palms and thatch huts, including one that is burning in the lower left foreground. In the lower right, native troops struggle in battle on a flaming hillside with weapons as diverse as spears, arrows, swords, shields, and muskets. The horizon features a cannonade from invading Dutch warships, which devastate small native boats along the shore. In the center, within clustered lances presented by the victors, local kings surrender afterward to Speelman. Numbers tied to a key help identify the actors and the actions for different scenes; together these annotations strongly imply that this exotic print offers eyewitness documentary value.

With this victory over Makassar, the last remaining holdout and Malay-controlled entrepôt at the southwest corner of Celebes (modern Sulawesi), the VOC finally achieved its desired monopolistic domination of the spice trade in the region. History here cements geography and ultimately consolidates for the Dutch their cohesive combination of territory and trade. This significant military milestone was proudly proclaimed and displayed back in Holland through Romeyn de Hooghe's commemorative news etching.

Dutch imagery thus encapsulated the rapid rise of the seaborne empire over the course of the seventeenth century. Beginning with tentative, highly specula-

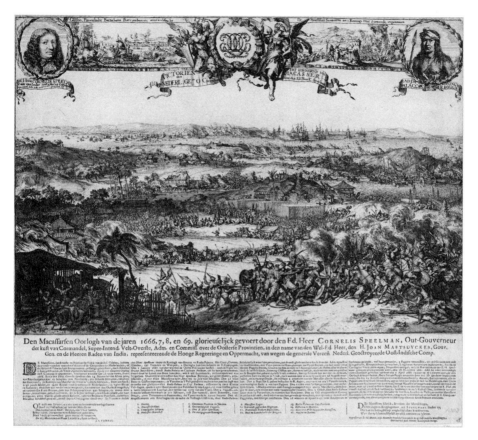

Figure 8.10. Romeyn de Hooghe, *Victories of Cornelis Speelman over the Kingdom of Makassar (1666–69)*, 1670. Etching, 50.8 × 54.1 cm. Rijksmuseum, Amsterdam, RP-P-OB-67.708.

tive voyages during the 1590s, published and illustrated travel accounts first introduced Asian destinations to Dutch audiences. After 1602 the formation of the VOC quickly led to territorial conquest and economic domination in the East Indies and the Indian Ocean. That regional consolidation would in turn further refine both sea charts and maps, secret at first but then published commercially as atlas maps, issued in Amsterdam by the Blaeu firm, under direct sponsorship by the VOC. Watercolors, but especially also large-scale site paintings by Johannes Vingboons, decorated the East India House in Amsterdam, displaying the distant lands and territories so proudly controlled by the VOC's Heeren XVII. By the time of the fall of Makassar in 1669, the ongoing efforts of Holland's peerless geographers to depict both the East Indies and the wider maritime world had established the Dutch seaborne empire as a setting widely integrated with the homeland through numerous representations in maps, print

documentation, and painted views as well as exotic natural objects imported for the privileged.

Taken together, then, this Dutch-based conceptual landscape of East and Southeast Asia circulated in public through printed imagery—travel accounts, illustrations, and maps—as well as through painted images of Dutch outposts in Asia within the nerve center of the VOC, the colonial merchant enterprise's directors. Thus it conforms closely to the "imperial landscape" of Mitchell, discussed in Stephen Whiteman's Introduction to this volume.[68] This kind of landscape representation served two purposes—one practical, for colonial exploitation of distant resources from Asia; the other, knowledge based, for confident consumption and ready possession in atlases and scenic views of travel. Yet (except for the de Hooghe etching of the Makassar battle), those seemingly neutral images seldom acknowledged the actual violence that lay behind possessions of territories and goods.[69] Landscapes, both printed and painted, abetted the nascent Dutch imperial project in its homeland and provided for VOC supervision and control of its overseas expansion, but they also simultaneously created and naturalized a discourse of power through representation.

Notes

1. Pieter Emmer and Jos Gommans, *The Dutch Overseas Empire, 1600–1800* (Cambridge: Cambridge University Press, 2021), esp. 245–399 for Asia.

2. Overviews: Jan de Vries and Ad van der Woude, *The First Modern Economy: Success, Failure, and Perseverance of the Dutch Economy, 1500–1815* (Cambridge: Cambridge University Press, 1997), 384–96; Anthony Reid, *Southeast Asia in the Age of Commerce 1450–1680, Volume 2: Expansion and Crisis* (New Haven: Yale University Press, 1993), 273–81; Femme Gaastra, *The Dutch East India Company: Expansion and Decline* (Zutphen: Walburg, 2003), with rich bibliography.

3. C. R. Boxer, *The Dutch Seaborne Empire, 1600–1800* (New York: Knopf, 1965); Jurrien van Goor, *Prelude to Colonialism: The Dutch in Asia* (Hilversum: Verloren, 2004), 25. See also Holden Furber, *Rival Empires of Trade in the Orient, 1600–1800* (Minneapolis: University of Minnesota Press, 1976), esp. 31–78.

4. Elmer Kolfin, "Omphalos mundi: The Pictorial Tradition of the Theme of Amsterdam and the Four Continents, Circa 1600–1665," in A. W. Boschloo et al., eds., *Aemulatio: Imitation, Emulation and Invention in Netherlandish Art from 1500 to 1800. Essays in Honor of Eric Jan Sluijter* (Zwolle: Waanders 2011), 382–92; Ernst van den Boogaart, "The Empress Europe and Her Three Sisters," in Paul Vandenbroeck, et al., ed., *America, Bride of the Sun: 500 Years of Latin America and the Low Countries* (Antwerp: Koninklijk Museum, 1991), 125–27.

5. Now see Marsely L. Kehoe, "Dutch Batavia: Exposing the Hierarchy of the Dutch Colonial City," *Journal of the Historians of Netherlandish Art* 7, no. 1 (2015), https://jhna.org/articles/dutch-batavia-exposing-hierarchy-dutch-colonial-city/, accessed 30 July 2021.

6. For the building and its decorations, Katherine Fremantle, *The Baroque Town Hall of Amsterdam* (Utrecht: Haentjens, Dekker, Gumbert, 1959), esp. 171–83; and Simon Schama,

The Embarrassment of Riches: An Interpretation of Dutch Culture in the Golden Age (New York: Knopf, 1987), 224, 228–29; for the ancient Batavians as a cultural precedent for the modern Netherlands, 76–81.

7. Kehoe, "Dutch Batavia": "The founders of the city of Batavia intended that it should look and feel Dutch as a means of establishing a dominant and cohesive Dutch population in a context of Dutch colonialism." Also, Kees Zandvliet, *The Dutch Encounter with Asia 1600–1950* (Amsterdam: Rijksmuseum, 2002).

8. On Van Meurs and the publication of richly illustrated books on global travel, originating in Amsterdam but quickly translated into English, French, and other European languages, see Benjamin Schmidt, *Inventing Exoticism: Geography, Globalism, and Europe's Early Modern World* (Philadelphia: University of Pennsylvania Press, 2015); for the earlier seventeenth century, see Elizabeth Sutton, *Early Modern Dutch Prints of Africa* (Farnham: Ashgate, 2012). Kees Zandvliet, *Mapping for Money: Maps, Plans and Topographic Paintings and Their Role in Dutch Overseas Expansion During the 16th and 17th Centuries* (Amsterdam: Batavian Lion, 1998), remains the essential study of VOC maps.

9. Roelof van Gelder, Jan Parmentier, and Vibeke Roeper, *Suffrir pour parvenir: De wereld van Jan Huigen van Linschoten* (Haarlem: Arcadia, 1998); Ernst van den Boogaart, *Civil and Corrupt Asia: Image and Text in the* Itinerario *and the* Icones *of Jan Huygen van Linschoten* (Chicago: University of Chicago Press, 2003), with bibliography. That work published the thirty-six engravings reissued with an abridged text in 1604 (Amsterdam: Cornelis Claesz) as *Icones et Habitus Indorum*. Translations quickly appeared in English (by Richard Hakluyt, London: John Wolfe, 1598), Latin (by the de Bry firm, Frankfurt: 1599), as well as French and German.

10. Zandvliet, *Mapping for Money*, 42–44. On Claesz as book publisher, Sutton, *Dutch Prints of Africa*, 21–44.

11. Van den Boogaart, *Civil and Corrupt Asia*, 54–55.

12. Van den Boogaart, *Civil and Corrupt Asia*, 56–57.

13. Van den Boogaart, *Civil and Corrupt Asia*, 58–59.

14. Van den Boogaart, *Civil and Corrupt Asia*, 58–59.

15. A Dutch equivalent "land yacht" for stadholder ruler Maurits of Nassau was invented by mathematician Simon Stevin and launched near The Hague. In 1602 it was engraved by Willem van Swanenburg (1580–1612) after a design by Jacques de Gheyn II (1565–1629).

16. Van den Boogaart, *Civil and Corrupt Asia*, p. 60.

17. Thomas Suárez, *Early Mapping of Southeast Asia* (Singapore: Periplus, 1999), 177.

18. Van den Boogart, *Civil and Corrupt Asia*, 108–15.

19. Vibeke Roeper and Diederick Wildeman, eds. and trans., *Om de Zuid: De eerste schipvaart naar Oost-Indië onder Cornelis de Houtman, 1595–1597, opgetekend door Willem Lodewycksz* (Nijmegen: SUN, 1997).

20. Michiel van Groesen, *The Representations of the Overseas World in the De Bry Collection of Voyages (1590–1634)* (Leiden: Brill 2008).

21. Roeper and Wildeman, *Om de Zuid*, 167.

22. Roeper and Wildeman, *Om de Zuid*, 168.

23. Roeper and Wildeman, *Om de Zuid*, 150.

24. Roeper and Wildeman, *Om de Zuid*, 152, noting that Malacca has no resources of its own and must import all staples, so it would be easy to starve into submission.

25. Roeper and Wildeman, *Om de Zuid*, 154.

26. Roeper and Wildeman, *Om de Zuid*, 160.

27. Roeper and Wildeman, *Om de Zuid*, 172, 174.

28. Roeper and Wildeman, *Om de Zuid*, 224–26.

29. Roeper and Wildeman, *Om de Zuid*, 230. This image essentially reverses the earlier Linschoten illustration; Van den Boogaart, *Civil and Corrupt Asia*, 88–89.

30. Roeper and Wildeman, *Om de Zuid*, 179–97, with eight labeled illustrations.

31. Roeper and Wildeman, *Om de Zuid*, 175–79, with three illustrations, including a claim to an alleged "chameleon or salamander of Madagascar," shown in the print, however, according to medieval legend as immune to fire.

32. George Keyes, *Mirror of Empire: Dutch Marine Painting of the Seventeenth Century* (Minneapolis: Minneapolis Institute of Art, 1990), 195–97, no. 50; Margarita Russell, *Visions of the Sea: Hendrick C. Vroom and the Origins of Dutch Marine Painting* (Leiden: Brill, 1983), 149–52, notes that the commission probably came from the fleet commander, Jacob van Neck, or more generally from the Oude Compagnie of Amsterdam, which sponsored the profitable expedition.

33. Keyes, *Mirror of Empire*, 326–27, no. 124; Zandvliet, *Mapping for Money*, 69, noting that the Dutch States-General purchased numerous copies from publisher Johannes Everardus van Cloppenburch.

34. Zandvliet, *Mapping for Money*, 69–71, figs. 3.11, 3.13.

35. Van Goor, *Prelude to Colonialism*; Gaastra, *Dutch East India Company*, emphasizes commerce over political possessions and calls the Dutch expansion "reluctant imperialism." The classic study remains Boxer, *Dutch Seaborne Empire*.

36. For Coen, see Van Goor, *Prelude to Colonialism*, 67–82; Boxer, *Dutch Seaborne Empire*, 107, quotes Coen as writing to the Heeren XVII in 1614 in his report on the "Dutch Indian State" (*Discoers touscherende den Nederlantsche Indischen Staet*) with the phrase "we cannot carry on trade without war nor war without trade."

37. Jan van Riebeek founded a VOC settlement at what is now Cape Town in 1652.

38. Gaastra, *Dutch East India Company*, 108–48. For the traces of VOC imports in Dutch paintings, Julie Hochstrasser, *Still Life and Trade in the Dutch Golden Age* (New Haven: Yale University Press, 200), 95–157, esp. 120–49 for Chinese porcelain, known as *kraakporselein*, because it was fetched back in ocean carracks. Now see Claudia Swan, *"Rarities of these Lands": Art, Trade, and Diplomacy in the Dutch Republic* (Princeton: Princeton University Press, 2021), esp. 213–33 for the lively trade for Chinese porcelain.

39. Van Goor, *Prelude to Colonialism*, 7–25, summarizes the historiography and debates.

40. Van Goor, *Prelude to Colonialism*, 23, notes that at the end of the eighteenth century Dutch rule encompassed more than six hundred thousand Asians and administered land ownership as well as administration over its subjects. He also notes: "The Asians regarded the Company as a political power and treated it accordingly. Not a single ruler in the Indonesian archipelago was capable of standing up to the VOC" (24). For Dutch diplomacy and foreign relations with local sovereigns, 30–47, where the rulers of Siam and especially of China asserted their superiority over all diplomats.

41. Van Goor, *Prelude to Colonialism*, 25. See also Furber, *Rival Empires of Trade*, esp. 31–78.

42. Zandvliet, *Mapping for Money*, 86–100. "[If our maps, logbooks, and drawings were to be] printed or in any other way would be known to the world in general, and in this way be known not only to all Kings, Princes, and Republics surrounding us but also to private merchants, they would allow them to also enter into the East Indian navigation and become active in the trade of the applicants, taking away their profit" (95).

43. On Blaeu and secrecy, Zandvliet, *Mapping for Money*, 128–30; C[ornelis] Koeman, *Joan Blaeu and His Grand Atlas* (Amsterdam: Theatrum Orbis Terrarum, 1970); Peter van der Krogt, ed., *Joan Blaeu Atlas Maior of 1665* (Cologne: Taschen, 2005), 511–13, 588. Also, Jerry Brotton, *A History of the World in 12 Maps* (New York: Viking, 2012), 260–93. Gerritsz died in 1632 with his work on the map copperplates unfinished.

44. Later the several expeditions by Abel Tasman (for whom Tasmania is named) between 1639 and 1644 would explore the Australian coast as well as New Zealand and Fiji. But since they held no commercial prospects and were inhabited by hostile locals, the VOC canceled further voyages.

45. William Eisler, *The Furthest Shore: Images of Terra Australis from the Middle Ages to Captain Cook* (Cambridge: Cambridge University Press, 1995), 78–99.

46. Eisler, *Furthest Shore*, 74–76; these discoveries were incorporated into the unpublished chart of the region (1628; Leiden, University Library) by Gerritsz (Eisler, *Furthest Shore*, fig. 32). The voyage was commanded by Jan Carstensz. For mapmaking in the East Indies VOC office in Batavia, Zandvliet, *Mapping for Money*, 101–17.

47. Zandvliet, *Mapping for Money*, 118–30. Günter Schilder, *Sailing for the East: History and Catalogue of Manuscript Charts of the Dutch East India Company (VOC) on Vellum, 1602–1799* (Houten: HES en De Graaf, 2010). General to Amsterdam map and atlas publishing, Paul van den Brink and Jan Werner, eds., *Gesneden en gedrukt in de Kalverstraat: De kaarten—en atlassen-drukkerij in Amsterdam tot in de 19e eeuw* (Utrecht: H&S, 1989), esp. 36–42 for Plancius, Hondius (father and son and son-in-law Johannes Janssonius), and the Blaeus.

48. Fremantle, *Baroque Town Hall of Amsterdam*, esp. 55–56, 172–85. The poetic dedication by Jan Vos reads as follows, with Asia also given pride of place in the text (translation by Fremantle, 55–56): "Bless'd Amsterdam, surrounded by water-multitudes, now wields Neptune's fork as empress of the freshwater and salt waves. Her head is bewigged with a crown of prows She has Trade, Plenty, Wealth, Unity and Faithfulness, whose nature is sincere, at her side. All her city wards are swarming with foreign traders. Black-coloured Africa gives her ivory, blood coral and gold. America gives her sugar cane, and silver, and wood which the unexplored forest of the west may boast of. And Asia gives her silks, and pears and flowers, with censers and other treasures. Their princes stand amazed now that they see the rich city on the Amstel blazing so gloriously on her throne So Rome boasted in the time of Augustus."

49. Zandvliet, *Mapping for Money*, 210–11; the map is illustrated as fig. 11.1; also Eisler, *Furthest Shore*, 94–96.

50. See my note 4.

51. Zandvliet, *Mapping for Money*, 211–12; Swan, *"Rarities of These Lands,"* 3–5, 63–64.

52. Erlend de Groot, *The World of a Seventeenth-Century Collector: The Atlas Blaeu–van der Hem* ('t Goy-Houten: HES en De Graaf, 2006), 7 vols.; Jacobine Huiskens and Friso Lammertse, eds., *Eenwereldreiziger op papier: De atlas van Laurens van der Hem (1621–1678)* (Amsterdam: Royal Palace, 1992).

53. De Groot, *Atlas Blaeu–van der Hem*, vol. 7, 226–27.

54. Eisler, *Furthest Shore*, esp. 68–99, for the Dutch expeditions.

55. De Groot, *Atlas Blaeu–van der Hem*, 188–89.

56. Zandvliet, *Mapping for Money*, 118–26, 179–81, 215–54. Vingboons was the son of a painter, David Vinckboons (1576–1632), who immigrated to Amsterdam from Flanders in 1586 and painted in the style of Pieter Bruegel. Vinckboons's print cycle of the Four Seasons was engraved after his designs by Hessel Gerritsz. For the family, Jacobine Huisken and Friso Lammertse, eds., *Het kunstbedrijf van de familie Vingboons* (The Hague: SDU, 1989); see especially Zandvliet, "Joan Blaeu's Boeck vol kaerten en beschrijvingen van de Oostindische Compagnie," in Lammertse, *Familie* Vingboons, 59–95.

57. De Groot, *Atlas Blaeu–van der Hem*, 189. The gift to Queen Christina emerged from close Dutch commercial ties to Sweden, including imports of armaments, iron, copper, and tar by such wealthy merchants (and Rembrandt patrons) as the Trips and the de Geers.

58. Zandvliet, *Mapping for Money*, 220–27. The depicted sites include: Cochin, Cananor, and Raiebagh in India; Canton, China; Ayutthaya, Siam: Lawec, Laos; and Banda Neira in

the Moluccas. Three lost works, based on surviving Vingboons watercolors, showed India scenes: Sualy Bay near Surat; the city and castle of Surat; and Bijapur.

59. Caspar Barlaeus, quoted by Zandvliet, *Mapping for Money*, 220–24. Duke Cosimo III Medici visited East India House in 1667 and ordered copies of many paintings (226).

60. On profile views, perspective plans, and bird's-eye views, Zandvliet, *Mapping for Money*, 230–36; also Richard Kagan, *Urban Images of the Hispanic World, 1493-1793* (New Haven: Yale University Press, 2000), 1–18.

61. Zandvliet, *Dutch Encounter with Asia*, 34–36, fig. 11; Kehoe, "Dutch Batavia," fig. 1.

62. Eisler, *Furthest Shore*, 119–44; Rebecca Brienen, "Nicolaes Witsen's Collection, his Influence, and the Primacy of Visual Knowledge," in Debra Cashion et al., eds., *The Primacy of the Image in Northern European Art, 1400-1700* (Leiden: Brill, 2017), 222–238. For other collectors' atlases in the Netherlands, see de Groot, *Atlas Blaeu–van der Hem*, 278–306. For Dutch *Wunderkammern* and collections of exotica, Ellinoor Bergvelt and Renée Kistenmaker, eds., *De wereld in handbereik: Nederlandse kunst—en rariteitenverzamelingen, 1585-1735* (Amsterdam: Historisches Museum, 1992).

63. Witsen's art collection was inventoried for sale in 1728. His loose drawings have not survived as identifiable, though they doubtless included drawings produced on VOC voyages. De Groot, *Atlas Blaeu–van der Hem*, 288 nn. 81–83.

64. Zandvliet, *Dutch Encounter with Asia*, 162–64, fig. 76.

65. Zandvliet, *Dutch Encounter with Asia*, 143–47; Leonard Andaya, *The Heritage of Arung Palakka: A History of South Sulawesi (Celebes) in the Seventeenth Century* (The Hague: Nijhoff, 1981), 73–136.

66. Zandvliet, *Dutch Encounter with Asia*, 144–46, fig. 69; Michiel van Groesen, "De geplukte Tapoeir: De verbeelding van de buiten-Europese wereld," in Henk van Nierop et al., eds., *Romeyn de Hooghe: De verbeelding van de late Gouden Eeuw* (Amsterdam: University of Amsterdam Library, 2008), 58–61, fig. 5.1. In 1677 the same printmaker produced an etching of a Dutch sea victory over the French at Tobago in the Caribbean Sea, commissioned by the Amsterdam Admiralty.

67. The term "arung" means ruler, or more generally nobleman.

68. W. J. T. Mitchell, "Imperial Landscape," in Mitchell, ed., *Landscape and Power*, 2nd ed. (Chicago: University of Chicago Press, 2002), 5–34, esp. 14: "Landscape is a medium in the fullest sense of the word. It is a material 'means' (to borrow Aristotle's terminology) like language or paint [or print], embedded in a tradition of cultural signification and communication, a body of symbolic forms capable of being invoked and reshaped to express meanings and values . . . serving as a theoretically limitless symbols of value."

69. Schmidt, *Inventing Exoticism*, whose subtitle, *Geography, Globalism, and Europe's Early Modern World*, provides an essential, Dutch-based analysis of the cultural context.

PART IV

Imagining Spaces

Landscape and Emperorship in the Connected Qing

Leng Mei's *View of Rehe*

Stephen H. Whiteman

Rising more than two and half meters high and nearly two meters wide, *View of Rehe* opens, corolla-like, before the viewer (figure 9.01 [plate 27]). In it, the Kangxi 康熙 emperor's (r. 1661–1722) newly constructed Rehe Traveling Palace (*Rehe xinggong* 熱河行宮) lies nestled in a protective ring of blueish-green mountains, which climb in layered forms from the valley floor. Carefully depicted courtyards and halls are precisely arrayed around the lakes and in the hills along the left side of the composition. In open spaces and among the trees, cranes and deer stand singly and in pairs, while two geese, birds of the steppe, fly northwest across the lower lakes. The landscape is otherwise devoid of living creatures; several boats, a few garden tools, and a lantern and banner hung outside a hall are the only signs of human habitation, as if the imperial estate awaits its royal occupants. The composition is highly unusual for its creator, Leng Mei 冷枚 (act. ca. 1677–ca. 1742), an artist in the early Qing (1644–1912) court best known for painting figures in divine or mytho-historical narratives, often in small album formats.[1]

Located in modern Chengde, Hebei, and constructed by Kangxi and his grandson the Qianlong emperor (r. 1735–95) in multiple stages over the course of the eighteenth century, existing scholarship on the fourteen-hundred-acre park-palace depicted here has largely focused on its architectural forms and the scenic itineraries charted by the two emperors and recorded in a number of painted albums and printed books.[2] Beyond these more familiar readings, the Rehe landscape—both the physical site and its many representations—should also be understood as a response to and product of the richly connected early

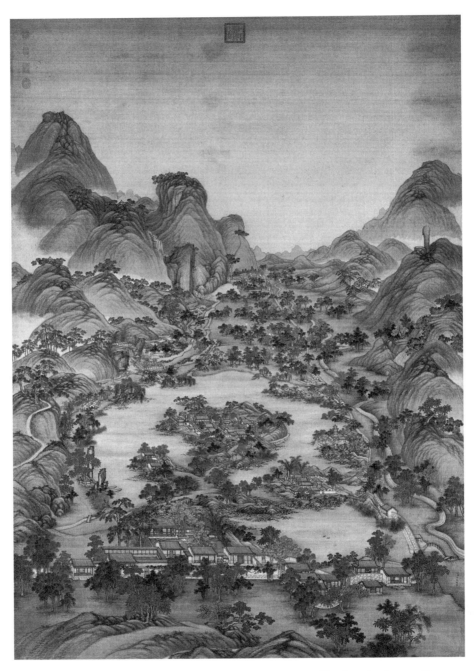

Figure 9.01. Leng Mei, *View of Rehe*, ca. 1709. Hanging scroll, ink and color on silk, 254.8 × 172.5 cm. The Palace Museum, Gu8210.

modern Qing regime. The Traveling Palace's social and political valences relied integrally on emerging understandings of pictures, science, and space in the Kangxi court, combining references to the past, innovative technologies, and multivalent connections between real and pictorial environments to convey a complex notion of early modern rulership.

Expressed through a range of materials and media, including imperial poetry, travelogues, and pictorial tours of the park-palace and the site itself, the court's use of landscape to articulate imperial authority takes especially compelling form in *View of Rehe*. Leng Mei was among a group of court artists active in the late seventeenth and early eighteenth centuries who sought to define a new pictorial mode through which they recorded imperial territory and environments, moral and didactic themes, and the emperor himself. Integrating endogenous and exogenous pictorial elements into a coherent visuality, Leng Mei and his fellow court artists conveyed the intra-Qing and trans-Eurasian cosmopolitan underpinnings of Kangxi's rulership.

View of Rehe reflects an admixture of stylistic modes, generic leitmotifs, and para-pictorial references drawn from Chinese painting and the court's own evolving landscape manner. It reveals a complex construction of pictorial space based both in established, endogenous modes and in European techniques acquired through missionaries at the court. Significant intersections between image making, mathematics, and space such as those evident in Leng Mei's work were by no means unique to the Qing. Measurement and representation defined the land and its mediation across early modern Eurasian societies.[3] The Qing— specifically the Kangxi court—offers an especially compelling example of the role of transcultural encounter and exchange in this process, however. Integrating aspects of idealized placemaking with maplike qualities and even cartographic methods, the work underlines important characteristics of landscape in the Kangxi court. These dualities reflect a moment in which Chinese and European practices were experimentally and strategically engaged.[4] Thinking about the resulting method or style not as "hybrid" but as a technology unto itself— one that, as with any technology, could be developed, transmitted, adapted, and repurposed—allows it, and pictorial rhetorics more generally, to be seen as tools that respond to specific needs and audiences. Understanding the formal and technical underpinnings of Leng Mei's *View of Rehe* positions the painting as more than a mimetic record of the primary site. It embodies the court's evolving triangulation of landscape, technology, and emperorship within the currents of ideas moving back and forth across early modern Eurasia.

A Kangxi Synthesis

Whatever its methods and constituent parts, Leng Mei's work appears as a coherent, multifaceted composition, legible on formal and symbolic levels to its intended audiences.[5] The emperor's park-palace provided the nascent regime with a site for the performance of imperial authority for a range of constituents, simultaneously drawing on traditions of past social and political regimes and repositioning the court vis-à-vis China proper, Inner Asia, and Europe. Leng Mei's image does the same by combining a pictorial rhetoric drawn from contemporary court practice layered with vocabularies of historicity and auspiciousness and the veristic qualities required to make the new northern seat of power recognizable. In this sense, it acts as a sort of portrait, communicating through the tension between objective portrayal and subjective presentation.[6] By incorporating both historic and contemporary artistic modes, it also may be understood as a pictorial metaphor in formal terms for the legitimization of a newly established regime.

Generally speaking, *View of Rehe* fits within the tradition of palace paintings, a subgenre of history painting often invested with mytho-historical qualities.[7] *Emperor Minghuang's Palace to Escape the Heat* (*Minghuang bishugong tu* 明黃避暑宮圖), traditionally attributed to the court painter Guo Zhongshu 郭忠恕 (d. 977), is a quintessential example (see figure 5.07 [plate 14]). Ascending the right side of the composition are the serried halls of the Palace of the Nine Perfections (Jiuchenggong 九成宮), an imperial retreat located in the hills outside the Tang dynasty (618–907) capital of Chang'an. Already by the tenth century a remembered landscape interweaving history and legend, the palace, supposedly so massive that a horse was needed to navigate its lengthy corridors,[8] suggests the glories of the Tang and was identified by Kangxi as a paradigmatic example of retreat as a strategy for sage and effective rule.[9]

In *Emperor Minghuang's Palace*, compositional focus is on the towering forms of the imperial halls, their elaborate eaves and endless colonnaded corridors carefully rendered in *jiehua* (界畫, literally, "boundary painting"), the precise, measured technique for which Guo Zhongshu is best remembered. Soaring mountain forms in the distance echo the heights of the palace and perhaps relate to understandings of great peaks as a metaphor for Confucian social hierarchies.[10] They also locate the palace physically and conceptually: emphasizing its position beyond the distractions of the city, suggesting the refinement of remoteness, and drawing upon their status as liminal spaces between mundane and immortal realms.

In *View of Rehe*, the relative prominence of these pictorial elements is essentially reversed. Its architecture appears almost jewellike, set within a much

grander, but still meticulously constructed, landscape. Like Guo Zhongshu, Leng Mei employs a form of jiehua, albeit one less exhaustively detailed, more naturalistic, and smaller in scale. Precise architectural rendering emerged in Buddhist painting of the Six Dynasties (ca. 220–589) and Tang, if not before, and was used in illustrations of divine and royal palaces, associations that persisted with the style. Executed with straightedges, compasses, and squares—tools of measurement and regulation—jiehua was established as a formal technique by the Song dynasty (960–1279).[11] Its use in architectural manuals and technical renderings of complex structures led the style to be linked to imperial power through the control of technology and labor.[12] These connotations naturally extended to jiehua's use in depictions of urban scenes and the built environment, such as *Going Upriver at Qingming Time* (*Qingming shanghe tu* 清明山河圖, 12th c.). Attributed to Zhang Zeduan 張澤段 (fl. 12th c.), the handscroll offers a detailed record of the bustling Northern Song capital of Kaifeng that has long been interpreted as an image of prosperity and harmony, and thus the virtue of Song imperial rule.[13]

Alert to such connections, Qing court painters explicitly quoted *Qingming*'s composition, iconography, and architectural style in creating their own images of the Qing empire at peace.[14] The series of twelve monumental handscrolls entitled *The Kangxi Emperor's Southern Inspection Tour* (*Kangxi nanxuntu* 康熙南巡圖; figure 9.02), executed by the Orthodox (*zhengpai* 正派) master Wang Hui 王翬 (1632–1717) and a bevy of assistants, describes the Qing South as vibrant, ordered cityscapes buoyant with commerce. Recording the emperor's 1689 tour, it suggests an urban analogue to Kangxi's vision of a productive and harmonious agriculturalism expressed through the Rehe landscape.[15] Wang Hui's construction of space combines shifting points of view and ground planes in order to create a sense of compositional continuity within the progressive, almost cinematic, handscroll format.[16] Although it results in a less stable representation of architecture than that seen in *View of Rehe*, this dynamic approach to space, together with Wang's use of an aerial, three-quarter vantage characteristic of jiehua in the Kangxi court, is a key model for understanding Leng Mei's composition.

Leng, his teacher Jiao Bingzhen 焦秉貞 (ca. 1660–1726), and others in the Kangxi court continued to refine this manner, as architectural painting became an essential component in representing real and idealized spaces of myth, history, and the court—subjects central to the visual construction and documentation of imperial legitimacy from the Kangxi period onward. With a stable angle of vision and an aerial, informative point of view, the architecture in *View of Rehe* is closely related to the manner displayed in an album of architectural studies by Jiao Bingzhen (figure 9.03). In one leaf, a complex system of buildings,

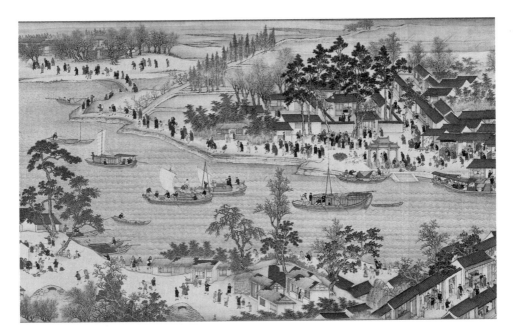

Figure 9.02. Wang Hui et al., *The Kangxi Emperor's Southern Inspection Tour*, 1698, scroll 7, "Wuxi to Suzhou." Detail of a handscroll, ink and color silk, 67.7 × 2220 cm.

walls, and pathways, precisely delineated with straightedges in carefully graded ink tones, sits astride a stream flowing from a lake ringed with pale mountains. The compositions demonstrate the court's newly developed approach to architectural perspective, joining the visual access of a broadly axonometric vantage with the dramatic spatialization of vanishing-point convergence. Moreover, the album can be considered a sort of pictorial manifesto for subsequent court treatments of architecturalized environments, combining jiehua with more stylized landscape elements.

Leng Mei's treatment of the landscape in *View of Rehe* combines reference to long-standing pictorial conventions and such contemporary developments at court. His manner draws on that of the so-called Orthodox School, which dominated late Kangxi court painting theory under Gao Shiqi 高士奇 (1645–1703) and Wang Yuanqi 王原祁 (1642–1715) and emerged as the leading mode in court landscape beginning with Wang Hui and the *Southern Tour* project.[17] In particular, *View of Rehe* follows Wang Hui's efforts toward a "Great Synthesis" (*Dacheng* 大成) of the Orthodox lineage and its adaptation to the pictorial demands of the ideologically maturing Kangxi court.[18] Leng Mei combines elements of Song monumentality and an archaizing blue-and-green (*qinglü* 青綠) palette with brushwork and compositional strategies derived particularly from Huang Gongwang 黃公望 (1269–1354), held by both Wang Hui and Wang Yu-

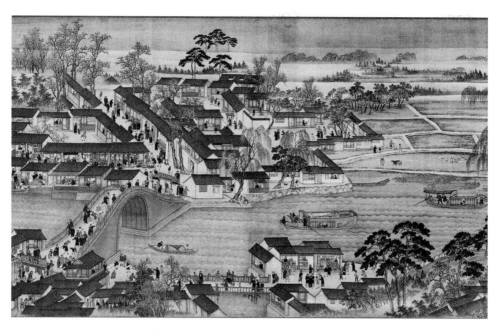

Mactaggart Art Collection, University of Alberta Museums, Gift of Sandy and
Cécile Mactaggart, 2004.19.75.1.

anqi to be the greatest of the Yuan (1271–1368) masters. The peaks that rise up on
both sides in *View of Rehe* are formed from a succession of graduated mounds
given shape by colored washes and the delicate layering of dry "hemp-fiber"
strokes (*pimacun* 披麻皴), which build upon one another to create winding
chains that move simultaneously up and back into pictorial space. At the same
time, like the peaks that stand mistily in the distance beyond Guo Zhongshu's
Palace of the Nine Perfections, both composition and scale in *View of Rehe*
evoke the so-called monumental landscapes of the Five Dynasties and Song
courts. Although more intimate compositions and formats based on Yuan mod-
els predominated in intervening periods, interest in earlier masters, including
Juran 巨然 (act. ca. 960–985), Fan Kuan 范寬 (ca. 960–ca. 1030), Jing Hao 荊浩
(act. ca. 870–ca. 930), and Guan Tong 關仝 (act. ca. 907–923), was revived under
the influence of Wang Hui and Wang Yuanqi.[19] Accordingly, the court style en-
gendered by Wang Hui and the Orthodox School bridged court and literati
manners across a range of dynastic periods: it may be thought of as synthesizing
not only the history of painting but history itself, the merging of artistic para-
gons into a single, coherent composition serving as an effective metaphor for the
Qing's own interest in establishing legitimacy through diverse cultural, politi-
cal, and territorial precedents.

Figure 9.03. Jiao Bingzhen, *Buildings in Landscapes*, Kangxi period (1661–1722), leaf 9. Album, ink on paper, 26.2 × 26.4 cm. The Collection of the National Palace Museum, Guhua3217-9.

The Auspicious Landscape

Qing court style was not limited to an abstracted expression of imperial legitimacy through stylistic and compositional reference, however. Late Kangxi painters combined formal and thematic elements to construct images of auspicious landscapes that functioned as metaphors for imperial virtue and the empire, particularly through connections with mytho-historical themes. Blue-and-green style, which originated in the Tang, if not earlier, was by the Song clearly associated with portrayals of immortal realms and, by extension, paradisiacal retreats such as Peach Blossom Spring, a site of fleeting escape from chaotic times described in the writings of Six Dynasties poet Tao Yuanming 陶淵明 (365–427).[20] With similar connotations to jiehua, the two manners were

often used in tandem, including in the Qing, when monumental depictions of mytho-historical and immortal realms were popular in courtly and commercial painting.[21] The blue-and-green palette adopted by Leng Mei, Wang Hui, and others in the court generally relied on thinner washes, rather than the dense mineral pigments used by earlier practitioners, and often incorporated other hues, especially light browns and pinks. Formally, these variations may be partially indebted to the influence of Huang Gongwang, whose use of pale color was frequently referenced by late Ming (1368–1644) and early Qing dynasty adherents to his style;[22] in practice, however, like the less rigid jiehua style seen in *View of Rehe* and elsewhere, they contributed to an increased sense of naturalism.

Leng Mei's use of blue-and-green and jiehua creates an image of a place apart, a site evoking not only historical paradigms of legitimate and sage rule but also an auspicious space on the border between mundane and sacred worlds. This status is reinforced by the depiction of cranes and deer within the composition. Because of their extremely long lifespans, cranes are linked with immortality.[23] Daoist adepts often flew about on cranes; on their own, the birds were understood either as markers of sacred space or as transmogrified immortals.[24] Though less common in Chinese painting, deer enjoy similar associations, both for their longevity and for the belief that they, alone among animals, possess the ability to locate *lingzhi*, the fungus of immortality.[25]

This combination of motifs and styles can be found elsewhere in early eighteenth-century court painting, reinforcing the associations they bring to *View of Rehe*. In *Nurturing Uprightness* (*Yangzheng tuce* 養正圖冊), an album now in the National Palace Museum datable to the first decade of the Qianlong era, Leng Mei portrays ancient emperors in idealized palace settings. Based on a didactic theme originating in the Song period,[26] *Nurturing Uprightness* depicts paragons of benevolent and righteous rule as analogies for the current regime.[27] In leaf nine, for instance, which depicts Tang Xuanzong 唐玄宗 (r. 713–756) in a garden setting, the blessings of heaven and the auspiciousness of the space are marked by coupled cranes, jiehua, and a blue-and-green palette.[28] In *View of Rehe*, as in Wang Hui's *Southern Inspection Tour*, this pictorial vocabulary was extended to the territory of the Qing itself, depicted in a manner suggestive of reading both imperial precincts and the empire as a whole as "paradises" on earth.[29]

The auspiciousness of the Rehe landscape is highlighted through Leng Mei's deliberate use of another formal element of Orthodox painting, the "dragon vein" (*longmai* 龍脈). Originally referring to flows of geomantic energy within the earth, in the painting theory of Wang Yuanqi current in the early eighteenth-century court, dragon veins describe chains of mountains that "rise and

fall" (*qifu* 起伏) and "open and close" (*kaihe* 開合) to give a painting compositional and perhaps metaphysical energy.[30] Along each side of *View of Rehe*, long veins of mountains frame the composition. Beginning in the foreground, near the valley floor, the veins ascend, twisting and turning, disappearing and reappearing, to reach a distant peak near the top of the picture plane. While primarily a compositional device in Wang Yuanqi's practice,[31] in certain Qing court works veins appear to connote the presence of geomantic energy in particular topographical contexts. An anonymous, undated court painting of Fuling 福陵 (figure 9.04 [plate 28]), the imperial tomb of Kangxi's grandfather, Nurhaci, serves to illustrate this.[32] Rising in angled parallel, tiered mountains encircle the tomb, tilting it toward the viewer, rather than rising around it, as in Leng Mei's work. The purpose is ultimately the same, however: depicting the embrace of significant imperial compounds within an auspicious web of geomantic energy.

Geomancy may also have factored into the composition of *View of Rehe* in another way. When we compare the painting to a topographical map, the mountains along the right side of the scroll appear closer to the eastern wall of the park than they are in reality, in effect narrowing the valley and encircling it in a nearly continuous horseshoe of mountains. One product of this composition is the elision of a key geomantic problem with the site—its openness toward the "ghost's gate" (*guimen* 鬼門) of the northeast.[33] At the same time, it allows the inclusion of a key scenic feature of the immediate area, the columnar rock formation known as Chime Hammer Peak (Qingchuifeng 磬錘峰).

Ghost's gate notwithstanding, much about the topography of the Mountain Estate was unquestionably auspicious. Following classical principles for the fortuitous siting of homes, cities, tombs, and the like, the Rehe valley possessed numerous desirable attributes, including south-flowing rivers, northern protective mountains, a gentle downward slope from north to south, and, with the early dredging of the lakes, a beneficial balance between mountains and water.[34] Court experts on natural phenomena played a central role, particularly as the project progressed, since officials from the Board of Rites (Libu 禮部) joined those from the Board of Works (Gongbu 工部) to ensure an auspicious design.[35] The emperor's description of the natural landscape similarly highlighted signs of positive geomantic energy, including "clear winds and refreshing summers (*fengqing xiashuang* 風清夏爽)," "purple mists (*qing'ai* 青靄)," and the fertility of the land.[36]

Auspicious signs also manifested literally at the park-palace through landscape formations, particularly within the central lakes. In a firsthand account of visiting the park in 1708 by the senior official Zhang Yushu 張玉書 (1642–1711), he recalled the emperor comparing the central lakes' dikes and islands to

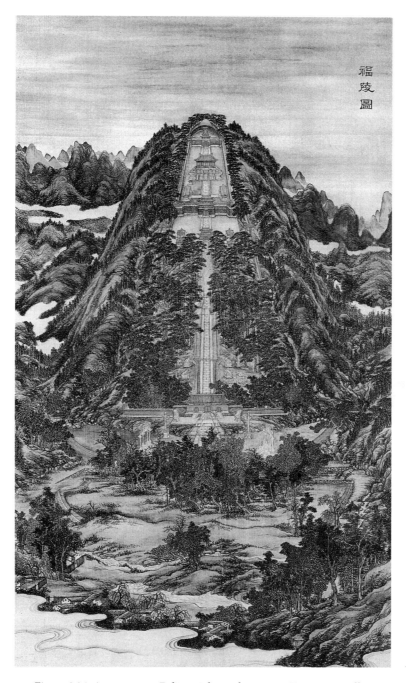

福陵圖

Figure 9.04. Anonymous, *Fuling*, eighteenth century. Hanging scroll, ink and color on silk, dimensions unknown. Collection of the First Historical Archives of China, Yu1809.

"a sort of lingzhi 靈芝 fungus," a resemblance preserved in the area's name, *A Lingzhi Path on an Embankment to the Clouds* (Zhijing yundi 芝逕雲堤).[37] This image is echoed in Kangxi's *Imperial Poems on the Mountain Estate to Escape the Heat* (*Yuzhi Bishu shanzhuang shi* 御製避暑山莊詩), where, in the emperor's words, "An embankment, flanked on both sides by water, winds and curves as it divides into three paths leading to three islands, large and small. They are shaped like a *lingzhi*, or like a cluster of cloud-flowers, or like a *ruyi*."[38] Through their evocative shapes, the artificially shaped lakes and islands of the park conveyed the properties of the lingzhi fungus, specifically longevity, and the ruyi 如意 scepter, a symbol of sagacity and authority especially popular in the Qing court.

Leng Mei's composition draws out many of these natural and human-made elements, particularly the mountains against which the palaces are positioned and the flow of water through the site, features it shares with the painting of Fuling. More subtly, *View of Rehe* emphasizes the ruyi forms in the landscape, even creating ones where they did not naturally occur. Through a combination of the overall composition and the sense of spatial foreshortening, Leng Mei's painting exaggerates the central lakes and islands compared to the rest of the valley, focusing on the northernmost island, now called Ruyi Island. Comparison with the topographical map shows that while Ruyi Island and *A Lingzhi* Path on an Embankment to the Clouds do resemble a ruyi scepter—a shape echoed in Leng Mei's work—the same cannot be said of the main lakes or the valley floor. Yet in Leng Mei's rendering, the island, lake, and valley appear to form a series of concentric ruyi, a virtual layering of auspiciousness.

Drawing attention to the islands at the center of the park also emphasizes the site's imperial status. Prior to the construction of the Palace of Righteousness, the compounds on Ruyi Island were the emperor's primary residence and, as such, the earliest center of imperial authority in Rehe. That there were three such islands in a single body of water echoes an auspicious garden design known generically as the "one pond, three mountain" (*yihai sanshin* 一海三山) plan, which had its roots in Han Wudi's 漢武帝 (r. 141–87 BCE) Jianzhang Palace 建章宮 gardens. Complementing his pursuit of immortality through elixirs and other magic, a surrogate paradise was created in the garden's primary lake, Taiye Pond 太液池, which contained imitations of three mythical islands of the immortals that were believed to lie off the eastern coast of China.[39] Taiye Pond became the model for many imperial gardens, including those in the Tang capitals of Chang'an and Luoyang, and in the successive capitals of Jin (1115–1234), Yuan, Ming, and Qing Beijing.[40] For Kangxi, one significant aspect of garden building was the opportunity to follow this historical line, to construct a landscape both auspicious and clearly associable with legitimate regimes of the past.[41] Among

the Mountain Estate's visitors and the painting's audience alike, those familiar with historical garden designs would have understood multiple meanings in the three islands branching off from the central path. The lingzhi, the ruyi, and the Islands of the Immortals all suggested wishes for longevity, symbols of wisdom and refinement, and the succession of imperial states to which the Qing was now the true heir.

At one level, immortals' realms and mytho-historical paradises such as Peach Blossom Spring seem to run counter to the politics of the late Kangxi period. Kangxi was emperor of a relatively young dynasty, and many of his subjects had lived through the wars of conquest, much like those Tao Yuanming imagined his poor fisherman escaping. Kangxi's rhetoric of rulership thus strongly foregrounded the Qing's claim to the Mandate of Heaven, particularly through demonstrations of active and attentive governance. Peach Blossom Spring and other paradises, by contrast, suggest disengagement from the problems of the world. Yet in describing the Rehe landscape, the emperor chose terms—purple mists, great mountains and deep gorges, and pavilions amid streams and caves—that all feature in later commentaries on Peach Blossom Spring, making the connection explicit.[42] By framing the park-palace in this manner, Leng Mei allowed Rehe to function as a metaphorical landscape for the Qing. If, rather than seeing the site simply as a place to which the emperor might escape, we read it as a metonym for the dynasty, then the landscape becomes one not only of place but also of time—in the Peach Blossom Spring of the Qing, Kangxi's subjects have escaped from the chaotic and perilous world of the Ming. Through its idealized topography, historiographic formal elements, auspicious denizens, and tranquil environment, *View of Rehe* embodies this vision of empire, framing the emperor's park-palace as epitomizing, instead of endangering, righteous and humane rule and a harmonious realm.

Perspectival Encounters

While drawing on well-established modes of picture making, *View of Rehe* also reflects innovative approaches and techniques circulating in the Kangxi court, particularly around spatial construction. In it, Leng Mei devised a solution to integrating aspects of perspectival representation within the broad framework of monumental landscape painting. This included not only diminution into distance but also a compositional structure that defines and constitutes the position of the viewer vis-à-vis the painting. While Leng Mei's mountains generally seem to follow Chinese models, the valley most certainly does not. The viewer looks down on an essentially level, continuous ground plane that stretches away

Figure 9.05. Zhang Hong, *Wind in the Pines
of Mount Gouqu*, 1650. Hanging scroll, ink and
color on paper, 148.9 × 46.6 cm. Museum of
Fine Arts, Boston, Keith McLeod Fund, 55.464.

from the picture plane and into the distance in a manner almost unprecedented
in Chinese painting. Several works by the late Ming painter Zhang Hong 張宏
(1577–after 1668) offer a rare comparison, most notably *Wind in the Pines of
Mount Gouqu* (*Gouqu songfeng tu* 句曲松風圖; figure 9.05), in which a narrow
valley winds into the distance between the walls of a steep ravine.[43] Zhang

Hong's valley is soon lost in mist, having carried the viewer only a short way into its depths. Leng Mei's viewer, on the other hand, is transported into the image, visually carried from the nearest foreground structures to the valley floor's farthest reaches.

Leng Mei constructed his composition through three separate lines of vision: one looking up the valley, the second delineating the architecture, and the last directed at the mountains on either side. The valley floor is defined with a loose single-point perspective that gives shape to the composition as a whole and guides the eye inward, while also effectively describing diminution into space. Most clearly evident in the edges of the valley itself, the orthogonals by which this recession is broadly defined meet atop a low mountain in the distance. Converging just right of center, they describe a slightly angled line of vision that cuts across the overall frontality of the composition. The second line of sight, defined by the perspectival diminution of the architecture, originates from the lower right of the composition. Its orthogonals meet outside the composition, to the upper left (figure 9.06). Together with the upward movement of the mountains, the leftward pull of the architectural orthogonals and the depth of the valley create compositional tension through three intersecting, albeit diverging, visual imperatives that destabilize the composition's presumptive point of view.

The valley and verticality of the high peaks define a frontal viewing position that, in turn, implies that the spatial construction of the painting is organized around a stable point of view. The pictorial vantage point—the "painter's eye"— is in fact mobile, however, though not in the sense generally understood in Chinese landscape painting. Early painters of monumental landscapes, such as Fan Kuan and Guo Xi 郭熙 (ca. 1000–ca. 1090), often used shifting points of view, angles of vision, and constructions of ground and depth to create noncontinuous, yet visually coherent, spatial compositions.[44] Leng Mei employs a different strategy, utilizing distinct but related vantage points to fashion the mountains and valley separately.[45] The mountains are constructed from along a horizontal line that transects the image approximately a third of the way up the composition, roughly between the top of Ruyi Island and the northern shore of the lakes. Accordingly, the painter's eye looks down upon the foreground mountains, straight at those in the middle ground, and up the rising veins of those in the distance. Each mountainous form is depicted from a directly frontal point of view, meaning that the eye shifts from side to side with the movement of the hills. By contrast, the valley is represented from a progressive vantage that moves upward along a central axis as the composition moves into the distance but remains stable from left to right. The painter's eye thus views the valley at a consistent angle of vision even as the composition moves into depth, rather than

growing flatter and more oblique, as it would if the painter's eye were fixed or the viewer were situated at ground level.

This complex system of spatial construction functions in concert with the act of looking. With the hanging scroll hung so its bottom roller sits at or just above the floor, a viewer of 165 to 177 cm in the thick-soled boots common to court dress would have been looking directly at the upper half of Ruyi Island.[46] The heart of the composition, this also corresponds with the approximate line along which the vantage point for the mountains moves. The viewer's physical position thereby reinforced Leng Mei's compositional construction: from eye

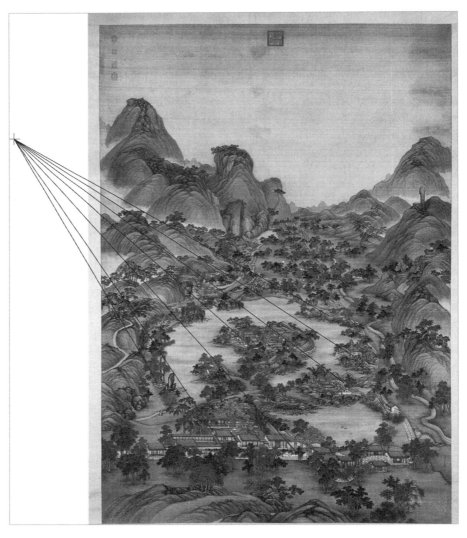

Figure 9.06. The architectural orthogonals in Leng Mei's *View of Rehe*. Drawing by Pen Sereypagna.

level, one looks down, straight out, and up at the hills in the foreground, middle, and distance, while at the same time, the vertically mobile vantage point allows the viewer to look up and into the valley as if floating above the landscape and following it into the distance.

While European perspective works to position the viewer relative to the composition physically, visually, and psychologically, the mobile vantage points conventionally employed in Chinese painting meant that the relationship between image, viewer, and physically situated vision was less determined. *View of Rehe*'s departure from this endogenous tradition is exemplary of a fertile period of artistic experimentation in the court beginning in the 1690s. During that time, Leng Mei, Jiao Bingzhen, and others associated with the studio of the Italian Jesuit Giovanni Gherardini (1655–1723?), who taught perspective in the court around the turn of the century, worked creatively to integrate diverse perspectival techniques into new modes of spatial representation.[47]

Like a number of other works produced in the Kangxi court around the same time,[48] *View of Rehe* relies on a form of accelerated perspective in which the perspectival illusion is predicated on an ideal viewing position. The scroll does not demand the degree of experiential specificity characteristic of such images in Europe,[49] however, which would develop in Qing court painting by the later eighteenth century.[50] In *View of Rehe* Leng Mei devised a system by which depth and height—the y and z axes of the pictorial space—could both be addressed, creating an image that incorporated features of ocular perspective into a system of mobile vantage points and multiple pictorial foci. The product was a painting that capitalized on new knowledge and techniques imported from Europe, while retaining the essential pictorial vocabulary and visual legibility of established genres and styles of painting for authority in China.

Measured Sight

Several aspects of Leng Mei's composition suggest not only an ideal position from which to view the painting but also that the work recreates its view of the Rehe valley from a specific real-world location. When viewers stand before the composition and follow it from bottom to top—effectively, south to north—the painting's ground plane extends before them. Though the terrain is essentially even and continuous, a point of discontinuity in it offers a subtle indication that the painting records the scene as it appears in life. In the foreground, an area of pale green is bounded at its upper edge by a thin, black outline, most readily visible in the open space between architecture and low mountains in the lower left. In the lower right, this same outline marks the boundary between ground and

lakes just above a perimeter gate and small hall. This line denotes not simply transition but a sharp drop in real-world elevation. In the painting, the ridge effectively obscures the lower portions of the lakes below. Here, the painting appears to capture not the omniscient bird's-eye view but the scene as if seen from a low angle at some distance away. Mountains just south of the modern city of Chengde, roughly three kilometers from the entrance to the Mountain Estate (Figure 9.07), provide just such a vantage point.

In his "Record of the Mountain Estate," Kangxi wrote of the process of design and planning that preceded construction of the park-palace: "Survey[ing] the contrasts between the heights and the plains, the near and far, reveal[ing] the natural formations of the peaks and mountain mists,"[51] the plan for the garden emerged in harmony with the landscape. Though the emperor's language makes specific activities difficult to ascertain, the measurement of elevations and depressions, as well as of distance, echoes that of early Chinese mathematical and cartographic treatises.[52] As long histories of civil engineering, urban planning, and cartography in China attest, surveying—first of flat planes such as fields and then of heights—existed as a progressively more sophisticated branch of practical geometry since the Zhou dynasty (1046–256 BCE), reaching significant sophistication during the Song.[53]

During the Kangxi period, this history was complemented by methods introduced by Jesuits at the court. Beginning with astronomy—in which the emperor had particular political interest, as it related to the setting of the annual calendar—the court's engagement soon expanded to cartography through the efforts of Ferdinand Verbiest (1623–88) and Jean-François Gerbillon (1654–1707). Verbiest charted topography and routes during the emperor's first seasonal tours north of the Great Wall in the early 1680s, and Gerbillon's mapping of the contested northern border with Russia was instrumental to the Treaty of Nerchinsk in 1689.[54] Following the conclusion of wars of conquest in the 1690s, the court sponsored a joint European-Qing surveying project of the much-expanded imperial territories that culminated with the "Map of a Complete Survey of Imperial Territories" (*Huangyu quanlan tu* 皇輿全覽圖), created between 1708 and 1718.[55] Leng Mei was not directly involved with any of these projects or the translation and application of pure and applied mathematics that occupied much of the Jesuits' efforts in the court, but his teacher Jiao Bingzhen may have been. In the 1680s, Jiao held a supervisory role in the Astronomical Bureau, where he worked with Verbiest.[56] It has been suggested that Jiao may have learned perspective from the Flemish priest, who was one of several Europeans at the court to introduce the technique to the emperor.[57] Regardless, Jiao was certainly expert in the mathematics that underpinned astronomy,[58] a branch of

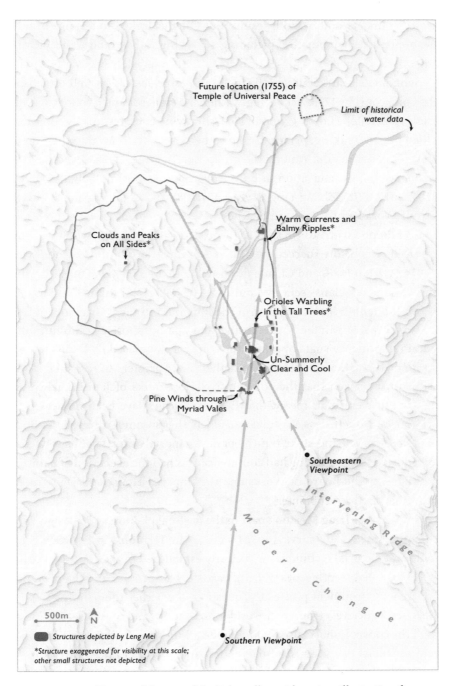

Figure 9.07. Topographic map of the Rehe valley, with vectors illustrating the southern and southeastern vantage points reflected in Leng Mei's *View of Rehe*. Map by Daniel P. Huffman.

knowledge understood by both Jesuits and Qing as linked to a range of other fields of applied mathematics, including surveying, cartography, and pictorial perspective.[59]

Trigonometric surveying, both small- and large-scale, was well established at the Qing court by 1703. Accordingly, when the emperor and a cohort of senior officials visited Rehe Lower Camp in 1702, surveying and presumably some form of allied picture making, perspectival or otherwise, were central to their preparations for construction. Among the group were several scholars who had long been engaged in his education in European sciences, most notably Li Guangdi 李光地 (1642–1718), Zhang Ying 張英 (1637–1708), and Zhang Yushu.[60] Both the Board of Works and the Board of Rites were represented, as were the Jesuits: Claudio Filippo Grimaldi (1638–1712), who had assisted Verbiest at the Astronomical Bureau before succeeding him as Administrator of the Calendar (*zhili lifa* 治理曆法) in 1688, and Claude de Visdelou (1656–1737), one of the original "King's Mathematicians" sent by Louis XIV (r. 1643–1715) to the Qing in 1688, are both thought to have been part of the imperial retinue.[61] Grimaldi, at least, was also a capable painter of perspective and anamorphosis—techniques that, in addition to their visual appeal for the emperor, were used by Jesuits to demonstrate mathematical problems.[62] Whether other painters were present is impossible to say, given that the comparatively low ranks of Jiao Bingzhen and Leng Mei, in particular, meant that they would not have been named in the court diaries. Nonetheless, an edict issued late that summer directed the Board of Works to survey and stake out the park. Memorials shortly after New Year, 1703, reported that surveying had commenced, as had the execution of paintings and designs by the Board of Works and the Imperial Household Department, which supervised court painters.[63]

Thus, whether Leng Mei took part in the original planning and design of the site or not, small-scale surveying, as well as the relationship between cartographic and pictorial techniques was clearly established in the court by the first decade of the eighteenth century. Leng's artistic background and the prevailing intellectual environment presses the question of whether the painting's apparent accuracy derives from real-world observation and measurement. Even though the conventional claim that premodern landscape painting in China was purely a product of the artist's imagination and studio has been discredited,[64] the prospect that Leng Mei relied upon surveying data in creating *View of Rehe* is without precedent.

No documentary evidence attesting to this proposition has come to light, and yet the painting, when compared with maps of the site, offers compelling evidence. Referring again to a topographical map, it is apparent that although the park-palace itself is oriented north-south, the valley angles to the northwest.

Broadly speaking, the vista obtained from the south is that of the painting: the valley stretches before the viewer, framed by succeeding ridges of mountains on either side and culminating in low hills in the deep distance. In the painting, three buildings align precisely with one another on a trajectory that extends directly to the center of the mountain that serves as the valley's vanishing point. The structures are also aligned in the physical landscape: extended north, a line connecting them identifies the painted valley's vanishing point as a low foothill northwest of the future site of the Temple of Universal Peace (Puningsi 普寧寺), constructed in 1755; extended south, this line perfectly intersects the site of a pavilion in the southern foothills.[65] Although its original date of construction is not known, the pavilion is in an ideal location for gaining a clear vista of the park.

Projecting a viewshed analysis from the site of the pavilion helps confirm the hypothesis of firsthand observation by explaining aspects of the painting that depart from topographical reality (figure 9.08 [plate 29]).[66] The pavilion stands roughly ninety meters above the park's central lakes (424 vs. 336 m above sea level), and between three and five kilometers from the southern- and northernmost structures that appear in the painting, resulting in an extremely low angle of vision. As a consequence, a ridge that extends from the east across the space between the pavilion and the park is high enough—at between 375 and 425 meters above sea level—to obscure visibility of much of the half-moon-shaped flood plain that forms the eastern side of the valley. The result is a viewshed in which the valley appears nearly straight along its eastern edge, just as Leng Mei renders it.

The manner in which the mountains are constructed similarly reflects their appearance from the low vantage of the viewing pavilion (figure 9.09 [plate 30]). On the left of the viewshed analysis, four bands of mountains extend southeast to northwest inside the park. Moving north, each of the four bands is higher than the last, the nearest standing at approximately 370 meters, while the most distant rises to roughly 430 meters. Thanks to the slight offset between an essentially northerly pictorial frame and a slightly northeasterly valley, only the very foothills of these ridges are detectable in the foreground of the painting, while multiple peaks emerge farther back. Essentially, the painting records this scene as it is in reality: a series of layered, progressively taller veins moving into distance. The same is true in the east, save for the fact that the southernmost reaches of these mountains are tall enough to occupy much of the viewshed, obscuring what lies behind until the eye reaches the taller peaks of the deep distance. While certainly outside the proper picture plane, the spire of Chime Hammer Peak is also visible from the viewing pavilion, helping account for its inclusion in the painting.

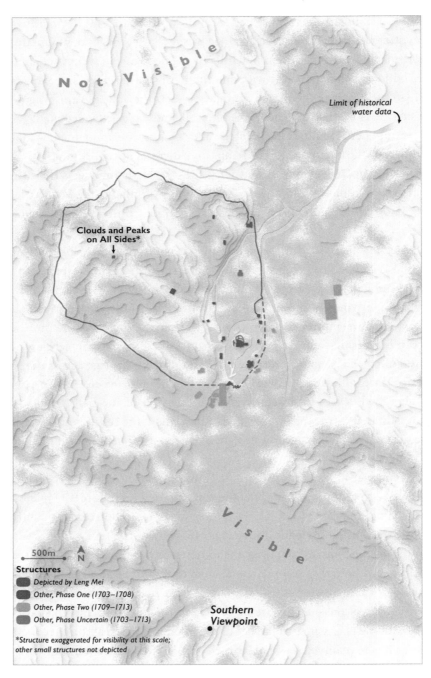

Figure 9.08. Viewshed analysis from the southern vantage point (40.955311°, 117.933394°). Map by Daniel P. Huffman.

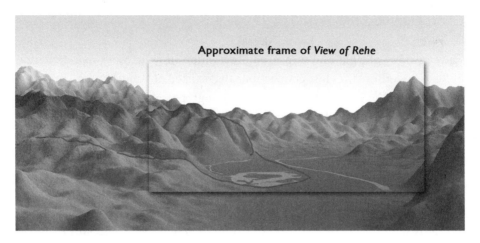

Figure 9.09. Three-dimensional pictorialization of the viewshed analysis from the southern vantage point (40.955311°, 117.933394°), reflecting the approximate frame of Leng Mei's *View of Rehe*. Map by Daniel P. Huffman.

The low angle of sight also explains the way in which the foreground ridge conceals the near shore of the lake, though not the extent to which it does so. The viewshed analysis indicates that the ridge ought to entirely obscure the lake south of Ruyi Island, yet a portion of this still appears in the painting. Indeed, while Leng Mei has correctly omitted a number of buildings that would have been concealed by various topographical features, several other buildings that should also be hidden appear nonetheless. Their presence may be accounted for by the use of a second viewpoint, a practical requirement for surveying by triangulation.[67] Looking again at the architecture's perspectival orthogonals, the vantage that corresponds with their approximate angle of vision is gained from points along the southern end of the low intervening ridge running between the viewing pavilion and the park-palace. Looking north-northeast from that ridge, the compounds of two central islands, Moonlight and the Sound of Rivers (Yuese jiangsheng dao 月色江聲島) and Ruyi Islands (Ruyi zhou 如意洲), are nearly aligned, the former just to the left of the latter, as they appear in the painting. Moreover, several structures that are hidden from sight when addressed from the south come into view, particularly Clouds and Peaks on All Sides (Simian yunshan 四面雲山) and A Northern Post Linking Paired Peaks (Beizhen shuangfeng 北鎮雙峰). As in the other examples outlined above, the accuracy of Leng Mei's representation is not simply to topographic reality but to the specific view of that reality gained from firsthand observation.

Chorographic Rehe

The centrality of sight and measured observation in Leng Mei's representation of Rehe underlines the close connections that existed not only between branches of applied mathematics but also between topographical landscape painting and more technical approaches to representing space. In what ways is it useful to think about *View of Rehe* as maplike, and how do these aspects of the work complicate or expand its operation within the genre of landscape painting? At one level, the early modern "cartographic impulse," in China as in Europe, often arose from interests in accuracy or verisimilitude, and with deeper forms of knowledge felt to be revealed by such priorities. Such concerns overlapped productively with smaller-scale genres of spatial representation, especially architectural plans. Yet the perception of accuracy, and particularly of the knowledge derived from firsthand observation, also worked rhetorically, allowing images to make claims in support of other pictorial goals. Equally significant, cartographic qualities help suggest some final answers to how Leng Mei's unusual composition came into being, in both visual and technical terms.

If Leng Mei's painting is to be considered as a map, it is useful to think of it not as a work of geography—the recording and representation of large-scale fields of spatial knowledge, which was the Kangxi court's primary concern in this area—but as one of chorography. Chorography records the small-scale and the local: city views and water systems, villages and temples.[68] In both China and Europe, the chorographic tradition combined descriptive and rhetorical qualities. This underlines the communicative imperative of mapmaking—namely, that quantitative veracity is but one way in which a map may be thought of as accurate or truthful, and that maps, like all pictures, also communicate through visual, textual, and symbolic codes mutually intelligible to maker and viewer.[69]

Chorography and "city views," in particular, return the discussion to the comparison made earlier with the work of Zhang Hong. As James Cahill provocatively argued, Zhang Hong's unusual treatments of space in such works as *Wind in the Pines of Mount Gouqu* show remarkable similarities to early modern European city views, such as those of the *Civitates orbis terrarum*, produced in Cologne by the topo-geographer Georg Braun (1541–1622) and the engraver Franz Hogenberg (1535–90) between 1572 and 1617.[70] Unnaturally elevated or bird's-eye points of view, shifting ground planes, hints of ocular diminution, even the use of specific motifs all strongly indicate that European prints, including chorographies, were in circulation among select artists and intellectuals in late Ming China.[71]

Views collected by Braun and Hogenberg followed a number of basic compositions; one offers a particularly compelling comparative model for *View of*

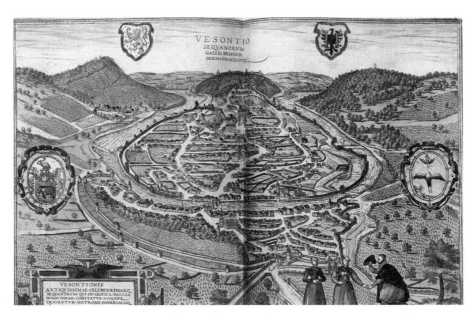

Figure 9.10. Pierre d'Argent, "View of Besançon" (Vesontio Sequanorum, Gallis Besanson, Germanis Byazant), in Georg Braun and Frans Hogenberg, *Civitates orbis terrarum*, vol. 2 (Cologne, 1575). Geography and Map Division, Library of Congress, g3200m.gct00128a.180.

Rehe. In *View of Besançon* (figure 9.10), a city in Franche-Comté near the Swiss border, a small foreground promontory affords an expansive outlook on the city and the surrounding countryside to three observers.[72] Designed by Pierre d'Argent,[73] this woodcut is an early example of what Lucia Nuti terms a "perspective view." The genre combines data drawn from surveying the city with pictorial strategies embedding the urban map within a surrounding landscape and a series of nonnaturalistic elements asserting the authority of the image.[74] Like *View of Rehe*, *Besançon* does not follow a consistent perspectival method, nor even any one form of spatial construction. Figures in the foreground notwithstanding, the viewpoint is unnaturally elevated above any available vantages. The city is positioned within a ring of surrounding hills, tilted subtly up from the predominant ground plane to make its plan more legible.[75] The mountains, by contrast, are essentially shown frontally, the viewer gazing into the deep distance. Roughly speaking, the lines of diminution converge at the summit of the central mountain against which Besançon sits, the focal point further reinforced by the river that wraps around the city. The appearance of perspective serves to heighten a sense of eyewitness accountability. Within the city's walls, individuated structures and the twisting particularities of streets likewise reinforce the viewer's trust in the image.

The perceived accuracy of such images, central to their viability as commercial products, is as much a matter of pictorial rhetoric as anything else. As a genre that existed stylistically and technologically between cartography and landscape painting, city views were rooted in first-person observation and surveying data. From the late sixteenth century, seeking out elevated points from which to observe and measure the city became a popular pastime in Europe among the educated elite.[76] The portability and precision of instruments, including quadrants, sighting tubes, and surveyor's plane tables, evolved significantly during this period.[77] City views were very much products of the studio, however, both for practical reasons and because the application of surveying data was a mathematical process, not one done strictly by the eye.[78] Since Leon Battista Alberti's (1404–72) mapping of Rome in the mid-fifteenth century, the procedures for visually rendering abstracted surveying data were well established, such that the surveyor and cartographer or painter could not only be different people but could easily be separated by both place and time.[79]

The compositional similarities between the two *Views* are notable.[80] Neither the elevated viewpoint nor the integrated use of multiple vantages and perspectives was new to Chinese painting, as was discussed above. Yet their particular combination in the manner seen here, together with an interest in a form of optical perspective, is strongly suggestive. So, too, are certain details, such as the shared use of a mountain as vanishing point in the distance and the foreground ridge. The latter is particularly unusual in the case of Leng Mei's painting: while Chinese landscape compositions frequently employ foreground landmasses, they are generally set slightly away from the picture plane. Rather than being a literal point of entry into the pictorial space, they function as a kind of *repoussoir*, visually mediating between the two sides of the picture plane. In *View of Rehe*, by contrast, a narrow path leads the viewer directly into the image. Finally, Leng Mei's central lakes are less dramatically tilted toward the viewer than the city of Besançon, a reflection perhaps of a seventeenth-century preference for flatter, more naturalistic chorographic representations. The silver-blue disc of Leng Mei's lakes is nonetheless subtly raised, readable both as continuous with the valley's ground plane and, given its scale and color, as shifted to highlight the imperial "city" upon its islands.

The basic tools for such measurements were present in the Qing court, well known even to the emperor through his mathematical education, as was at least one text in Chinese on their practical application.[81] These and other devices for land measurement, such as timepieces and optical aids, were made in imperial workshops as well as being imported from Europe by the Jesuits as gifts.[82] Kangxi is recorded by his teachers as being both familiar with the manufacture of surveying instruments—a number of extant examples from court workshops

bear explicit reference to being "produced at imperial command"[83]—and well practiced in their use.[84] Given Leng Mei's close connections to the study of mathematics in the court through his relationship with Jiao Bingzhen and his integral role in the development of perspective in court painting, it is reasonable to imagine that he, too, might have been acquainted with the basics of surveying. This would not have been a necessity, however, as others in the court could, and most likely would, have performed the fieldwork. Using a later version of Alberti's techniques, Leng Mei could have produced the more cartographic portions without ever having studied the site firsthand.

In whatever ways Leng Mei employed surveying data and direct observation to construct his painting, *View of Rehe* is, like *View of Besançon*, ultimately a product of the studio. The exact methods for the selection and translation of mathematical information into a larger representational image of the site is unclear in both European and Qing cases.[85] A partial explanation may be offered through the teaching of perspective in the court, however. The introduction of formal instruction in perspective at the Kangxi court in the 1690s coincided with new uses of perspective, particularly the illusionistic techniques of Andrea Pozzo (1642–1709), as core components of the global Jesuit mission's use of mathematics and art.[86] Pozzo was particularly known for *quadratura*, a technique that extends architectural space through complex illusions used on the ceilings and walls of churches and private spaces, and for theater sets from the fifteenth century onward. Giovanni Gherardini, the most significant among the Jesuit painters sent to the Kangxi court, was similarly trained in quadratura, and his ceiling in the Jesuit North Church (Beitang 北堂, completed 1703) in Beijing was one of the early monuments of illusionistic painting in the capital.[87] Forms of accelerated perspective related to quadratura ultimately became very important in Qianlong court painting.[88] Early evidence of the technique can be seen in the multiple ways in which *View of Rehe*, among other works, blurs the distinction between the viewer's space and that of the painting.[89]

As with other branches of applied mathematics, the court eventually relied on a combination of imported, translated, and domestically produced texts on perspective. Pozzo's own text, *Perspectiva pictorum et architectorum*, first published in 1693, would enjoy great significance in the late Kangxi and Yongzheng courts. It served as a key source for both Giuseppe Castiglione (1688–1766), the most famous of the eighteenth-century European painters in the Qing, and *The Study of Vision* (*Shixue* 視學), one of several related mathematical treatises published by the official Nian Xiyao 年希堯 (1671–1738) between 1718 and 1735.[90] Although Pozzo's text was likely not yet in Beijing when Leng Mei executed *View of Rehe*—the copy recorded in the catalogue of the North Church Library is a slightly later 1702–1723 edition[91]—a number of the seventeenth century's

most important texts on perspective were.[92] Moreover, the core ideas that help explain the perspectival construction of *View of Rehe* had been well established for at least fifty years, such that identifying a specific text is unnecessary.

The construction of the valley floor and its architecture appear to involve three basic steps. In the first instance, the primary line of sight was articulated through single-point convergent perspective, albeit at a "lateral aspect," offset slightly to the right.[93] The secondary line of sight, by which the architecture is rendered, utilizes a technique known as *veduta per angolo*, or "angled view." This had its origins in theatrical scenery painting, where it extended the perspectival illusion to the wings and center of the audience alike.[94] While these two methods assured a sense of depth in the painting, a final step allowed the architecture of the central lakes to be properly arrayed. Looking down, the buildings are located in precise relation to one another, simultaneously receding along with the primary and secondary lines of sight. Such arrangements appeared commonly in European perspective manuals, often expressed through the depiction of complex flooring patterns. Nian Xiyao includes a number of examples of this technique in *The Study of Vision*, illustrations that he characterizes not as means for illustrating inlaid floors but—much to the point here—more broadly as a "method of creating things on a ground plane" (*diping shang qi wujian fa* 地平上起物件法).[95] Laid within a grid defined equally by simple geometry and by trigonometric surveying, the pavilions and halls of the Mountain Estate were arranged much like the individual tiles in an intricately patterned mosaic.

The comparison with *View of Besançon*, and with city views more generally, suggests ways of accounting for aspects of the *View of Rehe*'s unusual compositional strategies and the means of its creation. These comparisons should not be taken as comprehensive explanation for these concerns but instead be understood in concert with other readings of the painting and the works that surrounded it in court. While it seems quite possible, even likely, that early European city scenes were known in the Qing court, later examples of the genre offer a more proximate source. Upon their return from Paris to Beijing in 1699, Louis XIV's King's Mathematicians carried with them numerous monumental volumes of the *King's Cabinet* (*Cabinet du roi*), a collection of hundreds of engravings of the French court bound in red calfskin and embossed with gold.[96] Among them were a great number of landscapes, such as scenes of French cities and royal gardens. The volumes entered the Qing imperial library, and later that of the North Church, where books in European languages were transferred under the Qianlong emperor.[97] Considered of exceptional quality even in Europe, the *Cabinet* prints' source, large scale, and remarkable detail would surely have been of interest to an emperor attuned to how his contemporaries presented themselves.

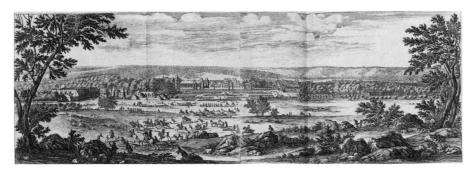

Figure 9.11. Israël Silvestre, "View of the Château of Fontainebleau from the Garden Side," in *Views of the Royal Palaces and Conquered Cities of Louis XIV, Cabinet of the King*, 1666–82. The Getty Research Institute, Los Angeles, 94-B18666.

Among the prints in Louis's *Cabinet* were a number of modern perspective and profile views that reflected up-to-date approaches to the types of chorographies included in *Civitates*. Images such as *View of the Château of Fontainebleau from the Garden Side* (*Veüe du Chasteau de Fontainebleau, du costé du Jardin*; figure 9.11),[98] by Israël Silvestre (1621–91), employed an expansive vista similar to that of *Besançon*, substituting a lower vantage point and more naturalistic perspective. The foreground figures are absent, replaced by a forking path that leads into a lively scene of a hunt. Although neither the scale nor the composition offers entry in the same quadratura-esque fashion as *View of Rehe*, the oversized format and broad outlook draw the viewer in nonetheless. It is, like earlier city scenes, an image of order, but with a changed emphasis: here, royal pleasure and imperial sovereignty replace the natural harmony and civic peace seen in *Besançon*.

Though compositionally different, the views of Rehe and Fontainebleau share important similarities as images of imperial authority through landscape. The two scenes naturally reflect the ways in which imperial parks—ordered, controlled landscapes reserved for an individual's pleasure—serve synecdochically for empire. That this is so in both Qing and French cases is partially a function of the meanings read into gardens across a range of cultural contexts. Yet the transcultural exchange of garden images between Paris and Beijing also speaks to the ways in which landscape functioned as a medium for communication and expression in the context of early modern cosmopolitan emperorship. Part of that function was the literal and metaphoric relationship between technology, especially that of measurement, and the land. Like a painted bird's-eye view, cartography constitutes a form of imperial vision, omniscient, possessing, and founded in the tension between claims to veracity and rhetorics of representation.

Portrait, Plan, Map?

The tensions between visual rhetoric and measurable knowledge, between idealized and literal landscapes, ultimately return us to the question with which this chapter opened, and which has been the principal occupation of those writing on the *View of Rehe*: What, or possibly more accurately when, does the scroll depict, and when was it painted?

In deemphasizing—even abandoning—the prospect that Leng Mei's painting will reveal something definitive about the chronology of its creation, new possibilities about its temporality come to the fore.[99] Representing a moment when the Qing court's engagement with new fields of knowledge intersected with established epistemological, political, and scientific understandings of space, *View of Rehe* offers particular insight into the processes by which these encounters occurred. As others have observed with regard to applied mathematics, astronomy, and cartography in the court, this approach represents neither a hybrid nor a process of straightforward influence or accommodation.[100] Rather, the Qing court painting style reflected in *View of Rehe* is one of strategic incorporation of new techniques into existing modes of picture making, coinciding with, and no doubt contributing to, a moment in which the court's perception of the ideological potential of images was changing. Ineluctably early modern in the sense of being dependent not only on the circulation of people, images, and ideas across Eurasia but also on the engagement with the networks of cosmopolitan empire and emperorship in a global context, Leng Mei's garden portrait is also essentially Qing. It draws together endogenous and exogenous modes of pictorial communication and diverse ways of thinking about space into a single, coherent image.

Notes

An earlier version of this essay appears in Stephen H. Whiteman, *Where Dragon Veins Meet: The Kangxi Emperor and His Estate at Rehe* (Seattle: University of Washington Press, 2020), as chapter 4, "Painting and the Surveyed Site."

1. For Leng Mei, see Daphne Lange Rosenzweig, "Court Painters of the K'ang-Hsi Period" (Ph.D. diss., Columbia University, 1978), esp. chap. 5.2; Osvald Sirén, *Chinese Painting: Leading Masters and Principles* (New York: Ronald Press, 1956), 7:372; and Yu Jianhua, *Zhongguo meishujia renming cidian* (Shanghai: Shanghai renmin meishu chubanshe, 2004), 267. For works by Leng Mei in the imperial collection, see Guoli gugong bowuyuan, ed., *Midian zhulin Shiqu baoji* (Taibei: Guoli gugong bowuyuan, 1971), 1:222, 453, 507, 628, 676, 761–63, 766; Guoli gugong bowuyuan, ed., *Midian zhulin Shiqu baoji xubian* (Taibei: Guoli gugong gowuyuan, 1971), 7:4105–26.

2. Major studies in English include James A. Millward, Ruth W. Dunnell, Mark C. Elliott, and Philippe Forêt, eds., *New Qing Imperial History: The Making of Inner Asian Empire*

at Qing Chengde (London: Routledge, 2004); Philippe Forêt, *Mapping Chengde: The Qing Landscape Enterprise* (Honolulu: University of Hawai'i Press, 2000); Richard E. Strassberg and Stephen H. Whiteman, *Thirty-Six Views: The Kangxi Emperor's Mountain Estate in Poetry and Prints* (Washington, DC: Dumbarton Oaks Research Library and Collection, 2015) [hereafter, *Thirty-Six Views*]; and Whiteman, *Where Dragon Veins Meet.*

3. John Brinckerhoff Jackson, "The Word Itself," in John Brinkerhoff Jackson, *Discovering the Vernacular Landscape* (New Haven: Yale University Press, 1984), 1–8; Denis E. Cosgrove, *Social Formation and Symbolic Landscape* (Madison: University of Wisconsin Press, 1998), "Introduction."

4. On transcultural pictorial engagement as a process of experimentation, see Timon Screech, "The Meaning of Western Perspective in Edo Popular Culture," *Archives of Asian Art* 47 (1994): 58–69, here 59.

5. During the Qianlong period, the painting was stored in the Hall of Mental Cultivation (Yangxindian 養心殿), the emperor's private residence; Guoli gugong bowuyuan, ed., *Midian zhulin Shiqu baoji*, 1:676. Its location and display under Kangxi are not known.

6. Richard Ellis Vinograd, *Boundaries of the Self: Chinese Portraits, 1600–1900* (Cambridge: Cambridge University Press, 1992), esp. chap. 3.

7. See Zhang Hongxing, ed., *Masterpieces of Chinese Painting, 700–1900* (London: Victoria and Albert Museum, 2013), 224.

8. E.g., Yuan Jiang 袁江 (act. ca. 1680–ca. 1730), *The Palace of the Nine Perfections*, 1691. Metropolitan Museum of Art, New York, 1982.125a–l.

9. Kangxi emperor 康熙帝, Kuixu 揆叙, and Shen Yu 沈喻, *Yuzhi Bishu shanzhuang shi* 御製避暑山莊詩 (Beijing: Wuyingdian, 1712) [hereafter *YZBSSZS*], "Yanbo zhishuang 烟波致爽," "Zhijing yundi 芝逕雲堤," n.p., which cite Wei Zheng 魏徵 (580–643), "Jiuchenggong liquan ming 九成宮醴泉銘," Liu Xiaowei 劉孝威 (496–549), "Xingxing Ganquangong ge 行幸甘泉宮歌," Xiao Gang 蕭綱 (503–551), "Naliang 納涼."

10. Guo Xi 郭熙 (ca. 1020–ca. 1090), "The Significance of Landscape," in Susan Bush and Hsio-yen Shih, *Early Chinese Texts on Painting* (Cambridge, MA: Harvard University Press, 1985), 153.

11. Robert Maeda, "*Chieh-hua*: Ruled-Line Painting in China," *Ars Orientalis* 10 (1975): 123–24.

12. Heping Liu, "'The Water Mill' and Northern Song Imperial Patronage of Art, Commerce and Science," *Art Bulletin* 84, no. 4 (2002): 566–95.

13. Tsao Hsingyuan, "Unraveling the Mystery of the Handscroll 'Qingming shanghe tu.'" *Journal of Song-Yuan Studies* 33 (2003): 155–179, esp. 166–67.

14. E.g., Maxwell K. Hearn, "Art Creates History: Wang Hui and The Kangxi Emperor's Southern Inspection Tour," in Maxwell K. Hearn, ed., *Landscapes Clear and Radiant: The Art of Wang Hui (1632–1717)* (New York: Metropolitan Museum of Art, 2008), 129–183, here 138, 150–51, 173; Ma Ya-chen, "Picturing Suzhou: Visual Politics in the Making of Cityscapes in Eighteenth-Century China" (Ph.D. diss., Stanford University, 2006), esp. chap. 2.

15. Whiteman, *Where Dragon Veins Meet*, chap. 3.

16. Maxwell K. Hearn, "Document and Portrait: The Sothern Inspection Tour Paintings of Kangxi and Qianlong," in Ju-hsi Chou and Claudia Brown, eds., *Chinese Painting Under the Qianlong Emperor*, *Phoebus* 6, no. 1 (1988): 119–28.

17. On "Orthodox," see James Cahill, "The Orthodox Movement of Early Ch'ing Painting," in Christian F. Murck, ed., *Artists and Traditions: Uses of the Past in Chinese Culture* (Princeton: Princeton University Art Museum, 1976), 169–81; and Martin J. Powers, "Questioning Orthodoxy," *Orientations* 28, no. 10 (1997): 73–74.

18. Hearn, "Art Creates History," 136–39.

19. Chin-Sung Chang, "Wang Hui: The Evolution of a Master Landscapist," in Hearn, ed., *Landscapes Clear and Radiant*, 49–127, here 93–96.

20. Anita Chung, *Drawing Boundaries: Architectural Images in Qing China* (Honolulu: University of Hawai'i Press, 2004), 67; Stephen Little, ed., *Taoism and the Arts of China* (Chicago: Art Institute of Chicago, 2000), 377; Richard Vinograd, "Some Landscapes Related to the Blue-and-Green Manner from the Early Yüan Period," *Artibus Asiae* 41, nos. 2–3 (1979): 101–31.

21. Anita Chung notes that immortal realms enjoyed great popularity in eighteenth-century commercial painting but were not a common subject in the court. Chung, *Drawing Boundaries*, 117–19 and chap. 6.

22. Ginger Cheng-chi Hsü, "Imitation and Originality, Theory and Practice," in Martin J. Powers and Katherine R. Tsiang, eds., *A Companion to Chinese Art* (Chichester: John Wiley and Sons, 2016), 293–311, here 306.

23. Madeline K. Spring, "The Celebrated Cranes of Po Chü-i," *Journal of the American Oriental Society* 111, no. 1 (1991): 8–18, here 8. The empress dowager's compound at Rehe during the Kangxi period was known as Sonorous Pines and Cranes (Songhe qingyue 松鶴清越).

24. See, for instance, Su Shi's (蘇軾, 1037–1101) *Latter Prose Poem on the Red Cliffs* (*Hou Chibifu* 後赤壁賦), in which the crane that swoops over Su Shi's head in the text's climactic scene transforms itself into a pair of Daoist immortals at the end. Also, e.g., Chen Ruyan 陳汝言 (act. ca. 1340–1380), *Mountains of the Immortals* (*Xianshan tu* 仙山圖), Cleveland Museum of Art, 1997.95; Zhao Boju 趙伯駒 (ca. 1123–ca. 1162), attr., *Eight Immortals* (*Baxian tu* 八仙圖), Chinese Rare Book Collection, Asian Division, Library of Congress.

25. Robert Beer, *The Encyclopedia of Tibetan Symbols and Motifs* (Boston: Shambala, 1999), 55, 82, 96.

26. Lin Li-chiang, "Mingdai banhua 'Yangzheng tujie' zhi yanjiu," *Meishu yanjiu jikan* 33 (2012): 163–224; Julia K. Murray, "Squaring Connoisseurship with History: Jiao Hong's Yangzheng tujie," in Ming Wilson and Stacey Pierson, eds., *The Art of the Book in China* (London: Percival David Foundation, 2006), 139–57.

27. For a variant theme, see Leng Mei's *Spring Dawn at the Han Palace, After Qiu Ying* (*Fang Qiu Ying Hangong chunxiao tu* 仿仇英漢宮春曉圖), dated 1703, National Palace Museum, Guhua001717; and Chung, *Drawing Boundaries*, 102–7, on related Qianlong-era compositions.

28. Leng Mei, "Tang Xuanxong," in *Nurturing Uprightness*, leaf 9, National Palace Museum, Guhua6135/9–10.

29. In Scroll 9, "Shaoxing to the Temple of Yu" (Palace Museum Gu6302), a brief vignette in the blue-and-green mountain landscape shows two travelers walking while cranes perch in trees and fly overhead.

30. Wang Yuanqi, *Yuchuang manbi* 雨窗漫筆, in Mao Jianbo, Jiang Yin, and Zhang Suqi, eds., *Zhongguo lidai shuxue hualun congshu* (Hangzhou: Xileng yinshe chubanshe, 2008); Susan Bush, "Lung-mo, K'ai-ho, and Ch'i-fu: Some Implications of Wang Yüan-ch'i's Three Compositional Terms," *Oriental Art* 8, no. 3 (1962): 120–27.

31. James Cahill, *The Compelling Image: Nature and Style in Seventeenth-Century Chinese Painting* (Cambridge, MA: Harvard University Press, 1982), 196.

32. Cf. a similar image of Yongling 永陵, the tomb of Nurhaci's ancestors, in the First Historical Archives, Beijing; and Guan Huai 關槐 (act. l. 18th c.), *Daoist Temples at Dragon Tiger Mountain* (*Longhushan tu* 龍虎山圖), in the collection of the Los Angeles County Museum of Art (M.87.269), reproduced in Little, ed., *Taoism*, cat. no. 151.

33. Philippe Forêt, "The Manchu Landscape Enterprise: Political, Geomantic and Cosmological Readings of the Gardens of the Bishu Shanzhuang Imperial Residence at Chengde,"

Cultural Geographies 2, no. 3 (1995): 328. Forêt does not address Leng Mei in his discussion of geomancy.

34. Forêt, "The Manchu Landscape Enterprise," 328.

35. Liu Yuwen, "Kangxi huangdi yu Bishu shanzhuang—du Qing Shengzu 'Yuzhi Bishu shanzhuang ji' zhaji," *Qingdai yanjiu* 2 (1998) 115–119, here 118.

36. Kangxi, "Bishu shanzhuang ji 避暑山莊記," in *YZBSSZS*, n.p.

37. Zhang Yushu, "Hucong ciyou ji," in *Zhongguo bianjiang shizhi jicheng*, vol. 7, *Dongbei shizhi* (Beijing: Quanguo tushuguan wenxian suowei fuzhi zhongxin, 2004), 1–5.

38. 夾水為隄。透迤曲折。逕分三枝。列大小洲三。形若芝英。若雲朵。復若如意。 *YZBSSZS*, "Zhijing yundi," n.p.; trans. after Richard E. Strassberg, in *Thirty-Six Views*, 128.

39. Lothar Ledderose, "The Earthly Paradise: Religious Elements in Chinese Landscape Art," in Susan Bush and Christian F. Murck, eds., *Theories of the Arts in China* (Princeton: Princeton University Press, 1983), 165–183, here 165–72; Jessica Rawson, "The Eternal Palaces of the Western Han: A New View of the Universe," *Artibus Asiae* 59, nos. 1–2 (1999): 5–58, here 18–19, 23–24.

40. Not all such garden ponds included three islands. See Fu Xinian and Nancy Shatzman Steinhardt, *Chinese Architecture* (New Haven: Yale University Press, 2002), 100–104, 205–7; Nancy Shatzman Steinhardt, *Chinese Imperial City Planning* (Honolulu: University of Hawai'i Press, 1990), 155, 172; David L. McMullen, "Recollection without Tranquility: Du Fu, the Imperial Gardens and the State," *Asia Major*, 3rd ser., 14, no. 2 (2001): 189–252.

41. Later Qing imperial gardens also followed this model. On immortals' palaces in the Garden of Perfect Brightness, see Chung, *Drawing Boundaries*, 117–19 and pl. 6; for Kunming Lake in Pure Ripple Garden, see Fu and Steinhardt, *Chinese Architecture*, 283–88.

42. Kangxi, "Bishu shanzhuang ji;" Susan E. Nelson, "On Through to the Beyond: The Peach Blossom Spring as Paradise," *Archives of Asian Art* 39 (1986): 23–47, here 26–28.

43. Museum of Fine Arts, Boston, 55.464. Also, *Complete View of the Garden to Rest In* (*Zhiyuan quantu* 止園全圖; 1627), Museum für Asiatische Kunst, SMB, 1988.463a; *Mount Shixie* (*Shixieshan tu* 石屑山圖; 1663), National Palace Museum, Guhua000639. See also Cahill, *Compelling Image*, chap. 1; Aoki Shigeru and Kobayashi Hiromitsu, *"Chūgoku no yōfūga" ten: Minmatsu kara Shin jidai no kaiga, hanga, sashiebon* (Machida-shi: Machida Shiritsu Kokusai Hanga Bijitsukan, 1995), chap. 2.

44. See Wen C. Fong and James C. Y. Watt, *Possessing the Past: Treasures from the National Palace Museum, Taipei* (New York: Metropolitan Museum of Art, 1996), 124–30; and Jerome Silbergeld, *Chinese Painting Style: Media, Methods, and Principles of Form* (Seattle: University of Washington Press, 1982), 37–38 and figs. 19, 21.

45. Contra Chung, *Drawing Boundaries*, 87.

46. Yang Boda, "Leng Mei ji qi 'Bishu shanzhuang tu'," 115, measures the current silk mounting of the painting—which, if not original, can be assumed to be roughly equal to whatever mounting it replaced—at approximately 68.1 cm above and below the painting. Setting the bottom of the painting 68.1 cm above the floor, 165 cm marks a point near the top of Ruyi Island, while 177 cm is just below the northern shore of the lakes. A number of sources, e.g., John Bell, *Travels from St. Petersburg in Russia to Diverse Parts of Asia* (Glasgow, 1763; reprint, Cambridge: Cambridge University Press, 2014), 214, state that Kangxi was somewhat taller than average among those in the court.

47. Elisabetta Corsi, "Late Baroque Painting in China Prior to the Arrival of Matteo Ripa: Giovanni Gherardini and the Perspective Painting Called Xianfa," in Michele Fatica and Francesco D'Arelli, eds., *La missione cattolica in Cina tra i secoli XVIII–XIX, Matteo Ripa e il Collegio dei Cinesi* (Naples, Italy: Istituto Universitario Orientale, 1999), 103–22; Kristina Renée Kleutghen, *Imperial Illusions: Crossing Pictorial Boundaries in the Qing Palaces* (Seattle: University of Washington Press, 2015), 47–52, 68–69.

48. E.g., *Kangxi Reading*, Palace Museum, Gu6411; *Gentlewomen in the Shade of a Paulownia Tree* (Tongyin shinü tuping 桐蔭仕女圖屏), Palace Museum, Gu210740.

49. E.g., ceilings by Andrea Pozzo, S.J., in the Church of Saint Ignatius of Loyola at Campus Martius, Rome, and the Jesuit Church, Vienna.

50. Marco Musillo, *Shining Inheritance: Italian Painters at the Qing Court, 1699–1812* (Los Angeles: Getty Publications, 2016), 109–10; Kleutghen, *Imperial Illusions*, 228–41.

51. 因而度高平遠近之差，開自然峯嵐之勢。 Kangxi, "Bishu shanzhuang ji."

52. Mei-ling Hsu, "The Qin Maps: A Clue to Later Chinese Cartographic Development," *Imago Mundi* 45 (1993): 90–100, here 96–97; Joseph Needham and Wang Ling, *Mathematics and the Sciences of the Heavens and Earth*, vol. 3 in *Science and Civilisation in China* (Cambridge: Cambridge University Press, 1959), 538–40.

53. Needham and Wang, *Mathematics and the Sciences*, 25, 30–31, 97.

54. Nöel Golvers, "An Unnoticed Letter of F. Verbiest, S.J., on His Geodesic Operations in Tartary (1683/1684)," *Archives internationales d'histoire des sciences* 50 (2000): 86–102; Mario Cams, "Not Just a Jesuit Atlas of China: Qing Imperial Cartography and Its European Connections," *Imago Mundi* 69, no. 2 (2017): 188–201, here 191–92.

55. Mario Cams, *Companions in Geography: East-West Collaboration in the Mapping of Qing China (c. 1685–1735)* (Leiden, Netherlands: Brill, 2017).

56. Hu Jing 胡敬 (1769–1845), *Guochao yuanhua lu* 國朝院畫錄, in Yu Haiyan, ed., *Huashi congshu*, vol. 3 (Taibei: Wenshizhe chubanshe, 1974), 1797; Catherine Jami, *The Emperor's New Mathematics: Western Learning and Imperial Authority During the Kangxi Reign (1662–1722)* (Oxford: Oxford University Press, 2011), 242.

57. Nöel Golvers, *The Astronomia Europaea of Ferdinand Verbiest, S.J. (Dillingen, 1687): Text, Translation, Notes and Commentaries* (Nettetal, Germany: Steyler, 1993), 298; Kleutghen, *Imperial Illusions*, 44; Musillio, *Shining Inheritance*, 110, 112.

58. Hu Jing, *Guochao yuanhua lu*, 1797, who ascribes this view to the Kangxi emperor.

59. Golvers, *Astronomia Europaea*, 21, 101; Jami, *Emperor's New Mathematics*, 5, 71–2, 245–53.

60. Arthur W. Hummel, ed., *Eminent Chinese of the Ch'ing Period (1644–1912)* (Washington, DC: Government Printing Office, 1943), 64–66, 473–75.

61. Liu Yuwen, "Bishu shanzhuang chujian shijian ji xiangguan shishi kao," in Dai Yi, ed., *Qingshi yanjiu yu Bishu shanzhuang* (Shenyang: Liaoning Minzu Chubanshe, 2005), 85–91, here 86; Jami, *Emperor's New Mathematics*, 107, 116.

62. Jami, *Emperor's New Mathematics*, 72; Musillo, *Shining Inheritance*, 110.

63. Liu, "Bishu shanzhuang chujian shijian," 87.

64. Consider, e.g., Wang Lü 王履 (1332–1391) and Huang Xiangjian 黃向堅 (1609–1673); see Kathlyn Maurean Liscomb, *Learning from Mount Hua: A Chinese Physician's Illustrated Travel Record and Painting Theory* (Cambridge: Cambridge University Press, 1993); and Elizabeth Kindall, *Geo-Narratives of a Filial Son: The Paintings and Travel Diaries of Huang Xiangjian (1609–1673)* (Cambridge, MA: Harvard University Asia Center, 2016).

65. 40°57'19.12" N, 117°56'0.22" E.

66. Employing a digital elevation model (DEM), which models the earth's topography, a viewshed analysis shows what is and is not visible from a specified vantage point. Note that DEMs, and therefore viewshed analyses, do not capture foliage and are only as precise as their resolution. In the model used here, each pixel is 10 x 10 m sq. A pixel registers as visible if the center point of the pixel can be seen from the designated viewpoint.

67. Uta Lindgren, "Land Surveys, Instruments, and Practitioners in the Renaissance," in David Woodward, ed., *History of Cartography*, vol. 3, part 1, *Cartography in the European Renaissance* (Chicago: University of Chicago Press, 1998), 477–508, here 482–89.

68. Lucia Nuti, "Mapping Places: Chorography and Vision in the Renaissance," in Denis Cosgrove, ed., *Mappings* (London: Reaktion Books, 1999), 90–108, here 90.

69. Hilary Ballon and David Friedman, "Portraying the City in Early Modern Europe: Measurement, Representation, and Planning," in David Woodward, ed., *History of Cartography*, vol. 3, part 1, *Cartography in the European Renaissance* (Chicago: University of Chicago Press, 1998), 680–704, here 687–96; see also J. Brian Harley, "Maps, Knowledge, and Power," in Paul Laxton, ed., *The New Nature of Maps: Essays in the History of Cartography* (Baltimore: Johns Hopkins University Press, 2001), 51–83; David Turnbull, *Maps Are Territories: Science Is an Atlas. A Portfolio of Exhibits* (Chicago: University of Chicago Press, 1989).

70. Cahill, *Compelling Image*, 16–22.

71. E.g., *Ten Scenes of Yue*, Collection of the Yamato Bunkakan, Nara; see Cahill, *Compelling Image*, 18; David E. Mungello, *The Great Encounter of China and the West, 1500–1800*, 2nd ed. (Lanham, MD: Rowman and Littlefield, 2005), 75.

72. Ballon and Friedman, "Portraying the City," 690; Lucia Nuti, "The Perspective Plan in the Sixteenth Century: The Invention of a Representational Language," *Art Bulletin* 76, no. 1 (1994): 105–128, here 114; Nuti, "Mapping Places," 95.

73. Originally published in Sebastian Münster, *Cosmographia* (Basel: Adam Petri, 1572); Matthew McLean, *The Cosmographia of Sebastian Münster: Describing the World in the Reformation* (London: Routledge, 2007), 177.

74. Nuti, "Perspective Plan," 105–28; Ballon and Friedman, "Portraying the City," 690–96.

75. A variation sees the city more markedly tilted and with less perspectival diminution; see, e.g, *View of Damascus*, in Georg Braun and Franz Hogenberg, *Civitates Orbis Terrarum*, vol. 2, fol. 55 (Cologne, Germany: Gottfried von Kempen, 1575), which also strongly resembles *View of Rehe*.

76. Nuti, "Mapping Places," 95; Nuti, "Perspective Plan," 121.

77. Lindgren, "Land Surveys," 495–500.

78. Ballon and Friedman, "Portraying the City," 690; Nuti, "Perspective Plan," 120–21.

79. Ballon and Friedman, "Portraying the City," 682; Anthony Grafton, *Leon Battista Alberti: Master Builder of the Italian Renaissance* (New York: Hill and Wang, 2000), 241–48.

80. Cf. Aoki and Kobayashi, *"Chūgoku no yōfūga"* ten, 128–29.

81. *Practice of Instruments for Measuring Heights and Distances (Celiang gaoyuan yiqi yongfa* 測量高遠儀器用法), cited in Jami, *Emperor's New Mathematics*, 194.

82. Mario Cams, "Converging Interests and Scientific Circulation Between Paris and Beijing (1685–1735): The Path Towards a New Qing Cartographic Practice," *Revue d'histoire des sciences* 70, no. 1 (2017): 47–78, here 60–61; Golvers, *Astronomia Europaea*, 115–16.

83. E.g., Liu Lu, *Qinggong xiyang yiqi*, Gugong bowuyuancang wenwu zhenpin quanji 58 (Shanghai: Shanghai kexue jishu chubanshe, 1999), nos. 15, 46, 47, 97–99.

84. Cams, "Converging Interests," 58–60; Jami, *Emperor's New Mathematics*, 194.

85. Nuti, "Perspective Plan," 120.

86. Kleutghen, *Imperial Illusions*, 47.

87. Kleutghen, *Imperial Illusions*, 47–49.

88. Kleutghen, *Imperial Illusions*, chap. 6.

89. See my note 49.

90. Elisabetta Corsi, "Envisioning Perspective: Nian Xiyao's (1671–1738) Rendering of Western Perspective in the Prologues to 'The Science of Vision,'" in Antonino Forte and Federico Masini, eds., *A Life Journey to the East: Sinological Studies in Memory of Giuliano Betuccioli (1923–2001)* (Kyoto, Japan: Scuola Italiana di Studi sull'Asia Orientale, 2002), 201–43; Kleutghen, *Imperial Illusions*, chap. 2.; Musillo, *Shining Inheritance*, 100.

91. Lazarist Mission, *Catalogue of the Pei-t'ang Library* (Reprint, Beijing: Beijing guojia tushuguan chubanshe, 2009), nos. 2511–12.

92. *Catalogue of the Pei-t'ang Library* records at least nineteen such treatises published before 1700; though it is not possible to date the precise arrival of these volumes, most, if not all, would have come with missionaries in the mid- to late Kangxi period. For a list and further discussion, see Hui-hung Chen, "Chinese Perception of European Perspective: A Jesuit Case in the Seventeenth Century," *Seventeenth Century* 24, no. 1 (2009): 97–128, here 111–14. Also, Golvers, *Astronomia Europaea*, 115.

93. E.g., Jacques Androuet du Cerceau, *Leçons de perspective postive* (Paris: Patisson, 1576), illus. for leçon III.

94. Musillo, *Shining Inheritance*, 92.

95. Nian Xiyao, *Shixue* (Beijing: s.n., 1735), 20r; Kleutghen, *Imperial Illusions*, 73–74.

96. 19 February 1699, "Registre des livres de figures et estampes qui ont esté distribuées suivant les orders de Monseigr le Marquis de Louvois, depuis l'inventaire fait avec Mr l'abbe Varés au mois d'aoust 1684," Bibliothèque nationale de France, Paris, Est. Res. Ye 144.

97. Lazarist Mission, *Catalogue of the Pei-t'ang Library*, nos. 284, 667, 705, and 706.

98. In the volume, *Veües de maison royales et de villes conquises par Louis XIV*; Lazarist Mission, *Catalogue of the Pei-t'ang Library*, no. 705.

99. See also Monica Juneja, "Circulation and Beyond—The Trajectories of Vision in Early Modern Eurasia," in Thomas DaCosta Kaufmann, Catherine Dossin, and Béatrice Joyeux-Prunel, eds., *Circulations in the Global History of Art* (Farnham: Ashgate, 2015), 59–77, here 68.

100. Cams, "Not Just a Jesuit Atlas," 198; Jami, *Emperor's New Mathematics*, 3–4.

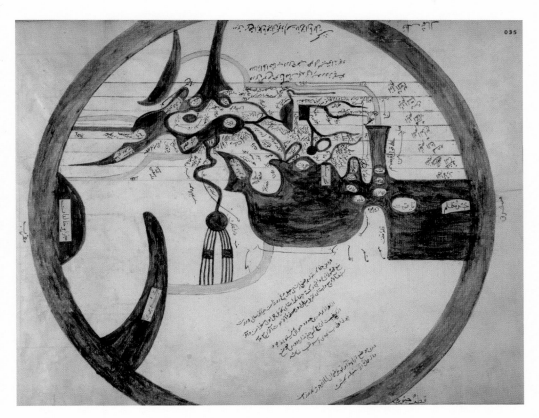

PLATE 1. Jání (?), World Map, in Kaempfer's "Persian Album," ca. 1684–85. Ink wash on paper, 210 × 300 mm. British Museum 1974,0617,0.1.35, originally Sloane 2925.

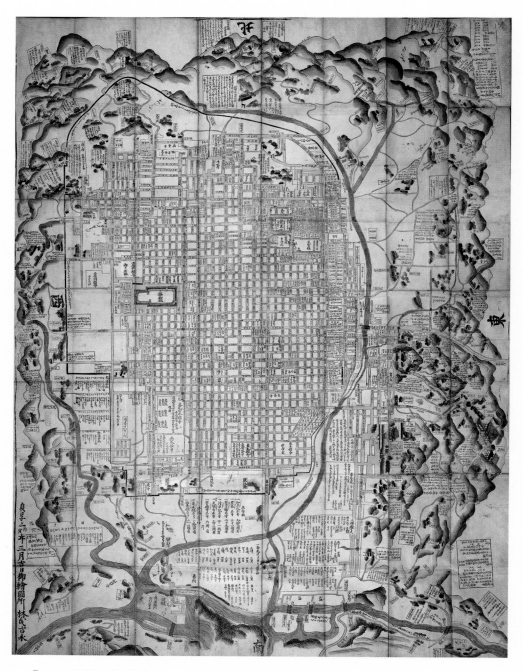

Plate 2. Hayashi Yoshinaga, *Kyō ōezu*, 1686, after a 1668 original. Colored woodcut on Japanese paper, 166 cm × 121 cm. British Library, OIOC Or 75.f.16.

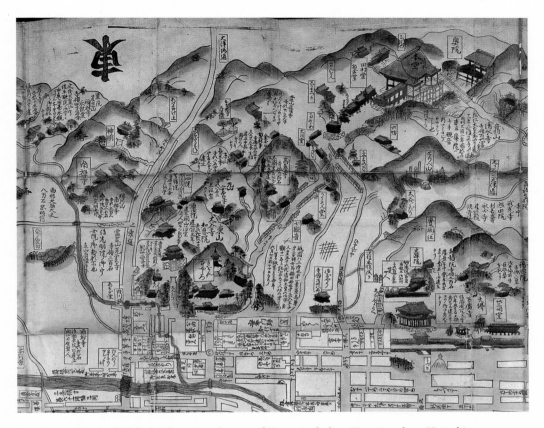

Plate 3. Detail of the landscape to the east of Kyoto, including Kyomizu-dera. Hayashi Yoshinaga, *Kyō ōezu*, 1686, after a 1668 original. Colored woodcut on Japanese paper, 166 cm × 121 cm. British Library, OIOC Or 75.f.16.

PLATE 4. Anonymous, "Saihō-ji," from Kaempfer's album of famous sights of Japan. Painting on Japanese paper, 215 × 322 mm. British Library Add.MS.5252, fol. 1.

PLATE 5. *Maison à double étage* (Two-story construction). In *Essai sur l'architecture chinoise* (ca. 1773), vol. 2, illus. 17, ink and color on paper, approx. 35 × 45 cm. Bibliothèque nationale de France, Paris, Département des estampes et de la photographie, Oe-13a-Pet. fol.

PLATE 6. *Salle chez les Gens aisés* (Room in the home of wealthy people). In *Essai sur l'architecture chinoise* (ca. 1773), vol. 2, illus. 31, ink and color on paper, approx. 35 × 45 cm. Bibliothèque nationale de France, Paris, Département des estampes et de la photographie, Oe-13a-Pet. fol.

Plate 7. *Tai.* Voyez la note de la *Page 39 & Suivantes* (*Tai*, [Imperial building with red lacquered columns on a high platform; see the notes on pp. 39ff.]). In *Essai sur l'architecture chinoise* (ca. 1773), vol. 2, illus. 41, ink and color on paper, approx. 35 × 45 cm. Bibliothèque nationale de France, Paris, Département des estampes et de la photographie, Oe-13a-Pet. fol.

Within the illustration, the following handwritten labels appear:

Girouette

Parasol

Sonnette

Dessin du couronnement du Pavillon chinois

J L Q

œufs d'autruche

chaton

PLATE 8. Jean-Jacques Lequeu, *Dessin du couronnement du pavillon chinois* (Design for the sculpture crowning a Chinese pavilion), ink and watercolor on paper, 21.2 × 16.6 cm, ca. 1780. Bibliothèque nationale de France, Département des estampes et de la photographie, EST VA-78 (2).

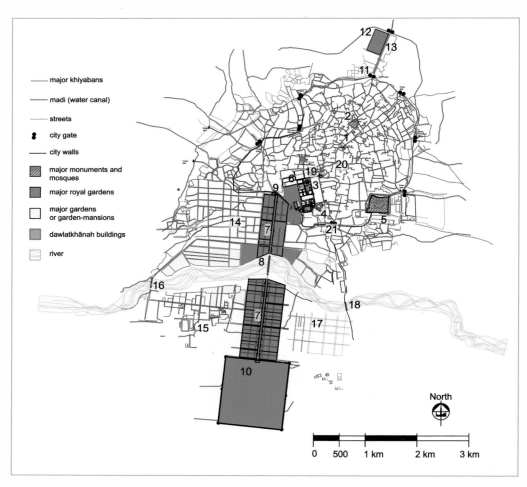

PLATE 9. Restored plan of Isfahan and its gardens in the time of Shah Abbas I. (1) Old Square (Maydān-i Kuhnah); (2) Masjid-i Jameʿ (Jameʿ Mosque); (3) Maydān-i Naqsh-i Jahān; (4) Royal Mosque (Masjid-i Shah); (5) Tabarak Fortress (Qalʾeh-yi Tabarak); (6) Dowlatkhānah-yi Naqsh-i Jahān; (7) Khiyābān-i Chahārbāgh; (8) Allāhverdikhān Bridge; (9) ʿEmārat-i Jahān Namā and Dawlat Gate nearby; (10) HizārJarib garden; (11) Toqchi Gate; (12) Qushkhānah garden; (13) Khiyābān-i Toqchi (or Khiyābān-i Bāgh-i Qushkhānah); (14) ʿAbbāsābād district; (15) New Julfa district (Julfa); (16) Mārnān Bridge; (17) Gabrābād district; (18) bridge; (19) bazaar gate; (20) Maydān-i Mir (Mir Square); (21) Hasanābād Gate. Map by Seyed Mohammed Ali Emrani.

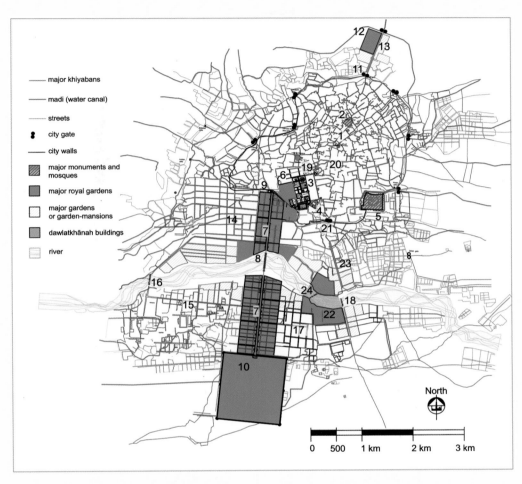

PLATE 10. Restored plan of Isfahan and its gardens in the era of Shah Abbas II. (1) Old Square (Maydān-i Kuhnah); (2) Masjid-i Jame' (Jame' Mosque); (3) Maydān-i Naqsh-i Jahān; (4) Royal Mosque (Masjid-i Shah); (5) Tabarak Fortress (Qal'eh-yi Tabarak); (6) Dawlatkhānah-yi Naqsh-i Jahān; (7) Khiyābān-i Chahārbāgh; (8) Allāhverdikhān Bridge; (9) 'Emārat-i Jahān Namā and Dawlat Gate nearby; (10) HizārJarib garden; (11) Toqchi Gate; (12) Qushkhānah garden; (13) Khiyābān-i Toqchi (or Khiyābān-i Bāgh-i Qushkhānah); (14) 'Abbāsābād district; (15) New Julfa district; (16) Mārnān Bridge; (17) Sa'ādatābād district; (18) Hasanābād Bridge (Khāju Bridge); (19) bazaar gate; (20) Maydān-i Mir (Mir Square); (21) Hasanābād Gate; (22) Sa'ādatābād royal garden; (23) Khiyābān-i Khāju; (24) Juyi Bridge. Map by Seyed Mohammed Ali Emrani.

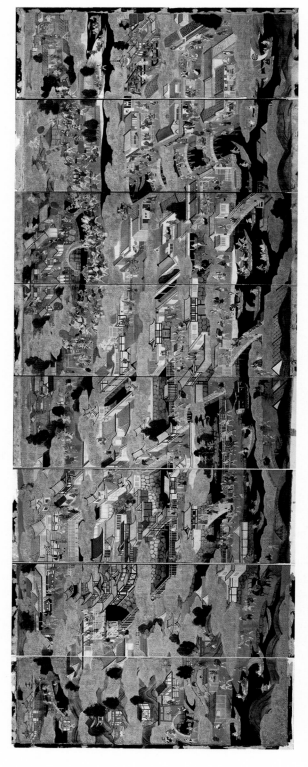

PLATE 11. Anonymous, *View of Osaka*, second quarter of the seventeenth century. Virtual assembly of individually mounted panels. Eight-panel folding screen, ink, color, and gold on paper, approx. 182 × 480 cm. Courtesy of Schloss & Park Eggenberg/Universalmuseum Joanneum, Graz.

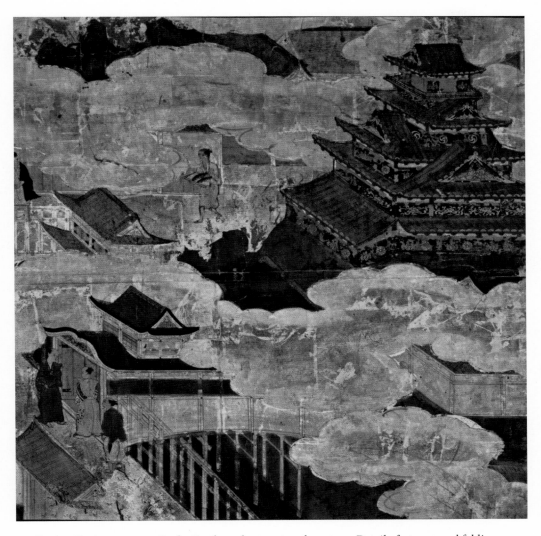

PLATE 12. Anonymous, *Osaka Castle*, early seventeenth century. Detail of a two-panel folding screen, ink, color and gold leaf on paper, approx. 130.0 × 53.2 cm. Osaka Castle Museum (formerly Kawakami collection, Tokyo). Photograph by Anton Schweizer, courtesy of Osaka Castle Museum.

PLATE 13. Karamon Gateway, Kannon Hall of Hōgonji Temple, late sixteenth century. Chikubushima, Shiga Prefecture. Photograph by Anton Schweizer.

PLATE 14. Attributed to Guo Zhongshu, *Emperor Minghuang's Palace of Escaping the Heat*, second half of the fourteenth century. Hanging scroll, ink on silk, 161.5 × 105.6 cm. Abe Collection, Osaka City Museum of Fine Arts.

PLATE 15. Ritual banner, dated on wooden container to 1517. Shanain, Nagahama City, Shiga Prefecture. One of a pair, openwork and engraved gilded copper, 105.5 × 13.2 cm. Courtesy of Shanain, Nagahama City (Shiga Prefecture) and Nara National Museum.

PLATE 16. Detail of Johann van der Hagen, *Overmantel view of Drogheda, Co. Louth with Beaulieu House in the background*, ca. 1740. Beaulieu House, Drogheda, County Louth, Ireland. Photograph by Finola O'Kane, 2016.

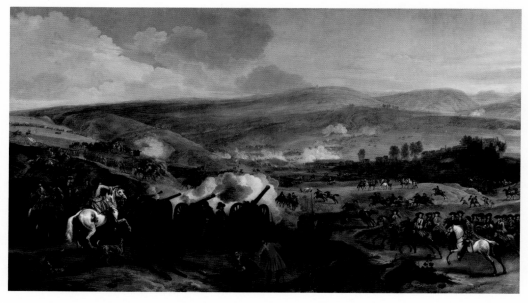

PLATE 17. Jan Wyck, *The Battle of the Boyne, 12 July, 1690*, 1693. Oil on canvas, 223 × 386.5 cm. The National Gallery of Ireland, NGI.988.

PLATE 18. Gabriel Béranger, *View of Dowth Neolithic mound, with Lord Netterville's summerhouse*, ca. 1775. From the Béranger Sketchbooks, The Royal Irish Academy, 3C 30 F5.

PLATE 19. Thomas Mitchell, *A View of the River Boyne with Gentlemen and Horses by a Statue to William III in the Foreground, the Boyne Obelisk beyond*, 1757. Oil on canvas, 106.8 × 175.5 cm. National Museums Northern Ireland, BELUM.U4813.

PLATE 20. The stump of the Boyne obelisk with tricolor. Photograph by Finola O'Kane, 2010.

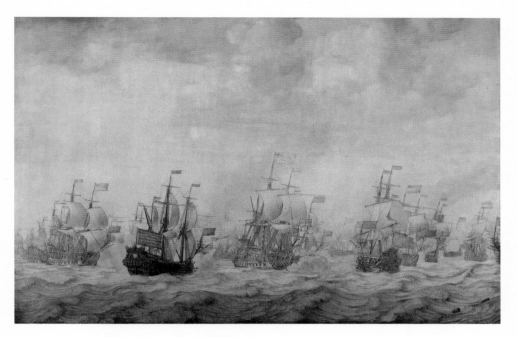

PLATE 21. Willem van de Velde the Elder, *Episode from the Four Days Battle, 11–14 June 1666*, 1668. Canvas and ink, 119 × 182 cm. Rijksmuseum, Amsterdam, SK-A-840.

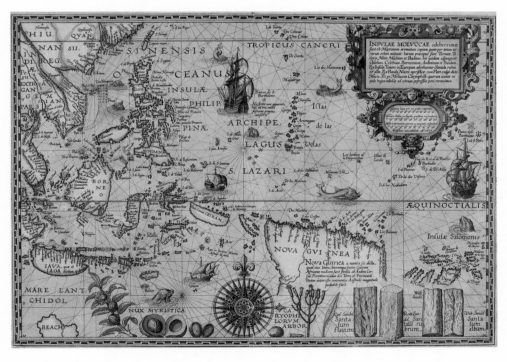

PLATE 22. Joannes van Doetecum, *Map of Southeast Asia*, designed by Petrus Plancius, originally published 1594 (Amsterdam: Cornelis Claesz). Etching, 36.7 × 53 cm, printed in Amsterdam by C. J. Vischer, 1617. State Library of New South Wales, SAFE/M2 470/1617/1.

PLATE 23. Hendrick Cornelisz Vroom, *The Return to Amsterdam of the Second Expedition to the East Indies*, 1599. Oil on canvas, 102.3 × 218.4 cm. Rijksmuseum, Amsterdam, SK-A-2858.

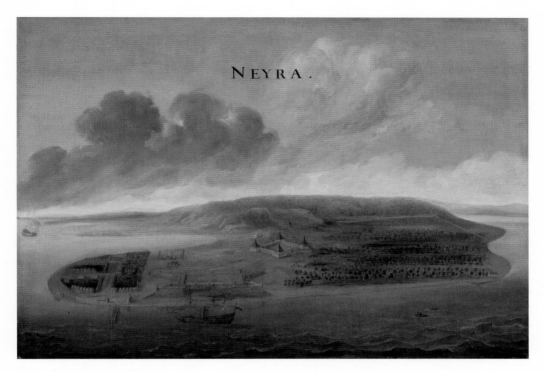

PLATE 24. Johannes Vingboons, *Neyra* (Island of Banda Neyra), ca. 1662–63. Oil on canvas, 97 × 140 cm. Rijksmuseum, Amsterdam, SK-A-4476.

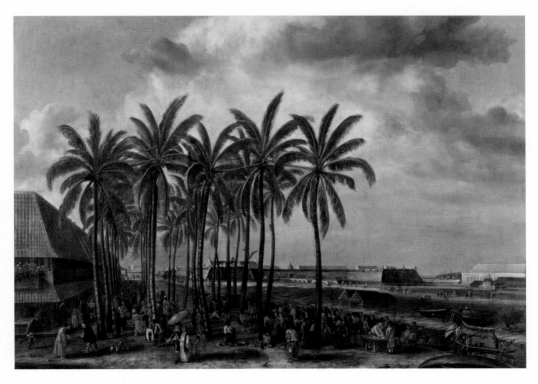

PLATE 25. Andries Beeckman, *Castle of Batavia*, ca. 1661. Oil on canvas, 108 × 151.1 cm. Rijksmuseum, Amsterdam, SK-A-19.

Plate 26. Govert Flinck, *Gerard Hulft*, 1654. Oil on canvas, 130 × 103 cm. Rijksmuseum, Amsterdam, SK-A-3103.

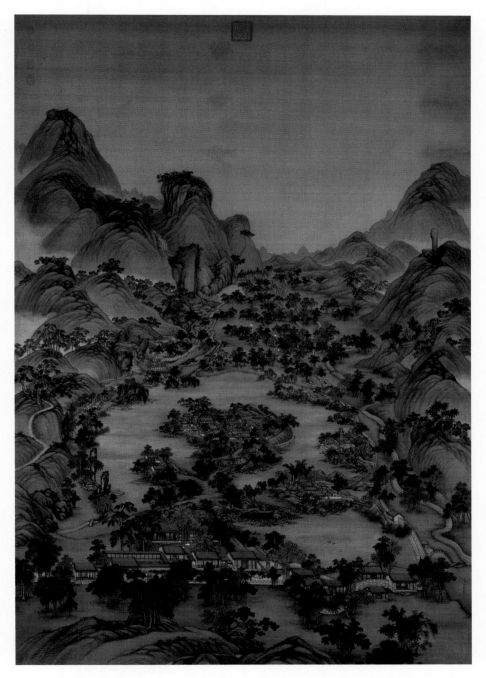

PLATE 27. Leng Mei, *View of Rehe*, ca. 1709. Hanging scroll, ink and color on silk, 254.8 × 172.5 cm. The Palace Museum, Gu8210.

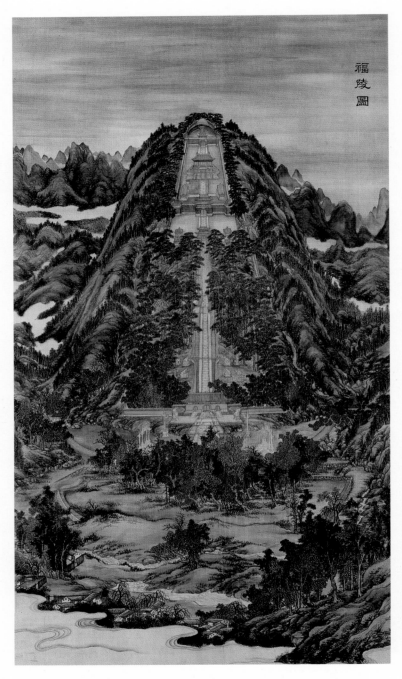

福陵圖

PLATE 28. Anonymous, *Fuling*, eighteenth century. Hanging scroll, ink and color on silk, dimensions unknown. Collection of the First Historical Archives of China, Yu1809.

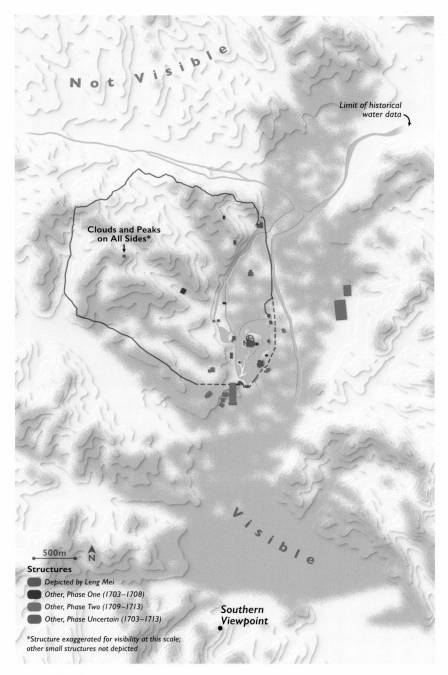

Not Visible

Limit of historical
water data

Clouds and Peaks
on All Sides*

Visible

500m

N

Structures

Depicted by Leng Mei

Other, Phase One (1703–1708)

Other, Phase Two (1709–1713)

Other, Phase Uncertain (1703–1713)

*Structure exaggerated for visibility at this scale;
other small structures not depicted

**Southern
Viewpoint**

PLATE 29. Viewshed analysis from the southern vantage point (40.955311°,
117.933394°). Map by Daniel P. Huffman.

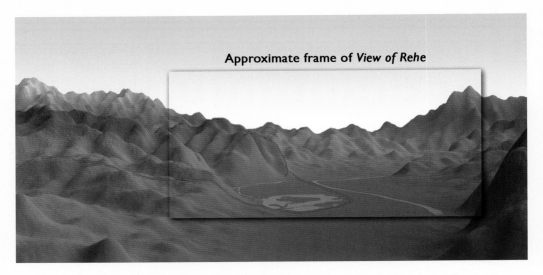

PLATE 30. Three-dimensional pictorialization of the viewshed analysis from the southern vantage point (40.955311°, 117.933394°), reflecting the approximate frame of Leng Mei's *View of Rehe*. The red line indicates the location of the garden wall. Map by Daniel P. Huffman.

The Princely Landscape as Stage

Early Modern Courts in Enchanted Gardens

Katrina Grant

The designed landscape, or garden, stands in for the wider landscape: it is a microcosm of nature, intended to embody an ideal of nature held by the individual or group that created it. In the garden, art and nature work together to generate meaning, and in this they shape how the broader landscape is understood. For courts in Europe in the early modern period, the pleasure garden constructed around the villa or suburban palace was a midpoint between the organized but constrained urban world of the city and the disorganized, often threatening world of the wilderness.[1] Gardens, especially the large-scale gardens built by dukes, princes, and kings for the use of their courts, were usually set amid agricultural land, but their primary purpose was not to be productive. To these courts the garden was at once a site of retreat (an attitude reflected literally in such names as the Buen Retiro) and as a stage to the performance of princely power.[2] This dual purpose created a tension between the experience of pleasurable relaxation and the constant reminder of an individual's own responsibilities and power (or lack thereof) within a tightly organized court structure.

This chapter examines a series of seventeenth-century performances staged by three different courts in three different European countries: the Medici court in Florence (1625), the court of Philip IV in Spain (1635), and the court of Louis XIV at Versailles (1664). Each performance was based on almost identical narrative episodes found in the sixteenth-century epics *Orlando Furioso* (1516) and *Jerusalem Delivered (La Gerusalemme liberata)* (1581), by Ludovico Ariosto (1474–1533) and Torquato Tasso (1544–95), respectively. The narratives followed the hero as he was trapped within an enchanted garden created by a powerful enchantress, such as Circe or Alcina. The hero would enjoy the pleasures of dal-

lying within this paradise, but the performance then concluded with destruction of the earthly paradise and the hero's return to his duty. The chosen narratives functioned as political allegories that differed from court to court, though they shared the central theme of the need to balance pleasure with responsibility. But this narrative does not reflect a simple desire to escape reality by retreating into an idyllic landscape; it represents the contradictions inherent in this desire. There is, obviously, an enjoyable concurrence for the audience between the wondrous world supposedly conjured by the enchantress and the spectacle being "conjured" onstage.[3] Gardens, with their long history of being experienced as real and tangible spaces but at the same time places that absorb and enthrall the viewer in an imaginary world, were perfectly suited to being exploited as the settings for immersive spectacles.[4] As the narratives were enacted within the gardens and courtyard spaces of the villas and chateaus, by the close of the performance the audience would realize that reality (and the responsibilities that come with it) cannot be escaped. This choice of narrative, and the way that the performances were staged, reveal that these early modern courts were not only conscious of this tension but also fascinated by it, and by the apparent impossibility of resolving these conflicting experiences of the courtly landscape.

To reconstruct the experience of gardens, the historian must move beyond the physical space and structure of the garden itself and turn to the many traces—letters, diaries, sketches—that have been left by past visitors. These reveal to us what they saw, thought, and imagined when they moved through these landscapes. As well as these direct accounts, we might also look to representations of gardens and landscapes in novels and poems or their depiction in prints and paintings. These representations, although not necessarily documenting specific gardens, reveal to us something of the cultural ideology that visitors brought to bear on their experiences of landscapes, what Michel Conan has described as the "garden imagination." He has argued that the experience of a garden is one that calls both upon observation and sensory experience of the immediate materiality of the garden and upon the "imagined gardens" in the minds of the people present within gardens.[5] The social activities that take place within gardens act as a "hinge," connecting the material with the imagined.[6] It follows that an examination of performances held within gardens—which present stories about ways of experiencing landscape while simultaneously being an experience of the landscape—must surely reveal something quite important about the "garden imagination" of the courts that staged these events.

These performances generated several different experiences for several different audiences, and each of these experiences must have had an impact on subsequent experiences of landscapes by these audiences. Most immediate was

the spectacle of the performance itself, the temporary stage sets, the costumes, and the special effects, all of which invited audiences to believe they were present in a fantastical space. This experience was in turn reinforced by the written text that (in different ways in each performance) encouraged audiences to conceptualize the garden they were in as an enchanted fragment of a wider landscape; a place where different rules applied. Finally, there are the official engravings that were generated to create a permanent record of the performances, which turned a live, three-dimensional, multisensory experience into a pictorial one that could be recreated in the imaginations of audience members beyond those in attendance at the event. Despite the centrality of performance and festival to the life of seventeenth-century European audiences (especially at princely or ducal courts), the visual culture of performances is still underrecognized in terms of its place in the broader visual culture of the seventeenth century. Previous studies of the performances discussed in this chapter have focused mainly upon their place within festival culture, and how they acted as vehicles for the demonstration of political power.[7] In this chapter the focus is instead on how these particular performances shaped the audience's "ways of seeing" the landscape. The way in which these performances shaped and reshaped attitudes toward the landscape deserves specific consideration in and of itself. For instance, although the idea of the garden as the realm of an enchantress becomes very common in performances (both those staged in gardens and those staged in theaters), we do not see this reflected in the design and permanent decoration of the gardens themselves to the same extent.[8] Instead, the story of the enchanted garden seems to be one most often explored through theatrical spectacles.

The use of the garden as a performance space was not a new phenomenon. There is a notable intensification of the conception of the "garden as stage" during the seventeenth century, but what is significant about these performances is the way in which they deal directly with what it means to *be* in a garden. Each performance discussed in this chapter considers to some degree the line between pleasurable relaxation and indolence, between retreat and responsibility, and each performance obliges the audience members to question the reality of their own experience. In the following pages, I examine—mainly through a close examination of the texts, descriptions, and images that were produced as part of the staging of them—how these performances explored the relationship between space and imagination.

The performances seem to reflect a desire from rulers across Europe to trigger a shift in the way courtly audiences experienced princely gardens in general. The engravings and booklets that were created to record the staged events demonstrate that there was a desire for these ephemeral events to be known

beyond the moment of the performance. Both the formal records (commis-
sioned descriptions and printed views) and the informal records (ambassado-
rial accounts and other reports) of these performances meant that the
experience was preserved and in turn multiplied and disseminated to audi-
ences beyond those originally in attendance. The experience of the landscape as
stage and the scene of the court performing in this landscape were made avail-
able to a much broader audience. The prints were made to preserve the memory
of the event for the court itself but were also always intended to be dissemi-
nated across Europe, to share ideas and prompt emulation and rivalry between
courts across a broad geographical area. As well as glorifying the princely fig-
ures, this documentation also disseminated a particular mode of viewing the
landscape.[9] The prints, for instance, fix the point of view of the observer, usu-
ally in a position no member of the audience on the day of the actual perfor-
mance would have had, such as from a bird's-eye view or from an ideal
centralized viewpoint. The prints and descriptions emphasize some things and
elide others; in particular, they blend the depiction of the landscape of the real
garden with that of the fantastical realm being depicted in the performance,
deliberately making it difficult to discern where the fictive garden ends and the
real landscape begins.

The Enchantress at the Medici Court in Seventeenth-Century Florence

Our first performance takes place in the courtyard of the Medici Villa del Pog-
gio Imperiale. In 1625 Archduchess Maria Magdalena (1589–1631), the regent for
her young son Grand Duke Ferdinando II de' Medici (1610–70), staged a perfor-
mance of an opera ballet in the cortile of the newly renovated Villa del Poggio
Imperiale.[10] The performance was an opera with ballet interludes, a type of per-
formance common at the period; it was performed on a temporary stage with
changeable scenery and was followed by an equestrian ballet.[11] It is described as
having taken place "at the villa Poggio Imperiale in the loggia of the palazzo"
and was held in honor of the state visit of Prince Władysław Sigismund (1595–
1648) of Poland to Florence.[12] The opera ballet was called *The Liberation of Rug-
giero from the Island of Alcina* (*La liberazione di Ruggiero dall'Isola d'Alcina*),
with music by Francesca Caccini (1587–1641) and poetry by Ferdinando Saraci-
nelli (1587–ca. 1640). The narrative was based on events that take place in cantos
7 and 8 of *Orlando Furioso*, though in some places it conflates Ariosto's epic
with Tasso's *Jerusalem Delivered*.[13] The court diarist, Cesare Tinghi, recorded
that Giulio Parigi (1571–1635) was the designer of the sets and stage machinery,

although it his son Alfonso (1606–56) who has signed the five etchings that accompany the libretto.[14]

The narrative of the performance—which followed the story of the knight Ruggiero, who fell under the power of one powerful woman (Alcina) and was rescued by another (Melissa)—reflected Maria Magdalena's dynastic agenda and political interests. At this time she was one the most powerful people in Florence, though not head of state; nor was it her native city. Maria Magdalena used the decorative program inside the villa to make a statement about the legitimacy of women's political rights. In it she aligned herself with powerful women such as Judith and Saint Ursula, who closely reflected her ideals, power and ambition.[15] The theme of the powerful female also appears in the narratives chosen for the many spectacles that the archduchess sponsored; between 1622 and 1628 there were eight spectacles that featured heroic female protagonists.[16] So the narrative of Alcina and her enchanted island fits within this program of patronage.

The use of the Villa del Poggio Imperiale as the setting for the entertainment of important political allies was also a symbol of the archduchess's power in Florence. She had purchased the villa in 1622, shortly after she had assumed the role of regent to her son Ferdinando, and in 1625 had recently finished renovating it. It seems likely that evoking the garden of a powerful woman like Alcina within the domain of the most powerful woman in Florence would not have gone unnoticed. Indeed, the design of stage sets that alluded to real gardens in theatrical spectacles was becoming relatively regular in performances staged by the Medici. In the last decades of the sixteenth century, Medici-sponsored productions had begun to include sets depicting classical landscapes that mirrored similar landscapes being designed in the gardens of their various villas. Most notable in this regard is Bernardo Buontalenti's (1531–1608) design for Mount Parnassus in an *intermedio* for the 1589 celebrations of the wedding between Grand Duke Ferdinando I de' Medici (1549–1609) and Christine of Lorraine (1565–1637).[17] In this set, recorded in a drawing and an engraving, the mountainous home of the muses rises sharply amid a rocky landscape, mirroring the version of Mount Parnassus that Buontalenti had earlier designed for the Medici garden of Pratolino.[18]

After Buontalenti's death, it was his student Giulio Parigi who took over the role as a set designer to the Medici court. From this point we begin to see the emergence of the garden set as a specific type. Although the stylized nature of depicting spaces in stage sets meant that landscape sets had always looked similar to the designed landscapes of gardens, from the early 1600s the garden becomes a place represented as distinct from the pastoral landscape, with its own particular style and with a particular set of narrative associations. Parigi's set

for the third *intermedio* of the 1608 production of *Il Giudizio di Paride* (*The Judgment of Paris*), put on as part of the wedding celebrations between Maria Magdalena and Cosimo II de' Medici, shows the garden of Calypso, not an enchanted garden per se, but one in which heroes were tempted to dally.[19] So as early as 1608, at the very time that Maria Magdalena first arrived in Florence, we see emerging on the stage the idea of the garden as a delightful realm from which escape was difficult. The gardens of the Florentine court continued to be associated with a range of other classical and pastoral landscapes. But this particular development suggests a shift in courtly attitudes toward the garden that we then see again in *La liberazione di Ruggiero*. Although the narrative served other purposes as well, it clearly underlines the tension between the idea of the courtly garden as retreat and as political stage. Whether or not Maria Magdalena explicitly wanted this is hard to say, but a closer examination of the images of the performance reveals elements that suggest those who produced the spectacle were keen to generate an experience that played upon the audience's experience of place.

The printed and descriptive record suggests that the garden in Saracinelli's narrative was evoked entirely through the use of sets. The etchings that record the sets for the opera ballet are typical of the period and show only the stage set, giving no real sense of the context of the performance within the villa and landscape setting; we see only the landscape created by the set designs.[20] The details of the staging that are shown are revealing, however. For instance, in the first etching, which shows a scene of rocky cliffs against a sea where Neptune is riding a chariot in the foreground, there is a circular basin with a small jet of water. This looks like the type of fountain common to gardens of the period, and it appears in all but the final scene of the opera ballet. Its presence is not explained in the libretto, but it could be read as a reminder of the villa setting of the performance, a sort of transitional point between the real villa and the landscape depicted in the stage set. As well as the basin there is a rocky ramp that leads from the stage space down to the audience space. This path from stage to audience also appears in every scene, though in slightly different forms. It is easier to see in the second scene, which shows the palace of Alcina rising from the sea (figure 10.01), where this path takes the form of a double staircase that curves from the stage around the basin and down to the audience's space. It reappears again in the third scene, surrounded by flames as Alcina's garden and palace disappear in an inferno (figure 10.02). This staircase or ramp merges with the audience's space in what Arthur Blumenthal has neatly described as a sort of "spatial co-penetration."[21] This staircase created a connection between performer and audience, suggesting the possibility of movement between the fictional landscape of Alcina depicted on stage and the actual estate of the Villa del Poggio Imperiale.

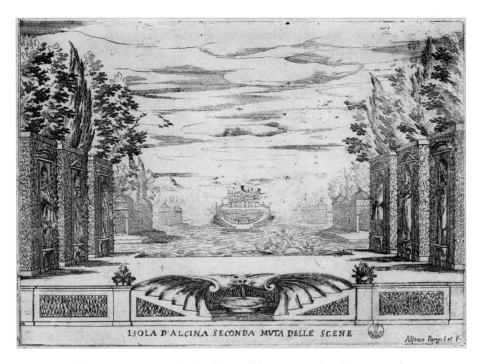

Figure 10.01. Alfonso Parigi, "Isola d'Alcina," for scene 2 of *La liberazione di Ruggiero dall Isola d'Alcina* (Florence, Poggio Imperiale, 1625). Etching, 18 × 24 cm. Gabinetto dei Disegni e delle Stampe, Uffizi, Florence, n. 2304.

The description of the performance by the court diarist Cesare Tinghi makes it clear that the staircase was in fact used in precisely this fashion. Tinghi writes that after the third scene, when Alcina had been defeated, the scene transformed (figure 10.03), and ladies of the court, who were dressed as nymphs, emerged from caves to present a "ballet in the courtyard." Shortly after them eight knights (*cavallieri*) came onto the stage and descended to the courtyard using the "real staircase" (*certe scalette*) to join the nymphs and perform a ballet in the courtyard.[22] The idea that performers would move out of the stage space was not a new one; many stages had staircases built in for precisely this purpose. But put together with the narrative of a hero who moves from the real world to an enchanted garden and back to the real world, this movement from stage to courtyard suddenly serves to underline that the enchanted garden depicted on stage was directly linked to the space in which the performance took place. The fact that it was the knights and ladies of the court who descended from the stage to the courtyard suggests that it was the members of the court, rather than professional performers, who could take advantage of this fluidity of movement between the two worlds.

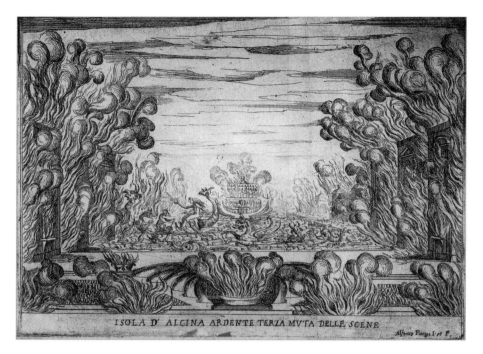

ISOLA D' ALCINA ARDENTE TERZA MVTA DELLE SCENE

Figure 10.02. Alfonso Parigi, "Isola Alcina ardente," for scene 3 of *La liberazione di Ruggiero dall'Isola d'Alcina* (Florence, Poggio Imperiale, 1625). Etching, 18 × 23.7 cm. Gabinetto dei Disegni e delle Stampe, Uffizi, Florence, n. 2305.

This link between real and virtual worlds was made more explicit in a performance held for the wedding of Maria Magdalena's son Grand Duke Ferdinando II de' Medici and Vittoria della Rovere (1622–94) of Urbino in 1637. In addition to the opera *The Wedding of the Gods* (*Le nozze degli dei*), which was staged in the courtyard of the Palazzo Pitti, the celebrations included an equestrian ballet in the newly constructed amphitheater in the Boboli Gardens, the first time it was used for such an event.[23] Like the performance at the Villa del Poggio Imperiale, this event also had a binding narrative about an enchantress, in this case from Torquato Tasso's *Jerusalem Delivered*. The text was again written by Ferdinando Saracinelli, and it followed the story of Armida, the Saracen sorceress who is sent to stop the Christian knights and murder the hero, Rinaldo, but who instead falls in love with him and creates a beautiful garden in which to hold him hostage.[24] The narrative celebrated ideals of chaste love and suitable marriage alliances and invoked the idea of the garden as an enchanted realm.

The records of the performance in the engravings by Stefano della Bella (1610–64) and the published *Descrizione dell festa* are both suggestive of the type of experience that the assembled audience was meant to have.[25] The entire event is represented on a single sheet (figure 10.04), and the performance is shown

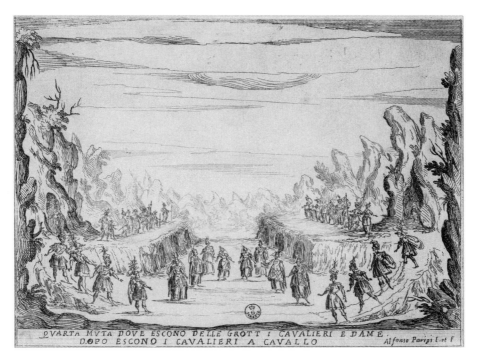

Figure 10.03. Alfonso Parigi, scene 4 of *La liberazione di Ruggiero dall Isola d'Alcina'* (Florence, Poggio Imperiale, 1625). Etching, 18 × 23.7 cm. Gabinetto dei Disegni e delle Stampe, Uffizi, Florence, n. 2306.

from different points of view so that the entire space and each key event are captured. The central image shows the moment when Armida had been drawn into the center of the amphitheater on a chariot, from which she descended and then sang an address to the audience.[26] The viewer of the print looks down on the arena from a point of view high above the amphitheater, a view no actual spectator could have had. The small figures in the foreground seem intended to be read as the top tier of spectators; the dimensions of the amphitheater have been exaggerated, and so the spectators and even the performers look tiny in the vast space. The scene is framed by curtains as though it is a stage set rather than a record of a real event, a pictorial device that underlines the idea that the gardens, the performers, and the assembled audience are meant to be read as a performance. Around the edges are fifteen small scenes that show the equestrian ballets. These are shown from a bird's-eye view, presumably chosen because it best captures the elaborate formations achieved by the riders. At the top a smaller image captioned "Carro d'Amore" shows the figure of Chaste Love on his chariot from the point of view of spectators looking back across the amphitheater toward the Palazzo Pitti. Again, the size of the amphitheater is greatly

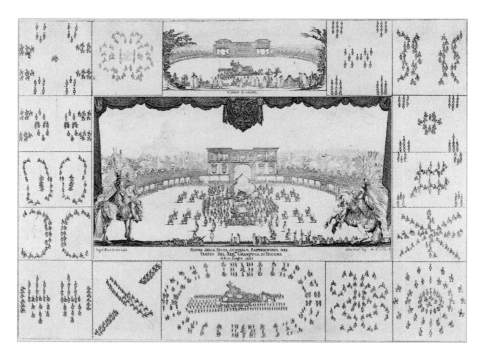

Figure 10.04. Stefano della Bella, *Spectacle for marriage of Grand Duke Ferdinand II of Florence with details of an equestrian ballet held in the Boboli Amphitheatre*, 1637. 33 × 44.5 cm. Gift of Dennis Adrian in memory of Max Guggiari, Art Institute of Chicago, 1968.21.

exaggerated, and any viewer unfamiliar with the real site would have gained the impression that the amphitheater was much larger than the palace itself (the reverse is true). The image shows the court immersed within a garden that has become a stage.

The official written record underlines the immersive nature of the event and the way in which the enchanted garden was "superimposed" upon the real garden. The theater is described as lit in such a way as to seem to be filled with stars, and there were so many torches that the "night was vanquished."[27] The *Descrizione* relates how Armida arrived in the amphitheater down the wide central avenue that led from the top of the Boboli Gardens to the theater, but this had been made to look like a "scena boschereccia" (woodland setting), and it was not really possible to distinguish "il finto dal vero" (the false from the true).[28] Throughout the description, the illusions of the special effects are described as though they were seamless, echoing the story of enchantment being told in the narrative. After Armida arrived in the theater, drawn on her carriage by four elephants, she sang of her power to enchant men and to control nature by turning night into day. Following this, the original scene undertook a number of

impressive transformations. The carriage Armida rode in was transformed with "prestezza incredibile" (incredible speed) into a mountain, terrifying in appearance, with caverns that spewed flame and from which emerged an enormous serpent. At the same moment and with "l'istessa celerità" (the same swift speed) the woodland scene was replaced by a beautiful castle (this is the scene shown in the main image on della Bella's print).[29] It seems unlikely that the special effects in the real event were quite so seamless, but the effectiveness of an illusion is always relative to the expectations of the audience, so it may well have seemed instantaneous and magical, and this, in turn, is how it is "remembered" in the records of the event.

In comparison to the records created of the events at the Villa del Poggio Imperiale, the official description and engravings of the 1637 spectacle more clearly situate the performance within the Boboli Gardens themselves. The garden as setting for the court is made more explicit. The central image in della Bella's engravings shows the tall trees of the real *boschetto*, and the description includes reference to the fact that the broad avenue that ran up the center of the garden (*largo viale conduce al Giardino*) was part of the performance. The imaginary character of Alcina is described as having traveled through the gardens to emerge upon the amphitheater stage, as though she was a real manifestation of the enchantress, not just a performer who had entered from backstage.[30] This makes explicit what was only hinted at in *The Liberation of Ruggiero*; there is a clear intention for the garden as a whole to be understood as being part of the stage set, even though the audience's focus was upon the amphitheater. This suggests to visitors who know the performance (firsthand or secondhand) that the real garden is a place where they might cross over into the enchanted realm of pleasure, an idea with obvious appeal to members of the court spending time in the gardens. But it is a portrayal of the garden that is ambiguous. Armida is ultimately defeated and banished, and Chaste Love (essentially a representation of Princely Duty) is triumphant over unbridled pleasure.

This portrayal of the tension between pleasure and duty chimes with the early modern understanding of emotional experience. Susan James in her study of ideas about emotions in seventeenth-century Europe has written that the emotions, the "passions," were regarded as an "overbearing and inescapable element of nature" that had the power to disrupt civilized order unless they were "tamed, outwitted, or seduced."[31] So the garden is presented as a place of pleasure and delight into which one can retreat, but where one must not fall prey to intemperate idleness or inappropriate amorous adventures. The wonders of the garden are impressive—but also fleeting. The garden is presented as a site where pleasure can be indulged, but also where it can be contained. The ideas presented in these Medici festivals were disseminated across Europe via engravings

and reports by travelers and the artists themselves when they traveled to other European courts.[32] The entertainments of other courts throughout the seventeenth century take their point of departure in part from the example of the Medici *feste*.

El mayor encanto, amor, Madrid, 1635

In 1635, a performance was held within the gardens of the Buen Retiro, a royal pleasure palace situated on the outskirts of Madrid. The court of Philip IV (1605–65) was presented with a performance of *Love, the Greatest Enchantment* (*El mayor encanto, amor*). The play was based on the story of Ulysses and his entrapment by Circe. The story follows a similar narrative trajectory to those in the epics of Ariosto and Tasso; indeed, the characters of Armida and Alcina are based in part upon Circe. No illustrated records or official description have been discovered, but the performance has been reconstructed from written sources.[33] A memorandum written by the event's stage designer and engineer, Cosimo Lotti (ca. 1600–ca. 1650), and the playwright, Don Pedro Calderón de la Barca (1600–81), details their plans for what was going to happen, as well as their disagreements over certain ideas.[34] Accounts by spectators give us some sense of what is eventually presented, though do not offer much detail on the sequence of events or the technical aspects of the production.

Although the text was written by Calderón, it is clear from the memorandum and other documents that both the idea for the subject of the narrative and the conception of the event as a large-scale outdoor spectacle came from Lotti.[35] Lotti had arrived in Spain from Florence in 1626. He was initially recorded as a hydraulic engineer working on fountains for the Spanish court, but it seems that his knowledge of staging large-scale theatrical events (gained while working for the Medici) was recognized, and he quickly established himself as the key set designer and stage engineer at the Spanish court.[36] He must have had direct knowledge of *The Liberation of Ruggiero*, as it was performed the year before he left Florence for Spain, and it seems likely he drew on this and other recent Medici spectacles when he made his proposal for *Love, the Greatest Enchantment*.[37] Calderón at first rejected Lotti's proposal, objecting to the idea he was being asked to simply provide a dialogue for a production that "although ingeniously plotted, cannot be performed as it is more concerned with the devising of the machines than with the pleasure of the performance."[38] Nevertheless, after some negotiation Calderón agreed to use some of the devices suggested by Lotti, and from the correspondence between the two artists we gain an impression of the performance that eventually took place.

A stage was constructed on the Great Lake (Estanque Grande), which was situated in the extensive park that lay beyond the formal gardens surrounding the palace.[39] An engraving by Louis Meunier (ca. 1630–ca. 1680; figure 10.05) shows the lake as it would have appeared around the time of the performance in the 1630s. The stage was to represent the island of Circe, and Lotti described it in his memorandum as follows:

> It is to be raised seven feet above the water, with a curving ramp or stair-case leading up to it. It is to have a parapet of rough stones, adorned with coral, pearls, and shells, and with waterfalls and other similar things. In the middle of the island there is to be a high mountain with precipices and caves, surrounded by a dark thick wood with tall trees, some of which have human faces, with green and tangled branches growing from their heads and arms. On the branches hang various trophies of hunting and war. The stage is lit with artificial lighting.[40]

The memorandum goes on to describe a prologue in which several floats, some representing ships, would move across the surface of the Great Lake.[41] The narrative of Ulysses and his men being trapped by Circe and then persuaded to leave by the ghost of Achilles was to be played out with the support of an impressive array of special effects. Lotti's plans included special effects that would create the sound of thunder and lightning (achieved by such methods as setting fire to squibs covered in shiny tin attached to a wire drawn across the stage) and an earthquake, and then the play would conclude with the appearance of a volcano that would seem to spew hot lava.[42] One member of the audience reported that the performance lasted four hours; another, Bernardo Monanni (secretary of the Tuscan Embassy in Madrid), said six, and that "no better thing has been done in Spain for a long time Cosimo Lotti, inventor and director of the machines and the concept, has given every satisfaction."[43] It is no surprise that Lotti wished to show off his skills as a set designer, but the use of impressive special effects of course had a broader political symbolism. The fact that the spectacle was held outside must have reinforced the impression that the king, like the character of Circe, had the resources to control the natural world: to light the outside world at night and to produce thunder, lightning, an earthquake, and a fiery volcano.[44] Set on a stage within the garden of the Buen Retiro, the narrative of an enchantress who could subdue nature and who had created a pleasure palace where anything was possible would have resonated more strongly than if it had been staged indoors. Although Monanni, who was obviously keen to report on the success of a fellow Florentine, gave Lotti the credit, to the wider audience the magnificence of the spectacle would have reflected upon the power of the king.

Figure 10.05. Louis Meunier, *The Estanque Grande of the Buen Retiro Palace*, 1630s. Engraving, dimensions unknown. Biblioteca Nacional, Madrid, inv. ER 5824.

As with the other performances discussed here, there are several layers of political symbolism at play, particularly in Calderón's text. But in this case the reading has close parallels with the broader theme of the tension between the garden as a place of pleasurable relaxation and the constant reminder of an individual's own responsibilities. Ulysses has been read as a representation of King Philip IV, dallying in the pleasures of his enchanted isle (the Buen Retiro) when he should be hearing the call to battle and joining his armies against France. In this reading Circe is generally understood to represent Philip IV's adviser, the Count-Duke of Olivares (1587–1645), who was widely hated throughout Spain for his ruthlessness as well as his overbearing and arrogant disposition.[45] Literary scholar Frederick De Armas suggests that in addition to this general dislike, popular opinion suspected that Olivares had been using sorcery to increase his sway over Philip.[46] This reading does chime with the tradition of "loyal criticism" in the court of Philip IV, and Philip's subjects had expressed concern that his sensual passions were distracting him from affairs of state.[47] In 1634 a piece of satire had circulated around the court that punned on the name of the new Buen Retiro and compared the king of France who was "on campaign" to the king of Spain who was "in retreat" (*en el Retiro*).[48] De Armas in a later article suggests that the spectacle could be read in a number of ways: as positive praise of the king and his adviser who were ushering in a new golden age, as criticism of the control of the king, and as a prudent criticism of the need for a king to attend to matters of state.[49] In light of these criticisms, *Love, the Greatest Enchantment* can certainly be read as highlighting the tension between the king's desire to retreat into the garden and his duty to continuously attend to matters of state.[50] The fact that Ulysses is not trapped but is in charge of his pleasures and

ultimately heeds the call to battle (in the play the ghost of Achilles appears to remind Ulysses of his duties) suggests that Calderón's play could also be interpreted as a response to such criticisms. The play conveys Philip IV's idea of the Buen Retiro as a pleasant retreat but not one where he is trapped.[51]

The performance also offered the audience a narrative about the experience of the princely garden as an enchanted space. In his memorandum, Lotti writes about his idea for the performance to include a giant with a flowing white beard who would represent the Buen Retiro (though Calderón vetoed the idea). This inclusion suggests that Lotti was aware of the way in which the narrative would create a reflexive relationship with the place in which the spectacle was performed.[52] If included, Lotti's giant would have made the garden not just a backdrop but one of the characters. In 1635 the gardens of the Buen Retiro had only recently been completed, and in a sense the performance inaugurated them and meant that from the beginning gardens were understood as an enchanted landscape, a place where the line between reality and fiction was blurred.

A few years later, in 1638, Lotti capitalized on this idea when he designed the back wall of the stage area of the indoor court theater, the Coliseo de Comedias, so that it could be opened up to reveal the gardens behind it.[53] Now the audience seated within the theater could look out into the "real" world, but the real world cast as a setting for plays and spectacles. Unlike the Medici spectacles, *Love, the Greatest Enchantment* was staged at least eight times, with the Buen Retiro made accessible to a paying public.[54] For these viewers, invited in to watch the court at play, the encounter with garden of the Buen Retiro as a stage for this spectacle must have reinforced the idea that the courtly landscape was a thing enchanted.

Les plaisirs d'Île enchantée, Versailles, 1664

In 1664, Louis XIV (1638–1718) of France had been ruling in his own right for just over three years, since the death of Cardinal Mazarin (1602–1661). The court was invited to a fête, or divertissement, entitled *The Pleasures of the Enchanted Isle* (*Les plaisirs d'Île enchantée*), to be staged at Versailles. Work on the gardens and buildings had been progressing rapidly since 1661. The king was impatient to show off Versailles, and the fête served as the inauguration of his pleasure retreat. It was also a response to a comedy-ballet by Molière (1622–73) called *The Bores* (*Les Fâcheux*) put on by Nicholas Fouquet (1615–80) in 1661 at his new chateau at Vaux-le-Vicomte.[55] Records of Fouquet's fête are patchy, but it seems that the main drama was performed in the gardens on a temporary stage with some movable scenery. Fouquet was arrested shortly after the performance, his downfall attributed in part to this fête that had introduced his new palace and gardens

to the French court, the magnificence of which had threatened to outshine the king himself. With the exception of the stage designer, Giacomo Torelli (1608–78), who left Paris after the imprisonment of Fouquet, the same artists worked on both the Vaux fête and the Versailles fête.[56] The Versailles fête also included a performance of *The Bores*, but radically altered to suit the new setting.[57] Many of the audience members would have been in attendance at both events, and the similarities (and differences) between the two fêtes would not have been lost on them.

Although some of the events for *The Pleasures of the Enchanted Isle* took place within the chateau, the majority of the performances were held within the gardens. The fête, which apparently entertained well over six hundred people, was ostensibly held to honor the queen mother, Anne of Austria (1601–66), and Louis XIV's wife, Maria Theresa of Spain (1638–83), but it also celebrated the king's new mistress, Mademoiselle La Vallière (1644–1710).[58] The fête included plays, carousels, ballets, feasts, and fireworks. The gardens were embellished with temporary architecture under the direction of the set designer, Carlo Vigarani (1637–1713). The entire event was structured according to a single narrative, based on Ariosto's account Ruggiero (Roger, in the French) landing upon the island of Alcina.[59] This use of an overarching narrative transformed the gardens into a stage, not only for the duration of a single performance, but for several days. This was the beginning of an enduring association of the gardens of Versailles with the enchanted gardens found in literature.[60] Molière's description of the first day's festivities makes exactly this point when he states, "This is a château that could be called an enchanted palace, since refinements of art have so admirably complemented the efforts of nature to make it perfect."[61] His words convey the idea that the festivities were intended to align the real gardens and chateau with those described in the fictional narrative.

The sources for our knowledge of the divertissement are a range of descriptions, including the booklet *Les plaisirs de l'Isle enchantée*, which was printed in two editions.[62] Of most interest to this study is the edition that was republished in 1673–74, with engravings by Israel Silvestre (1621–91), which illustrate the performances and the settings designed for them by Vigarani at Versailles.[63] Although the set of nine prints were not published until 1674, a drawing by Silvestre shows the setting for Alcina's palace on the third day with only the wooden frames of the screens and the island base for the palace. This implies that Silvestre made sketches during the preparations for the fête and possibly also during the fête itself, suggesting that the production of engravings illustrating the fête was always planned.[64] They created a permanent record that was widely disseminated; this meant that across France and Europe a range of people could observe the court at play in the enchanted gardens of Versailles. Their publica-

tion ten years later means the fête continued to inform the reception of the gardens well after the actual performance had finished. Silvestre's prints illustrate the costumes, stage settings, temporary architecture, seating arrangements, and final fireworks display that were part of the first three days of the fête. The invited members of the court are shown enjoying the pleasures of the fête and of the gardens. The magnificence of the king is underlined; he appears as the focal point in every engraving. The written description also underlines the king's control over nature—the opening lines suggest that the fine weather for the festival is a symbol of the king's foresight and power—an idea that was to become central to the meaning of Versailles.[65]

As with all festival books, the printed record of *The Pleasures of the Enchanted Isle* is not a straightforward record of the event but one that has been carefully designed to convey the correct interpretation of the event.[66] What is interesting about the descriptions of the fête is the way that the language and the images slip between describing the actual events as they took place and relating the fictional elements of the narrative as though they were true. For example, the description of the beginning of the third day reads: "The closer we moved towards the Grand Rondeau [the pool where the final performance took place] the closer we got to the end of the entertainment of the Enchanted Isle, and it seemed unjust that so many brave knights should dwell any longer in idleness, which was harmful to their glory."[67] The description emphasizes that the audience members were meant to feel as though they were wholly immersed in the narrative, something that was enjoyed by those at the fête itself and, presumably, by the readers of the printed booklets.

Silvestre's frontispiece introduces the fête; the image is framed by fruit swags and curtains drawn back to reveal a view of the garden facade of the old chateau and a simple parterre garden. Silvestre depicts the chateau and garden as though they are a stage set, emphasizing its temporary role as a fantastic space. In the foreground we see a procession of horses and a carriage, presumably depicting the arrival of the king, a prologue to the grand performance. The second print represents the procession of the king and courtiers in costume, the Marche du Roi. The king can be seen dressed as the character of Ruggiero in military gear and seated upon a white horse. As in each engraved view of the fête Louis XIV is shown in the center of the composition, as the focal point for the viewer (except for the title page, where he is symbolically represented by the sun). In the illustrations of the procession and the carousel, the king is given the place of lead performer, and in subsequent prints, where the king is part of the audience, his position is that of the most privileged spectator. This view of the Marche du Roi presents the gardens as a stage set; the open area, which is the intersection of two allées, is the stage, and the tall clipped hedges (*palissades*) are the wings.[68]

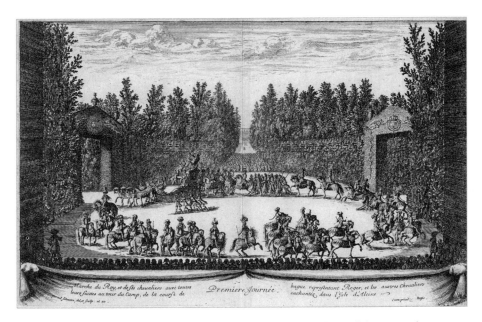

Figure 10.06. Israel Silvestre, "Première Journée—Marche du Roi," from *Les plaisirs de l'isle enchantée*, 1674. Etching, 35 × 49 cm. New York Public Library Digital Collections.

In the center we can see the view down the grand allée toward the chateau. This long vista acts as an "accelerated perspective," a common feature of stage set designs of the period where the set designer would use converging lines to create the illusion of almost infinite depth on a shallow stage. This technique had been adopted by André Le Nôtre (1613–1700), the designer of the Vaux and Versailles, to manipulate the visitor's impression of size of the garden.[69]

Another four engravings record the rest of the first day's events. As with the equestrian ballets in the Medici performances, the display of chivalric skill by the ruler and his knights was a key part of the performance. In *The Pleasures of the Enchanted Isle* the king and his knights performed in character, as is underlined by the inscription on the engraving (figure 10.06), which reads: "Running (or tilting at the ring) contested by the King and his knights, who represent Ruggiero and the other knights enchanted on the Isle of Alcina." In Silvestre's engraving we can see the empty chair in the center of the audience where the king is no longer sitting. This illustrates the fluid movement between spectator and performer, as does the engraving (figure 10.07) of the banquet where we see the king, his brother the duc d'Orléans, and the women of the court seated at a banquet while the male courtiers stand and watch. The servants carrying the plates are dressed as shepherds and shown in formation, like dancers upon a stage. It is

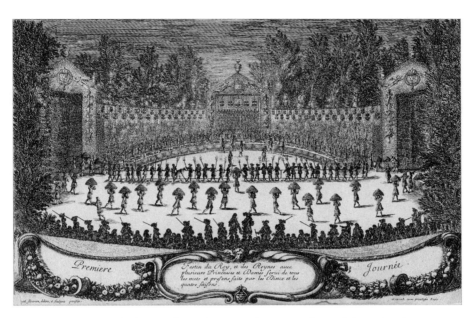

Figure 10.07. Israel Silvestre, "Première Journée—Festin du Roy," from *Les plaisirs de l'isle enchantée*, 1674. Etching, 28 × 41.5 cm. The New York Public Library Digital Collections.

impossible to look at an image like this and make any meaningful distinction between spectators and spectacle; these images emphasize the fact that the entire court was on display as part of the fête.

Only one event from the second day was illustrated by Silvestre, the performance of Molière's play *The Princess of Elis* (*La Princesse d'Elide*) (figure 10.08). Although the play itself does not continue the story of Alcina and Ruggiero, it was absorbed into that narrative on the conceit that it had been ordered by Alcina to entertain Ruggiero.[70] The play was performed, as was customary, with a number of interludes throughout, which extended the story of Alcina and Ruggiero.[71] The engraving shows the stage that was set up at an intersection of walkways in the garden where Vigarani had designed a theater of greenery. The walls were formed by the hedges of the allée, and the ceiling was made from draped canvas, which kept the wind away from the many torches set up to light the stage. The king can be seen in the privileged position in the center of the audience. Most members of the noble audience are seated perpendicular to the king, which suggests that they were expected to observe a double spectacle, that of Molière's play and of the king himself. The orchestra can be glimpsed hidden away behind a partition stretching across the middle ground of Silvestre's composition, and it is unclear to what extent the musicians would have been visible

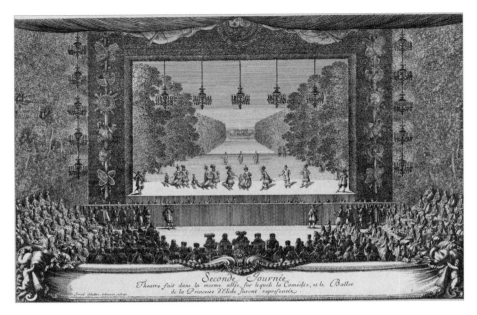

Figure 10.08. Israel Silvestre, "Seconde Journée—Performance of the Princesse d'Elide," from *Les plaisirs de l'isle enchantée*, 1674. A nineteenth-century print after the 1673 etching by Silvestre. Steel engraving, 27.8 × 42.3 cm. The New York Public Library Digital Collections.

to the audience. On other occasions, musicians were expected to be invisible, as during the promenades of Versailles, when members of the court orchestra were often hidden within palisades to perform music as the king approached.[72] The effect made the music seem to be magical, as though it was an inherent part of the garden environment. Silvestre's print suggests that the music for *The Princess of Elis* may have been similar. The reality may be that the musicians were completely hidden and that Silvestre altered his depiction in order to indicate the presence of the orchestra. An eyewitness account by Jacques Carpentier de Marigny (1615–70) hints at this idea: "The plan of this second fête was that Ruggiero and his knights—after having accomplished marvels at the courses which, by order of the beautiful *magicienne*, they had performed in honour of the Queen—continued in this same design for the following divertissement. The floating island having not yet gone away from the coast of France, they gave to his majesty the pleasure of a comedy whose location was Elide [Elis]."[73] If the musicians were entirely hidden, and the music seemed to come from nowhere, it created an illusion that would have fitted perfectly with the conceit of the event's binding narrative: that all the audience saw and enjoyed was an illusion of the enchantress Alcina.

The location of the theater also seems to have been designed to heighten the feeling that there was no clear distinction between the real world and the fantasy world of Alcina. The official description states: "When the night of the second day had come, their Majesties betook themselves into another round space surrounded by palisades like the first, on the same line, always advancing towards the lake, where it was pretended that the palace of Alcina was built."[74] This closely corresponds to Marigny's description, he does not give an exact location but mentions that "a great theatre was erected, about a hundred paces below the circle where the knights had run the courses."[75] It seems likely that this refers to the area at the very end of the allée, between the parterre and the *tapis vert*. The official description emphasizes several times that each performance site moved the entertainments of the fête away from the chateau and toward the Grande Rondeau. This makes it likely that the audience for the play would have been positioned on the central allée, looking toward the next performance site, the large pond where the Palace of Alcina had been erected.[76] On close inspection, it is possible to make out the outline of the basin where the palace was located and also the U-shaped form of the palace of Alcina, which differs from the long, even facade of the old chateau, visible in the title page of the booklet. As the performance was held at night, it is possible that an illuminated, painted backdrop was used that imitated the real view.[77] In which case, the distinction between reality and artifice was again blurred through the use of a fictive representation of the physical landscape. Regardless of whether the backdrop was painted or real, the effect upon the audience at the fête and on the audience of the prints is essentially the same. The stage for the play appears to be suspended between the "real" space of the audience and the "real" space of the garden beyond, as though it were something conjured up by Alcina. The traditional separation of audience and performer is gone, as has any clear distinction between the fictional world occupied by the characters and the real world occupied by the audience.

The fête culminated with the finale of the Alcina and Ruggiero story on the third day and the "destruction" of the enchanted isle and its castle. After dark the audience assembled at the end of the Allée Royale on the rim of the pond (the aforementioned Grande Rondeau), where Vigarani had built a chain of rocky islands and a palace upon the water.[78] Silvestre's engraving shows a view of the basin, palace, and assembled audience (figure 10.09). Two large screens have been erected on the two opposite sides of the basin, angled toward the palace in the center, which draw the audience members' eyes toward the palace. The effect is similar to the view that would have been afforded the audience members in the opposite direction, if they turned their heads to look back toward Ver-

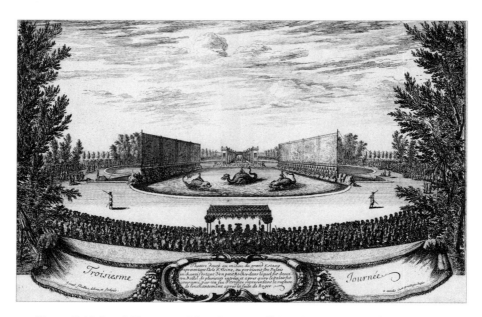

Figure 10.09. Israel Silvestre and Jean Lepautre, "Troisième Journée—Theatre dressé au milieu du grand Estanq representant l'Isle d'Alcine," from *Les plaisirs de l'isle enchantée*, 1674. Etching, 28 × 42 cm. The New York Public Library Digital Collections.

sailles, where the long lines of clipped hedges would have looked like stage flats. The description informs us that the audience heard a concert of music by Lully (the musicians are seated along the inward-facing sides of the tapestry walls), after which Alcina appeared on a barge sailing across the lake, a move that apparently both startled and impressed the audience.[79] After Alcina and the nymphs had sung verses in honor of the two queens, the sea monsters turned and swam toward the palace, which opened to reveal its interior.[80] A ballet was danced by Alcina's retinue of dwarfs, Moors, giants, and demons until Ruggiero (no longer played by the king) arrived and a battle between his knights and Alcina's minions ensued. Ruggiero's possession of a magic ring ensured his victory, and the palace was destroyed in a blaze of fireworks (figure 10.10).[81]

Marigny emphasized the striking effect of the fireworks display thus: "Never was there seen a more pleasant conflagration: the air, the earth, and the water were covered with flying flares; a thousand coils of flame lanced out from the island over the spectators."[82] He goes on to describe the audience's reaction as one of wonder, observing that "it would have been believed that it was the creation of Vigarani had we not been forewarned that it was an enchantment of Alcina."[83] Marigny's description, perhaps intentionally tongue in cheek, suggests a very subtle conceit in regard to illusion and the marvelous effects. Mari-

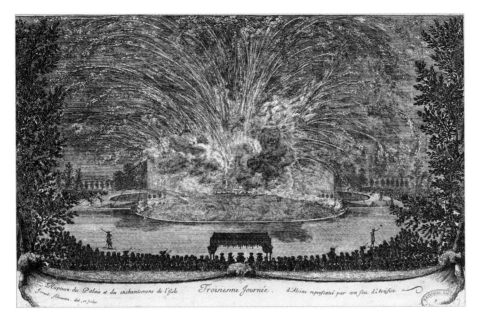

Figure 10.10. Israel Silvestre, "Troisième Journée—rupture du palais et des enchantements de l'île," from *Les plasiris d'îsle enchantée*, 1664. Etching and engraving, 27.8 × 42.5 cm. British Museum, London, 1889,1218.139.

gny implies that when the audience witnessed something wondrous they naturally supposed that the effect was created by the set designer, Vigarani. The audience then discovers, however, that it is actually Alcina who has deceived them into thinking it was a real-world wonder, rationally explicable as the work of a stage designer, whereas it is *really* a magical enchantment.

This destruction of the enchanted palace, and Silvestre's evocative image of it, may well have been understood as being directed at the recently deposed figure of Fouquet, and the final set representing a palace floating upon water a deliberate evocation of Vaux-le-Vicomte. A visitor to Vaux who has walked behind the large square pool at the end of the lawn parterre and turns to look back at the chateau sees the chateau reflected in the water as though it were sitting atop the pool itself.[84] This was a deliberate and conspicuous feature of the design (the reflection seems implausible given the distance between the pool and chateau), and the assembled courtiers may have been made aware of it when they visited Vaux. The view of Alcina's palace floating upon the Grande Rondeau can be read as a direct reference to Vaux-le-Vicomte, Jean Loret (1595?–1665), who had been a guest at Fouquet's fête and had penned a poem that presented Vaux as superior to the enchanted palaces invented by Ariosto and Tasso.[85] Alcina's palace was utterly destroyed in the explosion of fireworks, a symbolic destruction of Vaux.

The arrogance and audacity of Fouquet was represented by the pride of the enchantress Alcina, both of whom were permitted to entertain the king only briefly and both of whom were ultimately destroyed.

This finale also has important implications for the continued experience of the landscape at Versailles. A disjunction would have been present between the audience's observation of the destruction of the enchanted island and palace of Alcine, which in Ariosto's narrative is replaced by a barren wasteland, and the "permanent enchantment" of the gardens of Versailles. The court could have turned from the sight of the destroyed palace and seen at the other end of the Allée Royale the chateau of Versailles, in which Louis XIV played the role of creator, not of false and temporary enchantments like those by the sorceress Alcina, but of real and permanent ones. The permanent enchantment of Versailles was, after 1684, the place where the aristocracy was removed, like Ruggiero, from the world stage. At Versailles members of the aristocracy could parade their noble superiority but were constrained from doing much more than that. The garden was a pleasant retreat, but it also disempowered all but its creator, the ultimate power lying with those who possessed the power to create illusions. In her account *Promenade de Versailles* published a few years after the fête, Madeleine de Scudéry (1607–1701) frequently mentions enchantment. Of visiting the grotto she writes: "It is not possible, the first time that one sees such a beautiful thing, not to doubt what one sees and not to imagine that it is an enchantment. The eyes are delighted, the ears are charmed, the mind is astonished, and the imagination is overwhelmed."[86]

The integration of the audience with the fictional space is more marked at Versailles than in the case of the performances held at the Buen Retiro and in Florence. At Versailles the audience moved between different performance areas. The king was both performer and spectator, as were the courtiers who participated in the chivalric displays. Marigny frequently alludes to the idea that Versailles is a "thing enchanted," a theme also taken up in the official description by André Félibien (1619–95) of this and subsequent fêtes. In a description of the divertissement held to celebrate the capture of the Franche-Comté for France in 1674 he writes, "There is no one who does not believe that everything is accomplished there through miracles."[87] Félibien's description of the fête at Versailles echoes the descriptions of the enchanted garden of Armida in Tasso's *Jerusalem Delivered*: "L'arte, che tutto fa, nulla si scopre"—"The art which made it all, cannot be discovered."[88] During the fête the entire gardens were like an interactive set. The use of the garden as a stage for these performances transformed the experience into one that involved all the senses and stimulated the imagination to further engage with the garden beyond simple aesthetic appreciation.[89] The records of the fête set this idea of the experience of the garden as

enchanted down for future visitors, and the theme is introduced in other descriptions and guidebooks to the gardens.[90]

Conclusion

Each of the performances discussed here was a product of the specific musical and artistic culture of its particular court and ruler, yet they are clearly linked. The most direct link is between the Florentine and Spanish performances. Cosimo Lotti was present in Florence for *The Liberation of Alcine from the Island of Ruggiero* in 1625, and ten years later he created *Love, the Greatest Enchantment* in Spain. Louis XIV's fête in 1664 responded to both (and arguably surpassed both in terms of its skillfully engineered political symbolism). The French court had close relations with the Medici in Florence (Marie de' Medici [1575–1642] was the grandmother of Louis XIV) and with the Hapsburgs in Spain (Louis XIV's wife was the daughter of Philip IV). These performances were never directed only toward those actually in attendance. They were intended as grand diplomatic displays. Ambassadors and other foreign dignitaries were always in the audience, and correspondence between the courts reveals that performances and fêtes were of great interest and frequently reported upon in great detail.[91] For example, Cardinal Flavio Chigi (1631–93) arrived in France as a papal envoy shortly after the 1664 fête and was shown a reprisal of *The Princess of Elis* at Fountainbleau and taken to visit Versailles and Vaux-le-Vicomte. Despite not being at the fête itself, the idea of it evidently left such an impression on Cardinal Chigi that in 1668 he staged a performance in the gardens of the Chigi villa in Rome that was closely based on *The Pleasures of the Enchanted Isle*.[92]

The enchantress narrative that connects these performances had potential for both particular and general political symbolism. The performances were part of the wider practice in seventeenth-century Europe of using grand displays and performance as a political tool. But they also served to make a particular statement about each court and its relationship with the landscape of the pleasure garden. While the narratives of these performances presented an ideal of the garden as a place of escape that nurtured the arts of pleasure and love, they also made a potent statement about the power of the ruler who had created a "miraculous" garden.[93] Each of these performances served to inaugurate a new, or newly redesigned, garden. These newly designed landscapes were in many cases also a new type of princely garden, on a new scale and intended for the extensive use of the court as well as the prince. The narrative is therefore symbolic of the creation of the gardens themselves. These new types of princely landscapes came with their own creation myth; the trope of the enchantress

would continue to shape responses to gardens even after the performance was over. The stories played out on the garden stage, on which the spectator could then wander around and reenact, or at least reimagine them, could even be read as a set of instructions on how to experience these new courtly gardens. The spaces in princely landscapes provided necessary respite for members of the court and allowed them to retreat from the world, but responsibilities were never to be forgotten; the passions and the senses were to be indulged but not given free reign.

Notes

1. On these ideas see Eugenio Battisti, "*Natura Artificiosa* to *Natura Artificialis*," in David R. Coffin, ed., *The Italian Garden* (Washington, DC: Dumbarton Oaks, 1972), 14–15.

2. On the seventeenth- and eighteenth-century princely garden in Europe see the excellent overview in Michel Conan, "Garden Displays of Majestic Will," in Henry A. Millon, ed., *The Triumph of the Baroque: Architecture in Italy 1600–1750* (New York: Rizzoli, 1999), 279–313. See also Peter Burke, *The Fortunes of the Courtier: The European Reception of Castiglione's* Cortegiano (Cambridge: Polity Press, 1995), 147, on the change in the way villas and gardens were named (and therefore understood) in the early modern period in Europe.

3. It is worth noting that from the very earliest operas around the turn of the seventeenth century the stories of these enchantresses became popular narratives, much more so than they had been for plays in the century when they were first published. For a list of operas and other works based on Tasso and Ariosto, see Alfred Einstein, "*Orlando Furioso* and *La Gerusalemme Liberata*: As Set to Music During the 16th and 17th Centuries," *Notes (Music Library Association)* 8 (1951): 623–30.

4. On these ideas about the garden as a virtual space, see John Dixon Hunt, *The Afterlife of Gardens* (London: Reaktion Books, 2004), 36–46.

5. Michel Conan, "Methods and Perspectives for the Study of Gardens and Their Reception," in Conan, ed., *Gardens and Imagination: Cultural History and Agency* (Washington, DC: Dumbarton Oaks Research Library and Collection, 2008), 3–10.

6. Conan, "Methods and Perspectives," 10.

7. Kristiaan P. Aercke, *Gods of Play: Baroque Festive Performances as Rhetorical Discourse* (Albany: State University of New York Press, 1994); José Antonio Maravall, *Culture of the Baroque: Analysis of a Historical Structure* (Minneapolis: University of Minnesota Press, 1986).

8. Examples of permanent features include the grotto at the Palazzo del Te, Mantua, discussed in Ugo Bazzotti, "Storie di Alcina nella grotta di Palazzo Te," in Wolfgang Liebenwein and Anchise Tempestini, eds., *Gedenkschrift für Richard Harpath* (Munich: Deutscher Kunstverlag, 1998), 24–32; and the Sacro Bosco at Bomarzo, for which see Jessie Sheeler, *The Garden at Bomarzo: A Renaissance Riddle* (London: Frances Lincoln, 2007), 47–48. For a discussion of the idea of the enchanted garden in literary descriptions, see Michel Conan, "Friendship and Imagination in French Baroque Gardens Before 1661," in Conan, ed., *Baroque Garden Cultures: Emulation, Sublimation, Subversion* (Washington, DC: Dumbarton Oaks Research Library and Collection, 2005), 323–84.

9. On the impartiality of festival documentation see, for instance, Claire Goldstein, *Vaux and Versailles: The Appropriations, Erasures, and Accidents That Made Modern France* (Philadelphia: University of Pennsylvania Press, 2008), 157; Helen Watanabe O'Kelly, "Early

Modern European Festivals—Politics and Performance, Event and Record," in J. R. Mulryne and Elizabeth Goldring, eds., *Court Festivals of the European Renaissance: Art, Politics and Performance* (Aldershot: Ashgate, 2002), 15–25.

10. Angelo Solerti, *Musica, ballo e drammatica alla corte medicea dal 1600 al 1637* (Florence: R. Bemporad e Figlio, 1905), 180–83. The printed images of the performance are reproduced in Arthur Blumenthal, *Theatre Art of the Medici* (Hanover, NH: University Press of New England, 1980), 135–37. The performance has also been studied from a view of female patronage; see Kelley Ann Harness, *Echoes of Women's Voices: Music, Art, and Female Patronage in Early Modern Florence* (Chicago: University of Chicago Press, 2006), 152–62, and Suzanne G. Cusick, *Francesca Caccini at the Medici Court: Music and the Circulation of Power* (Chicago: University of Chicago Press, 2009), chap. 9.

11. It seems likely that its form was similar to a *balletto a cavallo,* which was a type of short musical work that usually preceded equestrian ballets. The equestrian ballet was likely considered as important a part of the *festa* as the opera itself, if not more so, as suggested by the great effort and considerable expense that the archduchess went to in order to procure a large number of well-trained horses; see Harness, *Echoes of Women's Voices,* 152–53n34.

12. This is recorded by the court diarist Cesare Tinghi; see the transcription in Solerti, *Musica, ballo e drammatica,* 181. The archduchess wished to arrange a marriage between her daughter and Prince Władysław, and the narrative also speaks to this, highlighting the need to make the right alliance; see Harness, *Echoes of Women's Voices,* 163.

13. The score and libretto have been reissued in a facsimile edition; see Francesca Caccini, *La liberazione di Ruggiero dall'Isola di Alcina* (Florence: Studio per Edizioni Scelte, 1998). On Caccini and the Medici, see Cusick, *Francesca Caccini at the Medici Court.* The use of the two sources is traced in Harness, *Echoes of Women's Voices,* 153–54.

14. Blumenthal, *Theatre Art of the Medici,* 138, suggests that it was probably a collaboration for which Giulio allowed his young son full credit. See Solerti, *Musica, ballo e drammatica,* 183, for Tinghi's account.

15. Harness, *Echoes of Women's Voices,* 43–61.

16. Harness, *Echoes of Women's Voices,* 44–45.

17. The drawing is in the Victoria and Albert Museum, E.1187–1931. On this performance see James M. Saslow, *The Medici Wedding of 1589: Florentine Festival as* Theatrum Mundi (New Haven: Yale University Press, 1996), 209–11.

18. Luigi Zangheri, *Pratolino, il giardino delle meraviglie: Testi e documenti* (Florence: Gonnelli, 1979). There is a drawing recording the mountain by Giovanni Guerra in the Graphsiche Sammlung of the Albertina in Vienna.

19. Blumenthal, *Theatre Art of the Medici,* 47–49.

20. When sets were recorded, the depictions usually did not show the entire theater; see, for example, the engravings of sets by Giulio Parigi; for *The Judgment of Paris* performed in 1608, see Arthur Blumenthal, "Giulio Parigi's Stage Designs: Florence and the Early Baroque Spectacle" (Ph.D. diss., New York University, 1984), 128.

21. Blumenthal, *Theatre Art of the Medici,* 144.

22. See Tinghi in Solerti, *Musica, ballo e drammatica,* 182.

23. The space had been used for performances already, but with temporary seating; see Michel Baridon, *A History of the Gardens of Versailles* (Philadelphia: University of Pennsylvania Press, 2008), 208, and Blumenthal, *Theatre Art of the Medici,* 42, 109–11.

24. This story is found in canto 6 of Tasso's *Gerusalemme Liberata*; see Torquato Tasso, *Jerusalem Delivered / Gerusalemme liberata,* trans. Anthony M. Esolen (Baltimore: Johns Hopkins University Press, 2000). The spectacle was recorded in Ferdinando Bardi, *Descrizione delle feste fatte in Firenze per le reali nozze de serenissimi sposi Ferdinando Il. Gran*

Duca di Toscana, e Vittoria Principessa d'Urbino (Florence: Zanobi Pignoni, 1637), 36–51. See also the discussion in Blumenthal, *Theatre Art of the Medici*, 179.

25. The wide dissemination of these spectacles to an audience beyond Florence was intended; see Saslow, *The Medici Wedding of 1589*, 15–16.

26. Bardi, *Descrizione della festa*, 38.

27. Bardi, *Descrizione della festa*, 38.

28. Bardi, *Descrizione della festa*, 38–39.

29. Bardi, *Descrizione della festa*, 42.

30. Bardi, *Descrizione della festa*, 38–39.

31. Susan James, *Passion and Action: The Emotions in Seventeenth-Century Philosophy* (Oxford: Oxford University Press, 1999), 1.

32. Stefano della Bella, who engraved many of the Medici festivals, subsequently worked in France for more than ten years, from 1639 until 1650. Michel Baridon also points out that Marie de' Medici, especially after she became regent, imported many ideas and traditions from Florence into the French court; Baridon, *A History of the Gardens of Versailles*, 16.

33. For a description of the play as put together from various accounts see N. D. Shergold, *A History of the Spanish Stage: From Medieval Times Until the End of the Seventeenth Century* (Oxford: Clarendon Press, 1967), 280–84, and Aercke, *Gods of Play*, 139–64. Shergold (284) notes that the Maria Luisa Caturla claims to have found documents pertaining to the performance of "Los encantos de Circe" in the Archivo de Protocolos in Madrid, but it is not clear if these have ever been published. See also the two accounts by Florentine diplomats reproduced in Shirley B. Whitaker, "Calderón's *El mayor encanto, amor* in Performance: Eyewitness Accounts by Two Florentine Diplomats," in Manuel Delgado, ed., *The Calderonian Stage: Body and Soul* (Lewisburg: Bucknell University Press, 1997), 81–104.

34. The letter has been published in L. Rouanet, "Un autographe inédit de Calderon," *Revue hispanique* 6 (1899): 186–200, and is also discussed in Jonathon Brown and J. H. Elliot, *A Palace for a King: The Buen Retiro and the Court of Philip IV*, 2nd ed. (New Haven: Yale University Press, 2003), 47. Lotti's work in Spain is recorded in Vincenzo Carducho, *Diálogo de la pintura* (Madrid: Francesco Martinez, 1633), 152–53. See also Shergold, *A History of the Spanish Stage*, 275–76, and Silvio D'Amico and Sandro D'Amico, *Enciclopedia dello spettacolo* (Rome: Unedi-Unione, 1975), 6:1671–73.

35. Shergold, *A History of the Spanish Stage*, 26.

36. See the biography in Filippo Baldinucci, *Notizie de' professori del disegno da Cimabue in Qua*, Eurografica S.p.A., Florence (Florence: V. Batelli, 1847), 5:7–15. A letter from the Florentine designer Giulio Caccini (1551–1618, father of Francesca, who wrote the music for *La liberazione*) to the secretary of the Grand Duke Andrea Cioli (1573–1641) records that Lotti provided the sets for a performance of *Andromeda* by Cicognini; see D'Amico and D'Amico, *Enciclopedia dello Spettacolo*, 6:1672. Whitaker, "Calderón's *El mayor encanto*," 83, alludes to the fact that Lotti was hired to assist the Spanish court to devise spectacles on the level of those in Florence. See also Ariel Núñez Sepúlveda, "El sueño de Ulises: La visión onírica en 'El mayor encanto, amor' de Calderón," *Revista chilena de literatura* 102 (2020): 61–82.

37. Whitaker, "Calderón's *El mayor encanto*," 88–90, and A. Bartlett Giamatti, *The Earthly Paradise and the Renaissance Epic* (Princeton: Princeton University Press, 1966), 6.

38. The full sentence reads: "Avunque esta trazada con mucho ynjenio, la traza de ella no es representable por mirar mas a la ybencion de las tramoyas que al gusto de la representación." Translation from Shergold, *A History of the Spanish Stage*, 280.

39. On the use of the Great Lake for performance, see David Sánchez Cano, "*Naumachiae* at the Buen Retiro in Madrid," in Margaret Shewring and Linda Briggs, eds., *Waterborne Pageants and Festivities in the Renaissance* (Ashgate: Farnham, 2013), 313–28.

40. Shergold, *A History of the Spanish Stage*, 280.

41. Lotti had already designed machinery that would move "ships" across water for Lope de Vega's *La selva sin amor* performed before the king and queen in 1629. Shergold, *A History of the Spanish Stage*, 276.

42. The techniques for achieving special effects such as these are detailed in several treatises from the same time, including Nicola Sabbattini, *Pratica di fabricar scene e machine ne' teatri* (Ravenna: Per Pietro de' Paoli e Gio. Battista Giouannelli stampatori, 1638); on how to create thunder and lightning, see 156–59.

43. Bernardo Monanni in a letter dated 4 August 1635, Archivio di Stato, Florence, Mediceo, filza 4960. The original text reads: "Non si è fatto cosa meglio in Spagna da un gran tempo in qua. Et Cosimo Lotti inventore et direttore delle machine et dei concetto ha dato sodisfazzione." Author's translation.

44. On the role of wonder and special effects in the creation of political power in this period in Spain see Maravall, *Culture of the Baroque*: "Capacity to transform the order of the universe, however fleeting it might have been, showed overwhelmingly the greatness of whoever had so much power over natural and human resources as to achieve such effects" (247).

45. Frederick A. De Armas, *The Return of Astraea: An Astral-Imperial Myth in Calderón* (Lexington: University Press of Kentucky, 1986), and Margaret Rich Greer, "Art and Power in the Spectacle Plays of Calderón de La Barca," *PMLA* 104 (May 1989): 329–39.

46. De Armas, *The Return of Astraea*, 144; Greer, "Art and Power in the Spectacle Plays," 332; and Cano, "*Naumachiae* at the Buen Retiro," 314.

47. For example, the nun María de Ágreda, who maintained a correspondence with the king that included regular criticism of the monarchy; Greer, "Art and Power in the Spectacle Plays," 330. See also Brown and Elliot, *A Palace for a King*, 32–33, 234–35.

48. Brown and Elliot, *A Palace for a King*, 206.

49. De Armas, *The Return of Astraea*.

50. On this issue in the court of Philip IV, see Maravall, *Culture of the Baroque*, 245.

51. This reading is suggested by Sebastian Neumeister, "*El mayor encanto, amor*, de Calderón: Aspectos lúdicos," *Bulletin of Spanish Studies: Hispanic Studies and Researches on Spain, Portugal and Latin America* 90 (2013): 807–19.

52. On the giant see Brown and Elliot, *A Palace for a King*, 207.

53. Barbara von Barghahn, "The Pictorial Decoration of the Buen Retiro Palace and Patronage During the Reign of Philip IV" (Ph.D. diss., New York University, 1979), 82; and Shergold, *A History of the Spanish Stage*, 360–82.

54. Louise K. Stein, *Songs of Mortals, Dialogues of the Gods: Music and Theatre in Seventeenth-Century Spain* (Oxford: Clarendon Press, 1993), 105.

55. The story of Fouquet's downfall is well known; see, for example, Charles Drazin, *The Man Who Outshone the Sun King* (London: William Heinemann, 2007), and Goldstein, *Vaux and Versailles*, 31, 34–40. The text of Molière's play survives, as do descriptions by Jean de La Fontaine and Jean Loret; see Per Bjurström, *Giacomo Torelli and Baroque Stage Design* (Stockholm: Almsquist och Wiksell, 1962).

56. Torelli coordinated the festivities, a position others had declined, possibly because they were aware of Fouquet's precarious position at court; Bjurström, *Giacomo Torelli*, 180.

57. Goldstein, *Vaux and Versailles*, 51, observes that at Vaux the play was about self-mockery but at Versailles the performance consisted of the king mocking his courtiers. See also John S. Powell, *Music and Theatre in France 1600–1680* (Oxford: Oxford University Press, 2000), 152–59.

58. Marie-Christine Moine, *Les fêtes à la cour du Roi Soleil, 1653–1715* (Paris: Fernand Lanore, 1984), 145, states that this fête entertained six hundred, while the later fêtes entertained up to fifteen hundred.

59. Ludovico Ariosto, *Orlando Furioso: An English Prose Translation*, trans. Guido Waldman (Oxford: Oxford University Press, 1974), cantos 6:33–8:21, 54–72.

60. The French fascination with linking gardens in general with enchantment and its connections to literature are discussed in Michel Conan, "Friendship and Imagination," 356–62, and more recently in Mary D. Sheriff, *Enchanted Islands: Picturing the Allure of Conqest in Eighteenth-Century France* (Chicago: University of Chicago Press, 2018), 70–73.

61. Jean-Baptiste Poquelin Molière, *Oeuvres complètes* (Paris: Le Pléiade, 1959), 1:603–4. Translation from Baridon, *A History of the Gardens of Versailles*, 193.

62. Edmond Lemaitre, "Les sources des *Plaisirs de l'Isle Enchantée*," *Revue de Musicologie* 77 (1991): 187–200. Several digital editions of the original booklets are now available. For example, Isaac de Benserade, *Les plaisirs de l'isle enchantée* (Paris: L'Imprimerie Royale, 1673), via the Bibliotheque nationale de France's Gallica repository, https://gallica.bnf.fr/ark:/12148/btv1b8626216h, accessed 1 August 2021.

63. André Félibien, Israel Silvestre, and Francois Chauveau, *Les plaisirs de l'isle enchantée. Course de bague; collation ornée de machines; comedie, meslée de danse et de musique; ballet du palais d'Alcine* (Paris: Sebastien Mabre-Cramoisy, 1674).

64. Israel Silvestre, "Préparatif de decoration d'un basin du parc de Versailles," Département des arts graphiques, Musée du Louvre, Paris, RF 4951, recto.

65. Félibien, Silvestre, and Chaveau, *Les plaisirs de l'isle enchantée*, 4.

66. Helen Watanabe-O'Kelly, "The Early Modern Festival Book: Function and Form," in J. R. Mulryne, Helen Watanabe-O'Kelly, and Margaret Shewring, eds., *Europa Triumphans: Court and Civic Festivals in Early Modern Europe* (Aldershot: Ashgate, 2004), 3–18.

67. Félibien, Silvestre, and Chaveau, *Les plaisirs de l'isle enchantée*, 81.

68. The creation of this "set" is described in Molière, *Oeuvres complètes*, 1:603–4.

69. Michael Brix, *The Baroque Landscape: André Le Nôtre and Vaux Le Vicomte*, trans. Steven Lindberg (New York: Rizzoli, 2004), 84–98.

70. Goldstein, *Vaux and Versailles*, 31–52, and s, *Music and Theatre in France 1600–1680*, 337–53.

71. Aercke, *Gods of Play*, 185–201, and Frederick Paul Tollini, *Scene Design at the Court of Louis XIV: The Work of the Vigarani Family and Jean Bérain* (Lewiston: Edwin Mellen Press, 2003), 44.

72. Robert M. Isherwood, *Music in the Service of the King: France in the Seventeenth Century* (Ithaca, NY: Cornell University Press, 1973), 259.

73. Jacques Carpentier de Marigny, *Relations des divertissements que le Roy a donné aux Reines dans le Parc de Versailles* (Paris, 1664). Translation from Tollini, *Scene Design at the Court of Louis XIV*, 45.

74. Félibien, Silvestre, and Chaveau, *Les plaisirs de l'isle enchantée*, 21. Author's translation.

75. Jacques Marigny, as quoted in Tollini, *Scene Design at the Court of Louis XIV*, 44.

76. Other sites have also been proposed. In her study of the fêtes of Versailles, Sabine du Crest positions the play in the Bosquet des Dômes; du Crest, *Des fêtes à Versailles: Les divertissements de Louis XIV* (Paris: Éditions aux Amateurs de Livres, 1990), 95. This does not correlate with Marigny's and Félibien's descriptions, however.

77. The official description also emphasizes the need to keep the wind away from the torches and chandeliers, hence the reason for the canvas ceiling; this would support the idea that the stage space was also closed off with a painted backdrop; Félibien, Silvestre, and Chaveau, *Les plaisirs de l'isle enchantée*, 21. The position of the performance is also discussed in Tollini, *Scene Design at the Court of Louis XIV*, 45, and Pierre-André Lablaude, *The Gar-*

dens of Versailles (London: Zwemmer, 1995), 29, who agree on the site but disagree on what is represented on the backdrop.

78. Tollini, *Scene Design at the Court of Louis XIV*, 46–47.

79. Marigny, *Relations des divertissements*, states that the audience was deeply impressed by the special effects. Also see Tollini, *Scene Design at the Court of Louis XIV*, 46.

80. Félibien, Silvestre, and Chaveau, *Les plaisirs de l'isle enchantée*, 81–85.

81. Félibien, Silvestre, and Chaveau, *Les plaisirs de l'isle enchantée*, 86–87.

82. Marigny, *Relations des divertissements*. Translation from Tollini, *Scene Design at the Court of Louis XIV*, 47.

83. Marigny, *Relations des divertissements*, 46.

84. The optical illusions at Vaux-le-Vicomte are discussed in Brix, *The Baroque Landscape*, 96, and Baridon, *The Gardens of Versailles*, 151–58.

85. The poem is translated in Conan, "Friendship and Imagination," 359–60: "O Novels, that represent / So many enchanted Palaces, / Ariosto, Amadis, Tasso, / Please, tell me, the three of you, / And you as well, Mister Maugis, / Did you invent any such dwelling, / That would compare to those of Vaux?"

86. Madeleine de Scudéry, *La promenade de Versailles* (Paris: Claude Barbin, 1669), 72. The original reads, "En effet, il n'est pas possible, la première fois qu'on voit une si belle chose, de ne douter pas de ce qu'on voit et de ne s'imaginer pas que c'est un enchantement. Les yeux sont ravis, les oreilles sont charmées, l'esprit est étonné et l'imagination est accablée." Author's translation.

87. Félibien, Silvestre, and Chaveau, *Les plaisirs de l'isle enchantée*, 5–6. Translation from Louis Marin, *Portrait of the King*, trans. Martha M. Houle (Minneapolis: University of Minnesota Press, 1988), 196.

88. Tasso, *Jerusalem Delivered* / Gerusalemme liberata, trans. Esolen, canto 15, 46.

89. Conan, "Friendship and Imagination," 358–60, notes the popularity of the works of Giovanni Battista Marino and the *Hypnerotomachia*, both of which described Venus's magical gardens on Cythera. He also mentions the fact that when Madame de Scudéry visited Versailles in 1669, she described it as enchanted but wished that "the enchanter" (the king) had been present (357).

90. Indeed, one of de Scudéry's characters notes that the very need for descriptions is because the memory of magnificence fades over time, and because the architecture "is not immortal"; de Scudéry, *La promenade de Versailles*, 8–9.

91. The correspondence between Ferdinand II de' Medici's secretary of state Andrea Cioli and the Tuscan ambassador in Spain, Averardo di Raffaello de' Medici di Castellina, frequently included reports of the performances at the Spanish court; Archivio di Stato, Florence, Mediceo filza, 4957.

92. David R. Coffin, *Gardens and Gardening in Papal Rome* (Princeton: Princeton University Press, 1991), 230–31.

93. Goldstein, *Vaux and Versailles*, 33.

Contributors

Robert Batchelor is professor of history and director of digital humanities at Georgia Southern University and author of *London: The Selden Map and the Making of a Global City* (Chicago, 2014) as well as *Ocean History* (Routledge, forthcoming). He also co-authored the board game "Fujian Trader" (2016).

Seyed Mohammad Ali Emrani is an independent scholar and architect who lives in Munich. His work focuses specifically on landscape and garden history and urban design.

John Finlay is an independent scholar based in Paris, France, and an associate member of the Centre d'études sur la Chine moderne et contemporaine (CECMC) at L'École des hautes études en sciences sociales. A specialist in the production of works of art for the Qing imperial court, his current research focuses on cultural exchanges between China and France in the eighteenth century.

Caroline Fowler is Starr Director of the Research and Academic Program at the Clark Art Institute in Williamstown, Massachusetts. A specialist in the early modern period, her research focuses on the materiality of prints and drawings, philosophies of conservation, and the archive and its absences, among other themes.

Katrina Grant is lecturer and research fellow in the Centre for Digital Humanities Research at the Australian National University. Her research focuses on the relationship between landscape and visual culture in early modern Europe and new methodologies in digital art history.

Finola O'Kane is professor at the School of Architecture, Planning and Environmental Policy, University College Dublin. She has published widely on the Irish landscape, including eighteenth-century Dublin, Irish urban and suburban history, and plantation landscapes, and is author of the prizewinning *Ireland and the Picturesque: Design, Landscape Painting, and Tourism, 1700–1840*

and *Landscape design and revolution in eighteenth-century Ireland and the United States* (Yale, 2023). In 2017 she was elected a member of the Royal Irish Academy.

Anton Schweizer is professor of art and architectural history at Kyushu University. He researches urban landscapes, site planning, architectural decoration, materiality, and depictions of architecture in Japan, 1500–1900. He also works on exchanges of objects and visual materials between Japan and the world during the First Global Age.

Larry Silver is the Farquhar Professor of Art History, emeritus, at the University of Pennsylvania. A specialist in painting and graphics of the Low Countries, he previously taught at the University of California, Berkeley, and at Northwestern University. He has served as president of the College Art Association as well as the Historians of Netherlandish Art.

Stephen H. Whiteman is reader in the history of art and architecture at The Courtauld Institute of Art, where his research and teaching focus on the visual and spatial cultures of early modern China in their transcultural contexts. Twice recipient of the John Brinckerhoff Jackson Book Prize in landscape studies, he is a past president of the Society of Architectural Historians Landscape History Chapter.

Index